PRAISE FOR
Lucky Child

"Both stories—Loung's, told in her own voice, and Chou's, narrated in the third person—are inherently fascinating and are recounted with a vividness and immediacy that make them even more so. . . . Written with an engaging vigor and directness, *Lucky Child* is an unforgettable portrait of resilience and largeness of spirit." —*Los Angeles Times*

"Deeply stirring . . . heartbreaking, and not less than brilliant."

—*Miami Herald*

"[Ung] captured my heart. . . . *Lucky Child* is captivating, deep, and delightful."
—*Chicago Tribune*

"At once elegiac and clear-eyed, this moving volume is a tribute to the path not taken." —*Vogue*

"Ung is a masterful storyteller whose fresh, clear prose shimmers with light and sorrow. Her stories are of the heroism and resilience of ordinary people beset by extraordinary tragedies. *Lucky Child* not only shares the stories of two sisters but also resonates to all of our stories in a world that, like Ung's family, is divided between the lucky and the unlucky."

—Mary Pipher, Ph.D., author of *Reviving Ophelia:
Saving the Selves of Adolescent Girls*

"*Lucky Child* is a tender, searing journey of two sisters, two worlds, two destinies. It is about the long-term consequences of war—how it changes everything, annihilates, uproots, and separates families. And it is about how humans triumph—building lives wherever they land and finding their way back to each other." —Eve Ensler, author of *The Vagina Monologues*

"Heartrending and eloquent. . . . A moving reminder of human resiliency and the power of family bonds."
—*Newsweek*

"The genocide and subjugation of millions of Cambodians under the Khmer Rouge have been well documented. . . . *Lucky Child* is a reminder that each of those terrible losses was suffered individually. . . . While [Ung] writes convincingly of terror, death, and loss—her account of the death of a young cousin in Cambodia is heartbreaking—even more fresh and perceptive are her observations of everyday life. When she looks in the mirror, she craves to see her family members, dead and alive, but 'we do not have a single picture of them and my face is now the only image I have to remember them by.' [A] fiercely honest and affecting memoir."
—*Seattle Times*

"Remarkable. . . . *Lucky Child* is part adventure, part history, and, in large, part love story about family. The Ungs' tenacity and enduring kindness testify to the very best of human nature. After surviving 'the worst kind of inhumanity,' the Ungs remain human."
—*Cleveland Plain Dealer*

"Ung brings third and first world disparities into discomforting focus and gracefully dramatizes the metaphorical joining together of her haunted past and her current identity as a privileged Cambodian American. When the narratives fuse at the sisters' long-awaited reunion, their clasping of hands throws wide the floodgates to tamped-down memories—a cathartic release that readers will tearfully, gratefully share."
—*Booklist* (starred review)

"This book is alternately heart-wrenching and heartwarming, as it follows the parallel lives of Loung Ung and her closest sister, Chou, during the fifteen years it took for them to reunite."
—*Publishers Weekly* (starred review)

lucky child

Also by Loung Ung

First They Killed My Father:
 A Daughter of Cambodia Remembers

lucky child

a daughter of cambodia reunites
with the sister she left behind

LOUNG UNG

HARPER PERENNIAL

NEW YORK • LONDON • TORONTO • SYDNEY

HARPER ● PERENNIAL

A hardcover edition of this book was published in 2005 by HarperCollins Publishers.

P.S.™ is a trademark of HarperCollins Publishers.

HarperCollins books may be purchased for educational, business, or sales promotional use. For information please write: Special Markets Department, HarperCollins Publishers, 10 East 53rd Street, New York, NY 10022.

FIRST HARPER PERENNIAL EDITION PUBLISHED 2006.

Book and insert design by Barbara DuPree Knowles, BDK Books, Inc.

The Library of Congress has catalogued the hardcover edition as follows:
 Ung, Loung.
 Lucky child : a daughter of Cambodia reunites with the sister she left behind / Loung Ung.—1st ed.
 p. cm.
 Includes bibliographical references.
 ISBN 0-06-073394-2 (alk. paper)
 1. Ung, Chou. 2. Ung, Chou—Family. 3. Cambodian Americans—Biography. 4. Refugees—United States—Biography. 5. Sisters—United States—Biography. 6. Sisters—Cambodia—Biography. 7. Cambodia—Biography. 8. Political atrocities—Cambodia—History—20th century. I. Title.
 E184.K45U54 2005
 973'.049593'0092—dc22
 [B] 2004054346

ISBN-10: 0-06-073395-0 (pbk.)
ISBN-13: 978-0-06-073395-7 (pbk.)

 12 13 NMSG/RRD 10 9

To the Khmer people—for theirs are not only the voices of war, but testimonies of love, family, beauty, humor, strength, and courage.

To Ma and Pa, you are my angels. To my sisters Keav and Geak, I will forever remember you. To my brothers Meng, Khouy, Kim, and sister Chou, thank you for inspiring me to live my life with dignity and grace. My deep gratitude to my sister-in-law Eang Tan, who nurtured and raised me, and to Huy-Eng, Morm, and Pheng; thank you for a lovely and amazing new generation of Ungs.

acknowledgments

To Bobby Muller, my boss, mentor, and friend; Bruce Springsteen's description of you is right on—you are a "cool rocking daddy!" To my hero, Senator Patrick Leahy, thank you for making this world a better place for all of us. Mark Perry, you are a great teacher. Tim Rieser, you are a true prince. And, Emmylou Harris—who not only sings like an angel but has a heart of one—thank you for all your support with VVAF.

To my wonderful agent, Gail Ross, at Gail Ross Literary Agency, my fantastic editor, Gail Winston, at HarperCollins, and the talented Christine Walsh and always cool Katherine Hill, thank you for all your support and encouragement. To the super team of George Greenfield and Beth Quitman at Creativewell, Inc., thank you for helping me to spread the word about the Khmer Rouge. Finally, my deep gratitude to the absolutely fabulous Jenna Free—my reader, teacher, and cheerleader. There would be no *Lucky Child* without you all.

I am also blessed to have so many amazing people in my life both in Cambodia and America, without whom I would not be who I am today. A special thank-you to Lynn and Gordon, for giving life to such wonderful people. My love to all of the Priemers because there is no bad apple in the bunch. To the Costellos, the Lucentis, the Willises, the Aleiskys, the Bunkers, Beverly Knapp, Ellis Severence, and all my friends and teachers

in Vermont—all of you helped to heal the hate and hurt out of this war child. To my friends Nicole Bagley, Wendy Appel, Michael Appel, Roberta Baskin, Joanne Moore, Tom Wright, Ly Carbonneau, Beth Poole, Rachel Snyder, Colleen Lanzaretta, Carol Butler, Erin McClintic, Chivy Sok, Kelly Cullins, John Shore, Noel Salwan, Sam McNulty, Paul Heald, Ken Asin, Mike Thornton, Lynn Smith, Jeannie Boone, Jess and Sheri Kraus, Chet Atkins, Terry and Jo-Harvey Allen, Bob Stiller, Youk Chhang, Heidi Randall, and many others—you all inspire me to be a better person. To Maria and Tori, I love you infinity. And most of all to my husband, Mark—I'm a happier person because you've kept me laughing all these years.

To the wonderful communities at Saint Michael's College and Essex Junction, Vermont—a place where the beauty of the foliage is matched only by the kindness of the people.

contents

preface

From 1975 to 1979—through execution, starvation, disease, and forced labor—the Khmer Rouge systematically killed an estimated two million Cambodians, almost a fourth of the country's population. Among the victims were my parents, two sisters, and many other relatives. *First They Killed My Father: A Daughter of Cambodia Remembers* (HarperCollins Publishers, 2000) tells the story of survival, my own and my family's. *First* was born out of my need to tell the world about the Cambodian genocide.

As a child I did not know about the Khmer Rouge, nor did I care anything about them. I was born in 1970 to an upper-middle-class Chinese-Cambodian family in Phnom Penh, the capital of Cambodia. Until the age of five, my life revolved around my six siblings, school, fried crickets, chicken fights, and talking back to my parents. When Pol Pot's communist Khmer Rouge stormed into the city on April 17, 1975, my charmed life came to an end. On that day, Cambodia became a prison and all its citizens prisoners.

Along with millions of other Cambodians, my family was forced to evacuate the city, leaving behind our home and all our belongings. For three years, eight months, and twenty-one days, we were made to live in villages more akin to labor camps, where every day was a Monday and every Monday was a workday, no matter if you were six or sixty. Inside our prison, our former life—religion, school, music, clocks, radio, movies, and TV—was banned. Rules and laws were enacted to control our travels,

friendships, and relationships, familial or otherwise. The Khmer Rouge dictated how we could dress, speak, live, work, sleep, and eat.

From dawn until dusk, we dug trenches, built dams, and grew crops. As our stomachs ballooned from hunger, the Khmer Rouge soldiers with their guns guarded the fields to prevent us from stealing. No matter how hard we worked, we were never rationed enough food to eat. We were always hungry and on the verge of starvation. To survive we ate anything that was edible, and many things that should never have been eaten. We ate rotten leaves, and fruits fallen on the ground to the roots we dug up. Rats, turtles, and snakes caught in our traps were not wasted as we ate their brains, tails, hides, and blood. If we had free time, we spent it roaming the fields hunting for grasshoppers, beetles, and crickets.

The Khmer Rouge government, or Angkar, sought to create a pure utopian agrarian society and to achieve this they believed they had to eliminate threats and traitors, real, perceived, or imagined. So the Angkar sent their soldiers out to hunt down former teachers, doctors, lawyers, architects, civil servants, politicians, police officers, singers, actors, and other leaders and had them executed en masse. Then they sent more soldiers out, and this time they gathered the wives and children of these traitors. With my father being a former high-ranking military officer, we knew we were not going to remain safe for long.

When the soldiers came for my father, I had already lost my fourteen-year-old sister, Keav, to food poisoning. As my father walked into the sunset with the soldiers, I did not pray for the gods to spare his life, to help him escape, or even to return him to me. I prayed only that his death be quick and painless. I was seven years old. Knowing that we were in danger, my mother sent us away to live in a children's work camp. By the time the soldiers came for her and my four-year-old sister, Geak, I was done with praying and plunged deep into my rage and hate.

At the age of eight, I was an orphan so lost, hurt, and full of rage that I was pulled out of the children's work camp and placed in a child-soldier's training camp. While children in other parts of the world went to school to learn and make friends, I was taught to hate and hurt. While others played hide-and-seek with their friends, I was counting under my breath—waiting for the bombs to hit our shelter. The shrapnel from one bomb pierced my girlfriend Pithy's head. I had to brush bits of her brains off my

sleeve and shut down my emotions to survive. Even when the bombs were quiet, there were still dangers lurking in the fields, trees, and bushes. I was lucky to escape them all—from poisonous snakes, diseases, land mines, bullets, to an attempted rape by a Vietnamese soldier. As I struggled to survive on my own, I asked the gods why no one cared.

In *First They Killed My Father,* my war story ended in 1979 with the Vietnamese penetrating Cambodia and defeating the Khmer Rouge army. Slowly afterward, my four surviving siblings and I were reunited, and shortly after that we made our ways back to the village where our family and relatives still lived. Then in 1980, in search of a better future for our family, my brother Meng and his wife, Eang, decided to make the dangerous journey out of Cambodia to Thailand. Sadly, Meng could borrow enough gold to take only one of his siblings with him—and he chose me because I was the youngest.

When it was time to leave, my extended family stood in the middle of our red dusty village to say their good-byes. My sister Chou and I held hands in silence. I was ten and she was twelve. Though we were still children, our war-torn hearts were grown and bonded over the deaths of our parents and our sisters. Kindred spirits, we were each other's best friend, protector, and provider.

As Meng pedaled me away on his bicycle, breaking Chou's hold of my hand, I turned my back to her. I knew she would not leave until we were out of her sight. My last image of Bat Deng was of Chou, her lips quivering and her face crumpled as tears streamed down her cheeks. Her face stayed with me all through the trip to my new world. I swore I would return in five years to see her.

Meng, my sister-in-law Eang, and I left behind Chou and my brothers Kim and Khouy for Vietnam where we joined the thousands of other boat people being smuggled into Thailand. After six months in a refugee camp, we were eventually resettled in Vermont through the sponsorship of the Holy Family Church in Essex Junction.

It would be fifteen years before I would be reunited with my sister again in 1995. Fifteen years of her living in a squalid village with no electricity or running water. Fifteen years of me in the United States living the American dream. It is my obsession with these fifteen years that has taken me back to Cambodia over twenty times.

In the years since our first reunion, Chou and I have spent many hours talking and sharing our lives with each other. As we continued to share our joys and sorrows, we decided to write our stories so that future generations of Ungs will know of our love and bonds. As the author, I have had to translate Chou's Khmer and Chinese words to tell her story in English. Admittedly, this involved interpreting not just her words, but often their meanings as well. As I was not there to witness Chou's life, this book is my best attempt to piece together her story from our numerous conversations, interviews with family members and neighbors, and our many literal and emotional walks down the memory lanes of our childhoods. The challenges of writing our separate lives into book form were made even more difficult because our memories of events and time wax and wane with each passing moon. In America, I was helped by the many date books, journals, diaries, homework assignments, clocks, calendars, and the sources that I kept to mark the passages of my life. In the village, Chou did not possess such items. Instead, time for her flows from one day to another, from one harvest season to the next, distinguished only by the rising sun, fallen stars, and the birth of a new generation of Ungs. And thus I was left with having to give the best "guesstimate" to the time and events that marked her life. Though inaccuracies in dates and time may exist in this book, the events that touched our lives and people who have healed our hearts are true. Here are our stories: mine as I remember it and Chou's as she told it to me.

Lucky Child begins where *First They Killed My Father* left off and follows both my life in America and Chou's in Cambodia. In telling our stories, *Lucky Child* brings us back to the caring people who went out of their way to find us and to extend a helping hand. Whether it was a kind word spoken to me as a child or a morsel of food that sustained Chou for one more day. It has been a pleasure for me to reconnect with many of the people in this book. However, to protect their privacy, I have taken the liberty to change their names, except for those who chose for me not to. I am thankful to all of them, for all of their efforts and encouragement gave Chou and me the chance not only to survive the war but to thrive in peace.

the ung family tree

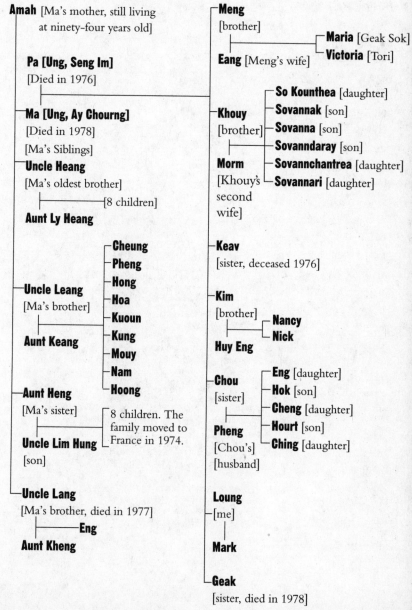

Amah [Ma's mother, still living at ninety-four years old]

Pa [Ung, Seng Im]
[Died in 1976]

Ma [Ung, Ay Chourng]
[Died in 1978]
[Ma's Siblings]

Uncle Heang
[Ma's oldest brother]
[8 children]
Aunt Ly Heang

Uncle Leang
[Ma's brother]
Aunt Keang
- **Cheung**
- **Pheng**
- **Hong**
- **Hoa**
- **Kuoun**
- **Kung**
- **Mouy**
- **Nam**
- **Hoong**

Aunt Heng
[Ma's sister]
Uncle Lim Hung
[son]
8 children. The family moved to France in 1974.

Uncle Lang
[Ma's brother, died in 1977]
Eng
Aunt Kheng

Meng
[brother]
Eang [Meng's wife]
- **Maria** [Geak Sok]
- **Victoria** [Tori]

Khouy
[brother]
Morm
[Khouy's second wife]
- **So Kounthea** [daughter]
- **Sovannak** [son]
- **Sovanna** [son]
- **Sovanndaray** [son]
- **Sovannchantrea** [daughter]
- **Sovannari** [daughter]

Keav
[sister, deceased 1976]

Kim
[brother]
Huy Eng
- **Nancy**
- **Nick**

Chou
[sister]
Pheng
[Chou's]
[husband]
- **Eng** [daughter]
- **Hok** [son]
- **Cheng** [daughter]
- **Hourt** [son]
- **Ching** [daughter]

Loung
[me]

Mark

Geak
[sister, died in 1978]

part one **worlds apart**

1 welcome to america

My excitement is so strong, I feel like there are bugs crawling around in my pants, making me squirm in my seat. We are flying across the ocean to resettle in our new home in America, after having spent two months living in a houseboat in Vietnam and five months in a refugee camp in Thailand.

"We must make a good impression, Loung, so comb your hair and clean your face," Eang orders me as the plane's engine drones out her voice. "We don't want to look as if we've just gotten off the boat." Her face looms in front of me, her nails working furiously in their attempts to pick crusty sleepy seeds out of the corners of my eyes.

"Stop, you're pulling out my eyelashes! I'll clean my own face before you blind me." I take the wet rag from Eang's hand.

I quickly wipe my face and wet the cruds on my lids before gently removing them. Then I turn the rag over to the clean side and smooth down my hair as Eang looks on disapprovingly. Ignoring her scowl, I ball up the rag, run it over my front teeth, and scrub hard. When I'm finished, I wrap the rag around my pointing finger, put it in my mouth, and proceed to scrape food residue off my back teeth.

"All finished and clean," I chime innocently.

"I do have a toothbrush for you in my bag." Her annoyance is barely contained in her voice.

"There just wasn't time . . . and you said you wanted me clean."

"Humph."

Eang has been my sister-in-law for a year and generally I don't mind her; but I just can't stand it when she tells me what to do. Unfortunately for me, Eang likes to tell me what to do a lot so we end up fighting all the time. Like two monkeys, we make so much noise when we fight that my brother Meng has to step in and tell us to shut up. After he intervenes, I usually stomp off somewhere by myself to sulk over how unfair it is that he takes her side. From my hiding place, I listen as she continues to argue with him about how they need to raise me with discipline and show me who has the upper hand or I'll grow up wrong. At first, I didn't understand what she meant by "wrong" and imagined I would grow up crooked or twisted like some old tree trunk. I pictured my arms and legs all gnarly, with giant sharp claws replacing my fingers and toes. I imagined chasing after Eang and other people I didn't like, my claws snapping at their behinds.

But no, that would be too much fun, and besides, Eang is bent on raising me "right." To create a "right" Loung, Eang tells Meng, they will have to kick out the tomboy and teach me the manners of a proper young lady—which means no talking back to adults, fighting, screaming, running around, eating with my mouth open, playing in skirts, talking to boys, laughing out loud, dancing for no reason, sitting Buddha-style, sleeping with my legs splayed apart, and the list goes on and on. And then there is the other list of what a proper girl is supposed to do, which includes sitting quietly, cooking, cleaning, sewing, and babysitting—all of which I have absolutely no interest in doing.

I admit I wouldn't fight Eang so hard if she followed her own list. At twenty-four, Eang is one year older than Meng. This little fact caused quite a stir when they married a year ago in our village in Cambodia. It also doesn't help that Eang is very loud and outspoken. Even at my age, I'd noticed that many unmarried women in the village would act like little fluttering yellow chicks, quiet, soft, furry, and cute. But once married, they'd become fierce mother hens, squawking and squeaking about with their wings spread out and their beaks pecking, especially when marking their territory or protecting their children. Eang, with her loudness and strong opinions, was unlike any unmarried woman I'd ever spied on. The other villagers gossiped that Meng should marry a young wife who could

give him many sons. At her advanced age, Eang was already thought of as a spinster and too old for Meng, a well-educated and handsome man from a respected family. But neither one cared too much for what the villagers said and allowed our aunts and uncles to arrange their marriage. Meng needed a wife to help him care for his siblings and Eang needed a husband to help her survive the aftermath of the Khmer Rouge war, Cambodia's poverty, and increasing banditries. And even though they got married because of those needs, I do think they love each other. Like the two sides of the ying and yang symbol, together they form a nice circle. Whereas Meng is normally reserved and quiet, Eang makes him laugh and talk. And when Eang gets too emotional and crazy, Meng calms and steadies her.

"Thank you for the rag," I smile sweetly, handing it back to Eang.

"Did you see what she did, Meng?" Eang crunches her face in disgust as she rolls up the wet rag and puts it in her bag. On my other side, Meng is quiet as he pulls a white shirt from a clear plastic bag and hands it over to his wife. The shirt gleams in Eang's hands, crisp and new. When Meng found out we were coming to America, he took all the money we had and bought us all new white shirts. He wanted us to enter America looking fresh and unused despite our scraggy hair and thin limbs. Eang kept the shirts in a plastic bag so they would stay fresh and unwrinkled for this very special occasion.

At twenty-three, Meng wears a somber expression that makes him look many years older. The Meng I remember from before the war was gentle, with a ready smile and an easygoing manner. This new Meng seems to have left his sense of humor in Cambodia when we waved goodbye to Chou, Kim, and Khouy nine months ago. Now, only deep sighs escape his lips. At the refugee camp, there were many times when I was in our hut, lost in my world of words and picture books, when suddenly I would hear this long intake of breath, followed by a rushing exhale. I knew then that Meng was hovering somewhere nearby, and I would turn to find him looking at me with his long face and sagging shoulders.

When I ask Meng why we had to leave our family behind, he sighs and tells me I'm too young to understand. My face burns red by his put-offs. I may be too young to understand many things but I am old enough to miss Khouy's voice threatening to kick anyone's bottom who dares

mess with his family. No matter how far we leave them behind, I still miss
Chou's hand clasped warmly in mine, and Kim's fingers scratching his ribs
in manic imitation of a monkey, kung fu style. I am young but sometimes,
when I would float alone in the ocean near the refugee camp, I'd feel old
and tired. I'd sink to the bottom of the ocean, staring up at Ma, Geak, and
Keav's faces shimmering on the water's surface. Other times, as I bobbed
up and down, I'd imagine my tears being carried by the waves into the
deep sea. In the middle of the ocean, my tears would transform into anger
and hate, and the ocean would return them to me, crashing them against
the rocky shoreline with vengeance.

At night at the refugee camp, I would gaze at the full moon and try
to bring forth Pa's face. I'd whisper his name into the wind and see him
as he was before the war, when his face was still round and his eyes flashed
brightly like the stars. With my arms around myself, I'd dream of Pa hold-
ing me, his body full and soft and healthy. I'd imagine his fingers caress-
ing my hair and cheeks, his touch as gentle as the breeze. But before long,
Pa's face would wither away until he was only a skeleton of his former
moon-self.

If Meng also could see Pa's face in the moon, he didn't tell me. I don't
know how or when it started, but Meng and I somehow have found our-
selves in a place where we don't talk about the war anymore. It's not as
though we sat down one day and decided not to talk about the war—it
happened so gradually we barely noticed it. At first he asked me questions
I was not ready to answer, and I would ask him for answers he could not
explain, until eventually the questions and talking just stopped. There are
times that I still want him to tell me more about Pa and Ma and what kinds
of people they were before I was born. But I do not ask because I cannot
bear to watch his face light up at the memory of them, only to see it dim
and darken when he remembers they are no longer with us.

When Meng and I do talk, we speak about our present and future. Of
my past, Meng says only that he thinks I am ten years old but he is not
sure. He shares that when he was a boy, Pa and Ma were so poor that they
sent him to live with our aunts and uncles in the village. He says that each
time he visited home, there was another little brother or sister to greet him
until, in the end, there were seven of us. He tells me that what papers or
records we had of our births the Khmer Rouge destroyed when they

entered the city on April 17, 1975. Without the papers, Ma and Pa were our only memories of our entrance into the world, but now they're gone, too. In Thailand, when Meng was required to pick a new birthday for me in order to fill out the refugee papers, he chose April 17—the day the Khmer Rouge took over the country. With a few strokes of his pen, he made sure I will never forget Cambodia.

In the time that I've lived with Meng and Eang, it is clear to me that Meng's thoughts are always focused on Cambodia and our family there. We have no way to send or receive words, so we do not know if Khouy, Kim, and Chou are still with us. In the Ung clan, Pa was the firstborn son in his family, and since Meng was Pa's firstborn son, he now holds the title role not only as the head of our family, but as the eldest brother to all the Ungs of our generation. Meng wears this title with pride and constantly worries about the well-being of the younger Ungs and how he can be a good role model. Before leaving Cambodia, Meng painted a bright picture of our future to our aunts and uncles to justify our leaving for America. Once en route and on the boat, however, Meng's eyes brimmed with tears and his face fell.

On the plane, I climb on my seat and turn around to wave at my friend Li Cho, seated a few rows behind me. Only a year younger than me, Li is part of the seven-person Cho family also on their way to make a home in Vermont. Because Meng and Eang mostly kept to themselves at the Lam Sing Refugee Camp, they did not know the Chos before today. However, Li and I met the first night I arrived there. Behind the walled prison fence of the refugee camp and in the midst of the porous thatched-roof huts, Li and I explored our temporary homes together and became friends. We shared our secrets by the ocean while spying on grown-up women and making fun of their large breasts. Li told me she was born in Cambodia to a Chinese father and a Vietnamese mother. Her mother and her father passed away when Li was young and now she lives with her adult brothers, sisters, and nephews. Fully clothed and with our sweaty hands clasped tightly together, Li and I would run into the ocean and talk about how much we wished we could buy a bottle of Coke and a bowl of noodles. I would tell her about how my father would hold my fried crickets for me at the movies, and she would tell me how her father used to read to her.

As the plane rocks and sways, Li looks green from motion sickness. Li's small body slumps over in her seat as her sister Tee pats her fine black hair. Even in sickness, Li is pretty with her large eyes and a small chin. Watching her, I remember a time when I thought I was pretty, too. It seems unreal that only five years ago in Phnom Penh, Ma and her friends would coo and pinch my cheeks when I entered the room wearing a new dress or a bow in my hair. They would comment on my full lips, large almond eyes, and wavy hair. To this, I'd smile and extend my hands until they emptied their purses of candies and money, before Ma shooed me away.

I turn back to look at Li. "Poor Li," I think. She has been sick and throwing up the entire plane trip. Awake, she is a sweet and mild-mannered girl, exactly the kind of girl Eang wishes I would be. With that thought, I sit down in my seat and open another bag of peanuts. Though Li cannot keep her food down, my stomach has no such trouble and like a good friend, I happily volunteer to eat her food.

As our plane begins its descent, the soft fluffy clouds part and open the world below to me. I lean over Meng to peer out the window and catch my first glimpse of my new home. Scanning the land, I am disappointed to see only mountains, trees, and water. I guess we are still too high up to see the tall, shiny buildings. My hands grip the armrest tightly, and I day-dream about the America I hope I'm going to. In their attempts to prepare us for life in the United States, the refugee workers would show us Holly-wood movies, where each plot took place in a large, noisy city with tall, shiny buildings and big, long cars racing down crowded streets. On the big screen, Americans are loud-talking, fast-moving people with red, blond, brown, or black hair, weaving in and out of traffic wearing heels or roller skates. In my seat, I imagine myself walking among these people and liv-ing an exciting new life far from Cambodia. These images set my heart racing with anticipation until Eang's voice brings me out of my reverie. Eang brushes her hand over the front of my shirt and complains about the falling crumbs. Meng hurriedly primps his hair with a small black plastic comb just as the captain announces we are landing.

On the ground, my hands lock in Meng and Eang's, and we enter the airport lobby to bursts of flashes and loud whispers. Bright lights blind and

scare me, and I lose eye contact with Li as she and her family are swallowed up by the crowd. With white spots swimming in my retinas, I shield my eyes with my forearm and take a step backward. The room falls silent as the throngs of pale strangers shift their feet and strain their necks to take their first peek at us. From behind Meng, I focus on one woman whose long white neck reminds me of a defrocked chicken, all skinny and leathery. Next to her, another woman stares at us from a face so sharp and angular that I name her "chicken face." Behind "chicken face" stands a man with round cheeks and a big nose whom I identify as "pig cheeks." Surrounding them are more people I can only distinguish with my special nicknames: lizard nose, rabbit eyes, horse teeth, cow lips, and cricket legs.

"Welcome!" a man calls out and walks toward us. His body is sturdy like a tree trunk and he towers one head taller than Meng as they shake hands.

After him, one tall person after another gathers around us. Making use of his English classes in Phnom Penh before the war, Meng smiles widely and answers questions as he pumps everyone's hand with vigor and energy. Standing beside him, Eang takes people's hands limply and nods her head. Not wanting to be crushed, I step out of the crowd and stand alone until a red-haired woman walks up to me. Remembering to show her my respect, I bow to greet her; at the same moment, she extends her hand and hits me square on the forehead. The cameras stop flashing and the room grows quiet as I stand there rubbing my forehead. From his corner, I hear Meng laugh and assure everyone I'm okay. A few seconds later, the room erupts into laughter. Instead of casting my eyes on the floor, I stare at the crowd with anger until Eang tells me to smile. Weakly, I curl my lips upward for the crowd. Suddenly, the red-haired lady steps forward again and hands me a brown teddy bear as more cameras flash to capture the moment. In that instant, I realize that I've buttoned my shirt wrong, leaving my white shirttail jagged and crooked, and me looking like I've just gotten off the boat.

In the car, Meng talks with our sponsors, Michael and Cindy Vincenti. As Meng speaks, Michael nods his head while Cindy answers with a series of "uh-huhs." Behind her, I stifle a laugh at her silly sound and pretend to cough. Sensing Eang's warning eyes burning the back of my

head, I stare out the window and watch the world go by. Outside, the scenery moves at a slow speed, as short grass is replaced by thick shrubs and trees. Every once in a while, the rolling hills are dotted with small houses and running dogs. There are no tall shiny buildings in sight.

After twenty minutes, the Vincentis pull their car into the driveway of a small, two-story apartment building. The building looks old and dreary with white paint flaking off its front like dead skin. And right next to it, on the other side of the driveway, is a large cemetery where, inside, the summer wind blows gently on the trees and makes the branches sway and the leaves dance as if possessed by spirits. My skin warms at the sight of the cold, gray stones jutting out from the earth like jagged teeth. Beneath the stones, I imagine decomposed bodies trapped in dirt, waiting for nightfall before they can escape.

"You're home," the Vincentis announce.

Meng tells Eang and me to get out of the car as I direct a steely gaze at the back of Michael's head.

"Eang," I grab her hand, "it's bad luck to live next to a cemetery. The ghosts will not leave us alone!"

"The ghosts here cannot speak Khmer," she says. "They'll make no trouble for us."

"But . . ." I refuse to give up. "What if there is a common language all the dead use?" Before I can continue, Eang tells me to be quiet and motions for me to hurry. Glancing back tentatively at the cemetery, I slowly follow the adults into the apartment.

The Vincentis climb the stairs to the second-story apartment and wait for Meng, Eang, and me to catch up. While the adults talk, I take in the layout of our apartment. With rooms connecting in a long row, our new home feels like a train, and its narrow rooms look like boxcars. To the left of the stairs, Meng and Eang's room resembles a square tan box furnished with a simple wood dresser and a queen-sized bed. Walking up to its one window, I am glad to see that it faces the parking lot. To the right of the stairs the kitchen is filled with all the modern amenities—a stove, oven, and refrigerator. In the middle of the room sit a small metal rectangular table and four matching chairs. Next to the kitchen, the bathroom is clean from the top of its ceiling to the white-yellow linoleum tiled floor. A few steps forward take me into the dining room.

"This will be your room," Cindy tells me cheerily.

With my hands clasped together in front of me, I turn a full circle to inspect my room. A frown forms on my face when I notice that the walls are not made of actual wood but a glued-on brown paper designed to look like fake wood. I have never seen such wall coverings before and reach out to slide my hand over its slippery surface. Suddenly I think of Chou living in a wooden hut in Cambodia. In an instant, I feel heavy and drag myself to the corner of the room where there is a small walk-in closet. Though I spy hinges on the frame, for some reason there is no door for the closet. My room is empty except for a small twin bed against the wall. I walk over and sit on the bed, testing its bounce with my weight while gazing quizzically at the drawings on my sheet. The drawings appear to be of girl and boy mice, ducks, dogs, elephants, and other animals, each playing or holding a musical instrument. All the characters are dressed in red, white, and blue costumes and smiling broadly. Covering my hands over my mouth, I giggle at the animals.

"Those are cartoon characters," Cindy offers. "See, they're at a circus."

"Gao-ut taa ay?" I ask Meng what she says.

With Meng as our interpreter, Cindy then goes on to tell me their names and that they belong to the Disney family. Tracing my finger over the mouse's large round ears and the duck's protruding fat beak, I smile and think what fun it would be to belong to such a family. When I imagine myself dancing and playing with these funny creatures, my insides swirl and unexpectedly giggles burst forth out of my mouth. As another chortle breaks to the surface, I think of Chou who always thought it was silly that I remember people by giving them animal names and characteristics. I wish Chou were here with me so I could show her this great new world where animals do look like people.

I get off my bed, cross my room, and enter through another large doorway into the living room. With its three bay windows, the living room is bright and attractive. Filling up the space is a couch and chair set, both covered in tropical floral prints. Standing in front of the middle window, I flatten my hands on the glass and stare at the traffic below before heading back to my room. It occurs to me that with no doors separating my room from the kitchen or the living room, there will be no sleeping in late for me with early riser Eang. I drop my shoulders in resignation and

walk back to my room, then cringe at what I see—my window looks directly into the cemetery.

"I am home," I whisper. I have traveled so very far and for so long to reach America and now the journey is over! I close my eyes and breathe a sigh of relief, expecting feelings of calm and contentment to flow into my body.

"I'm home!" I tell myself, but the world remains strange to me.

I lie in bed with my arms wrapped around my belly and glance out the window at the dark sky. Outside, the wind sleeps and the air travels quietly as if they, too, are afraid to disturb the spirits. It is a silence that I find unnatural; in Cambodia, night is always accompanied by the shrill mating songs of crickets. I turn my face to the wall and pull the blanket over my head. Eyes closed, I wait for sleep to come and make me unconscious until the time when the living can reclaim the world. But instead of sleep, the mouse and the duck dance on my sheets in their full circus regalia and top hats. Beside them, their female counterparts twirl their batons and parade to tunes I cannot hear. Soon the other Disney family characters begin to come to life, but I blink them away and force them back into the cloth.

The clock on the wall says it's eleven P.M. This is bad news. It is now close to the dark hours—the hours when spirits and ghosts roam the world and walk among the living. A long time ago, Kim told me never to be awake from twelve A.M. to five A.M., but I couldn't help it. He warned that if I needed to pee, then I should do my business quickly and quietly and get back to bed. He said the more noise or movements I made, the more I would attract the spirits and ghosts. And once that happens, they won't let me go. Kim didn't tell me what he meant by the ghosts not letting me go. He never finished his story but preferred to let the ending form a life of its own in my mind. I used to get so mad at him for this that I would chase him, my arms swinging karate chops at him. Thinking about Kim makes my heart feel tight, as if too many things are being pushed into it.

In the dark, I sit up and lift the blanket off my body. I take the flashlight out from under my pillow, shine a beam on my ankle, and locate the black X on it. Kim told Chou and me that by marking Xs on our ankles and the soles of our feet, we let the ghosts know that our bodies are taken.

It is our mark of ownership. Satisfied that the Xs are still there, I tuck the sheet back under my feet and pray the ghosts will not unloose them. Ghosts are very fond of bothering people by tickling their feet with the purpose of waking them.

When sleep does not come, my mind drifts off to find Chou. It is eighteen months since the Vietnamese defeated the Khmer Rouge and chased them into the jungle, and nine months since I pulled my hand out of her grasp. Though she is two years older than me, Chou had the luxury to weep openly at our separation, as was expected of her for being the more fragile sister. But I had to stay strong and smile for her.

In Vermont, alone in my bed, I grind my teeth knowing that I now have to stay strong for myself.

2 chou

Across the ocean in the tropical land of Cambodia, Chou stirs inside the hut where she has lived with Ma's brother, Uncle Leang, his wife, Aunt Keang, and their five children since the end of Khmer Rouge. Suddenly, a heavy arm flings across her chest, and Chou grunts and pushes it off. Beside her, in the female net, cousins Cheung and Hoa sleep soundly facing each other, their breath inhaling and exhaling in synch. Under the same mosquito net, on the far side of their wooden plank bed, toddler Kung curls up with her back to them, her tiny arms and legs wrapped around a rounded long body pillow. Next to them under another worn gray-pink net, Aunt Keang lies with her arm above her baby girl, Mouy. Snorting loudly across the room on their own plank bed, Kim, Khouy, Uncle Leang, and the two male cousins lay sprawled out like fallen logs in their nets.

"Bzzzzz," the mosquito whispers outside Chou's net but she does not hear it.

Under her closed lids, Chou's eyes follow the faces of Ma, Pa, and Geak. In her dream, they sit together at a teak table in their home in Phnom Penh as Ma serves freshly steamed pork dumplings. As she smiles, Ma's full lips crack open to expose her teeth and gums. Like large, white square pearls, Ma's slightly buck teeth line up evenly, as if to present a uniform team. Chou's stomach churns hungrily, but instead of staring at the food, she is fixated on Ma's mouth.

All of a sudden, a deep itch pierces her ankle and wakes her from her dream. In the dark, Ma's face and teeth slowly fade as a pang of sadness spreads over Chou. Not yet fully conscious, her mind struggles to stay on Ma's mouth, the only feature Chou believes she has inherited from her. Since the Khmer Rouge soldiers took Ma away two years ago, Chou has tried hard to keep Ma's face in her heart. But as hard as she tries, with each passing moon Ma's face slowly darkens until only the brightness of her teeth remains.

"Chou, do not be so sad," Aunt Keang told her when she spoke of her worries about this. "Loung may have your mom's face, but you will always have her mouth."

"Yes," seventeen-year-old cousin Cheung chimed in. "Your top lip points up like two mountains like your ma."

"And when you laugh, you can see all your teeth and gum!" eight-year-old Hoa agreed.

"Your ma," Aunt Keang added, "she was such a talker! She could talk about anything. Her lips were so big she could never keep them properly closed."

"Stop pursing your lips together," the cousins ordered and broke into laughter. Chou hadn't even noticed that she was trying to pull her lips over all her teeth.

Back in her bed, Chou is about to fall asleep again when her ankle begins to burn and itch. At first, she senses invisible ghosts scratching at her feet. Kim has told her that ghosts are very mischievous and like to scare people for fun. Not wanting to see them, she covers her lids with her hands, too scared to even peek through her fingers. But as conscious thoughts return to her, Chou realizes her foot has escaped the net and is now being feasted on by mosquitoes. Quickly, she pulls it back into the net and out of reach of the hordes of hungry bugs. Fully awake now, she is suddenly aware of her throbbing full bladder. She wants to wake up one of the cousins to accompany her to the outhouse but she knows better. The last time she did that, they almost pushed her off the bed.

Reluctantly, Chou sits up, quickly throws the mosquito net over her to prevent any bugs from entering, and drops her bare feet to the dirt floor. Guided by the moonlight shining through the slits of the wooden walls, Chou makes her way to the back door. Beneath her, small pebbles dig and

grind into her soles but her callused feet do not feel them. The last time she owned shoes was before the war.

At the door, she lifts the thick wooden board off its hinges, unlocks it, and pushes one panel open enough to squeeze her body through. The door whines and creaks but it lets her through. Outside, the air is cool and fresh but she knows that by midmorning, the June sun will burn hot and humid. Thirty feet away, the wooden outhouse sits, dank, dark, and partially hidden by thick bushes. Too scared to venture that far, Chou walks a few feet away from the door to a low brush area. There, she hitches her thumbs at her pant waist and swiftly pulls them down. As she squats to release her bladder, her urine splatters on the grass, bounces onto her leg, and warms the grass beneath her feet. With her eyes half closed, her hands automatically fan her bottom to scare away mosquitoes. Once she is finished, she walks over to the large round water jug and reaches for the plastic container floating on top. She scoops a bowl of water, and pours it on her hands and feet before walking inside.

Back in her bed, Chou tries to return to sleep but finds herself staring at the top of the mosquito net. Her gaze passes through the porous net, the wooden house frame, and then the layers of palm leaves to the big outside world. Out there beyond the village and Cambodia, she pictures America, a place filled with rich white people and big buildings. Though she has never seen pictures of it, Kim once told her they have buildings that are fifty, sixty, and even seventy stories high!

"Seventy stories!" she'd exclaimed then with disbelief. "People must look smaller than ants from that height!" To this, Kim could not answer.

She tries now to imagine what it must feel like to live that high above the earth, to be able to open a window and reach out to touch the clouds. For a moment, her thoughts shift to Loung and her heart squeezes tightly in her chest.

Chou closes her eyes and laces her fingers on her stomach. She wonders if Eldest Brother and Loung live in one of these homes in the sky. She hopes Eldest Brother doesn't let Loung lean on the railings the way Pa let her climb them in their home in Phnom Penh. Chou knows her sister can be bad and reckless sometimes but she still loves her. Loung doesn't know how much time Chou has spent worrying about her and all her antics. Like the time she went to see the public execution of the Khmer Rouge

soldier in Pursat Province. Chou cried and screamed for her not to go and even threatened to tell their brothers about it, but Loung didn't listen. Chou worries about her now and hopes she's not making trouble for Eldest Brother and Eldest Sister-in-Law, wherever they are.

Since the day they left, Chou's heard so many stories of other refugees who were kidnapped by Khmer Rouge combatants, captured by Thai pirates, and injured by land mines in their attempts to escape Cambodia. Chou's dark thoughts spiral like a tornado, sucking all the light out of her eyes. Quietly, she repeats her constant prayers to the gods to protect her family.

A few days before they'd left, surrounded by the uncles, aunts, and family, Eldest Brother explained that they had only enough gold to buy two seats on a boat to take them to Thailand. The family reacted to this news with nods. Hidden behind the cousins, Chou held her breath in her stomach. She knew she would be separated from one of her siblings. She turned and stared at Second Brother Khouy, Kim, and Loung. When Eldest Brother told the family he would take Loung, Chou's breath turned to ice that sent shivers through her veins. Eldest Brother then went on to describe the dangers of the journey, his feeling that Loung's fearlessness would allow her to adapt better in a foreign country, and, more important, that her young age would allow her to get a better education. Chou didn't hear many more words after that. She did not feel angry at not being picked. She simply accepted his decision no matter how heavy her heart felt. She never second-guessed Eldest Brother and believed that Khouy and Kim felt the same way. But on the day they left, she did not remember Eldest Brother's talk. She wanted to run after them and beg Eldest Brother to take her also. As she stood there with the family and watched Eldest Brother and Loung leave, her body felt like an old dead tree, her insides hollow, and her toes dug into the dirt like roots. While she cried silent tears, Kim stood beside her with his shoulders folded inward and his stomach concaved into his body. But when she leaned against him, his slim frame was steady and strong.

That was nine months ago and they have been as silent as the dead. Again, her throat aches at the thought that something bad might have happened to them. A lot has changed in nine months. She's thirteen years old now. But her frame is still small, her stomach protrudes from lack of

food, and her limbs are short and thin. She turns to her side and stares at the men's plank bed where Kim sleeps soundly.

At fifteen, Kim is a gentle old man in a child's body. A head taller than Chou, Kim's wiry body is muscular and strong from hard work. To the aunts, Kim is like a willow tree that can sit in dirty water and still grow beautiful and provide shade for the family. But to Chou, he'll always be Ma's little monkey who stole food and endured beatings to feed them all. On the other hand, Second Brother Khouy will always be the family's tiger. At twenty-one, Khouy walks with the graceful stride of a cat but will quickly pounce on his prey if he has to protect his territory and family. Even when he is relaxed, he is full of lightning and thunder, especially when he's had too much to drink. When he is drunk, he's like fire, temperamental and burning everything in his path. In the morning after all the alcohol has left him, he claims that it took away his memories of the night before. No one dares to question him; the war and lack of food did not take away Khouy's intimidating black belt karate–trained body. When he is not angry, Khouy can tell funny stories that keep everyone laughing for hours and everywhere he goes, family, friends, and girls are drawn to him.

Still, once during the monsoon season, Chou saw Khouy standing in the rain, a lone figure in the midst of the swaying palm trees. The warm rain had soaked his clothes to his body, and his bangs flopped over in his face as small children played around him. Every once in a while, a few children grabbed his hands and kicked up mud around him. He didn't seem to mind them and stood quietly. Chou wondered if he was thinking of Geak. But they don't talk about her. They don't talk about Pa, Ma, and Keav either. They also don't talk about Phnom Penh, the markets, the movie theater in front of their house in the city, the noodle shops they used to go to with Pa and Ma, Geak's red cheeks, their home in the city, and so many other things Chou remembers vividly.

She cherishes all these memories, even the ones in which Kim and Khouy teased her with stories that Pa had found her in a trash can. They said she was so dark and ugly that Pa felt sorry for her and adopted her. They said that was why she has the darkest skin of them all. While the others laughed, tears flooded her eyes and slid easily off her cheeks. Since then, her tears always flow easily when she is sad, angry, sleepy, hungry, or scared. They flow especially freely when she is missing her family. And

after the war, there were so many people to miss that her face was rarely dry. In the beginning, the family was wary because they never knew when the tears would start or stop. They looked at her with fleeting glances when she pulled the corners of her sarong to wipe her eyes. She wiped so hard and so often that her eyes became itchy and infected, and instead of tears, yellow mucus came out of her ducts. But as the days turned to months, the busy task of surviving stopped her eyes from leaking and slowly she began to heal.

As Chou's thoughts drift and float in her head, the moon disappears and the sun climbs above the horizon, painting the sky pink, red, and orange. As if on cue, the neighbors' roosters crow loudly and the dogs bark everyone awake. Tied to a tree beside the hut, the pigs snort in annoyance at having to wake so early. Inside the hut, the family answers the animals' calls with yawns, coughs, and cries as they slowly come to life inside their mosquito nets. One by one, the cousins wake and saunter to the water jar. While the boys take turns washing their faces, Chou and the girls take down the mosquito nets, roll them into small balls, and stuff them in wooden crates under the bed. Then Chou walks to the front door, removes the wooden bar, and pushes the door open.

In front of the family's hut, a small, red, dusty wagon trail passes their home and serves as the only road in and out of Chou's village. Over forty families have built their homes in the thick forest of this remote town. Half a day's walk to the east is Ou-dong, a thriving village of over three hundred families. Although Ou-dong has more people and a large market, the uncles feel it isn't a safe place to be if the Khmer Rouge return to power. The uncles continue to believe that the Khmer Rouge would kill and target city people and leave the farming peasants alone. After Meng and Loung left, the uncles packed everyone up and moved them into the woods, hoping to be left alone by the continuing civil war.

Chou steps out of the hut to feel the sunshine. Across the trail, her neighbors are already up and putting a heavy wooden yoke on a pair of cows. The cows moo at the burden but stand fairly still, only swishing their tails at the hovering bugs. A few feet away in another hut, a young woman balances her naked baby on her forearm and with her other hand pours water on the child's butt. The child screams and cries as the mother gently washes her cheeks and legs. When the baby is clean, the woman

unfolds a black-and-white checkered scarf from her neck and wraps it around the wet baby. Beside them, a young child sits on the steps, rubbing her eyes awake as her mother places the baby in her arms. In their small town, everyone knows one another.

During the day, the neighbors' conversations are easy, friendly, and full of superstitious tales and outrageous gossip as they collect water and work together. At night, the voices are quiet and the villagers quarantine themselves in their homes, afraid to go out for fear of being kidnapped by Khmer Rouge. Every once in a while, even though they are not in power, the soldiers still come down from their hideouts to raid a village, and take women, men, bicycles, cows, pigs, ponies, and rice.

For even though it has been almost two years since the Khmer Rouge's Angkar government was defeated by the Vietnamese troops, Chou is not sure who rules Cambodia in their place. Outside their small village, there is much talk about the Vietnamese intentions and whether they invaded or liberated Cambodia and are now refusing to leave. But here in the village, Chou revolves her life around the family, farming, fishing, collecting water and firewood, and running from bullets during raids—whether the gun-bearers are government soldiers or Khmer Rouge. Sometimes, while she serves the men their dinners, Chou listens to them discuss the ever-changing Cambodian government. Their faces snarl like rabid dogs when their talks turn to the Khmer Rouge still daring to leave their mountain hideouts to raid the surrounding villages and towns.

Back inside the hut, the other family members prepare their food for another day in the field. Chou reaches over the bed and retrieves two large metal pails and a thin, flat wooden board. She carries the wood on her shoulders, holds the pails in her hands, and leaves to collect water from the pond. On the short walk, her eyes search for thick brushes and bushes where she can hide in case of an attack. She wonders why Ma ever named her Chou. In Chinese, Chou means a beautiful gem or precious stones. Chou feels neither beautiful nor precious. Every day, she wakes up with her heart pounding and wonders if this will be the day she'll see a Khmer Rouge gun in her face.

3 minnie mouse and gunfire

Last night I dreamt I was in the middle of gunfire. There were people running after me, trying to kill me. I ran and ran but they were always nipping at my heel. I woke up sweating and full of fear. But in my closet, I am not afraid. The day after we moved in, Meng put up a curtain, gave me a chair, and turned the three-by-four-foot space into my own private world. Here, I am the creator, taker, and giver of life. My sun, the one lightbulb above my head, shines brightly at the flick of my wrist. At my command, it illuminates my box and bestows life to the shadow creatures on my floor. Like mischievous ghosts, they beg me to play with them. But I ignore them and bend my head closer to my sketchpad, my hand busily drawing away.

Outside my sanctuary, Eang clangs our pots and pans as she scrubs them spotlessly clean in the sink. I suppose I should be a good girl and go see if she needs my help, but for now the bad girl wins and I stay put. I tug my curtain to close it tighter and focus on my paper. In my closet, I know things and things are known to me. Outside of it, the world is big and bright and so full of things I need to learn that sometimes my brain feels like the cream-filled doughnuts Meng sometimes brings home, all crammed up and mushy. I envision that if I squish the side of my head with my hands, the overstuffed filling will shoot out of my nose. But inside my closet, my world is controlled and my brain pulses firmly and gently under my skull.

I lean back on my chair and stare at my creation. My brows furrow with frustration and my teeth gnaw at a thumbnail. Under my blue pajama pants, the gray metal pull-out chair cools my butt, sending a chill up my spine. Involuntarily, I shake out my shoulders to let loose the energy before returning to my task. My left arm cradling my small pad, I finish the mouse by adding its circle ears. Once I finish, I place the pencil behind my ear and observe my drawing at arm's length.

My feet start their rhythmic tapping on the hardwood floor. Normally, if Eang is within visible distance, I stop my feet by resting my hands on my knees. When my legs are still, my thighs and calves tingle as if hundreds of millipedes and their thousands of legs are crawling on my skin. Their friction creates static electricity, making the hair on my body stand up. From my knees, the millipedes' microscopic legs travel down my feet until their electrical current becomes a tickle in my toes. At this point, I imagine if I don't twitch to release the energy, the voltage will explode like ten tiny rockets out of my toes.

But Eang cannot see me in my closet so I let my knees knock and my feet tap to their content. I take my No. 2 pencil and shade in the pants, shirt, ears, and nose. My pencil presses down on the shape, darkening the circle ears, taking care to shade within the lines. Then I place the tip of the pencil in my mouth and wet the lead with my spit. With the wet tip, I blacken my figure's eyes until they stare back at me like two black coals. Sitting back on my chair, I observe my drawing with a smile of satisfaction.

"Minnie Mouse," I roll the name off my tongue. The name floats in the air like a catchy song.

"Minnie Mouse," I repeat. Minnie does not answer me. Staring at her, I daydream about how fun it must be to look like a cartoon character and make people smile. I wish people would like me the way they like Minnie. When people look at Minnie, they are happy. I wonder what people see when they look at me. Eang says I look like an street kid, all dark and thin with my spindly arms and legs and bloated belly. Meng is afraid my growth may have been stunted because of the years of starvation and malnutrition. When I look in the mirror, I don't see the girl they see. Instead, my hands pinch and pull at my features to bring forth Ma's nose, Pa's eyes, Keav's smile, and Chou's lips. I crave to hold their image in my hand and stare at their faces until their imprints are permanent in my brain. But we do not

have a single picture of them and my face is now the only image I have to remember them by.

From the white sheet, Minnie stares up at me with her wet eyes and pleads for friends. As I begin to draw her some friends, Eang's voice booms above me. I lift my head to see her standing in my closet's doorway, my tan cotton curtain all bunched up in her hand.

"What are you doing?" she demands, sounding irritated.

"Drawing," I reply nonchalantly.

"I've been calling you for the past fifteen minutes. Didn't you hear me?"

I want to scream out, *Of course I heard you! No amount of banging pots and pans can mute the shrill sound of your voice!* But instead, I cast my eyes down and say, "I'm sorry."

"All right," she sighs. "Come help me clean the house. The McNultys will be here soon to pick us up for a barbeque at their house. We don't want them to think we live in a messy house."

"Can I have fifteen minutes? I want to pick up my closet first."

"Oh, all right." With another resigned sigh, she exits my space.

I drag the curtain across the copper rod and shut myself in again. I close my sketch pad and lay it on the floor, then fold up the metal chair and lean it against the wall. Picking up a clothes hanger from the ground, I hang it on a wooden rod stretched across the back of the closet. Next to the other skeletal hangers, my one white shirt, now wrinkled and slightly stained, looks lonely and sad. I pull out a drawer where I store my few sets of clothes and gently place my drawing in among them. Above the drawers, on one shelf, I adjust my small rectangular standing mirror, straightening out my comb, brush, and pencil box so that they line up evenly next to one another, careful not to knock over the glass of water nearby. On another shelf, I pick up stray bobby pins, rubber bands, and safety pins and put them in a wooden bowl already filled with colorful ribbons for my hair.

I pick out a red ribbon and smooth it between my thumb and index finger. As the silky satin glides over my skin, my mind travels back to Cambodia where for four years we lived without colors and wore only the official Khmer Rouge black pants and shirts. The soldiers said that sporting colorful clothes separates people and breeds contempt and distrust among its citizens. They warned that children who longed for a red skirt, pink shirt, or blue pants were vain, and therefore had to have their vanity beaten

out of them. I wonder what the soldiers would say if they saw my bowl of colorful ribbons. Whatever they would say, I hope they spew their words from their dead lips and decomposed flesh. I tie a red ribbon in my hair, thinking how happy I am to be in America.

It seems so strange sometimes that I have lived in America for two weeks now. And even though I have learned to live with the ghosts and spirits next door, at dusk each night I still take out my pen and mark Xs on my heels and ankles before the sun hides completely behind the mountains. Under the blanket, with Mickey, Minnie, and the gang on top of me, I escape to a troublesome and restless sleep. In the morning before Meng and Eang see me, I rush to the bathroom and scrub off my Xs so they will not scold me for being crazy. But sometimes we are surprised with an early visit from one of our sponsors and I have to resort to other means to erase the Xs.

One such surprise arrived on our second day in Vermont when we were awakened by a loud knock on the door. While Meng went down to open the door, I groggily rushed into my closet and changed out of my pajamas and into my brown shirt and pants. I cleared my throat and attempted to spit but my mouth was dry; instead of saliva, a glob of mucus landed on my palm. I smeared it over my ankles and rubbed out my Xs. I fumbled for the comb and brushed down my fly-away hair before securing it down with bobby pins. Finished with my primping, I hurriedly left my closet to make my bed.

All the while, the cheerful lady huffed up the stairs, explaining to Meng that she was a member of the parish from the Holy Family Church that sponsored our family to America. Meng smiled and thanked her. She then walked into our kitchen and proceeded to show us how to operate the stove, oven, and refrigerator. Crossing the kitchen to the sink, she opened our cabinets and pulled out a mug. She explained that it is used to drink tea or coffee. She then pointed to cups, bowls, and plates, and with each item, she told us what they are used for. When she got to the new tableware set, she instructed us that for everyday use, we were to use the old set; we were to use the new set when we have guests. By the end of her speech, Meng and Eang's faces were tight and their smiles forced.

When the sponsor lady left, I asked Meng why so many people assume

we don't know about such things as fine china and cups. Yes, it was true that during the Khmer Rouge regime, our plate sets and silverware consisted mostly of coconut shells, banana leaves, our fingers, and our table was the rice fields. But before the war, our family sat for dinner at our big mahogany table and high-backed teak chairs while our house help served us food on fine china. Young as I am, I felt my ego bend like a bamboo tree each time the lady picked up another item, until in the end the reed was too heavy with burden and snapped, causing my face to darken and my eyes to harden.

"These people know nothing! They think we're backward villagers and peasants!" I blurted out.

Meng bent down to my level. His eyes bulged and his head expanded with hot air so that he resembled a praying mantis. He ordered me to be quiet.

"These people have busy lives. They don't have to help us at all but they do, so you be grateful." His voice low, he continued. "They may only know about Cambodia's war and poverty. They have no way of knowing we once came from a high-class family. Without them we wouldn't be here, so unless you want to return to Cambodia, you better show them gratitude." With that, he turned and left me. Ashamed and embarrassed, I vowed to be nicer and more grateful, and not complain anymore.

The next day, Michael Vincenti returned carrying a small, nine-inch TV. I followed on his heels and watched him set the TV down on the coffee table in the living room. As he pushed the plug into the wall, I bounced on the couch and waited for the magic pictures to appear. A few seconds later, the TV buzzed like a thousand bees, and black-and-white lines swam across the screen. Fascinated, I stared at Michael's fingers as they fumbled with the knobs and dials until finally a clear voice came through and with it a cartoon cat chasing after a little mouse. I clasped my hands together in a praying gesture and glued my eyes to the magic box.

For the next two weeks, the sponsor visitors kept arriving, each time to give us new life lessons on everything from how to take a bus to the grocery store to operating the machines to wash our clothes at the Laundromat. In between these visits Sarah, our English tutor, would come to our home to teach us the English language. In her mid-twenties, Sarah was

all smiles and big eyes that looked buggy behind her thick glasses. Each day, she would sit across from Meng, Eang, and me at our kitchen table and play cards with us. From her old cloth bag, she would retrieve her cards and teach us Go Fish and Memory. Each time we flipped a card, we would repeat the word after her. After we finished with our games, Sarah would take out of her bag many books with bright pictures of the rooms in the house, numbers, and letters. She would point to the various pictures or numbers and ask us to repeat after her.

As nice as Sarah is, I am happy when it's time for her to leave because it means I can turn on the TV. Although I don't understand the reason, Meng and Eang have a very strict policy that while there are guests in the house the TV must be turned off. This makes for many awkward and silent visits with our guest peppering Meng with questions as Eang and I sit silently nearby. Sometimes, a visitor looks in my direction and I smile, pretending to pay attention to words I do not understand. While the adults talk, in my mind's eyes I flatten, pull, stretch, and reshape their human faces into cartoon characters. A man with a big nose becomes a pig, a round face turns into a monkey, and a thin-lipped person transforms into a chicken. At times, I have a whole farm of animal people, all of them pecking, hissing, or spitting noises at me as I nod my head in reply.

When we have no visitors, I stay in my closet; outside, the sun makes the white people brown, the birds chirp their wake-up song, and the clouds roll by as soft as cotton balls across the blue sky. At three, I leave my closet and turn on the TV in time to hear the familiar Looney Tunes theme. Then for an hour I follow Bugs Bunny, Daffy Duck, and Tweety Bird as they chase, kill, and bash one another without bloodshed or anybody getting hurt. In shows where a cartoon character dies, it usually comes back to life in the next episode or flies up to heaven with its tiny white wings while strumming a harp.

Each time the Road Runner comes on, I hope for the coyote to catch the bird and sink its teeth into the bird's long neck. After all, I reason, the coyote isn't being mean; it is hungry and only wants something to eat. If I could create a show, I'd draw the Road Runner plucked of its feathers and hanging on a hook, all naked and skinny. Slowly, I would deep-fry the bird in hot grease until it was golden and crispy. Then the coyote and I would crunch on it, bones and all, like it was a pheasant.

The days I don't think about deep-frying the bird, I daydream about roasting the pig, barbequing the duck, and steaming the fish. This usually means that I need to fill my stomach with chips and cookies until the next mealtime. With my stomach full, I sit in front of the TV lost in a world where everything is light, silly, and young again. In the evening, when there are no more cartoons to keep me company, I tune in to the Brady family and laugh at their antics. Although I cannot understand their words, the largeness of their family and their crowded house make me feel less alone in mine. For half an hour each night, I live their lives and enjoy their family bonding and sibling rivalries. Watching them, I am taken back to a time and place when I, too, was part of a large family. But now, I am the only child of Meng and Eang.

As much as I like the show, I sometimes fantasize about beating up the Brady girls. In my mind, I lift their stick figures up in the air, their golden hair flowing like silk threads over my shoulders as I send them crashing on my knee, snapping them like dry old twigs. I think of doing this not to hurt them but to save them. In my mind, I worry that if fighting suddenly erupts in America, many of its frail citizens with their weaknesses will not survive. And I want them to live because it is so much harder to see them die. I know that in my new home, there is no war, hunger, or soldiers to be afraid of. Yet in the quiet recesses of my mind, the Khmer Rouge lurks and hovers in dark alleys, waiting for me at the bend of every corner. No matter how far I run, I cannot escape the dread that they have followed me to America.

To escape the soldiers, I sometimes find myself in a field not far from our apartment. With my hair loose and free, I run through elephant grass as tall as my thighs until I come to a brook. The sound of the gurgling water soothes and relaxes my mind, shutting out the thoughts of war. On the edge of the rushing stream stands a tree that reaches up high into the heavens with branches that dip toward the earth. I run and wrap my arms around its trunk, pressing my body against its hard bark. My eyes closed, I imagine Chou on the other side, her cheek smashed against the tree, her fingers reaching out for mine the way she used to when we were together. When I open my eyes, Chou is not there and my mind races to find her, wherever she is.

As I focus my thoughts on Chou, in the kitchen Eang is being noisier than ever.

"Loung! Come help me clean the kitchen!" Eang wakes me from my daydreaming. I ignore her call.

"Loung, come help me now!" she yells.

In the past few months, I'd noticed that Eang had been more impatient and spent a lot of time throwing up in the bathroom. Then last week, while Meng waited quietly outside our apartment, Eang told me that she was pregnant and that the baby will come in December. I burst out laughing then because I now knew the reason for her bloated face and bad moods.

"All right! I'm coming!"

I turn around and survey my closet to make sure all is neat and orderly. In my sanctuary, my world is decorated with a single picture—a drawing I made of Mickey holding Minnie's hand. Pulling the curtain open, I enter the big world.

A short time later, Joe McNulty arrives to take us to a barbeque at his house. At forty, Joe is a big Irish-Italian man of few words. Lumbering a head taller than Meng, Joe stands as strong as a tree and has a spirit as clean as the earth. Behind his thick glasses, his kind eyes inquire about our well-being and his hands are always ready to help fix anything broken.

At his house, Lisa McNulty swings open the door to greet us. Stationed regally near her feet, two gray fat fur balls with beady eyes regard us with suspicion before deciding we aren't interesting enough and saunter back inside.

"Welcome! Welcome to our home!" Lisa walks toward us.

Whereas her husband, Joe, is quiet and reserved, Lisa is a fast-talking, animated Italian woman with an easy manner and infectious laugh. Standing almost as tall as Joe, Lisa dispenses motherly energy to everything she touches. And thus her garden blooms, her husband grows, her daughter sprouts, and her cats multiply. Beside her, strutting confidently toward us, is their daughter, Ahn. Now thirteen, Ahn was only eight when she left the orphanage in South Korea and traveled by herself to America to live with her new mom and dad. Five years later, Ahn possesses the bright smile and kind eyes of a well-loved child.

As Lisa beckons us into her home, Ahn runs up to me and grabs my hands. Pulling me into her garden, she talks excitedly and points to the six

cats in her yard. Her hands mime that they're all hers. Before we can escape, Lisa stops us and whips out her camera. She then takes one picture after another of our family before asking Joe to take one of just the two of us.

With her arms around my shoulders, Lisa tells me how pretty I look. Eang laughs and explains that I chose my own outfit. As Joe aims his camera at us, I run my finger through my hair, tucking a piece behind my ear and beam at the compliment. After four years of living under Khmer Rouge rule, I now wear only brightly colored clothes.

From a few feet away, Joe waves for us to look into the viewfinder and asks for a smile as the camera flashes and commits our image on film for all to see. In the picture, Lisa looks light and happy. Next to her, my face is dark with a frown, my eyes squint, but I'm all dolled up in my floral pink tube dress with white spaghetti straps, blue-and-white striped socks, and green sneakers.

After a yummy barbeque of burgers, hot dogs, and Eang's special Cambodian chicken, we all walk the short path from the McNultys' house to the fairground. The sky has turned pink and orange and the air blows cool breezes that chase the bugs away. All around us, the mass of people stroll together, their voices a low hum broken by an occasional shrill call for their kids to slow down. As we march along, my skin picks up the excitement, a charge of electricity.

The mass is all heading in the same direction, to a field of grass and shrubs used to host the fair every summer, and an occasional concert or monster truck show in the fall. Soon the mass grows too large for the sidewalk and overflows onto the street, slowing down traffic as people stop to greet, talk to, and gossip with their neighbors. Looking around, I'm surprised to see the normally drab white people dressed in festive red, white, and blue colors. A man in front of me adds another foot to his frame with a blue-and-white striped top hat. Next to him, white stars bounce on the back of a woman's shirt as she jogs to grab a child's hand. The young child breaks free of the woman's grasp, her voice raised to its highest pitch, her arms out like the wings of a plane, as she runs to meet another friend her age. Once together, they wrap their arms over each other's shoulders and lean their heads together, whispering secrets into each other's ears.

Watching them, my palm feels empty and cool until Ahn sprints to my side and takes my hand. With her black hair and Asian features, Ahn is the only other girl who looks similar to me in the crowd, and she makes me feel accepted. Her acceptance warms me. Hand in hand, we edge along with the crowd toward the fairground. Ahn drags me along and talks excitedly about the exploding lights that cover up the sky like shooting stars. Behind us, Joe and Lisa explain to Meng the importance of the Fourth of July.

After a few moments of searching, Joe finds a bench in the first row with room enough for all of us. All around, children scream with joy; their arms shoot out sparklers and flap around like dragonflies. Somewhere in the distance, a band plays songs I've never heard. The drums and symbols roll and clash thunderously, lifting me into the air before the tuba drags me back down to the ground. Above us, the stars twinkle like the eyes of the gods, blinking in and out, as if they're spying on our festivities.

"It's almost time, it's almost time," the crowd whispers.

The crowd huddles in the dark, forming bumps on the field resembling burial mounds.

"It's almost time," the mass exhales.

My skin moistens from the sound of crackling gunshots from afar.

"Any moment now," the swarm murmurs as the excitement grows. Perspiration forms above my lip. I wrap my arms around myself, my hands rubbing my skin to warm my arms.

Suddenly, a cannonball shoots into the air; the whiz of its flight and brilliant explosion hovers above me. My hands clasp over my ears, my eyes shut, and my jaw clenches so tightly I feel the muscles of my cheeks cramp up. In the sky, the rocket explodes, and its deafening sound vibrates in my heart. Then another cannon hurls another weapon above the crowd and is followed by many more as I brace myself for the oncoming war. The smell of burnt powder, the brightness of the bombs, and the haze of smoke are so terrifying that even the stars leave us and disappear into their black holes. Somewhere in the crowd, a baby screams; its cries jump into my head and are trapped in my skull, flooding my senses. Another explosion sends me trying to scurry under the bench but Meng grabs my arms and holds me in my seat. I want to be a good, strong girl so I press my body against the back wall as more flares shoot into the night and burst into fire

showers. I flatten my body into the bench and try to disappear into the wood.

In my seat, my throat closes as I gasp for air. Suddenly, I am outside of time and space and in a world where Cambodia and America collide, with me stuck somewhere in the middle. A baby screams as the soldiers reach into the bomb shelter and pull out a woman. Her clothes are black and dirty and her face is muddy. She clutches her baby to her breast and begs for mercy, taking me back to the death of Ma and Geak. All of a sudden, my world goes red and I am back in America, disoriented and terrified. As the sky continues to explode, I count quietly under my breath, inhaling the falling ashes and damp earth through my nose and mouth.

"One . . . Two . . . Three," I breathe as pictures of Cambodia and America are superimposed one on top of the other. My eyes shut, I pray the bombs will not hit my shelter and bury me alive.

In the night sky, the gods battle their grand finale. In the bomb shelter, the Cambodians get on their knees, their palms together and pressed against their chest, and their lips singing incantations and prayers for the war to stop. Not caring, the gods throw firestorm and lightning, tearing the sky apart, while the souls of its people hide deep within the earth.

In my mind's eyes I see my friend Pithy crouching next to me, her mother and brother huddled together beside her. Another explosion splits open so loudly that even the gods desert us and leave us to the enemies. In my head, a mother screams and I turn to see Pithy, her head cracked like a coconut, her blood oozing out of her wound.

"I'm so sorry, Pithy," I whisper. Pithy's nine-year-old body lies unmoving, slowly sinking into the earth.

"I'm so sorry, Pithy!" I want to scream, but my mouth is dry, my spit caked around my lips. I clamp my hands over my ears and press my eyes closed, trying to squeeze Pithy out.

Then all is quiet. The bombs stop, the soldiers retreat, and the baby sleeps in its mother's arms knowing the war will never scar its mind or stay in its soul. The world shifts back into place and slowly Cambodia recedes from my focus, leaving me again in America. In the dark, Meng's voice calls out to me, his hand reaching into my shelter to pull me out. The mass departs; everyone is smiling and laughing.

"That was exciting! What a wonderful show!"

4 war in peace

Crack, crack, crack. Chou jumps out of her heat-induced stupor at the noise, her hands trembling so hard that she drops her ax. Beside her, cousin Cheung does not notice Chou's nervous reaction and gathers another handful of dead twigs. With her expert hands, Cheung shaves off the branches with her sharp knife. She then snaps them in half, creating a sound that reminds Chou of crackling gunfire. Chastising herself for being too jumpy, Chou hurries on with her work.

"Keav." Her name bursts out like a crab from a mud hole. It seems that as Chou approaches her fourteenth birthday, Keav is on her mind so much that she seems to follow Chou wherever she goes. Chou shakes her head and forces herself to leave the shaded spot under the tree to walk into the sun. The minute she is out from under the shade, the sun burns her skin and eyelids, and the bright glare makes the fields shimmer and sparkle like a mirage. Chou almost half expects Keav to walk out of the hazy world into hers. Sometimes Chou hears Keav in a stranger's laugh and almost turns her head around to look. Other times, the smell of mud and rotten compost brings Keav to mind. But Chou does not like to think about those times. Chou does not like to remember Keav sick and dying in her mess, smelling of feces and mold. Her eyes begin to sting again but she does not rub them. Instead, she runs her hand over her arms to wipe the chill off her skin.

"Chou! Are you working or dreaming?" Cheung yells out.

Chou turns to look at Cheung, who stares back at her with dark eyes. Cheung and Keav were great friends, but whereas Chou's sister was known for her beauty, her cousin is known for her ability to work hard. At seventeen, Cheung is slender and pretty, but the war, their poverty, and their busy lives do not allow her the free time to think about romance. Chou wonders how Keav would have adjusted to a life like this. In Phnom Penh, Keav was always dreaming of falling in love with a handsome boy who would treat her like a princess. Kim and Khouy thought her brain was uselessly muddled by romance.

"Keav," Khouy would call out to her as she sat in front of the mirror, pinning yet another new colorful barrette in her hair. "Don't primp so much. You know you're only going to grow up to marry a cyclo driver."

"Do you think so?" Keav scrunched her face with worry. Khouy and Kim would laugh at her readiness to believe them.

Chou often wonders if Khouy ever thinks about Keav and their sad times under the Khmer Rouge. Whenever Chou hears him talk about the war, he entertains his audience with gory details and humor. As he acts out his stories, his voice booms with drama and bravado but never sadness. When she listens to him, sometimes she forgets her sadness and laughs along. But when his stories are over, she is left with her memories of Geak's hunger and Keav's death.

If she were alive, thinks Chou, Keav would be seventeen years old. And without doubt she would be the most beautiful girl in the village. Chou does not know which one makes her drop more tears, the dream of Keav's life or the nightmare of her death. Shaking her head, Chou walks to the edge of the forest and picks up a dead branch from the thick brush. The brush holds on to the branch with its webs of vines and shoots, but they are no match for Chou's rusty ax as it crashes down on them, chopping off their hold. For the next few hours, Chou pulls, chops, and shaves as her woodpile grows. Her arms, which were like pliant, strong bamboo in the morning, are now stiff and weak like deadwood. Under her dark blue clothes, her body aches and burns, but Chou stops only to wipe the sweat off her face, her calloused hand dragging dirt and grime from her forehead to her cheeks. Her old shirt sticks to her skin and smells of sweat.

In the sky, the sun passes over her head, changing her shadows from

short and stout to long and lean. The sun grows weaker, but the humidity doesn't lose any of its strength. By the time they have collected enough wood, Chou's hair is damp and oily and Cheung's is plastered to her skull. Together, the cousins wrap their ropes around their piles. Then they sit on the ground facing each other, with a pile of wood in between them. They push their bare feet against the wood and, while pulling at the rope, they rock the pile back and forth until the rope is taut before Chou double-knots it. As they rise, they plant their axes and more branches in their bundles of wood and are ready to go. Chou then takes her tattered black-and-white checkered krama scarf off her shoulders, pulls both ends tightly, and rolls it into a spiral circle. She places the scarf on top of her head and bends her knees for Cheung to put the woodpile gingerly on her krama. After she's helped Chou, Cheung heaves her own pile onto her shoulder. Then with another push she lifts it off her shoulder and onto her head. With heavy woodpiles on their steady heads, the cousins look forward and march in single file back to the village.

As they approach their village and then their home, Chou's neck throbs painfully, her lower back burns, and her calves are tight from the long journey. But she does not complain. She knows that the life of a poor villager is always filled with aches and pain from hard labor. With no doctors or access to medicine, a villager will seek an herbalist for a specific potion or concoction only when the pain becomes unbearable. Often, the herbalist does not know if the potion will help the pain but charges for the service anyway. And with rice—the country's currency—so scarce, Chou decides to ignore her pain.

When she finally arrives at the hut, the sun is low in the horizon. Their wooded home is cool, as the trees take in much of the dampness in the air. Chou stiffens her neck muscles and gently lowers her chin toward her chest, allowing the pile of wood to fall off her head. As the wood crashes to the ground, Chou hurries her body, feet, and toes out the way. She picks the krama off the ground, shakes off the splinters and dirt, and wipes her face and neck with it. Then letting loose her thick curly hair, she runs her fingers through it and digs them into her scalp, giving it a good, long hard scratch. Without shampoo or soap, dirty hair, lice, and dandruff are also facts of village life. Chou twists her long hair into a bun again, secures it with a rubber band, and sighs. Because they did not have

time to collect water from the pond today, she will have to wait until tomorrow for a shower.

Coming up behind her, Cheung drops her wood and walks to the water jug. Quickly, she splashes a handful of water on her face and hurries off to meet her friends to catch fish for their dinner. In a rare moment of tranquillity, Chou stands quietly and watches Cheung's figure walking briskly away. The image of her faded black pants and shirt walking away reopens the scars in Chou's heart. But before her thoughts can drift to find the reason for her sadness, three-year-old Kung wraps her dirty, tiny hands around Chou's legs.

"Che Chou," Kung calls her, using the Chinese title meaning big sister Chou.

"Let go of my legs. I'm not going anywhere," Chou laughs, her voice high and hoarse.

"Che Chou, play with me," Kung implores, her eyes round and smiling, her hands gripping tight onto Chou's legs.

"I have no time to play. Go play with your sister."

"Play, play, play!" Kung pleads, jumping up and down, her hands extending up to Chou.

"If you don't stop I'm going to get mad." Chou pretends to glare at Kung and walks toward Mouy, who sits on the ground, happily gurgling to herself. Chou scoops one-year-old Mouy up in her arms and hugs her to her chest. Then she leans her face in, presses her nose against the child's cheek, and rapidly sucks in air through her nostrils to give Mouy a Cambodia kiss.

"I want kiss her!" Kung reaches out to Mouy.

"Your nose is flowing with mucus. You can't kiss her," Chou tells Kung as she gently puts Mouy down. Seeing her chance, Kung dashes to Mouy, wraps her arms around her, and shoves her nose in Mouy's cheek. When she is done, Chou looks at her with disgust before turning her attention to the green mucus streaking across Mouy's cheek.

"Chou," Aunt Keang calls out. "Watch the kids and make dinner. I'm going to help with the planting."

"Yes, Aunt." Chou knows that with farming, there's always a lot of work to do and the family needs every available hand to work. And thus, before Aunt Keang leaves the hut, Chou is already busy stocking wood

into a neat pile. As she works, Chou feels grateful to be part of their large family and takes great care not to get into fights or cause Uncle Leang and Aunt Keang to be angry with her. When they speak to her, she listens and honors their words as if they were from Ma and Pa. During meals, she serves them and their children first, before herself. In return, Uncle Leang and Aunt Keang treat her with kindness and tell her often that they love her as if she is one of their own. Yet even with all their kindness and love, Chou cannot forget that she is merely their niece and not their daughter.

"Che Chou, play!" Kung is holding her sister's hand and staring up at Chou.

"No, I have a lot of work to do. You watch after Mouy while I go make our food." Kung leads Mouy and together they toddle away to sit on the straw mat under the tree.

Leaving them to play with the fallen leaves and old sarongs, Chou goes a few feet from the hut, to where three large stones are placed around a small hole in the ground. She breaks a few handfuls of dry branches, crumples some leaves, and places them inside the hole. She lights a match and burns the dry leaves and branches into a fire before adding the bigger pieces of wood. She then places a pot of water on top of the stones to boil. While the water heats up, Chou walks into the hut and reaches under their plank bed to measure three twelve-ounce cans of barley into a plastic container. She fills the container with water and stirs it with her hands, forcing all the ants and bugs to float to the top. She pours out the water and bugs before taking the barley back to the fire, and then dumps the barley in the pot. Because barley takes longer to cook, Chou waits for thirty minutes before going through the same process with the rice.

When the rice and barley have turned into a thick gruel, Chou takes the pot off the fire to cool down. She places another big pot of water to boil while she chops stocks of bok choy, turnips, mushrooms, and other vegetables and tosses them into the pot. She then adds a few spoonfuls of salt and sugar, and a pinch of MSG to bring more flavor to their soup. In all, six cans of grains, some vegetables, and hopefully a few fish Cheung will bring home are all Chou has to feed their family of thirteen. It is getting harder and harder to grow the vegetables and to harvest rice, so she has to carefully ration their meals. While she adds more wood to the fire, her eyes shift constantly between the pot and the children. Gazing at

Kung, Chou is reminded of Geak, whose laughter and giggles seem to echo from the mouths of these new babies.

"Please gods," Chou prays under her breath, "wherever Geak is, do not let her suffer." Chou still believes in the gods' and spirits' ability to help and watch over people. She also prays because everyone she knows prays. And although Pa was a monk as a child, and the family is Buddhist, Chou does not know what sect of Buddhism she was born to, and she has never read any Buddhist texts. And yet, throughout the year, she will pray to the god of harvest, full moon, river, sun, fields, land, and protection. She does not know the differences between each god but prays to them all and hopes that they will grant her good karma for her next reincarnation. She also feels closer to Pa when she prays.

"She was a good sister and daughter. Please gods, let her be reincarnated as a beautiful, rich girl in another country," Chou pleads with the gods. "And, please gods, protect my eldest brother, Meng, and Loung, wherever they are, and keep Khouy and Kim safe from harm."

With Loung gone, Chou is now closest to Kim. Even though Loung is no longer there, when Chou talks about the war, it is always with stories of the three of them together. During the Khmer Rouge time, they were together when the soldiers sent Meng, Khouy, and Keav to work camps, and when soldiers came for Pa. When the Vietnamese invaded the country, they were together and helped one another survive. And now that there are only the two of them, Chou and Kim look out for each other.

When the soup is cooked, Chou pokes at the red embers and hopes that cousin Cheung will be home with fish before they completely burn out. Chou piles the wood neatly beside the house, washes the pots and pans left by the others, takes the laundry off the line, and sweeps the floor. As time creeps slowly forward, making her shadow grow longer and longer, Chou begins to worry about Cheung. Inside the house, the toddlers have fallen asleep together in a hammock, their bodies nestled warmly in the pouch. Chou walks over to the hammock and gives it a push, lulling her cousins into deeper their dreams.

When she hears scuffling feet, she exits the hut and sees Aunt Keang approaching. "Where's Cheung?" Aunt Keang asks, washing her hands beside the water container. Behind her, the rest of the family drags their feet slowly home.

"She went fishing and hasn't returned," Chou answers, her voice shaky and quiet. Then, suddenly, Kim is standing near and her voice grows stronger. "She left this afternoon and hasn't returned."

"It's very late. Where can she be?" Aunt Keang's round face wrinkles in fear.

"Second Aunt, it's not dark yet. We'll go find her," Kim says reassuringly as Chou takes Aunt Keang by the arm. "Chou, take Aunt Keang inside. I'll go and tell the news to Uncle Leang." Chou looks gratefully at him.

Outside, Kim speaks quickly with Uncle Leang and Khouy. While Uncle barks out orders, Khouy hangs an ax on his belt and leads the men in search of Cheung. The girls sit around Aunt Keang. The heat suddenly becomes even heavier and more oppressive, making it difficult for them to breathe. In the growing darkness, the mosquitoes and bugs come out and buzz around the circle of women. Quickly, Chou goes to light a green mosquito coil and places it on the floor beneath the women's plank. Then she picks up a round palm leaf and fans Aunt Keang. Still silent, Aunt Keang crosses and uncrosses her arms and legs in agitation.

"It's going to be night soon," Aunt Keang laments and sighs.

In the hammock, Mouy wakes up screaming. Chou leaves Aunt Keang to pick Mouy up and holds her tightly against her chest. Chou gently rocks the baby to sleep, and as her body moves from side to side, in her mind she is back in the Khmer Rouge time, sitting on the steps of their hut in the village of Ro Leap waiting for Kim to return. With Pa taken by the soldiers, and Khouy and Meng away at their work camps, Kim was the only man in their house. And when he saw that the family was slowly starving, Kim went to the cornfields to steal food for them but was caught by the guards who beat him with the butt of their rifles. Her eyes blink as she remembers the blood pouring out of Kim's skull. Her lips begin to quiver but she forces herself to smile and play with Mouy to push away the tears while continuing to stare at the door.

Before the sky turns black, the women hear Cheung's voice.

"Ma," she calls out in a child's voice.

"My daughter, my daughter." Aunt Keang leaps off the plank, runs outside, and wraps her arms around her daughter. "My daughter, we have been very scared. What happened?" Aunt Keang puts her arm protectively

around Cheung's shoulders and guides her into the house. Once inside, Aunt Keang runs her hands over Cheung's arms and takes her into another embrace.

"Ma, there was another Khmer Rouge attack!" After she utters the dreaded Khmer Rouge's name, Cheung cannot stop her tears from spilling.

Alone with the women, Cheung sits in the middle of the circle as they gather around, their hands brushing her hair, touching her back, rubbing her arms, and holding her hands. Feeling safe, she recounts her story.

"My friends and I were fishing in a muddy brook," she begins.

When she arrived at the big pond, she saw that the sun had dried up much of the water, but along the edge she could see fresh crab holes. Before reaching her hand in, she poked a long stick into the hole to make sure no snake lived there. The memory of how blue that poor village boy turned when he was bitten by a snake still scared her to death! When the crab crawled out, Cheung grabbed it by its shell and plunked it into her basket.

Then she looked around and saw many bubbles rising from the mud. She knew the fish must be so hot that they were trying to cool down in the mud. She probed with her feet and found there were so many fish that she stepped on them just by walking around! Some were able to slither away but others she trapped, putting all her weight on them. She then quickly dragged the area beneath her feet with her wicker basket. She was rewarded with two wriggly fish, and she tossed them onto the grassy bank.

Cheung and her friends were so busy talking and rejoicing with each catch that they did not hear a group of soldiers running toward them.

"Stop and stand still!" the soldiers commanded. Cheung and her friends dropped their baskets and froze in fear. Suddenly, her friends sprinted into the forests like frightened animals and disappeared. A few of the soldiers took off after them, their AK-47s aimed in the direction of the fleeing teens. Cheung tried to run, but her feet had sunken deeply in the mud, and she couldn't move them quickly.

"You are Khmer Rouge. Stop and be still!" The soldiers' words sounded like a pronouncement of death to Cheung's ears. "We are the government's soldiers."

After so many years of war, Cheung did not trust any soldiers, whether they were Khmer Rouge or the government. She saw only that the soldiers wore dark uniforms. As the soldiers moved closer, she finally pulled out her feet and ran through the water.

"Stop!" the soldiers yelled. Cheung kept running and dove into the knee-deep brook as bullets whizzed by her. Cheung held her breath and tried to swim, but the water was too shallow. Despite the warmth of the water, her skin went cold. When her lungs were about to burst, she raised her head out of the water and froze as another bullet flew by the top of her scalp.

"Please don't kill me," Cheung begged, her voice hoarse. Twelve soldiers surrounded her, their guns pointed at her chest.

"Put your hands behind your head!"

"Please don't kill me." Tears slid out of her eyes and nose now.

"You are Khmer Rouge!"

"Please, good lords, I am not with Pol Pot. I am just a village peasant." The soldiers would not listen and ordered her on her knees. They grabbed her arms and tied them behind her back and jerked her off the ground.

"Please, good lords," Cheung pleaded.

"Stop talking!" A soldier pushed at her back with the barrel of his gun. "Walk!" Still sobbing, Cheung obeyed in silence as they led her away from the village. In her mind, she saw them shoot her dead and dump her body in a rice field. With each step, her hands became more swollen and her feet heavier. Under her breath, Cheung thanked the gods for stopping the bullet from hitting her and prayed to them to help her get home. Suddenly, the group saw an old man approaching them on the road.

"Please help me!" Cheung yelled when she recognized the villager. "They think I am Khmer Rouge. Please tell them I am not!"

"Good lords," the man pleaded with the soldiers. "Cheung is not a Khmer Rouge. She is from my village."

"No!" the head soldier exclaimed. "We were chasing after a group of Khmer Rouge who raided a village this afternoon. They ran in her direction. We told her group to stop but her friends ran away. If they are not Khmer Rouge, why did they run?"

"Good soldiers, I can swear that this girl is no Khmer Rouge. Her name is Cheung and she is the daughter of old man Leang and his wife,

Keang. I know them well. They are good farmers and kind people. She is their daughter. I beg you to let her go. I beg you to return her to her family." The man raised his hands to his chest in respect. The head soldier hesitated and stared at the man and then back to Cheung.

"Will you swear? And if she is a Khmer Rouge and you are hiding her, we will come find you and make trouble."

"Yes, I swear."

Listening to all this, Cheung's heart beat so rapidly she thought it would explode out of her ribs. When the soldiers untied her hands and told her she could go, she ran away so fast she never even thanked the kind man for his help.

When Cheung finishes her story, the women are all in tears. The men return later to find them laughing and smiling, with their arms still encircling Cheung. Chou smiles with relief when she sees Kim's silhouette walking through the doorway.

5 "hungry, hungry hippos"

On the TV screen, the girls sit in a circle around a table and laugh out loud. The laughs leave their mouths like light air bubbles, and their gleaming white teeth shine like pearls. In the background, a joyous chorus repeatedly sings the words "Hungry, hungry hippos." On the table, four fat plastic hippos crouch on a red plate, their funny eyes staring dumbly at one another. Each hippo wears either a pink, yellow, green, or orange skin and waits patiently for the girls to feed them the white marble balls. As the music rises and the singers urgently repeat "Hungry, hungry hippos," the girls release the balls and all mayhem ensues as each girl furiously pounds on the hippo's tail to open its big mouth and make it swallow marbles.

"The hippos are too tame!" I think smugly, imagining the hippos growing larger, their bodies ripping out of the colorful plastic casings to reveal shiny leathery black skin. Their eyes are bulging and bloodshot, and their teeth are sharp and jagged like fangs. The hippos' thick legs trample the red plate beneath them and chomp at everything in their path. Their noses flare, and they charge at the girls.

When the commercial is over, I remain transfixed on my couch. The "Hungry, Hungry Hippos" song is still swirling in my head, bouncing in my skull like a Ping-Pong ball, picking up momentum wherever it hits.

"Hungry, hungry hippos," echoes my mind.

"Growl, growl," my stomach sings back.

"Hungry, hungry Luanne," I whisper to myself, using the name so many of the sponsors seem to think is mine.

The name comes out of my mouth tasting like a spoonful of vinegar, and my mouth purses in response. I stick out my tongue and blow air out of my cheeks, spitting Luanne out with it. Then I jump off the couch, both my legs landing on the floor in hard thuds.

"Stop jumping and making noises," Eang calls out from the kitchen. "You know the dentist's office is still open below us. We don't want them to complain."

Quietly, I tiptoe to the kitchen, careful not to bump into anything or knock something down. Downstairs, the dentist and hygienists in their white coats and masks work on a patient's mouth, and the hum of their voices and their drills floats into our apartment. Above them in our new home, we live quietly and softly, our conversations kept low and our bodies scurrying from room to room with the softness of a cat.

At five-thirty P.M. the dentist's office closes, and when the last white coat exits the building, our home comes alive. Upstairs, I go from a fuzzy feline to a clunky elephant, thumping my feet into the kitchen. Eang's mood lightens as Meng plays with the radio. When he finds his favorite station, he turns the radio's volume to high, and together we snap our fingers to the sound of the classic oldies. Tapping my feet to the Beatles and Santana, I throw a spoonful of chopped garlic into a hot frying pan. The garlic pops as the oil hisses and splatters, spreading its aroma into all our rooms. Eang squats on the floor, raises a cleaver, and brings it crashing down on the dead white chicken. The bird splits in half with no droplets of blood, its bones cracking under the cleaver's sharp blade. Eang lifts the cleaver again and quarters the chicken, then chops the quarters into even smaller pieces. Then she dumps the meat into the frying pan and hands me the cutting board to wash. From the sink, I watch Eang add a spoonful of salt, a pinch of MSG, a few shakes of fish sauce, and globs of oyster sauce. Then she browns the chicken until it is golden and crispy. While she works on a vegetable dish, my mouth waters as my hands scrub clean the pots and pans.

Once we are seated, Eang serves us each a steaming plate of white rice. The rice tastes soft and sweet and its grains stick together like ants' eggs,

the way rice should. A few weeks ago, one of our sponsors brought us a box of Uncle Ben's rice and raved to Meng that it was the best rice she had ever tasted. She explained that all we had to do was add boiling hot water to it, wait ten minutes, and the rice would be ready to eat. As Meng translated, I could not believe her words. Meng, Eang, and I have eaten rice three times a day all of our lives, and between us have cooked more pots of rice than we can count. We know how to cook rice and we know that rice takes anywhere between twenty and thirty minutes to cook.

We know how to make rice firm, soft, or sticky. We know how to turn it into soup, gruel, congee, and even sweet fermented desserts or cakes, but in none of these recipes does it require only ten minutes of cooking! As expert rice eaters, we thought this America invention for quick rice had to be too good to be true. And it was. Uncle Ben's rice tasted like cardboard paper, all starchy and fluffy. I glance at our counter and smile at the box still sitting there.

Though I itch to shove a yummy morsel into my mouth, I restrain myself and sit quietly. In our Chinese-Khmer tradition, no one is allowed to touch his or her food until the male head of the household takes his first bite. Sometimes this could take a while if the head of the household was chatty. After Meng takes his first bite, I reach in and serve myself a heaping spoonful of chicken.

Meng's words break our slurping and crunching. "Tomorrow we'll go shop for food." I stare at him, my eyebrows knit together, and the food suddenly tastes stale in my mouth as I remember how much I hate going to the grocery store.

When I crawl into bed that night, I rub my round belly with happiness. Like the Buddha, my stomach sticks out under my shirt like a hard ball, but instead of being filled with air, it is filled with chicken and rice. Outside, the cemetery is still there; no one has come to answer my prayers and bulldoze it down. When I wake up in the middle of the night to use the bathroom, I make sure to walk quietly and sideways in the dark, so as not to peek out the window. I don't know what I expect to see, but my fear is that there will be a ghost pressed against the pane, its long tongue licking the glass as it tries to get in. Though I no longer mark my ankles with Xs, I still sleep with my back to the window.

As I drift off to sleep, the clock ticks away the hours on the wall. Suddenly, I am awakened by the sound of rumblings and growls. The noise grows like a ferocious animal caught in a cage, waiting to be let loose. My hands clench the sheets and, wide-eyed, I attempt to calm the thumping of my heart in my ears. Outside, the wind pushes the clouds in front of the moon, causing my room to go black. Shivering, I pull the sheet over my head and pray I have not attracted the attention of the ghosts. But at the moment, all is quiet and my heart slides back down my throat and into its cage.

Then, abruptly, another growl bursts forth and I quickly jerk the sheet down to my chin to scan the room before realizing that the noise is coming from my stomach. I spread my palms on my belly as if to soothe the hunger beast and return it to sleep. But it's awake. Below my rib cage, my organs follow the beast's command to move and slide, causing me great pain. Though I don't want to remember, my stomach reminds me of what I learned from the Khmer Rouge. Hunger means only one thing: death.

As my hunger grows, the dark shadows in my room expand with it and spread to my ceiling to hover above my bed. I flash to a picture of a Khmer Rouge work camp. In a thatched-roof bungalow, my fourteen-year-old sister Keav lies dying on a straw mat, her body a skeleton of its prior self. But I am far from Cambodia now and don't often imagine Keav's death as I once did—full of flies and foul vomit and stench. In America, as my life grows stronger, I am able to rewrite Keav's story so that she dies in her sleep and without pain. But sometimes, I still find myself traveling to her work camp, where again I hear her shallow breaths wheezing in and out from her purple lips. When my mind is flooded with the sounds of her fight, I am filled with hurt and a rage so strong that all I can think of are revenge and hate.

I grope under my pillow and pull out a bunched-up napkin. Carefully, I unfold it to reveal two broken sugar cookies. My greedy fingers grab a big piece of a cookie and shove it into my mouth, crumbs spilling on my shirt and into the bed. The sugar and butter dissolve on my tongue and numb my hurt as my teeth grind down the baked flour to lull the rage. Faster, I devour the rest of the cookies and send my hunger back to sleep.

In the morning, Eang, Meng, and I trudge a mile to the A&P supermarket. As Meng and Eang talk to each other, I fall farther and farther

behind. Because we do not have a car and Meng wants to save the three dollars for the three of us to take the bus to the market and back, we make the walk every week to buy our food. When I complain about all the walking, Meng answers me with a Cambodian rhyming phrase about savings.

"Remember, *dthoh, dthoh, pbing moi pong* [Translation: drip, drip, full container]," he tells me, a reference to how villagers in Cambodia collect palm juice to make sugar. They do this by climbing very tall, swaying palm trees, chiseling a hole, and hanging a bamboo or metal container to catch the juice. All night the juice drips, filling the container by morning. Meng says they use the same process here in Vermont with maple syrup.

Meng teaches with Cambodian sayings, and Eang uses Chinese ones to raise me to be a proper girl. Whenever she asks a question and I answer her with the unladylike "huh," she glares down at me and replies, "*Huh, mung ka, cachung sai leap pa.*" Which literally means, "Huh, mosquito bites, your butt grows a bump." So between Meng's drip and Eang's bump, I learn to be frugal and to protect my butt from bug bites. Still, this does not mean that I have to follow their path gladly or without fuss, so I dawdle behind and make them wait for me to catch up.

As we approach the store, the automatic doors slide open. Inside, Meng grabs a cart while I follow Eang as she goes about picking up our food for the week. I reach for a bunch of giant bananas in the produce section. Picking up a ripe yellow bunch, I wonder if the Americans are big because they eat giant fruits. In Cambodia our bananas are the size of a large thumb, and our apples are not much bigger than a child's fist. In our village, you're happy if you find a watermelon with the roundness and the size of a human head. But most of the time you have to settle for one so small you can eat it all in ten bites. I reach for an orange, lift it to my nose, and take a whiff. Like all the other fruits in our cart, the orange smells faintly of citric and some kind of cleaning agent.

As I walk the quiet aisles, I miss the noise and smell of our Cambodian markets. In my mind's eye, I am back in a Cambodian market where a pile of fish flaps on the dirt floor next to a mound of beef intestines, tripe, and chicken feet. A seller squats next to her goods, her mouth talking incessantly, praising the quality of her products or sharing a yummy recipe on how to cook them. When a deal has been struck, she wraps the goods in

a lotus or banana leaf and gives it to her customer. Then, with a wave of her hand, a black cloud of flies levitates and scatters, waiting for her hand to settle down before their eventual return. The smell of her fish, tripe, and chicken feet hovers in the humid air and floats fifty feet away to the people sitting on stools eating their fried chive cakes, pork dumplings, and shrimp patties. Boiling pots of noodle soups, yellow curry, pork-blood rice congee, and pans of hot oil filled with crunchy spring rolls sit on a makeshift oven. Crackling and browning in another oven are skewers of frog kabobs roasted to a crispy brown. The aroma of the soups and frogs hops over to another customer as she feels the firmness of a pink dragon fruit. From there, she inspects the wiry red ramutans, jackfruit, and durian before she pops a purple grape into her mouth. Drawn by songs of the dessert sellers, she finishes her shopping and sits down for a cool glass of mango fruit shake. As she sips her drink, the pungent smells of dried fish, squid, soups, frogs, fruits, meat, and fish seep into her clothes, skin, and hair.

Back in the A&P, I return the almost-fragrance-free orange to its stack and walk by the heap of grapes without popping one in my mouth. At the checkout line, Meng and Eang are busy loading food onto the moving belt to the soft background music of classic love songs. When they finish, Meng pulls a few sheets of money out of his pocket that look different from the U.S. bills. All of a sudden, the cold air freezes and the humming machines are quiet with shame.

"Food stamps?" the checkout clerk inquires.

"Yes," Meng replies.

Meng tells me that food stamps are money the American government gives to poor people to help them buy the food they need. He also tells me that by accepting this food help, we also have to accept the embarrassment, loss of face, and shame that come with the stamps. Each time we go shopping as a family, the shame stamps are imprinted on our faces like a mark that won't easily come off, no matter how often we wash.

When Meng hands the food stamps to the clerk, I turn my face away and stare at the pineapple in front of me. I imagine its hundreds of eyes shooting out beams of light like the disco balls I saw on the TV show *Solid Gold*. As I fall deeper into my daydream, Meng's voice orders me back to the present.

"Pay attention. See how he stares at us because of the food stamps," Meng tells me in Khmer. "Be embarrassed and ashamed by this, and don't forget it."

I turn my gaze from the pineapple to look at the clerk and notice that his once cheerful face is now an unmoving plastic mask and his mouth is a straight line. He keeps his eyes focused on the red numbers of his machine as he takes the food stamps from Meng's hand. Afterward, he hands Meng and Eang our groceries with a thank-you that sounds to me more like "I am angry you foreigners come here and eat free while I have to work for my food."

6 amah's reunion

September 1980

Despite her attack and miraculous escape, Cheung continues to search for food in the forest and rivers. Every day, the rest of the family works hard to grow rice and vegetables, but it takes many months before they can be harvested. Cheung's skills at catching fish are needed to supplement the family's food supply. So every day she trudges off with her friends carrying a wicker basket and an ax in her hands. If Cheung is afraid, she does not tell Chou. As their cook, Chou constantly worries about their food supply and prays that everyone has a successful day. Even in periods when the family has enough rice and supplies stored up to feed them for a few months, Chou still has nightmares that it will all disappear overnight and they will go hungry again.

On nights when Chou wakes up crying, Kim tries to alleviate her fears with reports of the government soldiers' crushing victories over Khmer Rouge troops in battles. Kim speaks of these rumored victories so often that sometimes Chou thinks Kim is trying to convince himself that the Khmer Rouge's threats to their lives are over. But they both know that this is not true.

For Chou, this constant anxiety has turned her into a light sleeper. During the nights while Khouy, Kim, and the family are able to escape the war, Chou jerks awake at the slightest sound. And on nights when the September monsoon electrifies and thunders across the sky and drenches

the grounds with rain, Chou wakes up in the morning nervous and easily startled by loud voices and noise. Normally it is only she and the women who are in a state of near panic after a thunderous and stormy night, but today she senses that the men are also uneasy. As she sets down their plates for dinner, Chou listens carefully.

"Yee Ko." Khouy addresses Second Uncle Leang by his Chinese title. "The Khmer Rouge will use the storm as a cover to attack the villages!" As Khouy talks, Uncle Leang's hands roll loose bits of tobacco onto a sheet of paper.

"Yee Haer." Kim uses his Second Brother's Chinese title. "Why doesn't the government help us?"

"The Heng Samrin government is very weak and their soldiers are too few."

The men continue their conversation without stopping as Chou puts steaming bowls of rice and sweet-and-sour fish soup on their table. As soon as she sets them down, the men dig into their food.

"Khouy." Uncle Leang puts down his half-smoked cigarette and finally speaks. "Whether they call themselves the People's Republic of Kampuchea or the Heng Samrin government, it makes no difference to us in the village."

"Yee Ko, it does make a difference," Khouy persists between slurps of soup. "We need a government to build schools, hospitals, roads, and so many other things the Khmer Rouge destroyed. Without these things, we will always be trapped where we are in this small village."

As the men continue to eat noisily, Chou sets up the women's table. The women take their seats and begin to feed the little ones.

"Khouy, we are safe in this small village," says Uncle Leang. "Ai, you talk like your father. Remember, when the Khmer Rouge took over, instead of leaving Cambodia, your pa stayed to help rebuild the country. Because he was a leader, the Khmer Rouge took him away." He pauses a moment as he chews another bite. "Look, it's too dangerous to get involved with any governments because you never know when they will turn on you. All people need is a good family. The government will not feed our family. The government will not protect the little ones from disease."

"But, Yee Ko." Khouy lowers his bowl and inhales deeply. "Only the government's army can stop the Khmer Rouge from taking over again."

Sensing that Khouy's plate is empty, Chou gets up to check on their food and to deliver cups of tea to their table. The men quickly gulp down the tea without even looking at the server. When the glasses are empty, Chou fills them up without being asked.

"Yes, but they do this by taking our boys away against their parents' wishes. You best stop talking all this government talk, Khouy. Your pa talked a lot about the government and they killed him for it."

"Yee Ko." Khouy finishes with his meal and lights up his cigarette. In between puffs, he spits out the loose tobacco and continues. "Pa was right for wanting to help."

At the mention of Pa, Chou returns to her table. Among the women's chatter and children's whines, Chou eats in silence.

When she finishes, she walks outside to check on the pot of boiling yams and potatoes. During the monsoon season, when she can, Chou cooks their food at night to leave her more time to do her chores during the muddy day. Chou approaches the fire pit and kneels on her knees. She presses her hands on the dirt, lowers her face to the ground, and blows into the fire. As the fire rages with each breath, her hair fans the ground like a fine palm broom. The rocks and dirt dig into her palms and knees, leaving deep pockmarks. Satisfied with the fire, she brushes debris of straw and bits of wood out of her hair and wipes her hands against her sarong. She squats by the fire as the smoke changes directions, floats directly into her face, and stings her eyes. She wipes the smoke from her eyes and stares into the fire, thinking of Loung. Again she prays to the gods to protect Eldest Brother and Loung on their journey to find a new home. Then she goes back to blowing into the fire.

Suddenly, an old woman's voice calls out Uncle Leang's name from the road. Chou can hear wagon wheels and, suddenly frightened, she runs inside the hut. Uncle Leang stands frozen: his cigarette hangs between his fingers in midair and half-inhaled smoke curls out of his nostrils. They can hear the wagon wheels grind to a stop on the dirt road. Uncle Leang suddenly gets up and rushes out of the hut, his long arms and legs swinging like wooden limbs. The family runs behind him in quick little steps. Balancing Mouy on her hip, Chou pulls hard at Kung, who trails on shaky legs.

Uncle Leang arrives just as a man with a wide smile jumps off the wagon. He grabs hold of his wagon yoke to steady his cows from the

excitement of the coming rush. In the wagon, a slight, ancient woman slides on her behind to the edge of the cart, her sarong wiping the dust below her. Beside her, a young woman in her early thirties takes the old woman's hand and gently helps her off the wagon. On the other side of the wagon, two young girls swing their legs over the side and leap to the ground.

"A-ai!" Uncle Leang calls his mother in Chinese, his eyes blinking rapidly. "Children, this is your amah." Amah, the Chinese word for "grandmother," creeps into Chou's mind.

"A-Leang." Amah stretches her wrinkled arms to him. The young woman smoothes out the wrinkles of the old woman's sarong.

"A-ai! Is it really you?" Uncle Leang's eyes continue to blink rapidly and uncontrollably.

As the old woman draws near, Chou searches her memory for traces of Amah, the mother of Ma, her maternal grandmother. But all she can find are loud voices, lychee fruits, and a screaming dog. Somewhere in the recesses of her mind, she remembers visiting Amah in the village of Battambang and being taught to tie a small, light wicker basket around a bunch of lychee fruit on Amah's tree. In her loud voice, Amah told her the baskets prevented the fruits from falling to the ground where her mangy dog would swallow them whole, pit and all.

But the old woman who stands before her looks nothing like Ma. This old woman has eyes so black, they look like coals hidden behind layers of folded brown skin. Her lids hang from brows so jutted, they look like they've been molded out of clay; her lips are dried fruits that cover only a few resilient yellow teeth stumps. All of her features sit on a face so small, it looks like a shrunken, miniature head.

"A-ai!" Uncle Leang takes her hands, his big palms closing over her small fingers and wrapping them like precious gifts. "We sent people to look for you in Battambang but no one could find you. We thought you were dead."

"I'm not dead." Amah lights up with a smile, transforming her face to the beauty she must have been fifty years ago. "And I've brought Kim and her daughter, Eng, and your daughter Hong back with me."

As Chou hears their names, memories of who they are come back to

her. Before the Khmer Rouge takeover, Chou had visited Amah in Bat-tambang where she lived with Ma's youngest brother, Uncle Lang, his wife, Kim, and their daughter, Eng. Also living with them at the time was six-year-old Hong, the daughter of Uncle Leang and Aunt Keang. When Chou asked Ma why Hong was living with Uncle Lang and not her own parents, Ma told her that on a visit with Amah, Hong loved Amah so much that she followed Amah everywhere. At night, Hong refused to sleep with her mother and instead crawled into Amah's bed. When it was time for them to return home, Amah asked Uncle Leang to let Hong stay with her and be her companion and friend in her old age until Hong was ready to enter school. And Uncle Leang agreed, not knowing that the Khmer Rouge would invade the country and separate him from his daughter for so many years.

"Hong." Uncle Leang rests his hand over his daughter's head.

Hong stands there smiling as Aunt Keang caresses her arms and face.

"My child, you've grown so big!"

The family rejoices their reunion; of their missing uncle, Uncle Leang's brother and Aunt Kim's husband, no one dares to bring up his name. Not yet.

"Come, come, let me look at you all." Amah motions for the family to gather around her. One by one, Uncle Leang points to the members of his clan and introduces them to their amah.

"And these are Seng Im and Ay Chourng's children," Uncle Leang says gently, his voice somber. "Khouy, Kim, and Chou."

"Amah," each sibling greets her quietly.

"Khouy, Kim, and Chou," Amah repeats. Her leathery face darkens but she has not yet the strength to ask of the fates of the other family members.

"Amah, come, we have much to talk about." Uncle Leang gently leads her inside to a chair.

Back as the matriarch of the family, Amah sits with her back tall, her hands poised on her knees, and her feet facing straight forward. When Amah smiles, Chou is now able to see the fine chin, upturned nose, and high cheekbones that were once Ma's. While the daughters-in-law and granddaughters brew tea and bring out sweet lotus seed for her, Uncle

Leang tells the family's story—of who has been lost, who has left, who remains. After he is done, many in the room are quietly wiping away their tears.

Then Amah begins to recount her story.

When the Khmer Rouge took over Battambang, at first the soldiers allowed First Uncle and his family to live on Uncle's land, but as time passed, Amah suspected that the village chief wanted the land for himself.

In midsentence, Amah's face crumples.

"The story is too sad. I cannot tell it. Hong, you finish." With that, Amah and Uncle Leang leave the room as Hong continues.

At eleven years old, Hong still has the body of a young girl, but her voice carries the wisdom and suffering of her grandmother.

"The story is sad but Amah is very strong," Hong begins. "Her karma must be very good because the gods have protected her life. In our village, no other person as old as Amah was kept alive by the soldiers. Many of her friends died but Amah's life is very strong."

Hong remembers clearly the day they took Uncle Lang away. He had just returned from fishing and everyone was so happy he had caught so many fish! Unlike other Khmer Rouge zones and provinces in 1976, the people living in Battambang were still allowed a little bit of independence. But similar to the situation in the rest of the country, food was scarce, hunger was widespread, and everyone's clothes were black and tattered.

Uncle Lang was so happy with his catch that he built the fire himself while Aunt Kim cleaned the fish. Hong went over to help him. As he blew into the fire, the mud on his clothes caked up on his skin, giving it a gray color. Hong and Uncle Lang were so focused on their fire that they did not hear the five Khmer Rouge soldiers coming at them. The next thing they knew, two soldiers grabbed Uncle Lang's arms and twisted them behind his back. Hong was eight years old and stood transfixed with fear. She felt as if her limbs had turned to stone.

"Do not resist!" a soldier screamed as Uncle Lang struggled to get free. Another soldier fired his gun into the air. Hong clasped her hands over her ears and screamed.

"We need to take you to reeducation camp. You will return in three days!"

By this time, Amah, Aunt Kim, and Eng had come running to the

scene. Aunt cried and begged them to let Uncle Lang go, but the soldiers paid her no attention. Tears streaming from her eyes and nose, Amah pressed her palms together in front of her chest. In her broken Khmer, Amah pleaded with the soldiers to show mercy and raised her hands to her forehead. The soldiers ignored her and pulled Uncle Lang by his elbows to leave. With AK-47s poking at his back, Uncle Lang turned around; with his jaw set, his shoulders stiff, and his eyes unblinking, he stared at his family.

"Pa," Eng cried, and reached for him. "Pa!" She made as if to run to him but Aunt crouched down and held her body back. The soldiers pushed their guns into Uncle Lang's ribs, and abruptly he whirled around and left with them. That was the last time they saw him.

As Hong goes on to narrate their lives under the Khmer Rouge, one by one the women come to fan her, touch her hair, or lay a hand on her back. In a corner of the room, Chou sobs as Hong describes their hunger and how Amah became so swollen that her pants would not fit around her waist. Hong tells them about how she saw a young boy beaten to death with sticks because the soldiers said he was lazy. Hong's words come out in spits and anger when she reports that the boy was slow with his work because he was sick and starving. Her hands twist together on her lap when she remembers how the boy didn't cry when he was beaten but instead whimpered like an injured cat. When he no longer reacted to their beatings, the soldier pushed his body into the rice paddy for all to see. After that, Hong became the best worker in her unit, even though she was many years younger than the others.

As Aunt Keang chases the flies off her arms, Hong tells them that after the Vietnamese defeated the Khmer Rouge, the family left Battambang to try to make their way to Uncle Leang's village. After a week of moving, Amah fell ill and could no longer walk. The other refugees marched on, and the family was the only group left behind in the forest. Without the protection of traveling with a big group, they lived in fear of being kidnapped by the Khmer Rouge, eaten by tigers, and bitten by snakes. They waited alone in the forest for many days before a Vietnamese truck drove by and gave them a ride to the nearest city. There they stayed, tried to grow vegetables, roamed the forest for berries, and stole food from others when they had nothing to eat. They were able to trade some of Amah's

gold jewelry for some herbal medicines to heal her. When Amah was well, they sold the rest of the jewels and made their way to Phnom Penh. From there, they were able to hire a cow wagon to take them to the village.

When Hong stops talking, Aunt Keang pours tea and presses it into her trembling hands. Cousin Cheung peels tiny sweet bananas for her to eat, but Hong sobs so hard her tears leak out of her eyes and nose. When it seems that Hong's sadness will never end, she suddenly looks up and laughs. Through their tears, the other women join in her laughter, their hands covering their mouths to catch flying spit or yanking up their kroma to wipe their faces. Chou watches Aunt Keang embrace Hong with joy and dreams of a day when she, too, will be able to rejoice in her own reunion with Eldest Brother and Loung.

7 square vanilla journal

In my bed, I hug my pillow and my brain sends me to a place not even my shadow can follow. In this dreamland, the sun is as bright as a twenty-four-karat-gold disk against a blue sky and cotton-ball clouds. My whole being feels light—like a breeze that cools the world but sticks to nothing as it passes by. With my arms spread out, I skip merrily along a path as a song floats from my throat into the gentle air.

Suddenly, I am far from home and I begin to run, hoping to leave the panic behind. I stop in front of a cemetery where there is a shortcut. I walk up to the black iron fence and peer inside, searching for suspicious signs of trouble. My gaze follows the brown brick path, resting fleetingly on the swaying trees, gray headstones, and thick shrubs. Nothing looks amiss; everything appears quiet and calm. But then the wind abruptly picks up and whips my hair about my face. The gusts swing the iron gate back and forth slightly, as if beckoning me to enter. Slowly I walk in. In the sky, the white clouds grow dark and follow me.

Once inside, I open my mouth to sing, but instead of a song only a nervous hum comes out. My eyes flicker here and there and all around me. In the distance, I see a dark silhouette of a man standing near the path. With my heart pushing against my shirt, I walk closer and closer to him. The dark clouds expand and shut out the sun. The wind blows angrily at the man but he stands as still as the headstones around him. As I draw near,

I see that the man is old, unshaven, and dressed in a gray, loose-fitting shirt and pants. Next to him is an erect shovel with its head dug deep into the earth. I tell myself to walk past him as fast as I can, but my feet move like two ironclad, lopsided hooves.

As I am about to pass, he blocks my path.

"Come here," he hisses between his unseen teeth. "I have been waiting for you."

"Get away from me!" "Leave me alone!"

"Don't worry. I won't hurt you. I have something you want to see. I have what you've been looking for." He extends his hand toward me as the light catches the white of his open palm.

"I don't want to see it!" I push past him.

I am surprised that he does not stop me. My legs surge with a new strength and move me quickly away from the man but strangely, after a few feet, I stop and turn to face him. I walk back toward him. He greets me with a nod. Against the dark shadows of trees and stones, his fingers direct me to an open grave. Cold beads of sweat dampen my scalp and slide down my forehead and neck. Step by step, my feet take me toward the grave, until I am standing at the edge of it.

Inside the grave, a little girl sleeps in her coffin. She looks about nine or ten years old. Her hair is black and shiny and fans across her face like a veil. Her smooth brown skin is made darker by the whiteness of her dress. From under her puffy sleeves, two arms rest across her chest, holding a bouquet of white daisies. Peeking out of her flared skirt, her small feet are dressed in white socks and black Mary Janes. She has knobby knees just like me. She looks as if she is napping and I do not want to disturb her.

I crouch on my knees and as I stare into her face, a loud scream bursts forth from my throat. The girl looks exactly like me! Like a ghost, she opens her eyes, reaches out her hands and grabs my shirt.

"You can't leave me. Don't leave me behind," she pleads with me from her dead mouth. But her eyes! Like shiny black orbs, they gaze at me with sadness and anger.

"Noooo!" Her white dress is now covered with blood. There is blood all over her chest, soaking into her daisies.

"Noooo!" I thrash at her in panic when I see the hole in her chest. It looks as if someone has cut her open and taken out her heart. I press my palms against her shoulders, pushing her back down into her grave.

"Let me go! Let me go!" I beg.

As I begin to hyperventilate, I float out of my body and hover above the two girls. Like a silent movie, I watch from the clouds as one girl clings desperately to stay together while the other fights to escape.

With this last vision still lingering, I am jolted awake. In front of me the girls continue to struggle. The residue of the ghost girl's desperation, the tight grip of her hands, her palpable fear as she tries to hold on to me hang in the quiet air like a mist. I lie paralyzed in bed as the girls gradually begin to fade before disappearing altogether into the white ceiling. On the wall the clock ticks past midnight when I close my eyes and drift back to sleep.

In the morning, I awake alone in the cold apartment. Meng and Eang have been long gone to their jobs. Because he speaks Khmer, English, Mandarin, and Chiu Chow Chinese, Meng now works as an interpreter and support person for newly arrived refugees in Vermont. Meanwhile, Eang is employed in a nearby manufacturing company. With both of them working, Meng has been able to take our family off welfare and now we can buy our food without shame. I'm glad for that but still, sometimes, I miss waking up to Eang's pots and pans clanging in the kitchen.

Today the stillness of the house does not dampen my spirit because it's my first day of school! I have spent all summer watching TV and now know a few words and enough phrases that I hope will be enough to make me new friends. I've spent a lot of time with Li and Ahn, but at school, I want new friends who are not Asians, who aren't "different." Even though I pretend it doesn't matter, I hate that whenever the three of us are together, people stare as if we are as rare a sight as a three-headed snake. My normal friends at school will have blond or brown hair and blue eyes, very much like the girls I see on TV. On the small screen, these white girls always seem so light and happy. I just know that if I'm friends with them, I'll be normal and happy, too!

Before the alarm clock even rings, I crawl out of bed and walk into

the living room to find the outfit Eang and I picked out for my first day of school. The new pink dress is spread out on the couch with my black-buckled shoes lined up below. At 6:55 A.M. Mrs. McNulty arrives to walk me to school. Mrs. McNulty teaches grade two and since I'm going to grade three, she has volunteered to deliver me to my class. On our short walk, I force my legs to be calm, keeping them from jumping and skipping. My pencils and crayons roll like miniature logs in my pink Barbie backpack. I fill my lungs with the cool fresh Vermont air and step over the dried-up earthworms on the sidewalks. When we get to the brown brick school building, I am nervous with excitement. In my mind, I picture myself holding hands with my new girlfriends as we go from one class to another.

At the wide glass double door, Mrs. McNulty enters and says hello to everyone young and old. I follow closely at her heels, my smile spreading widely across my face. Inside, the brown brick building is cool and has many doors on either side of its long hall. All around, swarms of girls and boys rush into these open doors, their new shoes clicking and clacking against the hard shiny floor. I imagine that they are all going to a party as the girls swish pass me in their new dresses and the boys saunter by in crisp new shirts and pants. I imagine their heads turning into balloons; yellow, brown, red, and black, the floating balloons make their way into rooms where parties await their arrival.

Then Mrs. McNulty takes me through one such door and instantly my balloons pop like bubbles, leaving behind the squints and frowns of curious faces gazing in my direction. I turn my eyes to the rainbow of butterflies hanging from the ceilings and cut-outs of alphabet letters on the walls. As Mrs. McNulty talks to the teacher, I clasp my fingers together in front of my stomach. Although it is the first day of school for all of us, the students gather in bunches to talk and laugh with the ease of kids who've gone to school together all of their lives. Because it's rude to stare at people, I watch them out of the corners of my eyes. Except for me, they all look like the kids I see on TV!

"Loung." Mrs. McNulty bends down and smiles into my face. "This is Mrs. Donaldson. She is your new teacher."

"Hello." Mrs. Donaldson greets me. Mrs. Donaldson is pretty like

Mrs. Brady on *The Brady Bunch* with her light yellow hair and her nice big smile.

"Mrs. Donaldson will take good care of you. I teach another class, but I'm sure we'll see a lot of each other soon." I nod. Then she walks out the door.

"Class, we have a new student joining us this year." Mrs. Donaldson stands me in front of the class and introduces me. The other students look at me but no one comes up to take my hand. Not knowing what to do, I cross my arms in front of my chest and wait for my next instruction. I feel my face color, my palms warm up and then begin to sweat, until Mrs. Donaldson sits me in a desk at the front of the class. When she returns to the blackboard, I spread my palms flat on the desk, letting the cool wood steady my hands.

As soon as I am in my seat, Mrs. Donaldson walks to the blackboard and writes down her name.

"My name is Mrs. Donaldson," she tells us.

I repeat it in my head again and again. Then she takes a piece of paper off her desk and begins to call out each student's name. Mrs. McNulty told me this would happen so I am ready. One by one, the students raise their hands and answer with a "present!" or "here!"

"Lu . . . onng Unng?" Mrs. Donaldson sounds confused and says my name like someone who is *ott kroup tik,* a person who's born with not enough water. In Cambodia that's what we call people who are born with something wrong in their head, so that they sometimes talk funny.

"Here!" I pronounce the word clearly and proudly because I've practiced it. As the word flies out of my mouth, my arm shoots straight up like a palm tree, my back stiff and tall.

"Good. You may put your hand down now," Mrs. Donaldson tells me.

"Thank you, Mrs. Donaldson." I smile and bow my head with respect. She returns my smile and begins to pass out thin square vanilla journals to all the students.

"Class, please take your pencil out and write in your journal what you did this summer. I will tell you when to stop writing. Begin." Her words flood over me like rushing water, too fast for me to catch their meaning. All around me, the other students open their journal so I do the same. As

the students begin to scribble onto the white pages, my knees begin to knock against each other. All summer I practiced English with Sarah and our sponsors, but I only learned to talk. I don't know how to write. And I'm too embarrassed to tell Mrs. Donaldson. Next to me a girl who said her name is "Barp-raa" is scribbling big, blocky letters in her journal. I quietly edge my desk closer to her and begin to copy her letters. On the wall, the clock ticks away very slowly.

"All right, class, you may stop now," Mrs. Donaldson announces after a while. "Please hand me your journals." I follow the other students and give her my book with a big smile.

After Mrs. Donaldson finishes arranging the journals in a nice neat pile on her desk, she speaks rapidly to the class about something called a "health check."

"Loo-unng, please come up here." She suddenly calls on me. I walk up to her as all eyes follow me.

"Class, open your reading book to the first page and read quietly to yourselves. I will be back shortly."

With Mrs. Donaldson leading, I trail a few paces behind her. As we walk the long, quiet hall, our steps click and clack against the hard tiled floor. This time the echoes sound lonely and scary.

"Please wait." Mrs. Donaldson smiles and walks into a small room. From outside the door, I peek at her talking to a woman wearing a white shirt and skirt. "Looung, please come in," she calls. I gingerly enter the sterile, alcohol-smelling room.

"This nice lady is the school nurse." Mrs. Donaldson introduces us as Sarah's flash card of a picture of a lady doctor pops into my head. "The nurse will give you a checkup," and with that, Mrs. Donaldson leaves.

"Hello, Loung." The nurse's mouth opens to show her beautiful white teeth. "Please sit down." She points to a chair in front of her. I sit down and glance up at her face, which is soft and pretty. While I swing my legs back and forth, she pulls out a wooden tong and lifts up my hair with it. The sticks move up and down my head, like a rigid finger; they part and unpart my hair, scratch my scalp, and tickle my neck. When she finishes, the nurse sends me home early with a note and a bottle of special shampoo.

★ ★ ★

"Lice!" Eang yells as her fingernails scrape my scalp.

I am sitting in a tub of warm, soapy water, naked except for my under-wear. Meng sits in the living room reading the one Chinese book he brought with him from Thailand.

"Lice!" Eang exclaims again, her flaring eyes and downturned mouth resembling the features of a stone garuda. "You have no lice. We washed you with lice shampoo many times already before we sent you to school!"

"Ooouuccchh!" I complain as my head begin to heat up. Furiously, Eang works on my scalp, her nails like tweezers as she pulls the dead eggs off strands of my hair.

"These are dried-up lice eggs in your hair! See, they're only flat sacks." Eang shows me a sack on a strand of hair she's just pulled out. "If they were live eggs, they would be plump and shiny. These are flat and dull. If they were live eggs, we would be able to pop them between our thumb nails and they would burst." She attempts to crush the egg between her nails. No pops. "These are dead and will not pop!"

"Ouch!" I scream. I know Eang's right but I don't have the words to explain it to the nurse.

"That nurse cannot tell the difference between a live egg and a dead egg."

As Eang works, she talks to herself about how we are from a good fam-ily and that we know not to send our children to school with lice. Then she begins her familiar tirade about how we must save face and do things to not embarrass our family name. For the next hour, my scalp is washed, rinsed, and pulled, and then the process repeats again until Eang is satisfied.

After she is done with my head, Eang wraps a big white towel around me and sits me down at the kitchen table. Her face softens when she looks at me wince as I drag a comb through my knotted hair. Then she opens the refrigerator door, pulls out the container of Bryer's ice cream, puts three scoops into a bowl, and hands it to me.

"Thank you," I tell her.

Without a word, she takes the comb from my hand and untangles my hair while I eat.

The next morning I set off to school by myself. This time I walk with a little less bounce and a lot more heaviness in my steps. Once in the class,

I sit in my desk with eyes downcast while Mrs. Donaldson returns the vanilla journals back to the students. Right away, the students open their journals to read Mrs. Donaldson's comments on their work. I don't receive mine, but I wouldn't be able to read her comments anyway.

"Class, please open your book and read the first story." My classmates put away their journals and open their story books.

"Loo-ung," Mrs. Donaldson calls me. This time I raise my arm like a vine instead of a palm tree. "Please come here." I walk up to her desk, my arms close to my side. She holds up the yellow book I wrote in yesterday. "This is what you did this summer?"

"Yes, Mrs. Donaldson." I flash my teeth and nod my head to show her I understand her words.

"Hmm. Let's read it together. 'What I did this summer,' " she begins. I stare at the words and mouth the sounds she makes.

" 'I visited my grandmother and grandfather. It was fun. I love seeing them. We got a dog. I played with it a lot.' " She looks up at me. "Is that so?"

"Yes, Mrs. Donaldson." My teeth feel less bright now but I do not want to disagree with the teacher. And I do not want to lose face in front of the other students.

"Do you understand the assignment?"

"Yes, Mrs. Donaldson." My cheeks are pink.

"Do you know how to write?"

"Yes, teacher." My face is now red.

"Can you write something for me?"

"Yes, Mrs. Donaldson."

In the journal, I write A, B, C, D, E, F . . .

"That's good, thank you." At last she understands and asks me to gather my pencil and journal. "Class, please continue to read quietly. I'll be right back." From their seats, the other students lift their heads out of their books and watch me gather my belongings. Then I follow Mrs. Donaldson out of the class; my legs feel closer to the ground than ever.

The next thing I know, I am sitting in a private room learning English words with another teacher through flash cards and games such as Go Fish, just like Sarah would play with us in our apartment this summer. When I am not in my special lesson, I am being tutored by Mrs. McNulty in her

class. I like being with Mrs. McNulty because I already know her and she is very nice. But sometimes I'm embarrassed to be there because at ten years old, I am two years older than all the other students.

I have been going to school for two weeks now but I have not made any American friends. In Cambodia, before the Khmer Rouge takeover, I had many friends and the kids thought I talked a lot and was very funny. But I don't know how to be funny in America or in English. So when the other students gather at one another's desks before class, I keep to myself and read my school books. When the bells ring for recess, I walk around the jungle gym by myself. Around me, other kids play and scream and run and swing. I find a bench to sit on while I eat Cheetos, my favorite junk food, which is as crunchy as fried crickets. The orange processed cheese that stains my hands reminds me of the monks' orange robes in Cambodia. When I look up from my bag, I see the boy called Tommy watching me. The other kids think we look alike because we're both Asians. Once a student asked if Tommy and I are brother and sister. She frowned when I told her Tommy is Vietnamese and I'm Cambodian. As I crunch on my Cheetos, Tommy stares at me hungrily, his tongue flickering in and out of his mouth.

For a brief moment, my heart aches for him but I turn my head and walk away. When I look back, I see Tommy picking up a Cheeto that I had dropped on the ground. Tommy purses his lips, blows on the chip a few times, and plops it in his mouth. My stomach growls at the memory of being so hungry that I would eat pieces of charcoal just to have something inside me. Looking at Tommy, I feel a wave of sadness crash over me, yet instead of sharing the remainder of my bag, I hoard it even more. Minutes later, all the Cheetos lie heavy in my stomach like a ball of bright orange shame.

A month into school, Tommy falls and hits his head while sliding down the school's banister.

"He hurt his brain so much he'll never be normal again!" the students whisper anxiously in the hall.

"I heard he split his head open and there was blood everywhere," a girl tells a friend in a voice full of fear.

"I heard some students saw him fall!" another gasps, horrified.

"I heard he's a retard now! Poor Tommy!"

As the days pass, more rumors circulate that Tommy will never walk, play ball, climb the monkey bars, read books, or have girlfriends. Like pecking chickens, the kids keep at the Tommy rumors and he never shows up to prove them wrong. By the end of the week, the word spreads that Tommy's parents have moved him to a special school.

The stories about Tommy hit me hard right in my stomach. Even though Tommy and I rarely spoke, I felt tied to him in our Asian-ness. When everyone else would play together during recess, I could always count on him to stay near me. At first, Tommy and his stupid banister act made me angry. Then sadness settled like a coat of gray paint on my skin. Soon I saw Tommy's sweet funny face. When I remembered his smile, my anger transformed into guilt, with its arrow piercing my skin and digging deep into my soul. It took me back to the times I stole rice from the mouths of my family members and, once, from a dying old woman. If only I could go back in time and share my Cheetos with Tommy.

With Tommy gone, I feel lost and alone in a field of pale skin and white faces. But after school, I escape to more familiar places and people when I meet up with Li and Ahn. Even though Li goes to another school, she still lives nearby. And while Ahn goes to a school for older kids, her house is only a thirty-minute walk from mine.

This Friday I rush home, drop off my books, and walk the mile to Li's house. Li and her family live in a big house where I often stay for the entire weekend. After they get out of work, Meng and Eang frequently join me at the Chos' house, and together we cook big Cambodian-Chinese dinners and listen to Cambodian music the Chos brought with them from Thailand. In one another's company, the adults speak easily in Khmer, shed their shy and unsure refugee skins, and change into funny, confident, and vibrant individuals. While the adults stay indoors, Li and I head outside to play kickball in her big front yard with her nephews Van and Chen. When we want to escape the boys, Li pedals me on the back of her small banana bike and together we race down the hills. Today, I'm on the back of her bike hoping to replace Tommy's split head with the wind blowing in my hair as we speed down the hill.

"Come on, Lee. Let me pedal." I pat her back at the bottom of the hill.

"No, you're reckless so I'm not letting you pedal." For a little person, Li possesses an iron will when her safety is in question.

Until last month, Li had allowed me to pedal while she sat in the back. Then one day I discovered speed. As Li sat with her arms wrapped around my waist, yelling for me to slow down, I pedaled faster and faster. When the road ended abruptly, I had to squeeze the break tight, sending the bike, Li, and myself tumbling to the ground. Now whenever we ride, Li always does the pedaling. Usually this is fine with me, but today Li's skinny legs are taking us around much too slowly. Behind her, I begin to twitch and itch with boredom.

"I promise I won't crash the bike again. Cross my heart, hope to die, stick a needle in my eye."

"Your knee is still scabbing from your last fall. And it will scar ugly."

"So?" I challenge, quite proud of all my scars. Li shakes her head softly.

If Ahn McNulty is my big sister, Li is my good twin. In Ahn, I see my strength and toughness. In Li, I see Chou with all her sweetness, friendliness, and generosity. Like Chou, Li is slender and petite in contrast to my sturdy and compact build. Next to Li's prettiness and neatly brushed clean hair, I am unkempt and loud. Compared to Li, I have that orphaned-child look, the one featured in the commercials for the Christian Children's Fund. Sometimes I wish I could be more like Li and Chou because everyone likes them.

"Stop picking your scabs. That's gross!" Li admonishes me as she huffs and puffs.

"If you let me pedal, I'll be too busy to pick at my scabs." Li will not hear of it and continues to pedal.

When we finally get home, I jump off while Li carefully parks her bike. For the next few hours, Li and I play kickball, chase each other in a game of hide-and-seek, and roll around on the grass trying to perfect our round-offs and cartwheels. When we enter her house, we are wet with sweat and covered with mud and grass stains.

"Shoes off at the door!" Li's sister orders us. "Then into the shower!"

"Okay, okay!" Li answers as we run into her bathroom. Behind the closed door, we strip off our clothes to our underwear and get into the tub. With the warm water raining on our bodies, we take turns scrubbing

the dirt and grime off each other's backs, making farting noises with our soapy armpits and blowing bubbles into each other's faces.

"Let's play soap skating!" My eyes widen at my bright idea.

"How do we play?" Li asks.

"Here's how we do it. I'll go first." I sit on the edge of the tub and lather up my feet with soap. With Li's hands gripping my elbow, I unsteadily get up and push myself forward, my feet gliding over the ceramic tub.

"Wheeee! This is fun! Now push me!" Li does as she is told and sends me flying to the other side of the tub. Laughing, I extend my hand to stop myself against the wall. "Now it's your turn."

"Well, I don't know." Li hesitates, her brows knit with uncertainty.

"Come on, it's fun!"

Tentatively, Li sits as I make her feet extra sudsy. Using her hands like spread-out wings, Li slowly skates her way across the tub. Suddenly, I reach out, flatten my palms on her back, and off she goes with a big push from me! Li's arms flail like a baby bird learning to fly as she glides all the way to the other side of the tub, then comes crashing down, hitting her chin on the edge.

"Li, you okay? I'm so sorry. Are you okay?" The water is red with Li's blood flowing out of her mouth.

"Li, are you okay?" I turn off the water. My hands are ice cold.

"Cut my lip," she replies and glares, her eyes flashing with anger. She gets out of the tub to check her lips, with me dripping behind her. "It's a small cut," she says when she notices my anxiety. "I'll be okay."

But *I'm* not okay. "I'm bad, I'm bad, I'm bad!" The thought repeats in my head. Guilt and shame weigh heavy in my stomach, making me weak. I want to reach out and strike someone, to kick, to scream, and to hate so much that it will overpower the pain.

When I return home, I run to sit alone in my closet. Minutes later, Meng stands at my door and peers his head in.

"You have to stop playing so rough," he says. His voice contains no anger, just traces of disappointment and sadness.

"It was an accident," I reply quietly.

"You are not a boy," he continues. "We are not living in a war any-

more. You do not have to fight so much now." His words fill my closet and I begin to feel suffocated. He stands there as if waiting for me to say something but I do not. Silently, he turns and leaves me alone. As the curtain rustles and closes me in, I press my lips harder together. In my mind the war rages on, even though I know I live in a peaceful land. There's no way I can explain that to Meng.

8 restless spirit

"I joined the army," Khouy announces to the family at dinner. Chou and Kim freeze midbite and turn to each other in horror and confusion.

"Khouy, the country is still at war. This is too dangerous." Uncle Leang begins and stops to take a deep breath. "Khouy, when did this happen?"

"Today I went to see the village chief in Ou-dong about becoming a policeman," Khouy responds matter-of-factly.

"That explains your absence from the fields," Uncle Leang replies.

Chou watches Khouy's jaw set at Uncle's quiet reprimand. She knows that Uncle Leang is angry that Khouy has no interest in farming and often disappears for long stretches of time while the family toils away in the fields.

"There are no police jobs in the villages, only in the army," Khouy continues. "All the police jobs are done by the army."

"Ai, Khouy," Aunt Keang says softly, "why did you do such a thing? The army is very dangerous."

"Khouy, think about what you're doing," Amah implores. "If something happens to you, what will happen to your brother and sister? Think about them."

"The army is useless. They do nothing but travel from one fight to another," Uncle Leang accuses. "And if you get captured, the Khmer Rouge will kill you."

"Khouy, joining the army means you'll have to leave the village. You'll

have to live near the army base. Think about your family. We need you here," Aunt Keang pleads. Chou peers at Khouy through the corners of her eyes and sees his face becoming hard. Slowly, she picks her plate up off the table and goes to the kitchen.

"You don't know what you're talking about!" Khouy yells suddenly, pounding on the table. In the kitchen, Chou cringes as the family becomes silent. "I *am* thinking about my sister and brother. I always think about my family!"

"Khouy, my nephew. No reason to get mad." Aunt Keang tries to soothe him.

"Uncle Leang," Khouy begins again in a soft restrained voice. Chou returns to the room but stands hidden behind the wooden door. From her safe place, she watches Khouy stiffen his shoulders and stick out his chin, making him look like a dog on attack. "The whole country is dangerous. Khmer Rouge soldiers are all around us and every day they attack villages and towns, kidnap women and cows. Sooner or later, we all have to fight them. At least in the army, I will be paid to fight them."

"You are twenty-one years old. You can do what you want. But Kim and Chou stay here," Uncle Leang declares. Khouy is quiet. Chou grips the door tightly, torn between wanting to agree with Uncle Leang's decision because he is their elder and head of the family, and wanting to live with Khouy, because he's her brother. As the moment drags on, Chou realizes with a heavy heart that it doesn't matter what she wants at all; she and Kim will stay with Uncle Leang. When Meng was with them, he took care of the siblings like a mother while Khouy protected them like a father. Without Meng, Chou knows Khouy cannot take care of them.

Chou turns her gaze on Kim who continues to eat slowly and stare into his bowl. Like Chou, he's caught in a struggle he has no power to change and no voice to speak. In the silence between Khouy and Uncle Leang, Kim stops eating and sets his jaw so hard the bones push against his skin. As Kim fights to keep his face still, Chou steps out of her shadow to serve Kim tea. Kim takes the cup from her hand and seems to relax a little.

"I leave tomorrow for Bat Deng," Khouy announces, finally breaking the silence. Then he sits back to roll his cigarette.

"We wish you well, my son." Uncle Leang blesses him and lights his own cigarette.

Just like that, the storm passes by. Around the table, the rest of the family members let out their breath. Chou takes a few plates outside to the kitchen where she squats next to a bowl of water. As she scrubs the wok clean, the realization sinks in that she has always known Khouy would one day leave them. Even when she was young, Chou knew that Khouy was restless in spirit and body. Ma said he was born with too much fire and this was why his spirit was so restless and why he got into so much trouble. Hoping to find ways to calm him down, Ma enrolled Khouy in karate classes, guitar lessons, and sports, all of which he excelled in. But still he found time to get into trouble and fights.

Inside the hut, Kim gets up to clear the rest of the dishes, making sure not to look at Khouy's face. Around him, the family continues their discussion about what to grow for the upcoming season, as if nothing has happened. Kim brings the dishes to Chou and squats down next to her. As a boy in a family with many girls, Kim does not have to do the women's work of washing and cleaning. Chou knows this and appreciates his gesture. As he helps her with the dishes, she knows he is trying to fulfill his role as her brother. With no words to comfort her, Kim rinses the dishes and stays with her as she washes them through her tears.

That night, Chou dreams again of the Khmer Rouge soldiers. The dark men chase after Khouy in the jungle as Chou watches hidden behind a bush, paralyzed with fear. As Khouy runs, his arms and legs brush against trees and bushes, the sharp leaves cutting into his skin. The soldiers make gains on Khouy and aim their guns at him as Chou screams for him to run faster. But no matter how fast he runs, the soldiers are always behind him. In her hiding space, Chou feels herself go dizzy as her heart beats faster. "Run, Second Brother, run! Don't let them catch you!" she yells at him. Suddenly, she dreams of watery pits filled with human skulls and bones.

In the morning Chou wakes early and quickly builds a fire to cook rice soup for Khouy's breakfast. As she blows into the fire, her thoughts return to her childhood in Phnom Penh. When she was young, Chou thought Khouy was the funniest, strongest, and most interesting brother. He never beat her, but she knew he could be mean because the parents of

the injured boys he and his gangs did beat up kept showing up at the front door and asking Ma for help. When they left, Ma would bustle around the house looking for places to hide Khouy from Pa's wrath. When Pa came home, he would storm all over the house, tearing open the closets, lifting up the beds in every room, trying to find Khouy. But Ma was always successful in sheltering him or sending him away to a friend's house until Pa calmed down. Khouy would eventually return home to Pa's simmering anger and threats to disown him if he continued to shame the family name. After a few days of tension, Khouy's wild stories and jokes eventually won Pa over until the next fight.

As the sun slowly brightens the sky over the village, the rest of the family stirs in their mosquito nets. Chou remembers waking up in Phnom Penh to the cuckoo clock bird that came out of its wooden house at the top of every hour. Khouy was always the first one up and out of bed. By the time Chou came to breakfast, Khouy would have already had his and would be outside on the balcony squatting and leaping like a frog, doing his morning exercise.

Chou stirs the soup and turns to see Khouy under the tree stretching and swinging his arms like a child. He pivots and sidekicks an invisible enemy with a force Chou imagines would crack ribs if it had landed on a real person. This early in the morning, there are no clouds in the sky, but it is the rainy season and by late afternoon, torrential rain will fall. Hurriedly Chou returns to her fire and soup because she knows Khouy will want to leave early to miss the rain on his long walk. Her hands shake at the thought of Khouy going into battle.

Until the Khmer Rouge soldiers stormed into Phnom Penh, Khouy's world revolved only around himself. But during the war, Chou watched Khouy change; his spirit was calmed and his feet took root around the family. When the soldiers reduced the family's food ration, Khouy volunteered for the most physically demanding jobs because it meant he would get more food. Day and night, rain or shine, Khouy worked fourteen to sixteen hours a day for a few extra ounces of rice and salted fish. Even when he was sick and coughing up blood, he worked hard and always saved a portion of his rice to bring home to the family. Every other week, he would visit and deliver the food. As Ma and the young siblings clamored around the food, Khouy and Pa would sit and spend some quiet time

together. When it was time for Khouy to return to his work camp, Pa would grip his shoulders and tell him he was a good son.

"Chou, come have breakfast before Second Brother leaves," Kim calls out to her.

Inside the hut, the family is getting up and preparing to leave for the fields. In the kitchen, Kim wears a tight smile as he serves Khouy his breakfast. While they chatter away about the farm and the weather, Chou slowly folds Khouy's clothes and lays them on the plank. As her hands work, Chou remembers the one time Khouy lost control of his emotions. When Kim told him that the soldiers took away Ma and Geak, Chou watched Khouy's bottom lip quiver and his eyes redden. "She was so small. She was so small," he uttered in a raspy, broken voice while his hand lifted another cigarette into his mouth and his tears disappeared in the smoke. Sitting beside him then, Chou's throat ached as she cried the tears Khouy could not. She no longer saw the mean brother she'd feared in Phnom Penh, but a man who loved his family so much he would go hungry for them.

Though everyone in their family has worked hard to adjust to a new, postwar life, for Chou and Kim the adjustment has been easier than for Khouy. To Chou, Khouy has seemed more lost with each day, his legs shaking with more urgency under the table. Chou believes that Khouy no longer knows where he needs to be, only that he must go.

When Khouy finishes his breakfast, he walks over to Chou.

Khouy imparts his brotherly advice to her. "Be a good girl and don't fight with your cousins." An awkward moment stands between them but neither one knows how to talk to the other. He then gently takes the sack Chou's been packing and goes over to Kim.

"Look after your sister," he says casually to Kim. Kim nods as Khouy swings his sack over his shoulder and follows the road to Ou-dong. Watching him go, Chou is visited by long-ago memories of Keav and Pa walking away, their backs thin and strong. Then she remembers Eldest Brother pedaling away with Loung on the back of his rickety bicycle. Just when she thinks she cannot stand to be alone, Kim comes and stands by her. He doesn't say anything or touch her but Chou feels herself enveloped in his embrace.

Chou whispers a prayer under her breath. "A bullet flies in front; it

passes on. A bullet comes from the back; it will melt like wax in the sun. May the goddess Neang protect you." Together, Kim and Chou watch as Khouy's figure disappears into the bend in the road.

As the monsoon rain drenches the country, the ponds fill up and the fish feed on the bugs hovering above the surface. The snakes leave their flooded mud homes to swim across the rice paddies in search of drowned rats and other delectable critters. From his army base, whenever he can, Khouy sends word that he is well and living in a soldiers' compound. Of the details of his life in the army and training, he does not say. In the village, news of Khmer Rouge attacks in nearby provinces drives the villagers to dig bomb shelters in the backs of their huts. Now every time Kim leaves the hut, Chou waits anxiously for his safe return at the end of the day. After a long day of growing their own food and collecting wood and water, the family quickly eats their meal and heads out back to dig bomb shelters in the ground. For Chou, life is so busy that whenever she has a little time to play, she relishes it like a precious gift.

And on this day, that gift comes in the form of a short bicycle ride with Hong in the countryside. Outside of an occasional bike ride and molding farm animals out of clay, Chou spends her spare time making drawings in the dirt, folding origami, making colorful necklaces and bracelets for herself from dried-up berries, playing hopscotch and sometimes a game of hide-and-seek.

Hong reminds Chou so much of Loung, it's almost as though she lost one loud, reckless sister and gained another. In front of them, Chou sees a woman walking to the road carrying a metal pail. The woman stops, tucks her shirt in, and tightens her green sarong around her waist. She then lifts her pail and dumps its contents into a ditch beside the road. The garbage of banana leaves, sugar can stocks, coconut shells, and orange peels gives off a sweet decay smell.

"Chum reap sur!" The girls scream hello as they pass by.

They ride by rice paddies, thatched-roof houses, and palm trees. Chou takes in all the details. She loves the country so much, sometimes she can barely believe she was born and raised in the city. No matter how many rice harvests she's endured, she never grows tired of seeing the rich green rice stalks. At harvesttime, the rice paddies transform into beautiful

golden fields. Chou loves the small ponds that fill the country landscape with white and pink lotus flower that are always in bloom. Nestled beside the road, thatched-roof huts that were once bare and empty now have bright colored ribbons hanging at their front doors and makeshift altars to guard the residents from evil spirits. Surrounding the homes, banana, palm, coconut, mango, guava, and papaya trees provide shade and food for the villagers.

As the girls pass by another hut, a naked little boy saunters out to watch. He stands by the road, his stomach sticking out so much that it pokes out his little belly button. The girls wave to him as they ride by. Suddenly, his arms and legs pumping, he runs after the bike. When his mother calls, he reluctantly turns back, his little bottom bouncing behind. Chou follows him with her eyes and dreams of one day having children of her own. For a moment, her thoughts shift back to Geak, but then she decides to let the wind carry her away.

As they race down a small hill, Chou holds on to Hong as they descend upon a herd of cows grazing on the side of the road. Sensing danger, the cows scurry out of the way in midchew, their hooves kicking up rocks, their tails swinging with haste. The cowbells ring sweetly as Chou and Hong zip past, their hair flying and their mouths open wide. In front of her, Hong laughs gleefully, her legs pumping the rusty chain. The old faded bike squeaks and rattles, weaving like a drunk, but Hong pushes on, moving the bike forward as its bald tires kick up dirt in the air, creating a tiny dust storm behind them. With the wind blowing in her hair, Chou finally feels her old age stripping away, leaving behind a girl of twelve.

9 ghosts in costume and snow

"What's Halloween?" I ask Ahn McNulty. Since the beginning of October, the kids buzz like swarms of flies around piles of cow manure as they go from one table to another to discuss their costumes.

"It's a children's holiday," Ahn tells me in her grown-up tone. "And it's the time when all the ghosts come out to play!"

"What?" I gasp.

"I'm kidding, I'm kidding!" Ahn laughs and slaps my arm.

"The kids at school said it's a holiday for the dead," I continue. My superstitious mind doesn't like the sound of that at all.

"No, no. I don't think so. Look, what's important is that we get to wear costumes and ask for candies."

"Costumes?"

"Yes, you can be anything you want to be. A witch, a princess, any cartoon character, a ghost."

"No, no ghosts."

Then Ahn goes on to tell me that on Halloween night, kids all over the country dress up and walk around the neighborhoods demanding "something good to eat," and they get it! I cannot believe my ears! What a great country this America is!

For the next three weeks, while the green mountains surrounding Essex Junction turn crimson, red, and orange, my mind is fixated with

dreams of Halloween. Oblivious to my preoccupation, Meng and Eang marvel at the changing colors from our second-floor apartment. In Cambodia, we have three weather seasons. From September to December, our winter season is cool and green. The scenery changes little from January to April, the dry season when the weather is hot and humid. Then from May to August, monsoon rains drench the land, and the green, lush tropical jungles come to life with blooming flowers. As the rainy season progresses, the water soon overflows the ponds all over the country, creating puddles teeming with fish and crabs. But in Vermont, the changing weather does not bring rain or fish but rather a storm of out-of-state cars inching along on narrow, one-lane roads winding through the countryside. On a recent drive with the McNultys, Meng, Eang, and I finally understood why people drive so horribly slow through the mountains during the fall. As we crawled along in the McNultys' car, the foliage spread before us as far as the eye could see. In the bright sun, the colorful leaves shimmered and danced as if the mountains were on fire.

But as October approaches its end, the temperature drops; the mountain colors burn bright and then quickly turn brown. The cold wind blows and strips the trees of all its leaves. Once on the ground, the leaves no longer dance but lie dead and decompose back into the earth. From afar, I stare somberly at the naked trees before returning my mind to the joys of Halloween.

When the big night finally arrives, I slip on my Tom the Cat costume that Meng has bought for $2.99 at the A&P. I'd rather be the hardworking princess Cinderella but she costs $9.99, so Meng made me be a cat instead. But I don't complain because if I make him mad tonight, he might not let me go with Ahn. Meng and Eang do not understand Halloween and think it is bad etiquette for children to go begging for treats. But Mrs. McNulty explained to them that on Halloween night, it's not begging or rude for children to ask for candies. Although Meng nodded at her words, I don't think he understood.

"Okay, Mr. McNulty is downstairs. I'm going now!" I yell, and run out of the house.

"Remember, no begging. We are from a good family!" Eang calls after me.

"Don't cause our family to lose face!" Meng's voice follows hers as I roll my eyes in disgust and shut the door behind me.

At the McNultys' house, Ahn greets me wearing a long black cape and pointy hat.

"I'm a witch! Heeeeeheeehhhhh!" Ahn screeches.

"Yes, you are a witch," Mrs. McNulty chuckles and hugs her.

"Have fun, you two!" Mr. and Mrs. McNulty tell us as we trot off together.

When we come to our first house, I lower my plastic cat mask over my face and take a moment to admire the fat stuffed scarecrow sitting under a tree on the front lawn. Peering through the two eyeholes, I make my way up the steps and knock on the door.

"Trick or treat!" I scream when a woman carrying a big bowl of candy bars opens the door. "Trick or treat, give me something sweet to eat!" I repeat as my hot breath blasts back into my face.

"My, aren't you girls cute!" the woman exclaims, and drops a candy bar into my bag before moving over to Ahn.

"Thank you!" I yell and bounce off to the next house.

"Wait!" Ahn calls out, laughing.

When she catches me, she slaps me on the arm. Ahn does that a lot. She's a slapper when she laughs. If anyone else did that, I'd twist their arms behind their backs like chicken wings. But Ahn calls me sis and is very nice and buys me candies and books. Besides, I don't know if I can take her down. Because she was adopted from a Korean orphanage and all, Ahn is as tough as I am. And she's strong, too. But mostly, I don't want to twist her arms because I like her.

At the next house, another woman opens the door.

"Trick or treat!" I holler, and again I get candies. I cannot believe it. I remember years of begging Ma for candies. Here they give it away for free! I love America!

Two hours later, the night has grown cold, the candles in the jack-o'-lanterns have melted, and my sticky fingers have touched every decoration adorning the neighborhood homes, from eyeballs to intestines to worms. At Ahn's house, Mrs. McNulty checks all our candies to make sure they're safe for us to eat before sending Mr. McNulty to drive me home. In the

car, Ahn tells me that the eyeballs were peeled grapes and the intestines were cold noodles; Mr. McNulty chuckles at my contorted face. I rather wish they were real eyeballs and intestines.

After Mr.McNulty drops me off, I stand in front of my door and make myself hard again. Sometimes, after I've spent too much time laughing with Ahn, I return home feeling all soft and light. Then when I see Meng's heavy eyes and long face, I feel guilty for having laughed so much in one day when my brother has not laughed once in a week. So standing in front of our door, I quickly still my face, pull down my smile, and walk up the stairs to find Meng and Eang waiting up for me in the living room.

"Let's see, let's see," Eang waves to me.

"Have you eaten anything?" Meng asks, taking the heavy bag from me.

"Yes, but Mrs. McNulty checked the candies already."

"Let's check it again." Meng dumps the candies on the floor. "I heard that sometimes crazy people put drugs, pins, and needles into the candies." I sigh and slide on the floor as he inspects every individual piece and bag. Eang, who is seven months pregnant, watches from her seat on the couch. We both know that where our safety is concerned, Meng cannot be talked out of his actions. "This one, the edges look like it might be a rip or tear."

"It's crumpled," I reply.

"No, it could be a rip. Someone could have inserted a needle through this hole," Meng says of the nonexistent hole and tosses it into the bad pile. "This apple is no good. I read that some crazies inject poisons into fruits to hurt people."

"I got that from Mrs. McNulty's house."

"No good," he says and tosses it away.

As the pile of bad candies grows bigger, I wrap my arms over my chest tighter to keep from screaming out my annoyance. After what seems like many hours, Meng is finally done.

"Good job," he says with a satisfied smile. Then he tosses the bad candies into a bag. "These we will throw away."

As he and Eang head off to bed, I snuggle under my blankets and try to go to sleep. In their room, Eang and Meng are already snoring when I move back to the living room to watch TV. To my horror, all three channels are showing ghost movies! In the dark, I sit on the couch with my legs

pressed tight against my chest and the blanket pulled over my shoulders. Outside the window, the moon peeks in and out from behind the clouds and slowly climbs over my roof and out of sight. Around us, the wind laughs and the trees shake their branches like a parent's warning fingers. But it does not matter. On TV, as the fake blood splashes across the screen, I sit transfixed and watch all the killings until, in the end, humans finally triumph over the ghosts and monsters.

As October turns to November, the sky grows dark earlier and earlier in the day and the sun travels shorter and shorter paths across the horizon. Soon the crisp air turns cold and blows with force across the barren land, but no leaves are left to protest its stinging wind. In Essex Junction, with fall newly departed, winter moves in speedily until we all wake up one morning to find white stuff on the ground.

"Snow! Snow!" I scream excitedly, my palms pressed against the cold window. "Snow!"

"Stop screaming. I know already." Eang is now eight months pregnant and no longer working, so she is home with me.

As my breath steams up the windowpane, images resurface of snow-cone vendors grinding up their ice blocks. In my mind, shaved ice falls from the sky for me to gather into balls and pour orange syrup on! "I'll sell snow cones to make money to send to Cambodia!" I think to myself. Then I remember that Mrs. McNulty said we often don't go to school when it snows here.

"No school today!" I run into the kitchen to tell Eang.

"Yes, school today," Eang replies, waddling her way to the living room with my snow clothes.

"You never believe me," I complain.

"No arguing. Mrs. McNulty will call if there's no school."

"Hhhhh!" I stomp back into the bathroom, my arms and legs swinging like elephant trunks. As I go about my toiletry, Eang tosses an armload of winter gear on my bed. What follows is a lengthy bundling procedure where I get pushed, pulled, and stuffed into various outfits and items. When I finally toddle out the door, I'm wearing shiny blue snow pants over my long johns and jeans, two pairs of socks, my red winter jacket, orange hat, black mittens, and scarlet moon boots. I immediately dump my school bag on the front steps and flatten my body on the ground.

"Snow! Snow!" I scream, pressing my stomach on the frozen grass. With difficulty, I roll over on my back and stare at the white, empty sky as my nostrils blow out cold smoke like a dragon. Underneath me, the snow crunches like little crystals under my weight.

"Snow! Snow!" I yell with elation, my arms flapping to make my very first snow angel.

"No. Frost, frost," a neighbor girl replies, wearing only a light coat, scarf, and sneakers.

The frost soon melts but before long we have snow drifts, hail, and ice balls. While the world freezes and the sky stays gray, our family snuggles longer and longer in bed. If Eang and Meng let me, I would spend all day asleep. For when I leave the warmth of my blankets, my mood becomes dark and foul. On those occasions when we have to leave the house, we do so quickly and return to thaw our bodies under the electric blankets. Still, no matter the frigid weather, Meng and Eang continue to make sure I get to school, even if I have to trudge through unplowed sidewalks in knee-deep snow. Even beneath the many layers of clothes, hats, and scarves, my body craves for the hot sun and humid weather of Cambodia. And with each snow step I take, I dream of walking on beaches and warming my toes in sunbaked sand. But no matter how vivid my fantasies, my face still freezes and each stinging gust of wind feels like a hard slap on my cold cheeks. When I return from school, Eang wraps heavy blankets around me and tries to thaw my body with a bowl of her homemade hot and sour soup.

As the weather grows colder and colder, our hearts are warmed by visits from our friends and sponsors as they crowd our house with gifts wrapped in pretty boxes and papers. Usually after they leave, Eang waddles to the kitchen to make our meal while Meng works on his English homework in the living room. From my closet, I hear him read and reread his work, his thumb flipping through his Chinese/English dictionary.

Before the war, Meng was a top student in his class, a distinction that made Pa and Ma so proud they rewarded him with a car. And now even without their approval to encourage him, Meng continues to study all the time. For two months, Meng has taken the public bus to Massachusetts every Saturday to attend a university in Boston to study social work. In

Lowell, he stayed with another Cambodian family and studied all day. After a weekend of rigorous class work, he would return home on Sunday night to start work on Monday. But because of Eang's pregnancy, Meng had to quit school to work two jobs to support our family. And yet he still comes home every day and studies his English lessons. Sometimes I wonder if he studies so hard for himself or if he's still doing it all for Pa and Ma.

While Meng supports our family, my only job is to be a good student. Meng once told me that the reason he chose me to take to America instead of Chou or Kim was because I was the youngest and therefore would be able to get a better education. He said it was Pa's dream that we would all be educated. Like Pa, Meng believes that a good education is our only way into a better life. In their worlds, having an educated Ung brings honor, prestige, pride, and dignity to the whole family. The weight of this responsibility hangs heavily and noisily around my neck like a huge clunky cowbell. Sometimes it feels like it's going to close around my throat when I try to talk.

At times, it all still seems so strange. One year ago, I was afraid of being killed by soldiers, and now my big fear is that the teacher will call on me to answer a question. When I *do* get called on, my mind swirls and jumbles up all the grammar rules in my head. Then slowly I have to work my thoughts into a sentence and force my tongue and mouth to speak it. In Khmer and Chinese, there seem to be no pronouns, plurals, or tenses. In English, there are all these grammar rules and then there are the exceptions for all the rules, and the exceptions for all the exceptions. It takes so much energy, work, and effort to listen, understand, talk, study, learn, and remember everything in class that I often go off by myself during recess to be quiet.

While the other students play together in the snow, with my bag of chips I shuffle over to the monkey bars with Tommy's shadow by my side. Where Tommy stood a few months ago, three girls now stand. When they see me approaching, they lean their heads in and whisper with their hands over their mouths.

"It's fun to live in trees," I say, still hoping to make new friends.

"What?" a brown-haired, freckle-faced girl replies.

"Fun to live in trees, and swing around on ropes." I have been reading many books about the monkey Curious George.

"What a pain in the neck," the freckled girl says under her breath.

"What mean 'pain in neck'?" I ask, my voice steady as I move toward her. The freckled girl shrugs her shoulders and turns her back to me.

"What mean 'pain in neck'?" I demand, but she refuses to acknowledge me. "You are making me lose face!" I scream in Khmer. "I am sick of trying to understand! I'm tired of you making fun of me in your foreign language! I hate that you think you're smarter than me!" In my native tongue, the words spew out of me easily and rapidly.

The girls continue to lean into one another. Suddenly, I feel the heat from my head rush down my face to my neck before surging to my arms. Then, fast as a frog, my arm springs up and punches the girl in the back of her neck.

"This mean 'pain in neck'?" I taunt her, ready to deliver another punch. The girl screams and I grab her, pulling both of us down on the ground. As we wrestle, her two friends try to break us up but I knock off their hands like moths.

"Stop, stop it now!" I freeze, hearing an adult's voice. I dare not turn around and look at her face. "All of you, go inside!"

Meekly, I climb off the girl and head back to class. When the bell rings at 3:15 P.M., the principal sends me home with a note to Meng.

"Loung." Meng's voice is calm and hard even after I tell him what happened. "We cannot lose face in America."

I stay quiet. Meng does not understand that I was trying save face with the girls. He only thinks about us losing face as Cambodian refugees living in America. But what about my face at school?

"Loung." Meng looks me in the eyes. His anger is visible in his dark pupils and still face. "We are guests in this country. No matter how long we live here, we will always be guests. And a guest must never steal, fight, or harm the host. You bring much shame to the family by fighting. The next time you act badly, America might send you back to Cambodia."

Meng does not have to raise his voice; his gentle threat is enough to stop me from behaving badly. I do not want to go back to Cambodia; I do not want to return to the war. In America, I have grown so weak and soft that I don't know if I could survive the war again. I hate myself for this. Because I know that somewhere in Cambodia, Chou is waiting for me, but I do not want to join her.

10 a child is lost

"What's going on?" Hong asks, her voice full of worry.

Chou and Hong have returned from collecting firewood to find the hut in a state of panic. They walk over to Cheung, who paces outside with Mouy balanced on her hip. Inside, Aunt Keang and Uncle Leang sit beside a straw mat, their bodies leaning into each other but not touching. A medicine man moves quickly around the mat, his hands lifting and touching the small body lying there.

"Where have you two been?" Cheung demands.

"We went to gather wood," answers Chou, her voice appropriately subservient to her older cousin.

"While you were gone, Kung fell into a pot of boiling mountain potatoes," Cheung starts, but her throat closes up on her. "The potatoes were cooked already and Ma moved the pot to cool under the tree. While no one was watching, Kung waddled over and somehow fell in. When Ma heard her, she was sitting in the pot, screaming for help. Ma pulled her out. The medicine man is in there with them now."

Tentatively, Chou steps inside the hut. The air in the room is musty and wet and thick with burning incense. Away from the cool breeze, moisture quickly collects on Chou's skin. She wipes her forehead and upper lip with her krama. In the dim light, she sees Kung lying motionless on her stomach on an old brown sarong, her face twisted to one side and

glistening. The medicine man has placed a wet cloth on the toddler's little bottom and chants incantations to help heal the wounds. When he lifts Kung's arms and legs to check her burns, Kung whimpers softly like an injured pup. Chou's knuckles turn white as she twists her scarf around her hand. After the medicine man finishes examining Kung, he and Uncle Leang leave to go find more leaves and herbs for her wounds.

"Che Chou, please help," Kung begs, her eyes staring up at Chou as tears slide down the ridge of her nose. Chou unravels the krama from her hand and approaches Kung.

"Pretty daughter, pretty sister, my pretty Kung." Chou smoothes Kung's hair, and gently caresses her cheeks. Beside them, Aunt Keang weeps into her scarf, her shoulders heaving up and down.

"Che Chou, please help. I hurt so much." Kung's left cheek is pressed against the cloth that sticks to her skin. Chou lowers her face onto the plank and delicately runs her fingers along Kung's hairline.

"My pretty girl, you're so strong." Chou leans in to give Kung a Cambodian kiss. She smells of freshly ground salve and incense.

"Che Chou, so hot. Burn."

"Shhh." Chou shushes her. "My pretty girl, I'm going to tell you the story of why the cows cry and the horses laugh." Kung's eyes flicker slightly at the mention of her favorite folktale story. "Would you like that? I'll tell you the story again."

"Che Chou, I hurt so much." Kung's voice is smaller now. Chou kisses her hand and forehead, her tears dripping into Kung's wet hair.

"When the god made the animals, he made the cows fat, dull, and ugly. And he made the horses beautiful and gave them shiny hair and elegant long tails. But then he looked at the animals and thought that it isn't right to give one animal so much. To balance them out, the god gave the cows very special magic shoes that allowed them to run very fast. The god then gave the beautiful horses very big, clunky shoes that only let them go very slow." As she speaks, Chou's steady voice lulls Kung into half sleep.

"Che Chou, I hurt." Kung's eyes are closed now but her pain stays with her. Chou holds Kung's hand, touching each of her fingers delicately.

"Well, with their special shoes, the cows became very haughty and thought themselves better than everyone." As Chou continues, her voice grows more gentle and calm.

"Because they were very fast, the cows were always the first to arrive at the drinking hole. But instead of taking care of the water so others might drink, too, they would run around and splash one another, muddying up the pond. When the other animals arrived, they found the pond water all dirty and muddy. 'Please brother and sister cows,' the animals asked, 'we humbly beg you to consider us and not muddy the water so much!' " Chou mimics the tiny voice of a very small animal. " 'Ha!' the cows reply, 'it is not our problem if you are too slow. We will drink and play the way we want!' And with that the cows swish their tails and turn away from the other animals." On the plank, Kung breathes deeply as Chou lifts a strain of damp hair off her cheek and fans her forehead to keep her cool.

"Then one day," Chou lowers her voice, "the cows arrived at the pond and took off their shoes before going in. The horses saw this and slowly snuck up behind them. While the cows were busy muddying up the water, the horses took off their own clunky shoes. Since none of the other animals screamed out to warn the cows, the horses were able to put on the cows' fast shoes and run away. As they sped away, the horses laughed 'heee, heee, heee!' When the cows found out what had happened, they cried and mooed. And that's why cows moo and horses laugh today."

"Chou," Aunt Keang whispers and takes Kung's hand from Chou. "Go cook dinner."

"Yes, Aunt." Chou kisses Kung's warm cheek, and leaves her with Aunt Keang.

As she leaves the hut, the world becomes a blur. Her legs go weak and, leaning against the wall for support, she remembers a Khmer Rouge hospital filled with sick people but no real doctors or nurses. With her eyes closed, Chou remembers the last time she saw Ma and Geak in that crumbling, moldy, rat-infested hospital. Geak was five years old but her shrunken limbs and swollen belly made her smaller than three-year-old Kung. Surrounded by sickness and death, Geak's body cramped up and caused her much pain when she tried to sleep. Occasionally, Geak's cries were answered by women who came by and gave her a few small cubes of sugar and a cupful of water, but they could not tell the sick from the starving. Pol Pot's men had killed most of the doctors and nurses, and those who

survived hid their identities and themselves. Chou squeezes her lids tight together and wishes she can retreat into her hard shell like a turtle, taking Geak's and Kung's pains so they would not have to suffer. She rages against Pol Pot and his Khmer Rouge soldiers.

"Pol Pot's men killed the doctors. Now we have no hospital, no doctors to help us when they're sick. And it's all Pol Pot's fault!" Chou spits out the words like poison on her tongue. "I pray he dies a painful death, and his body rots with diseases. I pray he returns as an earthworm!" Chou sends her pleas to the sky gods, the trees gods, the rivers gods, and any other gods who will listen. But as fast as the fire of hate ignites in her, it burns quickly out. Chou pushes herself away from the wall and heads for the kitchen. She squats down to make the fire to cook the family's dinner. As the smoke flows into her eyes, she lets her tears fall freely down her face. Taking deep breaths and blowing it into the fire, Chou knows that wasting energy and anger on things she cannot change is useless when there's so much to do.

While Chou is busy preparing dinner, Uncle Leang furiously pounds a round-edged wooden stick into a bowl of salve. When his muscles burn, he takes off his shirt and returns to his work. From her place, Chou watches his long spine flex and bend like a snake crawling up his thin back. Once in a while he stops for Cheung to add more leaves and herbs. As he mashes the leaves into a thick paste, his face is stiff and his jaws are immobile. When he is done, Cheung takes the salve to Aunt Keang to apply to Kung's wounds.

The next day, Kung's burns turn into black blisters and infected boils. With no doctors or medicine, the family does all it can to help ease her suffering. With swollen eyes and dampened hearts, they take turns massaging her arms and legs, fanning her body, and turning her head from right to left to prevent a crick. When she complains of a belly itch, Chou slides her hand under Kung's little body and scratches her tummy. Sometimes, she goes outside to sit with Kim. In their silence, he cracks open a green coconut, empties its juice into a bowl, and serves it to her. Then he sits back down near her and stares at the hut. Chou watches Kim's fingers dig into his skin like a pair of plows into dirt as he rubs his tired eyes and face. When he looks at her again, she notices his eyes are red and puffy.

"Why don't you go see her?" Chou whispers to him.

"I have." His voice is resolute and grave. Chou knows that he has only entered the hut to glance quickly at Kung and leave.

"At least we can say our good-byes." Chou speaks the words they both don't want to hear. They never had the chance to say their good-byes to Ma, Keav, and Geak. Pa was the only one they got to hold and send off with their love. Silently, Kim gets off the bench and walks toward the hut. "We can say our good-byes," Chou repeats quietly as her eyes begin to sting again.

For three days, Kung hangs on to life as her family dresses her wounds, holds her hands, entertains her with stories, and tells her she is loved. With borrowed money, Uncle Leang buys beef and pork for Cheung to cook for Kung. Aunt Keang chews and grinds the tough meat in her mouth and feeds it to Kung with watery rice congee. When Kung is thirsty, Khouy and Kim rush out into the fields and return with bunches of green coconuts. Aunt Keang dips the tip of a krama scarf into the bowl of coconut milk and wrings out the liquid into her parched lips. As her life dims, Kung continues in her small voice to beg for help to relieve her pain.

When Kung stops talking, the men try without success to find a monk to help Kung pass easily from this life to the next. Knowing they can do nothing to ease her pain, the men leave the hut to sit outside. Inside, the women wash Kung's body, hair, hands, feet, between her toes, and under her nails. Then they move to her face, wiping away the dirt in the creases of her neck, eyelids, and ears. Slowly, Kung's breath becomes uneven and jagged. Sitting in a circle around her, the women kiss her face, whisper in her ear, and sing her favorite songs. Outside the sun moves across the sky and passes over the village and the hut, waking up the owls, bats, and crickets. Together, the night creatures sing as Kung's body goes into shock and becomes damp and cold.

Chou lays her hand on Kung's arm and marvels at how beautiful she still is. Chou regrets all the times she spoke harsh words to her and wishes she could take them back. She prays to the gods to help Kung be born into a better life in her next incarnation. She buries her nose in Kung's cheek and says the farewell she wished she'd said to Geak. As the candlelight flickers on Kung's face, Chou kisses her forehead, eyes, and hands. The smoke from the incense rises and spreads all about the small hut, as if infusing the

room with Kung's spirit. Chou then leaves the room and turns her face up toward the dark sky, forcing her tears to stay down her throat.

"Ma, Pa, Keav, and Geak. Please take care of Kung." The stars blink in the sky as if to answer her. "She's a good girl," Chou whispers, and goes to prepare the family's meager meal. As the fire cooks their soup, Chou digs enough red clay from the ground to mold it into figures of Ma, Pa, Keav, Geak, and Kung. From the dirt, she creates crude wagons, horses, and cows for them to have in the nether world. She lines them up to dry by the fire. When she looks up from her clay family, she finds Kim looking at her knowingly from beneath the tree.

Inside, Aunt Keang gently massages Kung's neck and holds her tiny face in her palms. In the soft light, Kung looks asleep and at peace. Hooking her arms under Kung's shoulders and knees, Aunt Keang lifts her daughter and presses her into her bosom. In the dark, she rocks her child in her arms, but Kung is gone and makes no sound. More candles and incense are lit as the men and women gather around. One by one, each family member goes up to Kung to say a final good-bye.

11 the first american ung

"Here she comes," Mrs. McNulty announces, her voice dancing on the walls. "Isn't she a beaut?"

Behind her, Eang climbs the stairs to our apartment slowly, carrying the first American in the Ung family. I rush over to the living room and arrange the cushions and pillows in a nice neat order on the couch. When they walk into the living room, I see that Eang's face is pale and puffy like a marshmallow, but I keep my mouth closed. Next to her, Meng's skin is brown and dry like stale crackers.

"Well, Meng, you and Eang have to wait for five years before you can become Americans. But this little girl, she's an automatic citizen!" Mrs. McNulty exclaims, laughing.

Meng has already explained to me that while he and Eang will have to live in America for five years before they can apply for their citizenship, because I'm a minor, I will have to wait until I become an adult at eighteen to become an American.

"She is a beauty, Meng. You must be very proud," Mr. McNulty tells Meng quietly.

"Yes, I am happy she is healthy." Meng smiles as he follows Eang into the living room.

"Yep, the Medical Center Hospital of Vermont knows how to take good care of its people," Mr. McNulty declares with hometown pride.

It is December 23, and outside the world is fluffy and white again. Meng says that falling snow looks like white Chinese blossoms. Inside, our home is warm and smells of the pine spreading out from the five-foot tree in front of the window. Colorful glass balls and popcorn strings hang from the thick branches behind the wires of white lights.

When one of our sponsors showed up at the front door with this ugly, spindly pine tree, I wanted to ask if we could have a prettier one with big green leaves and blooming flowers. Though Meng, Eang, and I don't understand what this needle tree has to with the birth of Christ or Christmas, we decorate it the way we've seen people do it on TV.

"Mrs. and Mr. McNulty, something to drink?" Eang asks as she rocks the baby in her arms. I smile at how much Eang values proper etiquette and showing respect to guests. Even if she's on her deathbed, I think she'll still try to offer her guests something to drink.

"No, no, thank you," Mrs. McNulty answers. "I guess we'll leave and let you rest." Mrs. McNulty gets up and Mr. McNulty follows.

"Thank you so much for bringing us back from the hospital," Meng tells them again as he walks them to the door.

I skip after Eang and sit myself next to her on the couch. Slowly, my hands part the white bundle of cloth in her arms. I peel the layers off like lotus flower petals to discover a light brown and smooth baby inside. With her eyes still closed, she squirms and suckles her lips. As Eang takes the baby out of her wrappers, I reach over and touch her pink baby pajamas and caress her wrinkled hands. She purses her mouth as if warning me to leave her alone and let her sleep. Slowly I pull off her little hat to see the mass of black hair covering her soft spot. She yawns and scrunches her face as if to let out a cry before I quickly replace the hat on her head. Then I lift her tiny hand to my nose and lips, giving her first a Cambodian kiss and then an American kiss.

"Hi, baby," I coo. Her eyelids squeeze together but she breathes so deeply it sounds like she just sighs. "You're so cute!" Her soft skin smells of baby powder. My head spins with visions of having my own living doll to play with, dress up, and feed. "Open your eyes, open your eyes," I urge her, but she ignores me.

"Her Chinese name will be Geak Sok." Meng is suddenly next to me, gazing warmly at his daughter. I stare at him, my breath caught in my

chest. As I exhale slowly, the room seems to grow darker and the lights on the tree less bright. In front of my eyes, the lines on Meng's face etch deeper in the creases around his eyes and mouth. For a moment, I fear he will break our unspoken rule not to talk about Cambodia, the Khmer Rouge, Ma, Pa, and especially Geak.

"Because she is born on December twenty-first, the first day of winter, her Chinese name means jade-snow." Meng continues and lets our rule stay unbroken. "She is named after Geak and snow." For a moment, Meng's voice is far away, but his smile never leaves his face.

"That's pretty," I agree, and continue to play with her soft fingers. Somewhere inside me, sad memories stir and try to push themselves to the surface. "Geak Sok." I whisper the name softly and stare at the baby's pink cheeks. I caress them with my finger and wonder if someday they will ripen like red apples just like her namesake's. But as the baby squints and attempts to open her eyes, memories of Geak's cries and swollen belly crawl back into their dark hole like a defeated mouse.

"But we'll call her Maria," Eang declares, and transfers the baby into my arms.

"That's pretty, too!" I giggle approvingly and try not to stare at Eang's heaving breasts that seem to have grown twice their size in the two days she stayed at the hospital. In my arms, Maria stretches and purrs peacefully in her sleep. "She's so tiny," I tell Eang, and focus my attention back on Maria. I gaze at her tiny lashes that look painted on and at how her tiny nostrils flare like a harmless baby dragon when she breathes. Not able to resist, I lower my face and nuzzle against her cheeks. With her head resting on the crook of my elbow, Maria feels like a small, lumpy, warm water sack. "Maria like *The Sound of Music*."

"Yes, good movie," Eang agrees.

And so Maria joins our family and the next two days she spends sleeping in each of our arms. On Christmas Day, we celebrate by opening our gifts, eating dried turkey, and settling down to watch on TV the movie all our sponsors talk about, *It's a Wonderful Life*. Outside, the snow falls softly and the world is quiet. At the end of the movie, the family cries and gathers around Joe Bailey as he rushes back into his house after having gone missing all day. Joe Bailey's face lights up and his eyes glisten with tears when he sees the big crowd of family and friends waiting there for him.

Then there is much laughter, hugging, and kissing as everyone celebrates being together. All of a sudden, I cannot stand the movie anymore and quickly turn the TV off.

"The movie's over already?" Eang asks groggily.

"Yeah."

"Time to sleep," she yawns and taps Meng on the arm. And together, they slowly make their way into their room where Maria dreams in her crib.

In the dark, I lay my head on its cushioned armrest and lie diagonally across the rocking chair. Outside the window, above the phone and power lines, the moon frowns and the stars twinkle like the lights on the pine tree. As the chair rocks back and forth, I bring my legs to my chest and curl into a fetal position. "It's Christmas," I say to myself. "You should be happy. Everybody's happy on Christmas." The sobs come faster now, pushing against my diaphragm and out of my throat. "But I am so lonely." I cover my hand over my mouth so Meng and Eang won't hear me. I don't want them to know.

"I miss my sisters," I say out loud to the empty room. My chest heaves as I realize it's the first time I've said it, not just thought it. "I miss Chou."

The lights on the tree shine brightly on my skin, but inside my body the darkness grows. It's Christmas night and so many people are alive and together and happy! And tomorrow, more people will come and wish me a happy holiday and Eang will tell me to smile. But how do I tell them how difficult it is to curve my lips when anger makes my face stiff? When the other kids brag about what their parents bought them for Christmas, I am silent because I want nothing from Ma and Pa. I just want them to be here. I want to sit on Pa's lap. I want to see Ma's smile. I just want them to be alive.

Exhausted, I drift off to sleep in the armchair with the sound of bells still ringing in my ears. Then I see Ma and Geak together. It is daytime. The sky is bright and a light breeze sweeps their hair into their faces. Ma's eyes are shiny and when she smiles, her lips stretch widely, exposing her gum. On her lap, Geak laughs, her fat cheeks glowing with health as she reaches up and wraps her arms around Ma's neck. In silence, they lean their bodies in together, Geak resting her face on Ma's chest, Ma setting her chin on Geak's head. They look beautiful. A smile creeps onto my

face. They look so real. I want to throw my arms around them. I want to believe that they're alive. But I don't, not even in my sleep.

Suddenly they disappear. I run after them, calling out their names and begging them to take me with them.

"Please wait, wait for me!" I scream, but they are gone. "Come back, tell me when you will come back," I plead. Their disappearance hurts so much, I want to crawl into a grave and let the earth take me in until I lose my memory.

"Ma, wait for me!" I beg, but no one hears me.

In my panic, I finally notice the heavy load in my arms. I bend my head down to see that I am holding a newborn baby. The baby is pale as a ghost and lies limp and unmoving in the crooks of my arms. I stare at her and a cold chill travels up my spine before spreading like an artic blast all over my body.

"No, no! Wake up, wake up!" I shake the baby but she doesn't move. "Wake up, wake up!" Frantically, I squeeze the baby to my chest, hoping to give it life. But the baby lies dead in my arms.

part two **divided we stand**

12 totally awesome u.s.a.

March 1983

At six-thirty A.M. Madonna's "Like a Virgin" wakes me up for school on my alarm clock. I slam my hand down on the snooze button and close my eyes for a few more seconds. Outside the wind howls and blows cold air in through the cracks in the windowpanes. When I open my eyes again, it's seven A.M.

"Damn, I'm late!" I jump out of bed, throw on my big red sweater, and quickly slip on black tights, a skirt, and red leg warmers. In my closet, I quickly tease up my bangs and pull the rest of my big, permed hair into a banana clip.

"Damn, damn!" I swear, skipping and jumping while trying to cram my feet into a pair of Keds.

"Loung, stop swearing and jumping around," Eang says as she sleepily passes my room to lie down on the couch.

"Sorry, sorry. I got up late."

"Then hurry, but no swearing and jumping." Eang pulls a blanket over her shoulders and closes her eyes.

I tiptoe down the stairs and out the door. In my hurried pace, my body heats up and keeps me warm against the cold wind. As my feet half-jog the mile to ADL Intermediate School, I think about Eang and her aversion to swearing. When we first came to America I used to be able to throw these four-letter words around and tell Eang they were not swear

words, but she's caught on now and is always on my case about it. "Swearing," she says, "is not proper or ladylike." Sometimes I want to scream at Eang and her many rules. After three years in America, she is still trying to raise me to be a proper Cambodian. And it seems that in addition to not swearing, a proper Cambodian girl doesn't go out to movies with male friends, go the mall, listen to loud music, talk for more than five minutes on the phone, come home after dark, or go anywhere by herself. It seems to me, a proper Cambodian girl is just supposed to sit at home and be quiet. But I'm no proper Cambodian girl. And in English the bad words blow off of my lips without much shame or fear, yet I can't even silently mouth these same swear words in Chinese or Khmer without feeling like a very bad girl.

As I get near school, I stop jogging to coast along a patch of ice on the sidewalk. On the smooth concrete, I glide as if on a pair of roller skates, when suddenly I slip.

"Shit!!" I holler loudly.

Above me a row of birds frantically flutters off the telephone line. My right ankle rolls off a fallen branch and is growing fat before my eyes.

"What the hell! I'm late enough already. Jesus Christ!" I mutter to myself while I rub my ankle. Ahead of me, a group of kids turns and stares at me quizzically. Afraid that I look like a retard, I glower at them and make my eyes super small, as if to dare them to say something.

"Hey, are you okay?" a brunette girl asks.

"Umm, yeah," I answer meekly.

"You're sure?" she persists.

"Yeah, just a twist."

"All right, see you at school then," she smiles and leaves with her friends.

"Bye." My mouth feels sour at how quickly I assumed the group would make fun of me. But more often than not, that's exactly what the other kids do.

At thirteen I am only a year older than most sixth-graders at ADL, but those 365 days color my face with embarrassment and shame when the question of age comes up. And inevitably, the discussion will end with some kid making fun of me for it.

"So did you stay behind?" someone will ask.

"No," I'll reply with a nonchalant shrug of my shoulders.

"Did you start school late?"

"Yeah, very late," I'll laugh, all the while fully aware of their looks of disbelief because in their world everybody starts school at the same age. And if someone starts late, it must mean they're slow.

"I'm not stupid!" I want to scream at them, but instead I smile.

Sometimes I wish I had a T-shirt that reads "I don't speak like you. I'm from another country. We don't speak English there. So stop being rude!" But no such T-shirt exists. And I don't want to explain how I started school as a ten-year-old in second grade because then I will have to tell them about Cambodia and the Khmer Rouge.

I stand back up and tentatively walk on my tender ankle, but before I get to school I suddenly veer off the sidewalk to knock on Beth's door. A car in the road kicks and jerks forward loudly. Involuntarily, I lower my shoulders and bend my knees as if to crouch. As the car passes, I reprimand myself for being a scaredy-cat.

"Beth," I shout and rap louder.

"You're late," Beth says calmly when she opens her door.

"Sorry, I got up late, then twisted my ankle trying to rush here. It's just one of those days." Beth is quiet as she locks the door behind her.

Beth is my best friend in junior high. At five feet four inches, she is two inches taller than me. In contrast to my black hair and dark skin, Beth's a blond-haired, blue-eyed, pretty all-American girl. She's also one of the nicest and kindest girls in school and an extremely good teacher to me.

"If we hurry, we should be okay," she says and glances at my face. "And um . . . you should wipe off the ugly, sparkly blue eye shadow."

"Really?"

"Uh-huh. You're beautiful without it."

Part of the reason I love Beth is because she compliments me all the time. And yet as many times as I've heard her say I'm pretty, I don't see it in myself. How can I be when I'm so different from everyone else?

"Wipe it all off or leave a little on?" I persist.

"All off."

"Really?"

"I don't know why you don't believe you're pretty," Beth sighs in exasperation.

I take Beth's advice and clean up my lids. But she doesn't understand. She wasn't there last summer at the fairground when the boy turned his face away. I'd smiled at him as we both stood in line to buy cotton candy. Later, when he met up with his friends, they looked at me and laughed. Beth just can't understand how that feels—she's so perfectly normal that sometimes I wonder why she's friends with me.

Though Beth and I spend a lot of time together, I never tell her anything about the Khmer Rouge or the war. Instead, when I'm at her house, my favorite thing to do is to hang out in her kitchen and watch her and her mom interact. Ma Poole—that's what Mrs. Poole lets me call her— likes to hug and puts her arms around Beth a lot. And when I'm there, I get a lot of her hugs, too. So while I share with Beth what it's like to be a stranger in a foreign land, with her mom and in her house, I get to have my American family.

"Hey, Beth, let's buck it!" I holler and march ahead of her.

"What?" Beth asks, trying to stifle her giggle.

"Let's buck it, let's hurry." I explain.

"Umm, babe. The expression is 'book it.' " Beth cracks up, her face muscles jiggling like the cafeteria jello.

"But . . ." I stammer. "A buck is a male deer and deer move very fast. So we make like a deer and 'buck it,' right?"

"No, book it." Beth is certain.

"What? How? Why 'book it'?" Beth can't answer me.

I don't understand English expressions and idioms. When I hear these strange phrases, I try to analyze and find reasons for them. Buck it, book it; windshield factor, windchill factor; I pledge a legions, I pledge allegiance; ant, aunt; there, their, they're; I wonder why the Americans make it so difficult for themselves, not to mention for me!

When I'm not stumped by these weird sayings, I struggle with the sounds. Sometimes I listen with envy as Beth rolls out the words effortlessly, automatically, and with a perfect accent. Her lips move so fast when she speaks that they look like a sock puppet with somebody's hand controlling her mouth. I, on the other hand, have to sit in speech therapy class day after day to practice saying the sounds "S," "Th," "Str," "L," "V," and "O" with exercises that have me blowing air between my teeth, pressing my tongue against the roof of my mouth, and breathing through a straw.

Afterward, my tongue usually feels swollen and too fat for my small mouth. Sometimes my tongue gets so tired, it becomes cranky and grouchy and sputters out sounds that taste like dirty water. But still I make myself practice and repeat the sounds until the phrase "Susan eats snakes" echoes even in my sleep.

Beth and I reach school just as the bell rings.

"One more day, then it's the weekend!" Beth calls out as she walks off to her class.

"Totally awesome!" I yell back and enter my class.

Around the room, the popular students gather and socialize while the misfits sleep and pretend to look bored. In their corner, the Valley girls jingle their plastic bracelets and balloon out their cheeks like frogs before they pop their chewing gum. At my desk, I sit quietly and try to remember yesterday's grammar lesson. Early on, I learned that to pass the tests, I just have to memorize the rules even if I don't understand their usage. Then the day after the tests, the lessons can fly out of my ears like yellow busy bees. When the rules do stay in my head, they zip around and cross-pollinate with all the other lessons in my brain and get all mixed up anyway.

"All right, class, I trust you all did your homework." The teacher sends everybody to their seats.

The assignment was to take your assigned big word and find other small words in it. One by one, each student walks up to the front and gives a report; I avoid the teacher's eyes, hoping she won't call on me.

"All right, Loung," the teacher nods in my direction. "Your turn."

"Okay." I smile, my feet clunking heavily on the floor like they're stuck in blocks of cement as I approach the board. As I stand in front of the class and write my big word on the blackboard, I am careful to slant the chalk so it doesn't squeak. When I'm finished, I turn back to the class. My lips are dry and cracked.

"My word is Saturday," I say in a small voice. My feet want to tap from nervousness but I stop them. "My word is Saturday," I begin again in a deeper voice. "There's the word 'sat,' " I draw a line under *sat*. "There's also the word 'day,' " I draw two lines under *day* for emphasis.

"And in the middle," I continue, "is 'turd.' "

Twenty heads toss back and erupt into laughter. I turn around, my fingers gripping the chalk tightly.

"What?" I ask, confused.

"Loung, do you know what that means?" asks a girl in the front.

"It means cool," I answer. I have heard the cool kids call each other that.

"Well, no, it doesn't," another student answers, her voice cracking. Now even the teacher has her head bent to the desk, her right hand covering her mouth.

"But some kid called me a 'turd' the other day," I protest. At this, the class roars and finally the teacher asks a girl to explain the word to me.

The girl takes a long time to explain what exactly a turd is. She first tells me something about a galloping horse that lifts its tail up.

"You mean it flicks at flies?"

"No. You know," she persists, "when a horse lifts its tail and stuff comes out."

"The horse pees?" I crinkle my brows.

"Closer." She smiles. "All right." She looks me in the eye. "Rabbit poo, bird droppings, and elephant manure."

Finally, I get the picture.

"Oh shit!" I exclaim, but quickly cover my mouth with both hands.

When the bell rings again, I walk out of class wishing I were somebody else. As I find my way to the next class, I pretend I am a blond-haired, blue-eyed girl just like Beth. In my fantasies, I am named Jassy after a character I saw in an old black-and-white movie on TV. Right away I like the name because the girl in the movie rides horses and is a tomboy. But the first time I brought up the subject of a name change with Meng, he'd gazed at me as if I were crazy.

"But, Eldest Brother," I protested, "many other refugee kids have taken American names." Of the roughly two hundred Cambodians living in Vermont, many now call themselves by their new American names.

"It doesn't matter what others do. You're not changing your name," Meng had said. He can be very final when he wants to be.

What Meng doesn't know is that in school, my name has already been changed to its American variations of Loung.

"Hey Louie," a girl name Missy says to me as she greets me. "Don't you just *love* second-period gym class?"

"Barf me out!" I answer her and head into the locker room to change into my gym shorts and sweatshirt.

Outside, the sun is shining brightly in the sky and giving us an unusually warm day for the end of March. All the snow has melted, leaving the green grass below us cold and soggy. But still, I wish it were forty degrees warmer as I step onto the field, my sneakers soaking up the water like sponges.

"What a gorgeous day to play outside!" the girl next to me exclaims.

"Totally bitchin'," I grumble under my breath, rubbing the bumps popping out of my skin.

"All right, girls." The gym teacher blows into her whistle. "Gather around." We all do as she says. "Missy, you play center forward. Loung, you're left fullback. Colleen, you're right wing." While she split us up into two teams, I stare up at the sky and pray that the nice weather is here to stay. But in Vermont, we can still get snowed on in May.

"All right. Get into positions!" the teacher yells as I stroll to my spot. For the next twenty minutes, I stand around rubbing my thighs to keep them warm and run after the ball if it rolls by. Then suddenly, before I know what's going on, the ball flies high into my space and without thinking I jump headfirst into it. It hits my head with a loud thud, creating a vibrating shock wave all over my scalp and then bouncing off to the ground where it is pounced on by other players. I lie on my back, my arms and legs spread out on the grass, and squeeze my eyes shut. For a second, I see black spots and my heart leaps with excitement. "You may have amnesia!" my mind whispers. With that, I envision myself waking up and not knowing who I am. I see myself returning to normal life with Meng, Eang, and Maria—but as a new person with no memories of Cambodia. But then swirling stars burst forth into my sight, and as the sun penetrates my closed lids, my face darkens with disappointment.

"Lou, are you hurt bad?" the gym teacher huffs at me.

"Have you ever heard of anybody hurting good?" I snap back in annoyance. The teacher scowls.

"What did you say?" she demands.

"I'm sorry. I mean I'm okay." I chew on my lips to keep quiet.

The teacher smiles tightly and sends me to sit on the bench. While the game continues, I try to think of another way to erase my memory of Cambodia. In soap operas, it seems that every time a girl hits her head,

drinks too much, gets in a car accident, or merely faints, she gets amnesia. As my butt freezes on the cold bench, I realize that amnesia is a lot harder to get in real life than on TV.

The next period takes me to Mrs. Kay's English class. I listen to her gentle vioice reading the class announcements out loud and wonder what it would be like to have her read me bedtime stories at home. For the rest of the class, I sit with my face resting in my palm like a heavy coconut that'll fall down if I don't support it. When the bell rings to end our class, the students rush out the door like alligators being let out of their cages; I follow behind.

"Loung, can I talk to you for a minute?" Mrs. Kay calls me.

"Sure, Mrs. Kay." I go and stand next to her desk.

"Loung," Mrs. Kay begins tentatively. "Loung, I've asked you to stay behind because I want to thank you."

"Thank me?" I'm bewildered.

"Yes. You don't know this but my son died this last summer. And I've had a very hard time with it and you've helped me a lot." She smiles. "All through the year when I feel very sad, I just look at you. You're always smiling and working hard. I say to myself, 'This young girl has lost her family, her home, moved to a different country, and she still goes on smiling.' " I stare at Mrs. Kay not knowing what to say. I don't know how she knows about me. I don't talk about my past life to anyone. "You've helped me to go on. . . . And Loung, I think that your story is a very important story. If you ever want to write it down, I can help. If you want, you can even talk into a tape recorder and I can help you tran- scribe it."

"Thanks, Mrs. Kay. I'll think about it. And I'm sorry about your son."

"Anything I can do to help, just ask."

"Thanks, I will," I tell Mrs. Kay, even though I have no intention of ever sharing my story with anyone.

After school, I walk Beth back to her house, then stop in for a cookie before going home.

"Loung, you're late! It's three-ten!" Eang yells when I open the door.

"Sorry," I reply meekly, knowing their shifts start at three-thirty P.M.

"All right, food is cooked. You need to finish the laundry. Mop the floor." And like a tornado, Meng and Eang storm out of the house.

"Okay, okay," I call out after them, and go over to hug Maria.

"Hi sweetie," I say. She smiles but then turns back to the TV.

Maria is three years old and already can communicate in three different languages. Between the two of them, Meng and Eang speak Mandarin Chinese, Cantonese, Chiu Chow, Vietnamese, Khmer, and now English. They are pushing me to study French to add another language to our household. At home Meng mostly speaks to us only in Chinese, while Eang doles out her instructions in Khmer. Meng rarely bends his Chinese-only rule, even when I have Ahn McNulty over.

However, I don't see Meng and Eang enough to fight with them anymore. Both have found better-paying jobs working the evening shifts. For Meng, the extra money means that more funds can be put away to send to our family in Cambodia. This alone made it worth it for him to leave the job he loved as a social worker. Each day I leave for school before they are fully awake and rush home to look after Maria while they prepare to leave for work. By the time they return at midnight, Maria and I are fast asleep in my bed.

After I've finished with my chores, I feed and bathe Maria. Then it's time to tuck her into bed.

"What book tonight?" she asks in English, crawling under the sheets.

With her parents gone, I am the one who, with a flip of the page, turns Maria from a toddler into Snow White, Cinderella, or Sleeping Beauty. When she is not a princess, Maria makes friends with Snoopy and the Peanut gang, follows Froggy as he goes a courting, swings on vines from tree to tree with Curious George, and twirls around with the mysterious Twelve Dancing Princesses.

My closet, once a place to hide from the world, is now a library where I can escape into my books. The shelves that once held a big jewelry box filled with colorful pins and barrettes are now taken up by books of all kinds. Gone is the cold metal chair; in its place, Meng brought me a school chair with a folding table. Eang sewed me a pillow to warm and cushion my buns while I read. On the walls, magazine pictures of sunflowers, California palm trees, banana plants, and Wonder Woman intermix with numerous cartoons of Snoopy, Pooh Bear, Mickey Mouse, and baby pictures of Maria.

"How 'bout if we make up our own stories tonight?"

"Okay," she agrees, and I climb into bed with her.

"There once was a beautiful princess named Maria. And she was a very smart and clever princess. Then one day she walked into the woods and saw . . ."

"A giant butterfly!" Maria exclaims. "And the butterfly was very beautiful and had many colors and it flew very fast. Then the princess ran after it, and . . ."

"And she took out her magic rope and tried to catch it." Together Maria and I weave a story until the princess catches her butterfly in the end.

As she lies in the crook of my arm, I watch Maria sleep peacefully. In the soft nightlight, her round face is warm and full. Suddenly a fleeting image of Geak comes back to me. I try to imagine Geak's face when it was as full and round as Maria's. But without a picture to hold on to, her beautiful face turns to hallowed cheeks and sunken dark eyes. As my nose itches and drips, I fantasize again about killing Pol Pot. I still want him dead. I want to wrap my fingers around his neck, feel my thumbs tighten against his Adam's apple, and crush it. As hate boils in my body, it suppresses and overwhelms my sadness. In my arms, Maria moves closer against my chest, her breathing regular and deep. For a moment I feel old and maternal, but when I close my eyes the girl returns. When I open my eyes again, Meng and Eang are home. Quietly, they take Maria to their room and leave me to sleep alone in my bed.

In the morning, I'm awakened by other Cambodian voices in the kitchen. As I recede into my closet to read my books, Meng, Eang, and their friends talk about Cambodia. Because Meng's English is better than most of the other refugees', they flood our house every weekend asking for his help translating various documents or filling out job applications. Sometimes these refugees only stay for a few hours, and other times they stay for days. The longer they stay, the more they talk about Cambodia, making it very difficult for me to block it out. When I complain about the stream of visitors, Meng's only reply is that we need to help one another, especially other Cambodians.

The truth is all I care about is becoming an American. Already I wear jeans and baseball caps wherever I go, listen to Loretta Lynn, and watch Crystal Gayle on TV. At school, I even make myself eat boring cafeteria

meat loaf, hamburgers, and shepherd's pie without making faces. But Meng tells me that until I have my citizen papers, I still am only a legal alien.

"Eldest Brother, why do we have to wait so long before we can be Americans?" I asked Meng one night.

"Maybe the government wants to make sure we're good people."

Meng says that he and Eang have only two more years before they can apply for their American citizenship, but already he is studying the exams to make sure they'll pass their tests. Meng tells me that as an American he can begin the paperwork to sponsor Chou, Kim, and Khouy to come to America. When he sees how excited I am about seeing Chou again, his face clouds over and he cautions that even with his citizenship, it may still take many more years for us to bring the rest of the family over.

"But, Eldest Brother, when we left we told them we'd be together again in five years," I remind him. "They'll be waiting for us."

"They'll have to wait a while longer," he answers.

"How much longer?"

"I don't know," he says sadly.

Meng then explains how Cambodia is not recognized as a country by the United Nations because of the Vietnamese occupation. Meng says he believes that because the United States lost the Vietnam war, the government is still angry with Vietnam. As a result, the United States has no diplomatic relations with either Vietnam or Cambodia and therefore we cannot send any letter or packages there. But because Canada is a super nice country and likes everyone, their government has relationships with Cambodia and we can mail our packages to Cambodia from there.

Until America, Vietnam, and Cambodia become friends, we can't send letters or anything else to our family in the village. But every time Meng runs into a store, he brings his coupons and returns with multiple packages of Tylenol, cough drops, cold medicines, eye drops, tea, and Chinese herbs. When there is a big clothing sale at the department store, Eang comes home with shirts, pants, skirts, and dresses in all different colors and sizes.

Meng and Eang sort the items, tape on Khmer and Chinese instructions for their usage, and write the name of each recipient. In his letters, Meng describes our lives and growing family, and includes addresses of family and friends in Canada, France, Australia, and Vietnam. Then care-

fully he packs the items into a plain brown box and completely wraps it with packing tape. On all four sides of the box, he writes only Khouy's name and an address in Phnom Penh. While he prays that his message will reach Cambodia, I send no words for Chou in the box.

"Tomorrow we go to Montreal," Meng announces happily while I yawn and get ready for bed. Since we received our green cards two years ago, Meng has made the two-hour trek to Canada every month, often piling the rest of us in our used Nissan Stanza with him, so he can send his letters and packages to Cambodia.

The next day, in Montreal's Chinatown, while Eang fills our carts with fifty-pound bags of jasmine rice, salted fish paste, oyster sauce, dried squid, rice papers, dried golanga root, and other Asian food we cannot find in Burlington, Meng waits in line at a Canadian post office, his arms laden with boxes and letters. From the post office, Meng picks us up and we go to visit his friend whose address we put on all our boxes to Cambodia.

"No," his friend tells Meng. "Nothing from Cambodia." After the visit, Meng walks back to our car with stooped shoulders.

Back in Vermont, March gives way to April as the birds chirp loudly in the trees and peck at springtime's new buds. In our house, just when I'm sure the dark circles below Meng's eyes will never leave him, the phone rings.

"Hello," Meng answers. From my seat on the rocking chair, I watch Meng lean forward on the couch. His face breaks into a big smile. "When?" he asks, and his hand grips the receiver so tightly that his knuckles turn white. "Only three months old?" Meng exclaims, his voice sounding like a boy. "What does the letter say? Please read it."

"Who is it? Who is it?" I ask, but Meng waves me away. Alerted by all the commotion, Eang comes in from the kitchen to sit next to Meng.

"A letter from Khouy has arrived!" Meng finally tells us excitedly. "And it's only three months old!" Eang leans her head into his and presses her ear against the receiver.

Inside our home, it is as if time has stopped. For a moment, I can hear my breath inhale and exhale. In the silence, I watch Meng's facial muscles quiver as he fights to hold them still. When his friend reads that Khouy, Chou, and Kim are alive and well, Meng's smile shines with such brightness he reminds me of Pa.

13 a box from america

It is early morning and the sun has yet to burn through the haze. Beside the hut, Chou squats and grabs a handful of grass, her thick calluses protecting her palm and fingers. With her other hand, she cuts the grass with her sickle and tosses it on the pile in front of the cows.

"Second Brother," Chou hears Kim greet Khouy as his motorbike roars to a stop in front of their hut.

Chou drops her sickle and walks to the door to welcome Khouy. When she gets there, Kim is already beside him, his arms heavy with a big brown cardboard box with Western writing on it.

"It's a package from Eldest Brother," Kim announces excitedly.

"Truly?" Chou gasps and feels her legs bend like wilted plants.

It's been three years since Meng and Loung left them and this is the first they've heard from them. "Second Brother," she greets him, her heart racing in her chest. "Is the box really from Eldest Brother?" Chou clenches her sarong in her hands while she waits for Khouy's answer.

"Yes, it's from Eldest Brother," Khouy tells her gently. "I just got it last night. I got here as fast as I could this morning."

"Thank you for coming so early." Chou lets go of her sarong as the three of them rush into the hut. As the family gathers around the kitchen to eat rice porridge and eggs for breakfast, Khouy sits himself down at their new homemade wooden table.

"Second Brother, how did we get this?" Chou asks, her voice cracking.

"Eldest Brother writes that he's been sending boxes to all different addresses, but only this one got here," Khouy says and cups his hand to light his cigarette.

Next to Khouy, Kim's hands tremble as he opens the envelope. Suddenly he yells out, "But, Second Brother, this letter is dated four months ago!"

"It took three months for the box to arrive at the address in Phnom Penh, and my friend has had the box for another month."

"A month!" Kim gasps as Chou sidles up next to him.

"Kim, everybody is busy. It's not like before the KR in Phnom Penh when they can call us up on the phone and tell us to come get the box. On a motorcycle, the trip from Phnom Penh to our village is long and dangerous. My friend had to wait until he had some business in the village before he could come." Khouy looks up, takes a long, slow drag of his cigarette, and adds, "The box was already opened when my friend got it."

"Were many things taken out of the box?" asks Aunt Keang.

"From Eldest Brother's list of what he sent in the letter, they stole most of the clothes, shirts, pants, and dresses. There are still herbs, headache medicines, eye drops, and a few other things in there. Eldest Brother taped names of who they go to and instructions on how to use them."

Chou looks into her box and hides her disappointment because she knows the missing dresses were for her. The last time she owned a beautiful dress was before the Khmer Rouge. "Is everybody well? Eldest Brother, Eldest Sister-in-Law, and . . . Loung?" Chou hugs the box as if it is her family in the flesh.

As Khouy stubs out his cigarette, Kim reads the letter to himself with Chou peering over his shoulder.

"Read it out loud, read it out loud," Chou urges, grabbing his arm to lower the letter so she can see. Around them, other family members gather to hear the news from America.

"Here in America," Kim starts, his voice steady and smooth, "Eang and I have found good jobs working in a factory not far from home. From Monday to Friday we work, and on the weekend we spend our time vis-

iting with friends. Loung is a good student at school. Every day she studies and makes no trouble for the family. We now have a daughter we named Geak Sok." Kim stops and clears his throat at Geak's name. "Geak Sok is three years old and growing very fast."

As Kim's words flood her mind, Chou envisions Essex Junction to be a prosperous town with lots of paved roads, big houses, and large farms that house hundreds of cows, pigs, and chickens. Try as she might, Chou cannot imagine being so rich that she could own hundreds of animals. Here in the village, a family is doing well if they have a pair of cows, or a few pigs and chickens. Chou is shocked when Eldest Brother writes that these American cows are often twice the size of a Cambodian cow and that they don't do anything but make milk! It sounds very lazy to Chou; her cows work as hard as the family. They help carry water, plow rice, and pull the family's wagon. But then Chou thinks, if Cambodia had paved roads that could fit four or five cars, their cows wouldn't have to do much either!

Kim stops and takes the pictures out of the envelope. The sounds of sniffing and nose-blowing echo through the hut as Kim stares at the pictures in his hand. As his eyes widen and blink rapidly, Chou can wait no longer and grabs them out of his hand. One by one, Chou brings the photos close to her eyes and stares at the faces. As she gazes at the images, her throat begins to ache and soon tears slide down her cheeks and drip off her chin and onto her lap.

In the first picture, the sky is blue and the trees are full and green. The family stands on the grass in front of a clean, white building. There are no signs of dust, dirt, or grime. Standing straight, Eldest Brother is wearing a pressed blue cotton button-down shirt and brown khaki pants. Chou brings her nose closer to the print; as she stares at his face she sees that in spite of his cleanliness and smile, Eldest Brother's eyes are sad and somber. Next to Eldest Brother, in her pink, soft sweater and calf-length black skirt, Loung smiles widely.

"Loung looks like Keav!" Chou exclaims, laughing. "But look at her hair. It's so big and frizzy!" Next to her, Cousin Hong grips Chou's hand and they stare at the picture giggling.

"But it's pretty on her," Aunt Keang chimes in. Chou smiles; even if Aunt Keang thinks Loung's hair is ugly, she would never say it.

"Loung is beautiful," Chou says like a proud sister. "She has a lot of good flesh and skin on her, too. She looks very much like Keav but with more flesh." Chou looks at her own dark brown skin, colored from spending so much time working in the hot sun. Without thinking, Chou's fingers begin to scratch at her dry skin.

"This must be Geak Sok." Hong leans into Chou and points at the toddler. "She's beautiful." Standing beside Loung, dressed in a blue sweaterset and black pants, Eldest Sister-in-Law holds Geak Sok in her arms.

"Geak Sok is beautiful," Chou whispers softly. The family nods and comments on her round eyes, full lips, and little nose. Still staring at the picture of Loung, Chou tries to find the sister she held during the Khmer Rouge, the one who was fearless, who always wore a scowl, who was a dirty fighter. But the sister staring back at her looks so clean and unscarred. Chou tries again to spot the Loung she played with in Phnom Penh before the war, the clever girl who got in and out of trouble all the time. This time there is a flicker of recognition. For a moment, Chou's breath catches at the thought that she might never see Loung again. Quickly, she shakes off the feeling.

"Chou, pass the pictures," Aunt Keang urges. Reluctantly, Chou hands them the family portrait and slowly flips through the others—family poses in the different rooms of their home.

"Their home is so big!" Chou's voice breaks the silence. "Look at how long and big that chair is. It's as big as a bed!" The cousins chatter in their awe. When Chou is done looking at all the pictures, she waits for the images to make the rounds before taking them back so that she can stare once more at the faces of Loung and Eldest Brother. Before long, Khouy stretches his legs and announces that he has to return to Bat Deng.

"Second Brother, can I keep some of these pictures?" Chou clutches the photos to her chest.

"Take a few for yourself; the rest is to be shared among the family," he tells her.

Chou flips through the pile of pictures and greedily pulls out the ones showing all the family together and hands the rest back to him. After he leaves, the family returns to their work in the fields. Alone in the hut, Chou reaches under the plank for her personal wooden crate. Gently, she

pulls out a bundle and unfolds the cloth to reveal Ma's face in black and white. Under Ma's photo are her other treasures: pictures of Pa, Geak, and Keav. They are the only pictures that survived, and that they survived at all is a miracle. Chou remembers when Kim came home excitedly with them two years ago. He'd been to Phnom Penh and told her how he had come to possess them.

Though Chou has yet to return to Phnom Pehn since their forced evacuation in 1975, Kim and Khouy have made many trips there in search of surviving families and jobs. On Khouy's old rusted bicycle, that first trek into the city was over a half day long, bumpy, and painful.

When he first entered the city, Kim told Chou, he was shocked by the destruction of the many beautiful houses that were abandoned to the monsoon rains when their owners left in haste during the Khmer Rouge takeover. The buildings were blackened with mold, the walls damp, and the foundations crumbling apart. The once-wide, beautiful shaded boulevards were lined with tree stumps. Slowly, they rode along Charles de Gaulle Street on Khouy's bike, quiet and lost in their own thoughts.

As they weaved around potholes, Kim noticed that though the streets were noisy and overflooded with refugees and displaced people, there were no cars, no motorcycles or any other vehicles on the road. As they got closer to their old apartment, Kim focused more and more on the rolling of the bicycle wheels propelling them forward; when he looked up, everywhere he saw the child he'd been, running after food vendors, laughing with his friends, scaring his sisters, and walking to noodle shops with Pa and Ma. Holding tight to the seat of the bicycle, Kim made his body rigid and ground his teeth together. When they arrived at the movie theater, Khouy stopped the bike and Kim jumped off.

"It's not our house anymore," Kim remembers thinking as he looked up at it.

After the Khmer Rouge abandoned Phnom Penh, there were no laws regarding ownership of properties or land. At that time, whoever arrived and settled into a house first got to claim ownership. Silently, Khouy pushed his bike onto the cracked pavement, his feet shuffling heavily to their old door.

"Who is it?" A man's voice answered Khouy's knock.

"Hello, my name is Khouy. My family and I used to live here." The

man who cracked open the door looked to be about forty, although already his face was deeply lined and covered with brown aging spots. "My brother Kim and I would just like to see the house." An awkward silence fell between them as the man kept his hand on the door.

"Come in, come in," the man said kindly and stepped aside. Khouy and Kim quickly crossed the threshold and went inside. Accompanied by the new owner, Khouy and Kim briskly walked through the apartment, each traveling backward in their own memories. Kim stopped in the kitchen and noticed that the table, teak chair, all of their old furniture was missing. Khouy stood still for a moment in the family room. Both ended their tour on the balcony, staring out at the world from Pa's favorite spot. Another lifetime ago, Kim used to sit up here with Pa and gaze at the world below. Then, the city had pulsed with life beckoning the imagination of a ten-year-old boy. Now, across the street, black mildew covered the old movie theater. Once Kim used to look out at the world and dreamed of going to France to study, or of becoming a kung fu expert and starring in martial arts movies. Never did he dream of becoming a village peasant.

"Let's go," Khouy finally said. Kim did not want Khouy to see his red eyes and dared not look at him as he followed him back out.

As they were about to leave, the man stopped Khouy and handed him a few old papers. Kim's eyes widened with gratefulness when he saw that the papers contained pictures of Ma, Pa, Keav, Geak, and all of them when they were young.

"Thank you," Khouy replied, holding on to the pictures with both hands.

"We knew that sooner or later someone would come looking for them," the man shared. "When the roads are safe enough, we will return to our home and hope we'll find the same thing."

Khouy thanked the man again and left. Behind him, Kim glanced back at their home one last time and then followed Khouy with his eyes still stinging.

When Kim gave the pictures to Chou, her hands shook at the recovery of such treasures. Even though Khouy kept many of the pictures at his home for safe keeping, he left a few with Chou.

In the hut, Chou stares at her treasure. Not wanting to dirty the

photo, she traces the outlines of Ma's delicate face with her eyes. Ma returns Chou's love, her smile never dimming. With this picture, Chou knows that she never has to worry about forgetting Ma's Phnom Penh face as a beautiful woman with full lips and shiny black hair. She tries hard to erase the image of that other Ma, that sad, bruised old woman who was beaten for trying to find food for her starving child.

Chou rubs her fingers on her sarong many times before lifting Ma's photo to see Pa's handsome young face leaping out of the paper to greet her. Young and happy, Pa's almond eyes and big lips smile widely at Chou. Whereas Ma has lovely, wavy hair, Pa's thick black hair is short and curly. From inside her crate, Pa's round face fills Chou's mind with his wondrous stories. She remembers the story of their love, and how when Ma's parents refused to allow them to marry, Ma ran away and eloped with Pa. Wiping her hands on her sarong, Chou touches Pa's smile and asks him to look after the family.

Next Chou moves to her last picture. In it, Keav is a pretty ten-year-old who towers over her younger sisters. Chou stares at her five-year-old self all dressed up in white, standing next to three-year-old Loung, who wears only a long-sleeved shirt and her underwear. In her flowered-print outfit, Keav stands tall and proper next to them. And like a big sister, Keav has her hand on Chou's arm. Carefully, Chou puts her new pictures on top of the pile and refolds the cloth around it.

As she pushes her crate back under the bed, Chou hears Kim enter the hut.

"What are you still doing inside?"

"I was looking at the pictures of Ma and Pa," Chou answers softly. A short silence falls. "Kim, when are you going to Phnom Penh with Second Brother again?"

"I don't know. Second Brother is very busy right now," Kim tells her.

"I would love to go with you when you two go."

Kim tells Chou that it's not safe for the family to go too often to the city because the Vietnamese run it and they don't like the Chinese. After all, the Chinese gave money and guns to the Khmer Rouge and supported the regime's fight against the Vietnamese. And when the Vietnamese invaded Cambodia, the Chinese sent its large army across the northernmost border to help the Khmer Rouge fight. Chou starts to tune out as

Kim lectures about how for seventeen days, the Chinese fought the Viet-
namese troops in a battle that left many dead on both sides before the Chi-
nese finally withdrew. Now the Vietnamese ruling the Cambodian
government often target the Khmer-Chinese living in the city for the
smallest infraction of the law, and there have even been rumors that the
Khmer-Chinese will be deported back to China.

At this, Chou starts paying close attention to Kim. Nobody in the vil-
lage knows how true this rumor is but still, the Chinese Cambodians live
in fear. For Chou, the possibility of being forced to go to China leaves her
shaking. She has never been to China, but sees herself as both a Cambo-
dian and a Chinese. She speaks both Khmer and Chinese but is more flu-
ent in Khmer. When she eats her meals, Chou uses a spoon and plate like
a Cambodian, not chopsticks and bowls like the Chinese. When January
or February comes around, she celebrates the Chinese lunar New Year,
and also the Cambodian New Year in April. During the harvest seasons,
she prays to all Buddhist gods and goddesses in both languages. Chou loves
both cultures but wants to stay in Cambodia.

Even with all the rumors about the Vietnamese and the Chinese,
Chou knows that one day soon she will go back to Phnom Penh with her
brothers. Her stomach churns knowing that Pa, Ma, Keav, and Geak will
not be in their old house to greet her. When Chou thinks about them, her
body becomes weak with sadness and pain. Sometimes she misses them so
much, the tears flood the passages in her nose and face. The next day, she
wakes up with swollen eyes and a stuffed-up nose and for the rest of the
day feels slow and lethargic. Chou doesn't talk about missing Ma and Pa
with Kim much, because she can see the pain in his dark eyes and long face
when he watches Uncle Leang and Aunt Keang with their children.
When this happens, she pulls out her crate of pictures and together they
gaze at Ma, Pa, and their family together.

14 *the killing fields* in my living room

It's been two weeks since school let out. For me this means two weeks of having my days free to play kickball with Li and her nephews in her backyard, visit Beth to eat her Mom's delicious cookies, practice my wheelies on my new twelve-speed bike Meng bought me last month, and ride it to the pool to go swimming when the weather is hot. And today is such a hot day! In the blue sky the sun's bright rays reflect off the water and shoot into my eyes, temporarily making the world go dark. When the glare is out of my eyes, I see that the pool is filled with kids kicking loudly and splashing water at each other.

"Come on, Loung!" Li calls me, her head bobbing above the water. "You can do it!"

I'm standing in line, waiting my turn to make my first dive ever off the board! My hands shiver with nerves as the sun warms my skin, burning off water droplets on my exposed arms and legs. In the pool, Li and her nephews wait to see me walk the plank. My eyes follow a ten-year-old kid in front of me as he climbs the ladder. His father stands beside him, a big hand spread on the boy's back like a safety net. As the boy walks to the edge of the plank, his father yells out instructions and encouragement. The boy presses his lips together in concentration and leaps off the plank to cheers and applause.

When it is my turn, I rush up the steps and run to the end of the plank.

Then I wait. No voices call out instructions as I watch the father pull his son out of the water. Together they walk away, their arms around each other in a congratulatory embrace. I stand silently on the plank five feet above the shimmering blue water. Raising one arm above my head, I jump in, landing squarely on my stomach. The water slaps my body in painful admonition and pushes chlorine into my mouth and nose. I kick myself out of the water, gasping for air as I reach the surface. Embarrassed, I ignore Li calling my name and instead hurriedly climb the steps out of the pool.

Suddenly, over in the shallow end of the pool, a woman screams. The lifeguard blows his whistle and leaps off his chair, a father stops his conversation with his friends, and all three jump into the water. Together they run in the knee-deep water, their legs and arms slashing through the currents like hard, robotic limbs. When they get to the little boy who's excited them so much, three pairs of hands pull him up. The boy looks confused and starts to sputter words only a mother can understand. The mother cries and hugs him to her chest. The father rests his hand on her shoulder and assures her the boy is all right. Next to them, the lifeguard says that the boy was under water for only a few seconds. Safe in his mother's arms, the boy repeats that he's okay. The mother's friends console her with understanding words and commend her quick actions and vigilant eyes. They tell her she's a great mother.

A few feet away, I watch the mother's shoulders heave up and down, her arms clutching her child even tighter. I stare at all of them, and out of nowhere my anger rises like a hurricane, the wind picking up my breath, pricking my skin, and spinning me around in a chaotic whirl. From some sad deep place in my mind, I scream at the top of my lungs.

The boy was in the water for seconds. There was no real pain or danger. Yet you all reached out to him. I was drowning for years and where were you?!! Don't you all get it? Don't you know what real suffering is?!! My rant is growing faster now but no one can hear. If they looked at me they'd see that I am frozen with my fists clenched. But no one looks my way.

You all think your show of love and support here means something, but it means nothing. It means nothing until you have to watch the boy die. I've watched my mother die in my mind and I've followed my father into his mass grave hundreds of times and now I'm stuck there. I've died with my sisters, and yet have to live to miss my parents!

Exhausted, I quickly jump into the pool and submerge myself in the water. In the pool, my hair fans out to form sea snakes around my head, and the water cools my skin and forgives my hate.

Don't you see? I want someone's hands to reach out to me too, I plead and close my eyes.

"Wheee!" My legs push the roller skates faster and faster in the empty parking lot outside our apartment.

As I twirl, the leaves rustle in the trees as if they're applauding my performance. I look up at the bright sky and am reminded of the many reasons why I love summer in Vermont. I stop and stretch my arms tall, pretending to reach the wispy clouds floating above. I imagine holding on and having the clouds carry me all over the state before dropping me back to earth. The summer rays seep into my body, growing my hair thick and wavy, my skin soft and tan. From June to August, the birds sing sweetly in the full green trees; the mountain winds blow gently all over the state. In the fields next to our house, the bubbling brook invites me to explore its nooks and crevices.

"Whee!" I yell again, and spin on my skates. On the gravel lot, my shadow is long and lean. I pump my legs harder, steady my arms, and squat down on the ground, continuing to roll until the wheels come to a halt.

"Go, Kgo!" Maria calls me Auntie in Chinese and cheers me on from the sidelines. I stand up and push myself forward again before abruptly turning around to skate backward. Looking over my shoulder, I skate faster as the wind blows my hair in my face. Faster and faster I go; strands of hair fly into my open mouth, forcing me to spit them out in an unladylike manner.

"Yay! Kgo!" Maria claps her hands and reaches her arms to me, her little fingers wriggling as if to pull me in with her energy. "Pick me up, pick me up!" At four, Maria possesses a face like a fresh ripe apple and a smile like a split moon. I zoom over, grab hold of her arms, and spin her around in a circle.

"Faster, faster!" Maria calls out to me, spitting her laughter into the air, her small feet whirling in midair. But the world is becoming unfocused, and my feet are weak and unbalanced, so I put her down.

"I'm tired, sweetie."

"One more time! Please," Maria pleads.

"Sweetie, if you go pick the dandelions for a while I'll spin you again later, okay?" I rasp to her.

"Okay, Kgo!" And off she goes, bouncing and skipping away with joy. Watching her go, my eyes darken with envy. Her delicate little body dances with the freedom of a child who has never starved or been hurt. Sensing my stare, Maria turns and smiles. Something inside me snaps and I can hardly breathe for the rage.

I close my eyes and think about one of my favorite, calming places, the crab apple tree near the stream by our house. Often, when I've had a particularly bad day at school, I lean back against this special tree and lift my chin to the warmth of the sun. I imagine that the tree is a mythical creature, a comforting old soul with green moss for hair and branches that sway like arms. Closing my eyes, I sit quietly and imagine that her rustling leaves are whispering words of wisdom I cannot understand. When the breeze bends her branch fingers to caress my head, the touch reminds me of Pa.

"Oh, Pa," I whisper to him, still standing in my roller skates with my eyes closed, "where are you?" I try to remember the last time Pa visited me in a dream. I have been in America for four years and he hasn't followed me. I lay my hand on my head, and for a moment I feel Pa's touch. When I open my eyes, Maria is back, sitting on my stomach and pulling at my arms.

"Kgo, Kgo! Come look at this red bug!" she yells, and runs away. Slowly I go after her, my skates stomping heavily on the ground, and by the time I reach Maria, the world is no longer so dark and angry.

"Loung! Maria! *Nham-bay-e!*" "Eat rice," Eang calls out of the window in Khmer. In Khmer, there are no separate words for separate mealtimes. All you need to do is to add the word *morning, day,* or *evening* next to the word *eat,* and you have breakfast, lunch, and dinner. But all Eang needs to yell is "*Nham-bay-e*" and we come running.

"Wash your hands first," Eang tells us as Maria and I head into the bathroom. When we return, our meal of stir-fried chicken with ginger and turnips boiled in pork broth is already on the table.

"The movie *The Killing Fields* is still playing at all the movie theaters,"

Meng comments between slurps of soup. "The theaters are now advertising that all Khmer people can go see the film for free!" Meng laughs.

"Why see it? It's a movie about life under the Khmer Rouge. We lived it." Eang's face frowns as her words rush out. "I wouldn't pay to see it. I wouldn't see it if they paid me."

"I wouldn't see it either, no way, no how," I pipe in, hoping our unanimous agreement on this will put an end to the conversation because it's making the chicken in my mouth taste rancid.

"Well, we can go see *Ghostbusters* instead," Meng says, and smiles. Because Eang doesn't like to waste money on English-speaking movies she can't understand, Meng and I often go together.

I love going to the movies because it reminds me of Pa. One of my fondest memories of Cambodia was of sitting on Pa's lap in the dark theater. I would squirm and move around, one hand holding my soybean drink and the other a bag of fried crickets. The crickets were crunchier than popcorn and didn't get stuck in your teeth. When I didn't want to hold my own food anymore, I would tap Pa's hands and, without saying a word, his palms would turn upward and I would put my food and drink in them. Back then we didn't have cup holders in Cambodia. Pa's lap was my chair, his arms my armrest, his palms my cup holders. Pa was everything to me.

In Vermont, going to the movies with Meng was fun when I was younger, and I would still get scared by movies like *Clash of the Titans* and *The Beast Master.* Back then I didn't care that Meng stubbornly refused to speak to me in English in public, even when we saw people I knew. Now, I care. It's bad enough that *I* know I'm different. I can't do much about my skin color and the fact I wasn't born in America, but at least I can try to pass with new clothes, fluent English, and the latest hairstyle. But Meng doesn't seem to care that he isn't like everyone else, and he proudly announces his foreignness everywhere he goes. At fourteen, I've decided that I don't want to be seen with my embarrassing brother in public anymore. But I don't know how to tell him that, so I pretend to always have too much homework to leave the house.

After dinner, we all move to the living room. Meng and Eang sit on the couch while Maria plays with a doll between them. I'm lying on my

side on the floor, when the trailer for *The Killing Fields* splashes across our TV screen. The commercial begins with a group of helicopters flying into view like a swarm of dragonflies, then cuts to scenes of bombs dropping onto Cambodia, and the Khmer Rouge soldiers storming into Phnom Penh. On the screen, as the soldiers raise their guns and fists to the sky in victory, Haing Ngor, the actor playing Dith Pran, stands alone in a flooded rice field. Dressed in a wet black tattered shirt and pants that cling to his thin frame, his face contorts as he realizes he has stepped into one of Cambodia's many mass graves. As the camera pulls away, we see skulls, bones, and black shredded clothing floating in the murky, brown water.

From somewhere inside my brain, the smell of putrid flesh leaps off the television and fills my nostril. I blink but the smell remains and attacks my eyes, making them water. My scalp starts to sweat, while my heart squeezes into a tight fist. Lightly, I scratch my feet and crack my toes to distract myself from the smell.

"Americans will never know what it was truly like," I think.

They won't remember the smell, the sound, or the heat. For two hours, they'll sit in the dark and watch but they'll never know what it was like to be there for three years, eight months, and twenty-one days. What it was like thinking everyday that I was going to die and not knowing if the war would ever end. When the credits roll after two hours, the lights will come back on, and they'll leave the war. But I can't. Behind me, Eang and Meng sit still, each lost in thought. I shift my eyes to the corner of the living room without moving my head. I don't want Meng and Eang to see how upset I am and worry that I still feel and remember. I have to be strong because if I let myself cry, I'm afraid I'll never stop. So I force my body to be still while the actors dressed in black cry and scream. I tell myself that the actors are too fat to play starving Cambodians. Together, we wait silently for the movie trailer to end so that we can return to our show.

Before *The A-Team* comes on, Mr. and Mrs. Lee are on-screen to sell us something called Calgon. Though we've seen this commercial many times, Meng and Eang always watch it because the actors are Chinese. And they're *really* Chinese, not some white people with their eyes taped and bad accents playing Chinese people, like in the old black-and-white movies.

In the commercial, when Mr. Lee tells a customer his laundry is so

clean because of an "ancient Chinese secret," Eang and Meng laugh out loud. Then Mrs. Lee puts Mr. Lee down by calling him a big shot and confesses that his secret is Calgon.

"Calgon's two water softeners soften water so detergents clean better. In the hardest water, Calgon helps detergents get laundry up to thirty percent cleaner," she pitches perkily.

"Ancient Chinese secret! That's funny!" I slap my knees a little too eagerly.

The *Killing Fields* moment has passed.

When *The A-Team* finally comes back to rescue our night, our moods have already been lifted by Calgon.

"Show's over. Time to sleep." Meng yawns and stretches his arms. Eang picks up Maria and carries her into the bedroom, with Meng following behind.

I take their place on the couch and sit alone to watch the news. I sink deeper into the cushions when a reporter shows footage of starving Ethiopian children. The long drought in Ethiopia is destroying the crops and forcing many families to go hungry. The camera then zeroes in on a skeletal woman with big, liquid eyes. A brown cloth covers her head and drapes past her shoulders to protect her from the scorching sun. Peeking out of her sleeves, her skin hangs like wrinkled, black, unpolished leather on her thin arms. The camera slowly pulls away from her unflinching stare to reveal a small starving child gasping against her chest. As the child lies in between this world and the next, the woman fans her hand in front of the child's face to chase away the flies already feasting on her flesh.

I cannot watch anymore and turn off the TV. After I change into my sleep clothes, I crawl into my bed, lie on my chest, and half bury my face in my arms. Pushing against the mattress, my stomach is a hard ball and aches from too much food. When I close my eyes, I see the child from the news and watch as her skin turns pale, her black hair straightens, and her face turns Asian. Instantly, the mother also disappears and in her place, Ma now holds Geak. Ma gazes at Geak; her hand smooths her hair and caresses her face, but Geak's body is limp and shows no signs of life.

"I'm going crazy," I whisper and pull the covers over my head. Under the blankets, my breathing rings loudly in the confined space. I think I hear the Ethiopian child struggling to take in a lungful of air, a sound not

even picked up by the reporter's microphone. I picture her fighting and fighting to get enough oxygen into her body, her dry mouth opening and closing, her chest heaving painfully.

I toss and turn, but my thoughts float to Keav and her last moments of life. And though I wasn't physically there with her, my mind makes up images that my eyes did not see. Ma's voice weeps as she tells us about her visit with a sick Keav. "Her last wish is to see her family and be near us even after she's gone. She knows she will die but she will wait for Pa. . . . She will wait for him to bring her home." But Pa didn't get to bring her home and Keav died alone, scared and away from us all. On that day, Pa and the rest of us also died with her.

"Get out of my head!" I plead, but the ghosts, the killing fields, and the Ethiopian girl do not leave me. My lids twitch and flutter from too many images, and I know sleep will not come easily tonight. I give up and get out of bed. I walk into my closet and force myself to think about something else. My fingers run through my rack of old clothes from the Salvation Army. I fantasize of someday walking into a big expensive department store like JCPenney and buying clothes that don't have armpit stains on them.

"Armpit stains," I say in disgust, fingering the tassels on the red-and-white checkered cowgirl shirt hanging on the rack. I put a cowboy hat on my head and turn to the mirror. The girl looking back at me has long black wavy hair that hangs past her shoulders. As I lean closer into the mirror, she stares back at me with her almond-shaped eyes and a face so round that she looks fat. When I stand sideways, the girl looks skinny all over except for her big, protruding stomach. I spread my palms over my taut belly ball and frown at the mirror. Eang says it's still bloated from years of malnutrition. Meng tells me not to worry and to think of it as my Buddha belly. Finally the darkness lifts and I crawl back into bed praying that the Lord Buddha will keep the war away and out of my head.

15 living their last wind

April is the hottest month of the year, with temperatures that often climb above one hundred degrees. Today, the sun god shows no signs of mercy as it turns the ground below Chou's feet into hard, dry clay and the once green fields into brown dead land. On her way to the village market, Chou adjusts the krama on her head and wipes her dripping forehead with her sleeves. When she arrives, she scans the area to see only a dozen or so vendors selling their goods in the open field.

Chou has come to buy palm fruits and baby crabs seasoned with spices and deep fried to a crimson red. The few dozens vendors call out to Chou and the handful of other early buyers.

"Buy from me, sister," a boy calls, bringing over his basket of slippery black eels.

"You bought from him last week." A small girl shows Chou her bucket of live fish, splashing in an inch of water. "Buy from me this week, sister."

Chou is staring at the girl's fish when, suddenly, the earth shakes with a loud explosion that chases the birds into the sky. Instantly Chou's feet burn and her toes sting as if they've been pierced by dry, splintered wood. Next to her, the girl ducks, hugging her bucket to her chest. Around Chou, many villagers scream and run into their homes. For a moment, Chou closes her eyes tightly and crouches low to the ground. When she

opens them, she is crawling on her knees toward a nearby tree, hoping to find shelter.

"Another mine exploded!" a villager shouts.

"The man on the trail! He's hurt!" a woman yells as she runs back to the market.

From her tree, Chou sees the man lying on the ground in a storm of red dust. With a dazed look, he props himself on his knees, tentatively stands on one leg, and lifts up his bike. Slowly, he pushes his bicycle forward and hops the rest of the way into the village market. A chill runs down Chou's spine when the man passes, his face smeared with blood, his eyes big like crabs, and his dark shirt wet with brushes and twigs stuck all over it. As he passes Chou, his left leg pushes him on while his right leg drags in the dirt, dripping thick streams of blood as it goes. Chou suppresses a scream when she sees that his right leg is shredded and hanging by the skin to its stump, his foot only bits of charred skin and melting flesh. When he passes the crowd, his face is ashen but calm. Then abruptly, he falls to the ground; his body convulses for a few minutes and then is still.

"Does anyone know his family?" a man shouts, approaching.

"He's from another village!" another person yells.

"Someone has to tell his family he's dead," the first man says quietly.

"He looks as if he didn't know what had happened," a girl whispers sympathetically.

"He was living his last wind," an old woman tells her, referring to the moment when his life flashed before his eyes.

When blood returns to warm her face, Chou walks away from the crowd. In a daze, she continues her shopping for the family's eggs, chicken, and potatoes with her eyes opened wide.

The hot season comes to a close as April reaches its end. The humidity rises, the fine dust in the road settles, and soon the rain will come to drench the red land and make everything green once again. But that time is still a few weeks away. It is early morning and Chou is again on her way to the village market. Chou raises her hands to the sky to air the wetness in her armpits. By the time she lowers her arms a few paces later, tiny droplets of sweat have already collected above her lips.

When Chou enters the market, a village girl sitting on a low stool in

the hot sun greets her. Chou stops to look at the eggs she is selling and by chance glances up to see a friend's husband approaching the village on a trail Chou has traveled on many times. From a short distance away, Chou sees him pick up what looks to be a round green disk the size of a small cup. In the instant it takes for Chou to blink, the mine explodes and knocks the man to the ground. As if in slow motion, Chou feels the blast reverberate in her ribs and weaken her knees. Throughout the market, villagers gasp and stop in terror. In the distant fields, a cow moos and dogs bark in protest.

In the rising dust cloud, the man holds his bloodied hands in front of him and pushes himself off the ground with his elbows. He manages to get on his feet and run toward the village. As he nears, Chou sees that his face is dripping blood and is all scratched up as if he's just lost a fierce cockfight. On his jet black hair are bits of twigs, grass, flesh, and skin that shake loose as he staggers forward. In front of his chest, where his hands once were, are two shredded stumps that look as if they've been in a grinder, skin flailing, nails pulled off, knuckles and bones crushed, sticking out for all to see. As the man runs into the market, Chou sees only the whites of his eyes and then he begins to lick, bite, and gnaw at his bones as the blood spurts out, soaking his shirt and pants. The villagers move out of his way, covering their mouths, many gagging and dry-heaving in response to the spectacle.

Chou watches wide-eyed but feels herself close to fainting. In the middle of the crowd, the man stops. His face is eerily calm as he raises his mutilated hands to his eyes with a look of detached recognition. While his body staggers and sways like a drunk, his pupils roll back. The villagers watch in silence, as if paying respect while the man goes through his last wind of life.

When his wife finally arrives, the man is lying on the ground. Staring into his eyes, she kneels down, her pants soaking up the blood around him. She wipes the blood off his face. A loud wail ruptures out of her small frame with such agony that it breaks through the stone faces of the surrounding crowd. When the man goes into shock, his skin turns pale and cold. His lids slowly flutter and he stares at his wife. With her face inches from his, Chou's friend tells her husband she loves him; then he is gone. His wife screams and howls sounds of sadness, pain, and anger while her hands smooth down his shirt and pants. But there is nothing anyone can do for he

is a ghost now. All around him, the crowd slowly moves away to allow the widow's family room to console her. Chou leaves her friend and returns to the hut. Her body is drenched in sweat but her hands and feet are cold.

Before the rain comes, the water is at its brownest and murkiest. It is now May and still the rain gods have not turned the white clouds into black thunderstorms. Above Chou, the sun continues to burn and dry up the small water holes. Chou now has to travel an hour out of the village to a deep pond to gather the family's water. When she arrives, she climbs out of the cart, unties the cows, and leads them to the muddy water. When the cows have their fill, Chou ties the wagon yokes back around their sturdy necks. Chou takes her pail and walks over to the grassy bank of the pond where the water is clear and her movements will not dirty it. Even on the short walk from the road to the pond, Chou is careful to step only on well-used paths and avoids crossing over thick shrubs and rice paddies. For as beautiful as the countryside is, Chou knows that beneath the wildflowers, green grass, red dirt, and the wetlands are land mines, grenades, bombs, and other tangible remnants of war awaiting her every step.

Everywhere she looks, Chou sees ghosts roaming around the villages—so many ghosts, in fact, that she has lost count. Sometimes at night, she thinks she can still hear them weeping in the forest, calling out to the villagers for help. When the moans grow too strong, Chou closes her eyes and shuts them out of her mind. She knows she cannot allow herself to think too much about death; such a path will lead her to wonder about how Pa, Ma, and Geak died. Chou knows only that the soldiers came and took them away. When she is consumed too deeply by thoughts of their deaths, she becomes like all the other ghosts who wander the world not knowing if they are dead or alive. She remembers stories Khouy tells of The Lon Nol soldiers decapitating the Viet Cong and Khmer Rouge soldiers so they will not be reborn to invade Cambodia in their next lives. The Lon Nol soldiers said the Viet Cong and KR soldiers believe that if the head is not buried with the body, the soul is doomed to wander the earth forever.

But today she is too busy for the ghosts to haunt her. Quickly, she scoops up pails of water and pours them into the big round containers on her wagon. With each pail, her arms grow more tired and her back stiffens.

In the warm water, the grass scrapes her feet clean, leaving her skin soft and smooth but vulnerable to the cuts and nicks of the sharp small stones and pebbles in the road. Still, she works without stopping to rest. When the two containers are filled, Chou breaks off a handful of green, leafy lotus leaves from the edge of the pond. She rinses them of dirt and debris and covers the surface of the water in the container with the leaves. The leaves will prevent the water from splashing and spilling too much on the bumpy ride home. Satisfied with her work, Chou walks around in the water and quickly immerses her body and head, washes her krama, climbs in the wagon, and leads the cows toward home.

Shortly after she arrives at the hut, Khouy rides his motorcycle up to their door, the wheels tearing up the grass and kicking up dirt.

"Chou! Second Uncle!" Khouy calls urgently. The sun is already low in the sky and the mosquitoes are waking in swarms.

"Second Brother, what is the matter?" Chou asks, rushing to meet him, her mind full of fear that something is wrong. Why else would Khouy travel alone to the countryside this late in the day?

In the past year, Chou has seen little of Khouy, but it's been enough for her to know that he has at last settled down with a new wife. Khouy met Morm, a beautiful Cambodian, at the policemen's headquarters where she was working as an administrator. Morm comes from a small farming family in a nearby village and Khouy was charmed by her immediately. As the days turned into weeks and then months, Khouy pursued Morm with his sweet talk, small gifts, and funny stories. Eventually, Morm returned his feelings and Khouy rushed home to ask Uncle Leang and Aunt Keang to approach her parents for Morm's hand in marriage.

Chou and Kim were ecstatic for Khouy, as they'd both had to watch his distress when he was forced to marry his first wife, Laine. He did not love her, but married her in order to escape conscription in the Khmer Rouge army and also from being sent to work in the front lines, far away from the family. After the war, he and Laine went their separate ways; because they had no children together, they left each other's lives completely. Now twenty-three years old, Khouy has found love with Morm, and Chou hasn't seen him so happy in a very long time.

"Second Uncle," Khouy says, running up to Uncle Leang. "I need Chou to come help Morm."

"Khouy, how is the baby?" Aunt Keang asks, and presses her hands together as if ready to pray.

"She was born yesterday and she is fine and healthy." For a moment, Khouy breaks into a broad smile, but then worries return and pull his face down. "But Morm, she's burned badly."

Khouy tells them about Morm's difficult labor. While Khouy had waited outside the hut, the inexperienced midwife built a fire under their wooden plank bed to keep Morm warm and to loosen her back muscles. As the labor dragged into the night, the fire grew hotter and hotter, charring the wood beneath Morm's body. But it was Morm's first birth, so her whole body was in pain. She did not realize how badly she was burned until later, when her burns started to blister and boil. Chou and the rest of the girls in the family gasp as Khouy talks. When he finishes, Chou glances at their big cooking pot and remembers Kung's pain with her burns.

"Chou, I need you to come live at my house and help care for your niece," Khouy tells her. Chou nods quickly and, with Uncle Leang's permission, she hastily packs her clothes and leaves with Khouy.

When Chou arrives at Khouy's one-room wooden home, the sky is already dark. Inside, the house still smells of smoke and strong rubbing alcohol and body odor. While Chou goes to pick up the crying baby lying next to its mother, Khouy leaves the house to buy rice soup for his wife. Chou rocks the baby back and forth but the newborn continues to wail until Chou sticks a finger into her mouth. On the bed, Morm lies on her stomach, facedown in her pillow. She breathes deeply, as if asleep. For a moment, Chou is terrified that Morm has died while Khouy was gone. But then Morm stirs and opens her eyes, just as Khouy returns.

"Morm, I've brought Chou to help," Khouy tells her, and bends down to look at her face. Even in the soft dusk light, Chou can see Morm is pale. Her lips are cracked and perspiration glistens on her skin.

"Thank you for coming, Chou," she whispers. "I need to feed the baby. Please come help me." As Khouy moves out of the way, Chou turns Morm on her side. Then she puts the baby next to Morm's breast. She sits with them as mother and baby bond.

"Second Sister-in-Law, have you any medicine for the burns?"

"The midwife applied a burn salve before you came," Morm whispers. "It will have to be reapplied in the morning."

When night comes, Khouy sleeps in a hammock while Chou lies next to his wife and newborn baby. All night, Morm can only turn her head from side to side and moan until Chou wakes her to nurse. While Chou sits with them, Mom and baby soon fall asleep. By the time the sun peeks in again, all three adults are bleary-eyed and exhausted. Only the baby is well rested. Before Morm fully wakes, Khouy quickly leaves for work.

"Sokounthea, that's a pretty name," Chou coos, giving the baby her finger. The baby gums her finger and continues to wail loudly. "Shhh . . . shh. Let your mom sleep a little longer."

"Kac, kac, kac. Waaaaaaa!" Sokounthea screams.

"You like to cry? I'll call you Kac then."

"Chou, bring the baby to me," Morm calls out.

After Morm's milk puts the baby to sleep, Chou helps her to the bathroom. While Morm washes herself, Chou builds a fire and makes rice porridge for their breakfast. Back in bed, Chou turns Morm over on her stomach to reapply the herbal salve on her burns. As Chou gently lifts off the cloth that covers the layer of ground leaves, Morm clenches her hands into fists and bites down on her teeth. Next Chou peels the sticky, thick salve off Morm's back and bottom to reveal brown, burned skin that looks like melted rubber. Beneath the skin, the pink flesh oozes with wetness and small blisters. Chou grimaces and holds her breath.

"The top skin is drying up," Chou exhales calmly and carefully reapplies the leaves. "And the blisters have burst and are drying as well." Morm is quiet; her toes curl like claws rounding into her feet.

As she works, Chou feels her anger rise.

"But the gods must be looking after you because Kac is beautiful and healthy." Chou peers at Kac sleeping peacefully next to her mother and her lips curl into a sad smile. In the four years of the Khmer Rouge, she cannot remember seeing a child born alive and healthy. Through the hard labor, starvation, disease, execution, and fear, she did not hear of many women carrying a child to full term.

"Thank you, Chou. You are helping so much," Morm whispers and sits up. Chou walks to the kitchen and returns with a bowl of rice soup.

"Second Sister-in-Law, please eat this. You need to keep strong for the baby." Morm takes a few sips and pushes the bowl away. "You must make more effort to eat your porridge. You are too thin," Chou urges her.

"Thank you, Chou. You will be a very good mother someday." Morm manages a small smile and swallows a few more spoonfuls.

"Just rest now and get better." Chou straightens her mat and sheets before helping Morm to lie back down on her stomach. As Morm's breathing slows, Chou gently covers her back with a light blanket and leaves to wash the baby, the dishes, and all the family's clothes and diapers. Then she sits down to grind the herbal leaves to make the cooling salve for burns. As her hands work, Chou warms at Morm's compliment. At sixteen, Chou is pretty, and though she has caught the attention of a few men in the village, she doesn't care for them or their proposals of romance. Still, she dreams of someday having children and a family of her own to love and care for. What she doesn't know is how to factor into this dream the ways she'll be expected to be a wife to her future husband.

16 sex ed

"Five dolla, fa a goood time—five dolla," the boys cry in their fake accent as I make my way to Essex Junction High School. I glare ahead at them, taking in the details of their wispy mustaches and facial hair straining to grow from their red, pimply faces.

"Five dolla, fa a good time?" They laugh like hyenas, their mouths wide and fangs exposed.

"Losers," I curse, and hold my head high.

Since the movie *Platoon* came out, I have been beseeched with requests for "a good time." And though I have no plans—not now or ever—to see these war movies, many stupid boys somehow see me in them. I guess because I'm Asian and speak English badly, I must remind them of the Vietnamese prostitutes in these films. As I walk on, I brace myself for what I know will come next.

"Boom-boom or yum-yum?" the pack calls after me, spits of saliva foaming at the corners of their mouths.

"Losers," I yell at them again, unable to think of anything else to say.

Leaving the boys behind, I imagine I possess supernatural kung fu skills, like the girls in Chinese martial arts movies. In my fantasy, I reach the boys in two great leaps and a bound. Whirling around, I slap all their faces in one motion while their mouths hang open in shock and awe.

Then I twirl into the air and kick them in the gut with a series of quick movements before landing softly, like a cat, on the ground. The boys stagger on their feet like drunken fools, their arms flinging about their sides as they try to balance. From my low position on the ground, I stick one leg out and spin like a helicopter propeller, knocking them off their feet. Standing straight and triumphant, I smile as they each land on the ground, a plume of smoke rising from the impact, their hair flying, small teeth spewing out of their mouths like popcorn, and their faces grimacing and twisting in slow motion.

By the time my movie ends, I'm sitting in my finance class, buoyed by my imagined ass-kicking Supergirl alter ego and ready to show off my intelligence with my oral report. When it's my turn, I march up to the front of the class and write the equation on the board. I then turn to face the class and smile confidently.

At fifteen, I have lived in America for five years and am now a freshman in high school. The green-and-white sneakers and black stirrup pants that marked my days at ADL Intermediate School are behind me and have been replaced by white pumps and a long black fitted skirt. Above the skirt, much of my body is hidden under a bulky electric-blue V-neck sweater that hangs to my thighs. And though I spend time each night choosing what clothes to wear to school the next day, I spend even more time each morning coloring in my eyes and face. I make such an effort because a boy I met in Montreal's Chinese community once told me I was like a rose—all sticks and thorns but with a blooming face. I assumed that, like everyone else, he was making fun of my round cheeks; now I hide them with my long, teased-up hair. On my face, thick black liner makes my eyes appear more open and Western, while purple lipstick gives me the look of an ice-cool person. Even if I have no money to keep up with the latest fashion trends, I am content with being a cheaper version of what's in. Of course, Meng and Eang wouldn't approve of my style and that's why I continue to leave the house in the same boring plain-Jane outfit and change at school.

"My presentation is about CDs," I begin, then wait for the students to quiet down.

"Class, quiet! Settle down!" The teacher gives me his support.

"CDs or certificate of deposits." The students in the front row shift

their weight, making the chairs squeak. I straighten my shoulders and gently shake my head as all my hair moves as one complete unit.

"Now, let's say you have two thousand dollars. Instead of spending it on a car, you can invest that two thousand dollars in a CD and get five percent interest a year. If you keep that money in a CD until you're twenty-six, with compounding interest you'll . . ." The students in the back of the room move around restlessly while those in the middle section stare at me blankly. I try not to pay attention to them and continue to write the equations, interest rates, and percentages on the board to gear up for a big finale.

"So in conclusion, if you have two thousand dollars, instead of blowing it on an old car, with your money gained from your CD's compound interest, in ten years when you want to buy a place to live, you'll have your start-up money to invest in a nice condom somewhere.

"Oops," I gasp, not believing that "condom" just popped out of my mouth. All around the room, students roll their heads back, clutch their stomachs, stomp their feet, and spit out their laughter.

"I mean condo, not condom," I say meekly, but the class is so out of control that the teacher has to tell the students to settle down again.

For a moment, I wish that life could be like in a comic book, where your words are captured in balloons floating over your head. Then at horrifying moments, you could prick the balloons with a needle and watch the words tumble on the floor, falling on top of one another until they're indecipherable. If only life were like that, then I wouldn't have to be known as "condom girl" for the rest of the year. But in real life, I make myself laugh louder than the others and walk back to my chair in the back of the room, my body feeling so much smaller in my big clothes and big hair.

After school, I meet up with Beth at her locker.

"Heard about what happened in class," Beth says sympathetically. News in high school travels fast, especially if it involves humiliation or sex—and my news involves both.

"Ugh," I grunt.

A few lockers away, I see Chris. Even in the ugly fluorescent light, Chris is still the cutest boy in school. He is also the most popular, and towers over the boys hovering around him, hanging on to his every word and action like a pack of monkeys.

"Chris at his locker?" Beth asks when she notices my silence.

"Isn't he gorgeous today?" I whisper to her, happy to change the subject from the condom mishap.

"Yep," Beth agrees. And with that, we are both lost in our separate dreams of being Chris's girl.

I don't know when I started noticing boys in this way. If I ask Beth, she'll say that I've been boy-crazy since sixth grade. But before this year, I only saw boys as a way for me to fit in and possibly even become popular with the other students. It always seemed to me that girls who paraded the halls with their boyfriends all of a sudden became more visible, more important; they even started to look prettier. But something changed this year; now I find that my breath quickens and my heart jumps when I see Chris. But I don't want to like him because I know there's no chance in hell that he'll like me back.

And so I stare at my crush from afar and steal glances at his big hands deftly opening his locker, stuffing his books in his backpack, and shutting the door. Then Chris and his friends leave the school without even a tiny glance in my direction. As he disappears into the crowd down the hall, I can still see him. But while he's always visible to me, I am that black spot that appears in his eyes after someone blinds him with a flash.

Beth and I start for home. The May weather is cool and breezy, but my back is hot and sweaty from the weight of my heavy backpack dragging on my shoulders. One more month, and Beth and I will leave ninth grade behind for the better world of tenth graders.

"Hey, Beth, what's oral sex?" I ask. Beth giggles and turns around to make sure no one is within earshot.

Meng doesn't allow me to date—ever! Or at least until I'm nineteen and not living under his roof. So while many other students my age have kissed and even gone all the way with boys, I have yet to go on a date, hold hands, or kiss a boy. During sex education classes, while the guys snicker and girls giggle, I am fascinated and horrified by the drawings of men's anatomy. Strangely, when I look at the pictures of naked men, my eyes paste a pair of paper cutout shorts in front of their private areas. When the textbook deals with male sexuality, a fear that's hidden somewhere in the slippery ridges of my brain rises to the surface and makes my armpits sweat. So I close the book and instead study from diagrams. I

methodically memorize the medical terms for the parts and organs to pass the tests.

"So, what is it?" I hush my voice and lean closer into Beth.

"Well, it's when a girl . . ." Blessed with a nurse for a mom, Beth chatters on and is able to explain the mechanics of it to me.

"No!" I stop in my tracks and scream, my palms over my mouth. "I thought it was talking dirty!"

"Well, it's a bit more than that."

"No! That's disgusting!" I holler and make gagging sounds.

When I get home, I run up the stairs and quickly drop off my bags. The house is quiet and stale, devoid of life and smell. For a brief moment, I flash to our house in Phnom Penh and the memories of all the brothers and sisters running in and out of the rooms. In a far distant time and land, the whirring fans blow the sweet smells of rice and charred garlic all over the house. Outside on the balcony, Pa and Ma sit and observe the world below them, rejoicing in their lack of privacy as Geak and I climb into their laps, our hands sticky from candies and sweet fruits.

I leap back into my own time and shake off the uselessness of missing my family. The five years Meng said that it would take for us to make a home here and then bring Khouy, Kim, and Chou to live with us have come and gone. There are still no signs that the U.S. government will allow us to reunite. And even with the steady stream of letters we now receive every two or three months from Cambodia, Meng's smiles are beginning to tighten again.

As for me, I have come to accept that I might never see Chou again. I know that somewhere in Cambodia, the remainder of our large family is waiting to join Meng and me in America, but missing them has become too difficult. And so I've begun to think of myself as the only sister, even though I still remember being part of a big family. That life is gone and no matter how I wish it, it will never be so again. This thought makes me feel like the small dead critters I see on the road—crushed, flattened, and alone.

In my closet, I change out of my school clothes and into an old pair of long pants and a T-shirt, and rush out the door. It's three-fifteen P.M. and Eang and Maria will not be back for a few more minutes. Again eight months pregnant, Eang leaves work early to pick up Maria from kinder-

garten and will be home at three-thirty. Outside, I hop on the twelve-speed bike Meng bought me last summer and head for the road. As I pedal, the sun shines in the blue sky and the wind breaks apart the white clouds. Every once in a while I veer off to the side of the road to let the cars zoom by. With the wind in my hair, I leave 48 Main Street, the cemetery, the lonely house, and my warm closet behind. Yet no matter how fast I travel, Cambodia follows and I see Chou calling out to me, with her hand reaching. My hands clamp the handlebars and my legs push the pedals faster, rattling the chains as I try to push away memories of Chou's palm against mine, our fingers entwined, and tears streaming down her face when we were forced to break our bond. "Five years from now we'll see each other," I promised her then.

Every month, Meng continues to send letters and packages to Cambodia and waits for the U.S. government to normalize its relationship with the country of my birth. Until this happens, we will not be allowed to visit. The only other way for us to reunite would be for our Cambodian family to make its way to the refugee camps in Thailand. Then possibly we'd be able to sponsor them over. But that trek to Thailand would take them on a path littered with land mines and through Khmer Rouge–controlled jungles. They'd also risk being shot at by Thai soldiers in their attempts to cross the borders. In his letters, Khouy writes that he has settled down with his family and no longer wishes to leave, but, if possible, he urges us to bring Kim and Chou out.

My mind full of Cambodia, I race down the hill with my ponytail flicking back and forth like a tail as I bounce over the gravel and potholes. Faster and faster I pedal on the expanded country road and ride my bike forward into my future. In front of me, the horizon looks bright with opportunities, possibilities, and hope. As I stand up on my bike, forcing my legs to pump harder, my stomach begins to cramp with guilt and shame, knowing that I am riding into a future where my sister can never follow. Behind me, Chou stops running and follows me with her eyes, her arms dangling listlessly by her sides, her feet flattening against the land as I leave her farther and farther behind.

"Owwww!" I scream as my wheels skid on the gravel and the bike comes crashing down.

When I open my eyes again, I am on the ground as searing pain shoots

up from my knees and groin. Slowly I get up and pick the stones out of my flesh, watching droplets of blood beginning to ooze out of my skin. Except for the scraped knees, I'm not seriously hurt. I pick up my bike and straddle it. But as I lift my leg up, I notice a painful ache between my thighs that I've never felt before. Convinced that the burning sensation is a bruise from the fall, I get on my bike and head home.

By the time I arrive back home, the burning sensation in my groin has become cramps and a sticky wetness now flows down my thighs. I rush into the bathroom to check out my bruises and see that on one side of my inner thigh, a cut is caked with dried blood, but fresh blood still dribbles down my leg. Shocked by the sight of so much of it, I sit down in the bathtub to steady my shaky legs. Red liquid now stains the tub's white porcelain veneer. As I stare at the blood, my mind takes me back to the only other times I've seen so much blood coming out of a human body. Suddenly, my head feels light and the room begins to spin and fade out, for in all those instances the person was either dying or already dead.

In the bathtub, I wrap my arms around my knees and bring them close to my chest. Then I bury my head in my arms, as dark thoughts tell me I'm being punished for my bad behavior. Rocking my body back and forth, I try to push the images of the Khmer Rouge soldier's execution out of my head. But I can't stop the memory from resurfacing. I remember. I saw a man slaughtered like an animal while I'd watched without emotion. I'd stood in front of the crowd as an old woman stepped forward and approached the Khmer Rouge. Her face a mixture of hatred and sadness, she accused him of killing her family and smashed her hammer on his head. As his blood soaked the ground around him, I stared at it with fascination, knowing that when it all emptied out of his body, he would be dead.

"I don't want to die," I whimper.

I hear Eang playing with Maria in the living room, so I hold my breath to calm myself down. Part of me wants to go to Eang, but my fear of her seeing me so upset prevents me from getting out of the tub.

"Kgo, is that you?" Maria's voice from outside the bathroom shocks me out of my paralysis.

"Yes, honey. I'll be out in a few minutes. Go play with Mommy, okay?" I control my voice to make it sound calm for her.

"Okay," she agrees and off she trounces into her happy world.

My moment of weakness fades, and slowly I begin to feel the flickering of a warm fire in my stomach again. Then, somewhere in the recesses of my mind, I remember the sex education class about menstruation and puberty. I clean myself up and hide all evidence of my blood and weakness from my family.

the ung family

My mother, **Ung, Ay Chourng**.

My father,
Ung, Seng Im.

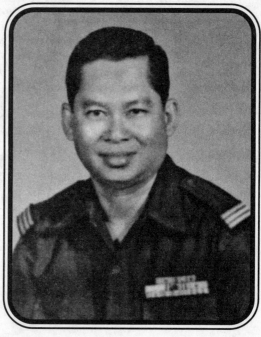

NOTE: *All photos courtesy of the author unless otherwise identified.*

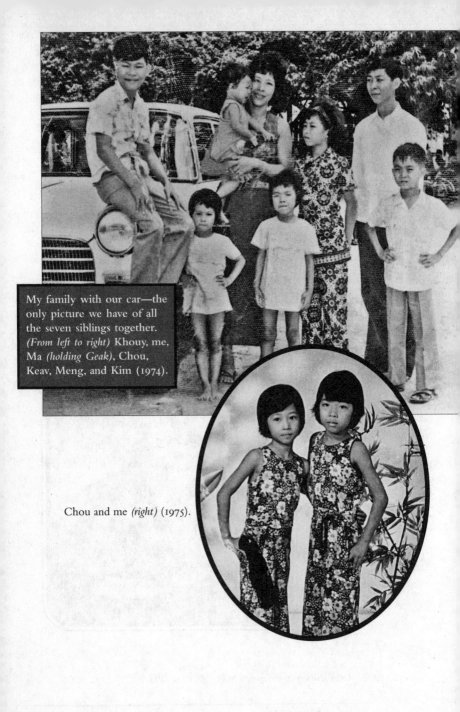

My family with our car—the only picture we have of all the seven siblings together. *(From left to right)* Khouy, me, Ma *(holding Geak)*, Chou, Keav, Meng, and Kim (1974).

Chou and me *(right)* (1975).

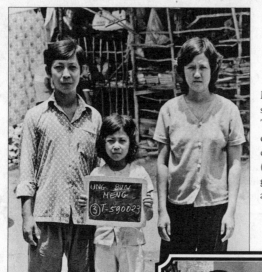

Meng, me, and my sister-in-law Eang Tan on our first day at the refugee camp in Thailand (1980). We had just gotten off the boat at Lam Sing.

Meng, Eang, and me on our last day at the camp (1980). Even eighteen months after the Khmer Rouge's defeat, my stomach, swollen from malnutrition, still carried memories of the war.

Meng, me, and Eang when we arrived
at Burlington International Airport,
Vermont. I was so excited,
I buttoned my shirt wrong (1980).

Eang was twenty-four and Meng was
only twenty-three in 1980, when they
became my protectors and parents.
As an adult, I'm grateful they raised
me the way they did.

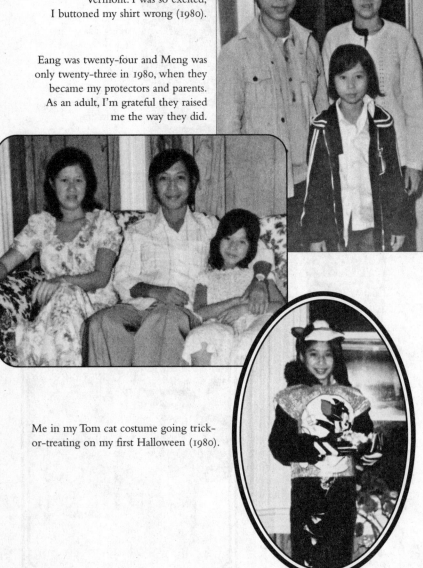

Me in my Tom cat costume going trick-
or-treating on my first Halloween (1980).

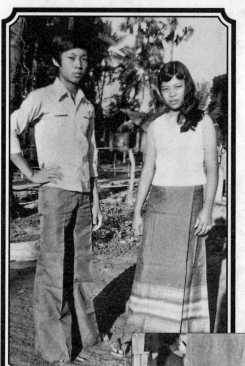

Kim and Chou wore their best clothes to pose for this picture to send to Meng when we reconnected again in 1984.

This is how I always remember Chou—gentle, soulful, and kind (1985).

Chou and Pheng on their wedding day (1985).

Their arranged marriage blossomed into love (1990).

My little angels, Maria and Tori (1990).

Hong and Chou remain great friends (2000).

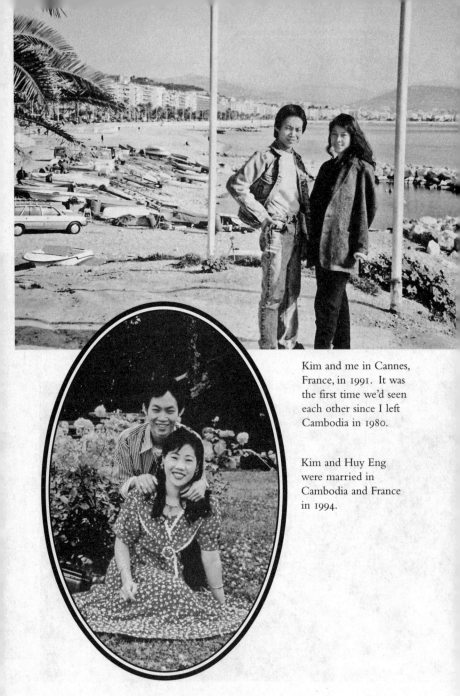

Kim and me in Cannes, France, in 1991. It was the first time we'd seen each other since I left Cambodia in 1980.

Kim and Huy Eng were married in Cambodia and France in 1994.

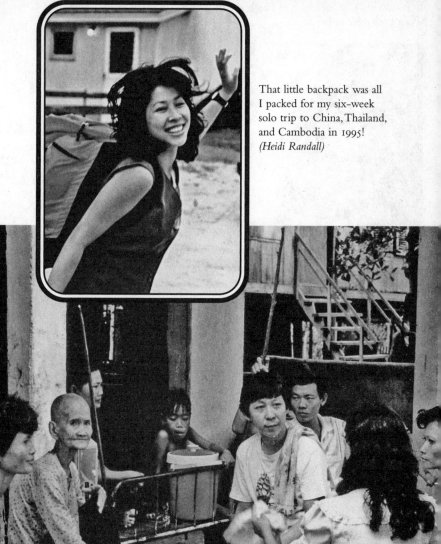

That little backpack was all I packed for my six-week solo trip to China, Thailand, and Cambodia in 1995! *(Heidi Randall)*

Meng, in the center, with friends and family during his 1995 trip to Cambodia.

In my twenty-plus trips back to Cambodia since 1995, I never cease to get excited when I see these sights:

Wat Byron is my favorite because it reminds me of Pa. *(Heidi Randall)*

A cyclo ride around the city still makes me smile with memories of Ma. *(Heidi Randall)*

Phnom Penh is now a busy, vibrant city. *(Heidi Randall)*

I love Cambodia's country landscapes.

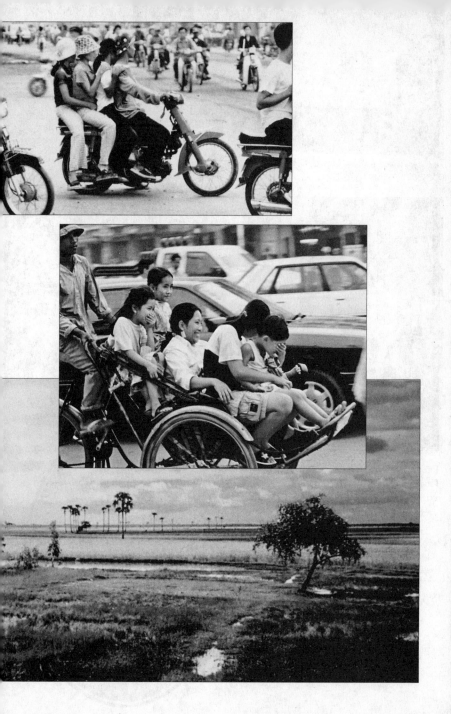

Khouy's house in the village (1995).

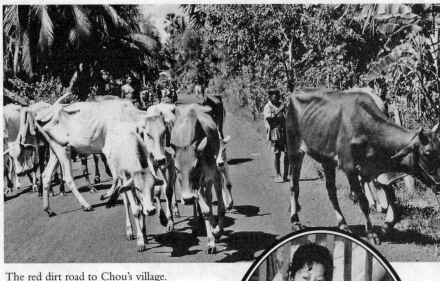

The red dirt road to Chou's village. This is what I see every time I return. *(Heidi Randall)*

At ninety-four, Amah is the matriarch of four generations of Ungs (1999).

Meng, Khouy, Kim, Chou, and me. This was the first time in nineteen years we were all together (1999).

When I arrive at Chou's house, the first thing I do is eat. (*Left to right*) Morm, me, Mum, Chou, Aunt Keang, Aunt Hearng, and Moi (2001).

After we eat, we look at the pictures Meng sends of our families in America.

Kim, Huy Eng, Nancy, and Nick (2001).

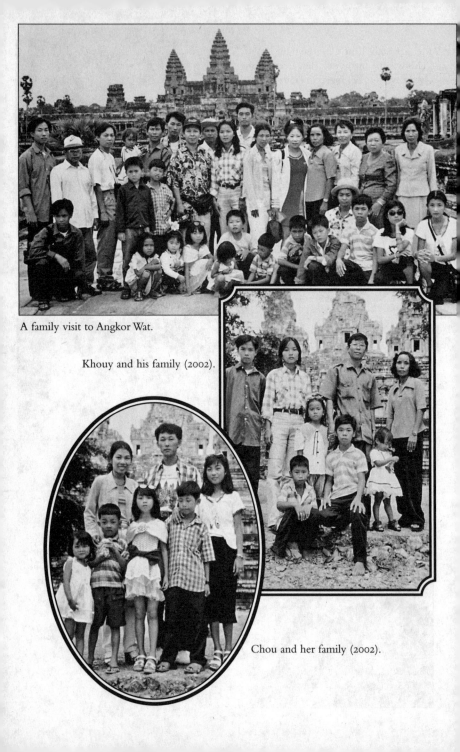

A family visit to Angkor Wat.

Khouy and his family (2002).

Chou and her family (2002).

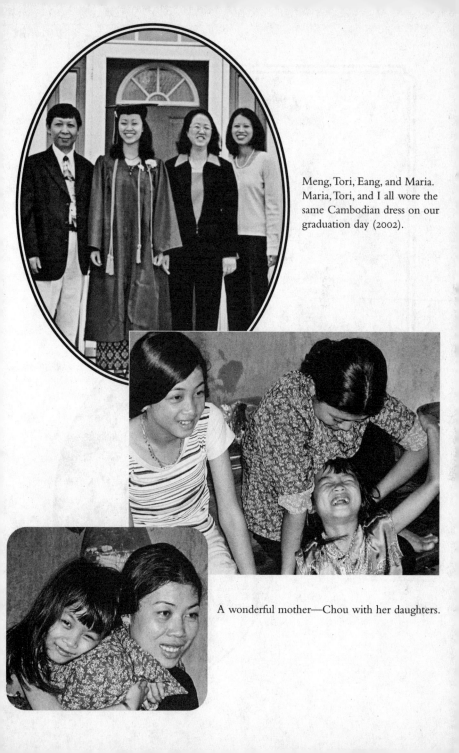

Meng, Tori, Eang, and Maria. Maria, Tori, and I all wore the same Cambodian dress on our graduation day (2002).

A wonderful mother—Chou with her daughters.

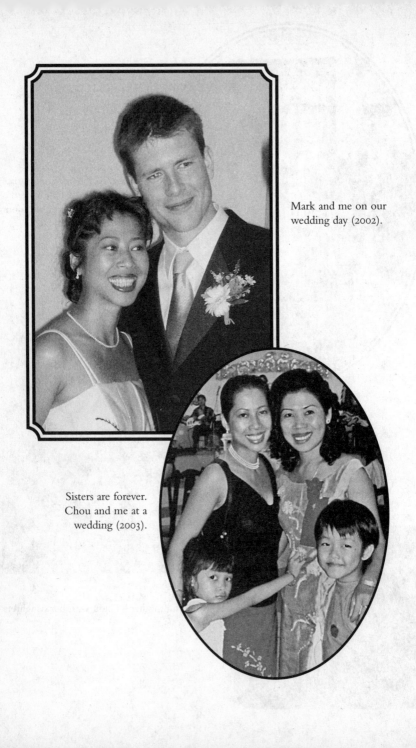

Mark and me on our wedding day (2002).

Sisters are forever. Chou and me at a wedding (2003).

17 betrothed

Chou wakes up to a red sky outside and wonders if the gods are angry today. Usually in October, the gods thunder relentlessly, turn the clouds black, and blow wind so powerful that brown coconut fruits drop from the trees. Then the skies open and heavy rains soak the ground and flood the lower land. Lately, the gods have been merciful and only wet the land with the morning dew. In the dry season, Chou can rise with the sun to cook the family meals and do her chores. But during the monsoon season, Chou has to get up when the moon is still bright to build a fire out of damp wood. Usually before the family rouses from their sleep, Chou has cooked rice soup and dried everyone's damp clothes by fanning them over the fire. Sometimes she is so tired that she takes a quick nap in her squatting position next to the fire, but never for too long so she has time to send her family off in warm, dry clothes smelling of smoke.

But the rain gods did not drench the land this night so Chou has been able to sleep in. The red sky is crimson orange when she finally makes her way to the kitchen. Aunt Keang has already made their rice soup. After each member of the family eats a hearty bowl, Kim and all the male cousins leave for school and the elders head for the rice paddies to grow their rice and for the ponds to catch their fish. From her spot leaning over the dirty dishes, Chou watches wistfully as Kim's figure disappears around the bend in the road.

"Chou," Aunt Keang says softly, "today is your school day." Chou's smile spreads widely.

"Yes," she says. "I'll get all my work done before I leave for school."

Since the school opened three years ago, Chou has dreamed of attending. But eight months before, Aunt Keang gave birth to her seventh healthy child, a baby boy she named Nam. Though the family rejoiced, Chou was not smiling very widely that day because she knew there was yet another baby she'd have to take care of. With her oldest cousin Cheung married with a family of her own, and the next oldest, Hong, busy looking after Amah, Chou is left to take care of the small children and do the chores. However, in Nam's first few days of life, Chou quickly fell in love with his sweet disposition and neediness. As the children's caregiver, Chou has to bring Nam everywhere with her while Aunt Keang works on the farm. As much as she loves him, having him attached to her has slowed down her work, leaving her no time to attend school. Then unexpectedly, Aunt Keang decided that Chou could go to school if she took baby Nam with her. Chou has been brimming with happiness ever since.

"No need to worry about washing the clothes today. I'll do it when I return from the fields. Why don't you go get our water while I look after the children," Aunt Keang tells her.

"Thank you, Second Aunt." Chou watches Aunt Keang with amazement as she scoops her infant son up with one arm while grabbing the hand of another small child running beside her like a baby chick.

Quickly, Chou ties the cows to the wagon and heads off to the pond to collect water. When she returns, Aunt Keang leaves Nam with her and returns to the fields. For the next hour while Nam sleeps, Chou washes the big pile of the family's dirty clothes and the baby's diapers. Afterward, she lets him cry in his hammock as she splits the wood for the fire. By the time Kim and the cousins return at half past eleven, Chou has cooked rice and stir-fried leeks and bamboo shoots with fish ready for lunch. After the meal, Aunt Keang and Uncle Lang rest in their hammocks while the young people continue with the housework. When her shadow is directly scrunched under her feet, Chou watches Nam while she scrubs the black pots and dishes and waits excitedly for her turn to go to school. Because there are many more students than teachers or

schools, Khmer classes run two times a day; the morning session runs from seven A.M. to eleven A.M., and the afternoon session lasts from one P.M. to five P.M.

"Stop!" Chou screams suddenly from the kitchen, startling the family. "Stop wasting my water!" Chou runs up to Kim, who stands dumbly next to a muddy old bicycle. "Stop wasting my water!" Chou grabs the water container from his hand and tosses it back into the jug.

"Are you crazy? What are you doing?" Kim flinches from Chou's raised fists.

"Don't use my water to wash your bicycle! Take it down to the pond! I'm going to school today and I don't have time to collect more water!" Chou glares at him, her eyes bulging.

"Fine, fine!" Kim is red-faced with embarrassment and quickly wheels his bike away. As her blood pressure returns to normal, Chou grabs a washcloth and runs to Kim.

Like many other Cambodians, Chou's education was halted the four years under the Khmer Rouge regime. After the Khmer Rouge, there were very few teachers available to teach because Pol Pot had killed so many of them. The teachers who survived opted to teach in the big cities like Phnom Penh and Siem Reap. Here in the village, there is only one school in Chou's province to serve all the children from the surrounding villages. And in families like hers where there are many children, it is usually the boys who are allowed to attend school while the girls stay behind to work and look after the other children.

"Kim, take this to wash your bike." Chou hands him the rag as a way to apologize.

"Learn well in school," Kim replies with a smile as he takes it from her.

As he walks away, Chou remembers the many times Kim has been there for her. When they have free time, Kim and the male cousins frequently roam watering holes and fields to pick morning glory, green tamarinds, mangos, and other plants and fruits to sell for extra money. But before they can take it to the market, the boys hide their goods under the plank. Sometimes, when they're not looking, Chou will steal from the stash and sell it back to the boys for cheap. Chou smirks while doing this, thinking she is very clever and mischievous. When the boys place the

money in her hands, her fingers quickly clamp over the bills like iron claws
before they can take it back. As she runs away, her smile widens because
she knows that Kim knows she stole from them and that he will never say
anything about it.

In addition to keeping Chou's secret, Kim also helps her learn to read
and write. At night, after the boys finish with their chores, Kim and the
cousins are usually allowed to burn one candle in order to study and do
their homework. As the candle flickers on and off their faces, Chou rocks
the baby in a hammock next to them and joins in when the boys sing the
Khmer alphabet songs. As the boys learn to put the vowels and consonants
together to form words, Chou repeats after them. Sometimes Kim
becomes so focused on his work that he doesn't realize Chou's been stand-
ing behind him for several minutes, peering over his shoulder. When he's
not too busy, Kim will take the time to teach her what he's learned. Other
times, he waves Chou away in annoyance, the way he would a fly. But
today, Chou will go to school to learn her own lessons.

"Aunt Keang, I'm going to school now!" Chou hollers and picks
Nam up.

"Go ahead," Aunt Keang replies from inside. Hurriedly, Chou grabs a
few kramas, a ball of rice wrapped in a banana leaf, and her blue cloth bag,
then rushes off before her shadow becomes too long.

On the short walk, Chou switches Nam from one hip to another. Her
free hand clutches at the faded bag containing the few sheets of paper Kim
spent his hard-earned money to buy. Nestled in between the clean pages
are the boys' used and discarded exams. To study, Chou would often take
these used exams and copy the questions on a clean sheet of paper so she'd
be able to take the same tests. When she'd get an answer wrong, she'd rep-
rimand herself like a real teacher and study even harder. And when her
marks had been good, she'd proudly show them to Kim and he'd shower
her with more old papers and lessons.

Walking with a brisk stride, Chou stays on the path and avoids the
roadside crowded with thick, reddish green, leafy shrubs covered in fine
orange dust. Above them, green tamarind trees hanging heavy with fruit
provide shade from the hot sun. In the distance, the wind blows lightly and
swirls dust into the air. Chou imagines Pa smiling proudly at her from afar
while Ma applauds her bravery.

"Ma, Pa," she calls out softly to them, "I am a good girl. I know how to work hard. Kim is a very good student. Second Brother is happy with his new family. And Eldest Brother and Loung are safe and well. You don't have to worry about us anymore."

As she speaks, she sees Ma and Pa's faces darken and wrinkle with worry every time they look at her. Wherever their spirits are, she wants desperately to ease their concerns. "Ma, Pa, I miss you every day very much. But you don't have to worry about me." She crinkles her nose, wipes her forearm against her eyes, and continues on.

When she finally arrives at the school, Chou walks to the back corner of the wall-less thatch-roofed building and takes a seat on one of the wooden benches. Chou places her bag on the rough wooden table, then quietly unwraps Nam and lets him loose on the dirt floor.

Around her, students of ages ranging from sixteen to eighteen sit quietly. Chou looks around the room and sees that she's the only one who has brought a baby with her to class. As the others take out their pencils and paper, Chou can hardly contain her excitement because, at seventeen, this is the first formal school she's attended since the Khmer Rouge takeover. When the teacher enters the room, Chou is surprised to see a handsome man in his twenties. Though he is not much older than she, his clean white shirt, blue slacks, and teacher status give him the authority of one who is much older. She sits primly in her seat but feels like she's a caged alligator who's just been released in the water.

"I see we have a new student today," the teacher announces. "Miss, tell the class your name."

"My name is Chou Ung," Chou stands up.

"Have you been to school before?"

"Yes, *lork kru*." Chou calls him *lork kru,* which means "lord teacher" in Khmer, and neglects to tell him it's been ten years since she last went to school.

"Do you know basic reading and writing?" *lork kru* asks.

"Yes, *lork kru*," Chou replies, and hopes he doesn't ask her to write something on the blackboard as a test.

"Good." *Lork kru* accepts her answer. Then he stares directly at Nam next to her and asks, "Is he yours?"

"No, *lork kru*. My apologies, *lork kru*. He is my nephew. My aunt is

busy with work every day and there's no one else but me to look after the baby. I want very much to go to school, *lork kru*. I—"

"Enough." *Lork kru* stops her and turns to the blackboard to write down the lesson for the day.

For the next few hours, Chou scribbles the day's words excitedly on the sheet of paper Kim gave her, and Nam quietly plays by himself. When the baby begins to fuss, Chou picks him up and bounces him on her lap.

"Shhhh. Shhhh," she shushes him when he starts to cry.

"Chou," *lork kru* calls. Chou closes her eyes briefly and mumbles a silent prayer.

"I'm sorry, *lork kru*," Chou speaks, raising her eyes to meet the teacher's.

"Keep the baby quiet," he warns.

"Yes, thank you," Chou answers. For the next few minutes, Chou tries to hush the baby, to no avail. The boy is awake and gurgling, and moments later Chou notices that her sleeves and lap are wet. In his body hammock, Nam laughs contently. *Lork kru* glares at Chou from his desk.

"Sorry, *lork kru*." Chou bows her head and walks outside with her back bent low to the ground to show the teacher respect. While the other students continue, Chou sets Nam on the floor, then wrings out his wet scarf and hangs it on a tree branch to dry. With one eye on the teacher and one on Nam, Chou chews the rice in her mouth to make it into paste and feeds it to the baby. After he's fed, Chou cradles him in a krama and ties it diagonally across her chest. Full and sleepy, Nam yawns and wriggles in his little hammock as Chou lightly pats his bottom. When he struggles against her chest, Chou calms him by putting a finger in his mouth. Nam holds on to her finger and suckles it like a nipple, until finally, slowly, he falls asleep.

Chou and Nam come home from school in time to witness Hong's viewing party.

"They're here already?" Chou asks Kim, who sits alone outside under a tree.

"Yes, they've been here for about half an hour."

Chou knows this is difficult for Kim to watch and that's why he's sitting outside by himself. A viewing party is when the prospective groom and the elder members of his family pay a formal visit to the prospective

bride and her family to find out if a marriage can be arranged between them. For many families, it is also a time for the two families to get to know each other, to see if they like each other, and if their children like each other. When all that is assured, they then discuss the dowry, the wedding parties, and where their children will live once they've married.

"Have you been inside?" Chou asks Kim gently.

"For a few minutes, but it's very hot inside, so I came out here for some air."

Chou knows that this is not entirely true; even though he no longer talks about Huy Eng, Chou knows Kim still thinks about her. It's been one year since Kim first saw Huy Eng climb a mango tree. While the other boys teased her for acting like a boy, Kim was impressed with her speed and skill as she balanced herself on the swaying branches to reach the fruit. He was then eighteen and Huy Eng was a petite and pretty sixteen-year-old girl. In the months that followed, he never spoke of his feelings for Huy Eng, but Chou could see how his face bloomed like an opened lotus flower whenever she was near. Huy Eng's family runs a small stall selling soy sauce and spices in the market, so every day after school and work, Kim could be found loitering around her family's stall, making friends and small talk with her eleven older siblings.

When he turned nineteen, Kim asked Amah, as the matriarch of the family, to help him approach Huy Eng's family and ask for her hand in marriage. But Amah refused and told Kim that Huy Eng was too strong-headed and full of spirit to be his match. Instead, she offered to arrange a marriage between him and Huy Eng's older, more subdued sister. Kim gave Amah the respect she was due as head of the family and bent his body low to her as he left the room. But his eyes were flaring and his hands were clenched into fists. Huy Eng's name was never again mentioned between Kim and Amah, and for the next few months many other villagers arrived at the hut to offer Kim their young daughters to take as his wife. Kim refused them all. When this news reached Huy Eng, she told people who knew Kim that she admired his kindness and gentleness. In her message, Huy Eng also said that if asked, she and her family would accept Kim's proposal. But until Kim can convince Amah that Huy Eng is right for him, he has to watch her from afar and dream that someday they will be man and wife.

Realizing how dirty she and Nam are, Chou leaves Kim to his silence and carries the baby to the round petroleum container they use to store water. Squatting down, she pulls a clump of wet coconut thatch from a brown coconut shell lying nearby. She pours a few spoonfuls of gasoline from a white plastic bottle into a bowl to soak the thatch. When it is thoroughly wet, she uses the gasoline-soaked shell to scrub the encrusted black dirt off Nam's legs and feet. After she rinses him off, she does the same to herself, dreaming of the day when they will be wealthy enough to afford such luxurious items as soap again.

After they are both clean, Chou hands Nam to Kim as she smoothes down the wrinkles in her pants. She gathers her wavy hair into a tight bun and secures it with a chopstick before tucking the loose strands behind her ears. Picking up a green coconut from the ground, Chou hacks off the top with a big silver cleaver. She then smashes the corner edge of her cleaver into the hard shell three times, creating a triangle break, which she picks off with her fingers. Placing a large tin bowl under the hole, she flips the fruit upside down and catches its juice. When the fruit is empty, she carries the container to Kim. As the juice slides down his throat, Chou watches his Adam's apple move up and down.

When Kim is done drinking, Chou leaves Nam with him and enters the hut. Inside, the prospective groom and his family, dressed in their finest clothes, sit on wooden benches across from the Ung family. The Ung men have their hair combed and slicked back and wear stainless light blue shirts tucked inside black trousers. Next to them, the Ung ladies have covered their faces with a powdery beige foundation two shades lighter than their skin, darkened their brows with charcoal, and stained their lips with berries. On both sides, the women have on their finest colorful sarongs and shirts, while the prospective bride wears a soft, fresh color that signifies her purity.

"Chou, come here." Aunt Keang signals for her to sit with the family. "This is my niece Chou. She and her brother Kim live with us."

"Chump reap sur." Chou bows to the groom's family.

"Hello," the groom's family greets her.

"We think the two of them are a good fit," the groom's family continues politely. Before they came to the viewing party, the groom's family

had already thoroughly investigated the bride's family history, their good name, and her Chinese animal sign.

"Though she is only seventeen, Hong is very clever and strong." Aunt Keang praises her daughter. "And as both our families have lived in the same province for many years, we know you are a good family. And we also know that your son is a good person. And you know that our Hong is a very hard worker and very loyal. When she was only six years old, she went to live with her grandmother. And during the Khmer Rouge, she took care of her grandmother and continues to do that today. She has a very good heart. We know your son is a hard worker and loyal to his family as well." In this manner, Aunt Keang gives her blessing.

As the adults talk, the prospective betrothed sit shyly, facing each other, and size each other up. From her seat, Chou watches Hong cast her eyes down and keep her mouth closed as the two families pick her wedding date, the wedding party, the food, the dowry, and whether the new couple will live with the Ung family or the groom's family.

Chou smiles with happiness that Hong will marry a man from the village. Her thoughts drift to Cheung, whose marriage was arranged to an outsider; now they see her very seldom. With Cheung living far away, it is harder for the family to help her if her husband beats her. But so far, the family rejoices that her marriage was a good match and that her husband is a kind man and gentle father.

Chou listens as Hong quietly agrees to her arranged marriage. Chou knows that she herself will not question Uncle Leang and Aunt Keang's choice of a husband when it is time for her to marry. Chou has heard that in the city, some girls fight their elders to choose their own husbands. Chou just doesn't know how someone at the age of sixteen or eighteen would know how to choose a good husband. And sometimes, if a girl refuses her parents' choice for too long, she will be thought of as too picky and spoiled, and the men will stop coming to look at her. When girls reach the age of twenty-five and are still not married, the villagers blame them for being old maids and look at them with pity. Chou knows she will not make this mistake.

Still, when it is her time to get married, she hopes Uncle Leang and Aunt Keang will choose someone from the village. To help make this hap-

pen, Chou is very careful not to travel too far from home and only to go to places frequented by local people. She has lost many friends who while visiting Phnom Penh and other places caught the eye of an outsider man. The next thing they knew, the man and his family were at their house having tea. After the tea, if both families agreed on the marriage terms, within two weeks to a few months, they were saying good-bye.

"Thank you so much," the groom's mother says as Hong pours tea and demurely offers everyone white sponge rice cake. "What beautiful clean hands you have, young daughter."

"She is such a hard worker but always keeps her hands very clean," Aunt Keang beams at her daughter.

Chou's eyes shift to Hong's hands resting on top of each other on her lap, palms down. Her hands are the cleanest Chou has ever seen, no dirt in the knuckles or creases, fingernails scrubbed clean, and cuticles pushed up to reveal white and healthy half moons.

When the marriage and dowries have been agreed upon by the two families, they decide that in two months' time, Hong will marry and leave her family to go live with her husband. After the groom's family leaves, Chou approaches Hong as she busily folds up their nice tablecloth.

"Do you like him?" Chou asks her cousin.

"He's a very nice man and comes from a good family," Hong replies.

"Do you think you'll like him?"

"Yes, I like him. But I don't know him. After we marry and have children together, I will like him more." Chou notices Hong has not mentioned whether or not she finds her future husband handsome. Then suddenly, Hong is still and quiet. Sensing her questions may have caused her cousin to worry, Chou returns to her work.

The next day, Chou returns to the school with Nam hanging on her back. But on this day, he refuses to sleep and cries loudly, disturbing the whole class. All through the afternoon, Chou bounces him on her knees, takes him outside to play, walks around the grounds with him, feeds him soft rice gruel, wrings out his wet underwear, makes faces at him—just to keep him quiet so she can stay in school. But no matter what she does, Nam screams, distracts the other students, and interrupts the class. After the first hour, *lork kru* stops asking Chou to quiet him down. *Lork kru* also stops glaring at her, addressing her, or looking in her direction. He treats

her as if she is already no longer in the class. After the afternoon session, he quietly informs her that she cannot return to school. No matter how she pleads, he tells her she cannot come back unless she leaves the baby behind. Dejected, Chou ties Nam to her back with her krama and shuffles off the school grounds with her eyes cast down. Behind her, three younger schoolgirls from a neighboring village circle around her on the path.

"Chou!" one of the girls jokes with her, not knowing Chou's been asked to leave school. "Your eyes are so big. I guess we'd better study hard with our small eyes or Chou will beat us in class!"

Hearing this, Chou swings around and stares at the girl. On her back, the baby stirs and stretches his limbs. With her next breath, Chou reaches into her pocket and stabs the girl in the hand with her pencil. The girl gasps in shock as the pencil punctures the skin and draws blood.

"You're crazy!" the girl screams, holding her hand in front of her eyes. "You're crazy!"

As Chou walks away, the baby weighs heavy on her back. She feels better for having unleashed some of her anger, but she's still mad. Leaving school means much more to her than just not being able to learn along with the boys, for Chou knows that girls who are not in school are often married off earlier than those who are. And now that she has started her monthly, everyone will soon see that her body is ready to bear children. With Nam bouncing on her back, Chou kicks her feet in the dust and resigns herself to leave the world of girls.

18 sweet sixteen

"So, heard from Chris about the note yet?" Beth asks, referring to the note I stuffed in Chris's locker last week.

"Nope," I reply sullenly. The mere mention of Chris makes my face hot, even though the sidewalk is icy and cold as we make our way to school. "I haven't seen him all week. I'm avoiding him."

"I hate to say 'I told you so,' babe, but I pleaded with you not to write the note and not to give it to him."

"Yep." I shrug my shoulders. No matter what Beth says, when it comes to Chris, my brain is mashed up like potatoes.

In hindsight, it was stupid to give Chris the note professing my admiration for his skills on the basketball court and telling him of my crush. But I had just returned from a trip to Montreal the week before and was still flushed with confidence by all the compliments I received from Eang's friends about my beauty. In the Cambodian and Chinese communities in Montreal, I am popular, beautiful, and funny. During the Cambodian New Year's celebration party there earlier that month, many Asian boys actually had lined up to ask me to dance! So when I returned to school and Chris smiled at me, I thought that he was seeing me in a different light. Then in my foggy state of mind caused by too many sleepless nights, I pushed my note through the slats of his locker.

"Well, assuming he found it and read it—and let's not rule out that

there's a chance he just threw it out with all the trash—so if he read it, he's nice enough not to make fun of you about it. And he didn't tack it up on the school bulletin board for everyone to see," Beth rattles on as I nod my head in agreement.

"I can't believe I did it. And I can't believe you let me!" I shoot a pretend angry glare in Beth's direction.

"Hey, I told you not to! So don't look at me. And at least the boys aren't going around calling you Smelly Fish." With that, we both laugh. Beth's last name is Poole and the boys somehow have connected it to dead fish floating in a pool.

"Boys are so stupid," I declare.

"Yeah, they're stupid! Who cares what they think?" Beth and I stop and look at each other and smile. We both care, but neither one of us wants to admit it.

When we arrive at school, Beth and I go straight to the bathroom. While Beth picks at her hair and sprays the individual strands into place, I change out of my long black pants and white button-down shirt into a form-fitting, floor-length black skirt and tight black sweater. I stand back and observe myself in the mirror.

"Yep, Meng definitely wouldn't approve," I say to the mirror and smile. "He'd think it's an outfit for a funeral and not proper enough for school." To finish off the look, I tie a tasseled pink scarf across my hips, gypsy-style. Then I let loose my long black curly hair and dangle large silver hoop earrings in my ears.

"You look good," Beth mumbles while she finishes putting on her lipstick.

"You, too." I return the compliment.

"So what are you doing this weekend?" Beth presses a sheet of tissue over her lips to even out the color.

"Packing and moving. Nothing fun." I continue to fuss with my curls.

"Want me to come over to help?" Beth gently peels off the tissues with her lip prints on it and tosses it into the trash can.

"Nah, Meng's got all his friends coming."

"Ready?"

"One more day of school and we're free." Beth and I smile at each other and head off to class. For the rest of the day I manage to go to my

classes, take my geometry test, eat my lunch, and sweat in gym, all with-
out once running into Chris or hearing anyone laugh about my note to
him. When the school bell rings to end the day, I join the stampede of stu-
dents rushing out the door.

The next two days, Meng, Eang, and I spend our day packing up our
lives into little cardboard boxes. By the time the McNultys and Li's family
arrive to load the boxes into Mr. McNulty's truck to move us into our
new home, most of our lives for the past six years have been reviewed,
sorted, folded, saved, or thrown out. And by dusk on Sunday, the crew is
finished and returns home, leaving us to make our last trip alone.

"Good-bye, closet," I whisper, and stare at the empty space. "You've
given me much happiness." In my arms, I hold a box containing rem-
nants of the private life I lived there—my pictures, journals, drawings,
curtains, and clothes hangers. Downstairs, Meng packs the last few boxes
into the car.

"Good-bye, room." I bid my farewell. In the bare room, I see myself as
a kid, jumping on the couch and hiding from the monsters under the sheets.

As I survey the apartment, the rooms look small and lonely without all
our things in them. I know I will miss this place. It was our first apartment
in America, and even though it's small, for a while I was happy to call it
home. It wasn't until I saw an episode of *Happy Days* on TV that I began
to feel differently. In the show, Joanie visited Chachi at his home, and
while they were sitting on the couch watching TV, Joanie asked to see
Chachi's room. When he replied that they were already sitting in it, the
audience erupted into laughter. At that moment, I suddenly looked at my
bed in the open dining room and was embarrassed. I hadn't realized peo-
ple might think of our family as poor because I slept in the dining room.
With Eang and Meng working, we had a place to live, heat in the house,
a new car to drive, clothes to wear, and a refrigerator stocked full of food.
But when I heard the laughter on TV, I became conscious of my Salvation
Army clothes and started to notice the Laura Ashley dresses and Polo shirts
that the other girls were wearing.

But that's all over now. I'm about to leave the shame behind and move
to a place where I'll have my own room. My own room! The thought

pumps bubbles into my skin and makes me feel light. So with one last lingering look at my closet, I exit my room and walk down the stairs into the parking lot.

"Co'on, Go!" Maria calls excitedly. "Let's go to our new house!"

"All right! Let's go!" I holler and climb into the backseat.

"Hey, Mup." I call Tori "Chubby" in Khmer and kiss her cheek. Eight-month-old Tori is strapped between Maria and me in her car seat, and responds by spitting more drool out of her mouth. From the front passenger seat, Eang reaches over and wipes Tori's wet mouth with an old cloth diaper.

"Let's go, Daddy!" Maria urges as the car gently moves forward.

As we pull out of the driveway and pass the cemetery, I silently thank the ghosts and spirits for leaving me alone all these years. On the trees, the green spring buds wave to me from their branches. Above us, the sun shines columns of light to illuminate the headstones, as if to announce my departure.

"Good riddance, graveyard!" I think to myself. "I hope never to sleep next to you again!"

"Good-bye house!" Maria and I call out as Meng takes us out of the complex.

Three minutes and less than half a mile later, we arrive at our new home and our very own driveway.

I gaze at the two-story box-shaped house with excitement and hope. "Maybe with my own house, I can be normal," I think. Then I unbuckle Maria and together we enter our new home.

Inside, Maria makes her way through the maze of furniture, boxes, and bags on the floor and up the stairs. I run after her and stop at the top of the stairs to quickly glance at the square clean rooms that will be Meng and Eang's and Maria's. The rooms are clean and sterile with their white walls and light blue carpet. Their beds and dressers are in their corner positions. I walk past the bathroom and into my room to find Maria sitting on my bed.

"Hi, Kgo!" she calls cheerily, her voice echoing in the empty room.

"Hi, sweetie," I reply and smile. My corner room basks in fading sunlight in three directions from its four windows. I look out of each and see

into the street, a neighbor's house, and our backyard. And there is no cemetery in sight!

"My own room!" I exclaim. "My own door." I swing the door closed and open it again.

"It's big in here!" Maria squeals and opens my closet door.

"Yep," I laugh and walk in to see if it'll fit me in it. It does! I stand in the middle of the room and twirl around until my head becomes dizzy with vertigo. As I fall to the floor, I daydream about getting dressed in my room alone, having a private phone conversation with Li, and listening to Bob Marley cassettes without Eang telling me to "turn that noise off!" When I invite Beth to my house, I can take her to my room!

"Hey sweetie, wanna help me unpack?" I ask Maria, who is lying on top of me.

"Okay." Maria jumps off me and runs through the sunspots. I watch the soft light dance on her hair and arms. She looks like my angel.

For the next hour, while Maria and I rearrange my room, Meng and Eang organize the downstairs clutter into our home. As they work, the sounds of cardboard boxes being ripped opened, clanging silverware, pots and plates, and doors opening and closing travel through the house. But soon afterward, the noises stop.

"Stay here," I tell Maria. "I'm going to check on Mommy and Daddy, okay?"

"Okay."

I leave Maria playing with her dolls in my room to search for Meng and Eang. In the kitchen, the refrigerator hums steadily. In the living room I find Meng and Eang napping on the couch with their feet sticking in each other's faces, their bodies look as if they've been swallowed up by the thick cushions. Beside them, Tori sleeps on her stomach in her playpen. In the fluorescent light, Meng and Eang look so pale and still that my lungs stop breathing. "What if they're dead?" I panic and rush over to them. "What if they've died and left me here alone? What will I do? Where will I go?" I steady my legs and kneel down next to Meng's face. Slowly I put my index finger below his nose. I sigh with relief as his nostrils exhale faint air that cools the skin on my hand. "He's alive!" I scream in my mind. Abruptly, Meng wakes up and sees me before I can withdraw my finger.

"What are you doing?" he asks.

"Checking your breathing," I reply nonchalantly. His brows knit together for a moment and then he laughs.

"Eang and I shared a can of beer," he explains, and points to the empty can on the coffee table.

"So you're drunk," I smile as he falls back to sleep. I pick up the beer can and toss it in the trash. Meng and Eang rarely drink alcohol, but when they do, one can of beer is enough to make them pass out. Leaving them alone, I march back upstairs. After a short period of tacking drawings of Mickey Mouse, Donald Duck, and the Jetsons on my walls, I bring Maria to play in the living room next to her sleeping parents. As I unpack the boxes, I watch over Meng and Eang until they gradually come back to life.

After dinner and more scrubbing of the bathroom sinks and floor, the family settles down for an early night. In their room, Meng and Eang sleep with Tori in their bed while Maria snuggles next to her teddy bear on a foldout cot in the corner. In my room, I hang up my dresses, fold my shirts and pants, and put them into drawers. When the digital clock's red numbers read 11:00 P.M., I've finished with all my tasks and stand in the middle of the room inspecting my work.

I catch sight of myself in the full-length mirror hanging on the door. "God, I hate my body," I say out loud. Beneath the big shirt and long pants, the girl staring back at me is thin and has no curves. I move toward the mirror, pull my shirt tightly over my chest, and wince. Under the shirt, my breasts are tender and sore.

"I hate them." My confession drowns in the thick, shaggy rug. "I must, I must, I must increase my bust," I sing quietly and wish for bigger breasts. Then I smooth my hands over my rumbling and bloated belly.

"I hate myself," I whisper. The words hang quietly in the air like an indictment of guilt.

I walk across the room and sink into my twin-size bed. Outside my window, a cold spell moves across Vermont and freezes everything in its path. Far away from the winter's sting, the bright moon leaves its distorted reflection on the icicles. As I lie face down, the wind whistles and howls like an angry beast slamming against the walls, trying to get in. Under two pairs of socks, my cold toes curl, wishing they were little piggies in blankets. The cold stings my skin and numbs my flesh wherever it touches, up my feet, across the softness of my arches, and around my exposed ankles.

Without looking, I reach across the bed and turn off the lamp. This morning I was so happy about everything, and now my mood is dark as night.

"Everything is great," I try to convince myself. This is true. After many years of struggle, the family is finally doing well.

Six months ago, Meng put on his pressed suit and Eang wore her best dress, and together the family made their way to the county court. There, Meng and Eang were sworn in as citizens with a roomful of other new Americans to cheers and applause. Before the jubilation even died down, Meng announced that it was time to buy a house. When he returned the next week from the bank with news that we'd been approved for a house loan, he looked as if he'd swallowed a lightbulb. For the next few months, he scanned newspaper ads, contacted real estate agents, and drove around the neighborhood scouring for FOR SALE signs. During meals, he talked excitedly about finding a home big enough to hold all of us, plus Kim and Chou when they come. With our first home, he explained, we are living the American dream, and in thirty years we will own a piece of that dream.

"Everything is great," I repeat. I know I have no reason to be sad, but despite the white shiny new paint in my room, inside I feel dull.

"Everything is *not* great. I hate myself." The thought makes the knotted muscles in my neck even tighter. I close my eyes, pinch my nose, and blow, trying to squeeze out the dark thoughts. For a brief time, nothing is in my head but the thudding sound of my heart pounding in my eardrums. But as soon as I let go, the sadness comes flooding back up my nostrils and into my brain.

"Why can't I be normal?" I turn violently in my bed, kicking off the covers. In my head, I see the Vietnamese soldier bending over me again, one hand gripping the back of my neck, the other covering my mouth and most of my face. As he lowers my head to the ground, he whispers "Shh, shh," but a scream crawls its way up to my throat. When he tugs at my pants and pulls them past my hips, the scream explodes. I slide on my bottom to get away from him but he grabs my legs and thighs. With a surge of hate, I twist myself out of his grasp and crash my feet into his chest. While he gasps in pain, I kick him in the groin and get away. But as my body bleeds and changes with each passing moon, the soldier returns. In

my sleep, he hovers over me as the war invades my body like worms burrowing into a dead corpse.

When sleep will not come, I get up and go to the bathroom to draw myself a bath. When the tub is filled, I slowly lower myself in. As the warm water laps at my body, I reach for the hand towel and soak it in the tub. Then I fold the dripping wet towel in half and put it over my face to see if I will suffocate. Lately, I've craved to know how it feels to fight for breath. The thought sends a chill down my body. Still, as my body grows cold in the water, I begin to wonder what it would feel like to drown. I pile another wet towel over my face and suck in more water with each breath. When breathing becomes more difficult, I try to imagine being buried alive. In my mind, I'm lying in a mass grave where I know so many Cambodians were bludgeoned, and where many were not yet dead when they were buried. My lungs burn with lack of oxygen as I envision dirt and corpses pushing against my skin. I make myself stay in the grave and scream for those who didn't escape, before letting myself pull the towels away. The water is cold when I get out of the tub and return to bed.

In my sleep, I dream I am again running from the Vietnamese and Khmer Rouge soldiers. I know that if they catch me they will rape and kill me. I scream and try to tell them I'm a boy. I wrap my arms over my breasts and hips to hide my new body. Paralyzed with fear, I suddenly look down to see my inner thighs dripping with blood.

"Help me!" I scream but no one answers my call. The blood slides down my legs and seeps into the ground between my toes. I reach down and try to wipe myself clean with my hands but succeed only in smearing the blood all over my thighs. There's so much blood! I stop and crouch down to the ground. My trembling fingers dig into the soft earth and rub the dirt on my bloodied toes. But the blood does not disappear. Instead, it cakes to the mud and sticks like adhesive to my skin. Somewhere in the dense wood, I know the soldiers are waiting for me. I know also that if they rape me I will kill myself. I want to turn and kill the soldiers the way I've done many times before in my dreams, but I no longer know if I am strong enough. I struggle with my pillow, my legs kicking at the blankets. Abruptly, I awake sweating in my own bed. In the dark, I curl into a fetal position.

When the alarm clock rings to get me up to begin the week at school, I'm already tired. My limbs are shaky when I climb out of my bed. I bend and stretch my aching back but flames of pain continue traveling down my legs and into my calves. When I pull my blanket back, I find a small pool of blood on the sheet. I strip off the dirty sheets and put new ones on before getting ready for school. On my new route to Beth's house, I push away the images of blood and wonder how I did on my geometry test last Friday.

19 a peasant princess

"Chou, you know I think of you as my own daughter." Aunt Keang speaks softly as she helps Chou tie up their mosquito nets. "And I've loved you as one of my own." Chou smiles at her while her hands continue to work. Except for the two of them, the hut is empty. Outside, the rest of the family sits and fans themselves, seeking relief from the oppressive heat.

"Chou, it is time for you to get married," Aunt Keang announces gently. Chou stops and looks at Aunt Keang, her throat tightening.

Already many months over eighteen, Chou is not surprised by Uncle Leang and Aunt Keang's decision for her to marry. Many of her friends married at sixteen and seventeen. But the news still warms her face and makes her hands shake. With Ma and Pa gone, Chou knows the task of finding her a husband is left to Aunt Keang and Uncle Leang. As she fights to still her hands, a small voice inside tells her that she can't say no even if she wants to. No girl in her community has ever refused to be arranged or rejected her family's choice of a husband. For a girl to refuse her parents' choice shows great disrespect; it tells the world that she does not trust her elders' judgment, and thus causes them to lose face. But no one in the village openly talks about those girls. If their names *are* brought up, it is only through gossip and scandals that spread through the village like an infectious disease, with each listener gasping.

Because of this stigma, even thirty-five years after Ma defied her parents and ran away to marry Pa, her scandal still has the power to hush people up. Chou has heard stories from Ma's childhood friends that when Ma refused Amah's choice and eloped with Pa, Amah stopped talking to her. Chou is horrified that Ma is still being judged. The friends described how Ma wept at Amah's feet and begged for forgiveness. "Ma and Pa loved each other," she wants to scream. They were devoted to each other and their family. But it wasn't until they had children that the family forgave them. While she struggles inside, outwardly Chou is calm and still. For a brief moment, Ma's story inspires Chou to protest that she is not ready to take a husband. But before the words can escape, Chou clamps her lips tightly together.

"Chou, your uncle, grandmother, and I have mulled over this for many months now," Aunt Keang continues, and takes Chou's hand.

"We looked for someone with a good family history, animal signs, who knows how to make money, and who will work hard to support his family. We searched for someone who is kind, gentle, and who will be a good father. After looking at all of this, we have arranged for you to marry Pheng." While Aunt Keang searches her face for a reaction, Chou stares at her hands on her lap. Then Chou exhales deeply and breathes with relief that at least she is to marry a man she knows. Though unable to express her emotions, she is grateful Aunt Keang has chosen someone her age, who is from the same village. In their girlish giggles, she has heard her friends say that Pheng is tall and handsome. She knows him to be kind, gentle, and nice.

"I think your Pa and Ma would approve." Aunt Keang's voice trails off.

Chou's face warms at the mention of Ma and Pa. Chou has worked hard to be the kind of daughter she thinks they wanted her to be. On the many mornings when she wakes up too tired to be patient with the crying children, she stops herself from screaming at them because Ma wouldn't have approved. When her anger rises with the amount of work she has to finish while the other cousins nap under the tree, she wills herself to be quiet and not to complain. Sometimes, she craves to burst out of her submissiveness, to scream, complain, and rebel against Aunt Keang's rules, or the cousins dirtying too many dishes, or even Kim getting to go to school while she stays behind. Instead, when the frustration rises, she

swallows it and pushes it down into her stomach. As her stomach cramps up, she remembers Ma's words. "A proper woman is neutral, doesn't gossip, never screams, complains, or throws tantrums, and blends in with the crowd. A proper woman is like warm water, not shocking like cold or burning like hot."

"Thank you, Aunt," Chou manages to whispers.

"Chou, do not cry. Be happy," Aunt Keang urges. "He will make a good husband and father to your children." Aunt Keang assures Chou and squeezes her hand. Chou finally looks up and wipes her eyes. In her blurred vision, Chou sees Ma smiling widely as she walks with Pa out of the village. She wishes she could follow them but resigns herself to her fate.

Three months later, on the night before her wedding, Chou dreams that Ma and Pa are together. They sit side by side at their kitchen table in Phnom Penh. Next to Pa, Keav bounces Geak up and down on her lap. They all look so young and beautiful. Chou leans against the wall outside, looking in, and cries. The dream is so vivid, but deep in her consciousness she always knows they are not on earth anymore.

"Ma, Pa, today is my wedding day." She walks over to stand behind their chairs but they do not respond. Since Aunt Keang told her she was to be married three months ago, Chou has found herself talking to Ma and Pa more and more. She aches to feel Ma's arm around her shoulders and Pa's hands on her head. "Eldest Sister, Geak, I am getting married today," she calls out to Keav and Geak.

"Today is my wedding day." The words float in her mind.

Above her, the black flies, brown bugs, and tiny grasshoppers hang on the mosquito net, their jagged little feet caught in the threads. She stares at them from bleary red eyes that sting from too little sleep. As she sits up, her head spins and she feels dizzy. She smacks the net a few times with her palms, freeing the bugs and forcing them to flee. Quickly, she swings her legs over the plank bed, wraps the sarong tight around her waist, and makes her way outside.

It is still dark. The stars sparkle brightly; the wind is quiet and cool. In their big round water jars, the smiling moon shivers when Chou dips her hands into the container. Under her feet, the grass and shrubs that lay

trampled from the previous day are healing slowly with the morning dew. But it is too early for Chou to really register anything. She does not know what time it is. She knows only that it is so early that even the cows, dogs, and roosters are asleep. When Chou finishes washing her face, she pours the rest of the water onto her palm and splashes her neck and arms. Suddenly a chill spreads all over her body and makes the hair on her arms stand. Her knees go weak from nerves as she gasps for breath and grips the water container for support.

After she is finished, she steadies herself and walks back into the hut. In her haze, she hears Aunt Keang and the older cousins rouse out of their sleep, their yawns and coughs echoing in the quiet air. Inside the web of nets, the young children, accustomed to loud noises, continue to sleep undisturbed.

"Chou," a soft voice calls from outside the door. Chou crosses the room to answer the call as Aunt Keang sidles off her bed and heads outside to wash her face. When she opens the door, Chou finds her next-door neighbor, a friend, and two distant cousins standing there. Usually, wedding banquets are held in the evening, but because the roads are unsafe to travel after dark, Aunt Keang decided to have the reception in the afternoon. This timing will allow the out-of-town guests to join in the celebration and return to their village without the fear of stepping on land mines or being kidnapped by Khmer Rouge soldiers during the night. Because an early wedding means less time to prepare, Aunt Keang has invited many people in the community to come help with the preparations.

"Cousins, sisters, please come in." Chou ushers them in.

"Chou, today is your wedding day!" her friend gushes. "Why are you up so early? You should sleep a little more. This is your only day to be a princess!"

"Sisters," replies cousin Hong, "in the village, a poor woman like Chou can only be a peasant princess. That means we work even on our wedding days."

"But a peasant princess is still a princess!" Aunt Keang walks in from the outhouse and greets the guests. "And thank you all for coming." She takes each of their hands in hers and guides them into the kitchen. "You have good hearts and generous spirits to come help."

"No need to thank us, Aunt Keang," says her friend. "We are all family. Of course we will help."

"Today is your wedding day," one of the cousins announces again, and touches Chou's arm. "We are so happy for you. Your aunt and uncle have picked a very nice man for you. May you be blessed with much happiness and many healthy children." Instantly, Chou's ears ring loudly as the words travel into her heart and speed it up.

In the dark, fear flickers across her face. After today, she will no longer be a girl but a woman and a wife. She is not sure she is ready to be either, but she accepts her fate in this world.

"When the sun comes out, the cook will come to make the dishes," Aunt Keang tells them. "For now, let's prepare the ingredients: cut the vegetables, wash the fruits, slice the meat, make the noodles, set the tables."

As she leads them around to their workstations, Aunt Keang tells the women that when the sky is bright enough for the men to see, they will go to gather the wood, leaves, and ropes to make the tent. Then while the women help with the cooking and cleaning, the men will do the hard work of chopping the wood and collecting the water. When they are done with that, they will go around the village to borrow chairs and tables from friends and neighbors for the festivities.

"Aunt Keang, how many have been invited?"

Chou listens intently as Aunt Keang tells the women about the four hundred friends, family, and guests expected to attend her wedding. As the women gasp, Aunt Keang explains that because Ma and Pa were so well known and loved in the village, she wants to give Chou a big wedding to bring honor to them. While the women nod, Aunt Keang then goes on to list the eight dishes they will serve at the reception.

"Young chicken soup to bless the new couple with healthy children, sautéed mixed vegetables, steamed fish with bamboo shoots, fried rice, shrimp lo mein, roasted whole chicken, lotus seed sweets, and rice cakes." Aunt Keang finishes and leads the women into the kitchen.

Leaning on the door frame, Chou is frozen by the thought of being a hostess to four hundred people. She is not accustomed to being at the center of attention. But her worries are cut short as more women arrive to help. Wasting no time, Aunt Keang quickly puts them to work while Chou washes dishes, knives, and cutting boards. Hong and a friend are

washing pink lotus blossoms for table flowers. As their fingers rub the dirt and mud from the leaves, they chat, laugh, and gossip. Near them, two more women sit on footstools with their cleavers busily chopping bunches of scallions and dicing garlic. Beside them, another woman splits wood to kindle the fire to boil the water. When the water is hot enough, Aunt Keang picks up a chicken from the pile of fifty and holds it upside down by its feet above the hot water. The limp bird has been sliced across the neck and drained of blood, as Aunt Keang dips it headfirst into the pot. After a few minutes, she pulls it out and repeats the process with another bird until there are none left. Chou takes the hot, wet chickens and delivers them to a group of women sitting in a circle. Between laughs and giggles, they pluck the feathers. Chou leaves them and goes to stir a big pot of white rice congee soup sitting on the fire. Then she reaches over for a metal spatula and flips over the chunks of dried salted fish sizzling in a frying pan. Once everything is cooked, she ladles the congee into bowls and carries the platter of soups, spoons, and fish to the women.

When the roosters crow at the brightening sky, the young children slowly wake to rub the sleepy seeds out of their eyes. By the time their mouths open with the day's first cry, the women have already peeled the potatoes, sliced the tomatoes, cut the carrots to look like bats, shaped the watermelons into flowers, made fresh noodles, scaled fish, and chopped the chickens. As the young mouths quiver and cry for milk, the first waves of women recruits return to their huts to tend to their own children while their younger, childless sisters arrive to take their place.

Chou brings the men breakfast at the outside table, making sure to serve Uncle Leang first, followed by Kim and the others. Before she heads back inside, Chou turns and glances quickly at Kim. Ever since Aunt Keang announced Chou's impending marriage, an awkward distance has come between Kim and her. Chou wonders if Kim is angry with her for accepting Aunt Keang's choice so easily. Chou has never worked up the courage to ask him, she's so afraid of his answer. While he eats, Chou's eyes linger on his face, and she notices how much his features resemble Ma's. And just like Ma, he has been brave enough to stand up to the family.

Inside the hut, Chou and the cousins sweep the floor, wipe the plank beds, decorate the room with wildflowers, arrange the chairs, and clean

out the incense bowl. On one altar, they replace the red ceramic bowl with a shiny gold brass bowl wrapped with dragon designs. Then they replace the old candles with new red ones. Next, they hang red paper Chinese wedding characters for health and prosperity on the walls and on top of all the doors.

The women steadily work to beautify the hut with their mixture of Chinese and Cambodian decorations. Soon they hear roars of motorcycles as Khouy and other male relatives arrive to help build the tent. When they have a big enough crew, the men drive away the cow wagons and their motorcycles. By the time the bright rays have dried up the morning's dew the men return with their wooden poles, palm leaves, and bamboo rope to build the tent. In a flurry of action, the men heave the posts into position and erect the frame. Chou comes out to watch and smiles as Khouy takes charge, directing people while he stands on the sidelines to smoke. While the others sew the palm leaves for the roof, Kim climbs on top of the tent and ties the skeletal frame together. Below him, Uncle Leang saunters from one group to another and spews out instructions in between puffs of his cigarette and swigs of coconut milk. All around them, the cousins, neighbors, and friends hammer poles and posts to stabilize the tent. In the corner of the tent, Chou sees Pheng gather a spool of thick nylon rope hanging on his arm. She quickly hides in the shadows but realizes that no butterflies flutter in her stomach at the sight of her groom. She becomes nauseous when thoughts of the marriage bed enter her mind, and she feels at a complete loss. Neither Aunt Keang nor her married women friends have disclosed anything or given her any advice about what to do on her wedding night.

For a brief moment, she envies the women who choose their own husbands, but she chases such rebellious thoughts away. Besides, she knows she is young and uneducated; even if she *could* choose her own husband, she wouldn't know what to look for in one. And so she will marry the man chosen for her and hope that one day she will love him. Her married friends assure her that love will blossom after the birth of their first child. She prays that they're right, and wonders if she is Pheng's choice or if his parents forced her upon him. She supposes it doesn't matter.

"Ma, Pa," she whispers, "today is my wedding day." Chou's voice is soft and firm as she tries to make herself sound like a woman. "Pa, thank

you for looking after me. Ma, you don't have to worry about me anymore. I'm going to be all right." She visualizes kneeling in front of them with Pheng to receive their blessings.

"Chou," Hong says as she rests her hand on Chou's shoulder, "it's time for you to get ready. The guests will be arriving soon."

Hong leads Chou into a makeshift room closed off by red cotton curtains. The girls stop their work and rush over to look at the dress laid out on the plank bed. Squeaking with excitement, a parade of hands guides her to a seat.

"Chou, I will turn you into a beautiful princess today," the wedding dresser declares, her hands heavy with her scissors and fake golden jewelry.

"I am but a peasant princess," Chou laughs and sits down. In her throne, Chou feels her tired body relax and wishes for a small nap. But the wedding dresser keeps her awake by pulling tiny hairs off her thick black brows and temples with tweezers. Chou's forehead is still numb when the wedding dresser splatters a pinkish-white foundation on her face, turning her two shades lighter. The wedding dresser applies dark charcoal to her brows and eyelids, then spreads her tube of red lipstick on Chou's cheeks and lips. When she finishes, Chou looks like a pink plastic China doll.

"Let's give her princess hair," the dresser says to the group. She then pulls, teases, and puffs Chou's curly hair into a big nest on top of her head. With dexterous fingers, the wedding dresser folds and twists her hair into one big bun and secures it with thirty large black bobby pins that poke into Chou's scalp. As the girls gasp, she places a fake diamond–studded golden tiara in front of the bun and again pokes Chou's scalp with another twenty pins. When she's done with the design, she cracks three eggs and separates the egg whites from the yolks. While one girl runs the yolks to the kitchen for the cook to whip into the yellow cake mix, the wedding dresser mixes the egg white with lime juice in a bowl. She uses this mixture to wet down Chou's fly-away hair and to hold the hairstyle in place.

"You look beautiful!" the girls tell her.

Chou teeters on her feet as she stands up, but she is smiling radiantly, looking like the golden goddess Apsara. For a moment, Chou forgets about the war, her dirty hands, and that Meng and Loung are not there. In her rented form-fitting shiny gold dress and her sparkling fake diamond

earrings, she feels beautiful. When she whirls around, the thick gold ban-
gles wrapped around her wrists and ankles dance with her.

"You look like a princess!" the girls exclaim in unison.

"I *am* a princess," laughs a new playful Chou.

As the guests start arriving, Chou exits out of the parted red curtains
and the room becomes still. The hut is filled with thirty or forty members
of the immediate family, cousins, and close relatives all dressed in their
finest, most colorful lace shirts and sarongs. Chou feels all their eyes on
her, the men appraising her appearance, the women looking for details
gone wrong. Chou lowers her head modestly.

"Chou's beautiful," Amah announces to everyone.

Chou looks up to see Kim and Khouy beaming brightly at her like
proud peacocks. Chou feels her face turn red under her pink makeup
when Hong leads her to the tent. Under the entrance of the thatched-roof
tent, dressed in a blue suit, white shirt, and black tie with a big red cloth
flower pinned to his breast pocket, Pheng waits for her. Shyly, Chou joins
him, her head down and her hands at her sides. One by one, friends young
and old arrive on foot, bicycles, wagons, or motorcycles and are greeted
by the young bride and groom. Once the guests pass the wedding party,
they go inside to sit on high-back plastic chairs at tables decorated with
bright fuchsia cloth.

Through the many decades of war and peace, the Cambodian-Chinese
culture has evolved in many ways, as people intermarry between the vari-
ous cultures and races. For Chou's big day, the family chose to modify and
shorten the traditional three-day-long Cambodian ceremony to just one
afternoon event. During the next few hours, Chou and Pheng go through
their own special truncated Chinese-Cambodian marriage ceremony. To
receive their blessings in a Chinese tea ceremony, the bride and groom
kneel in front of a pair of elder family members seated in chairs to offer
them tea. After a sip of tea, the elders give the couple a red envelope con-
taining a few Cambodian riel, small gold jewelry, and blessings for happi-
ness, prosperity, births of many sons, and good health. After the Chinese
tea ceremony, the new couple move to a corner of the tent where a red
blanket has been out spread out for the Cambodian string-tying ceremony.
Aunt Keang directs Chou and Pheng to sit close together with their knees

facing the same direction. Two elder women lower them so that they can prop their elbows on a large red pillow. As they sit with their palms pressed next to each other in a prayer, the cousins invite guests to participate in the ceremony by tying a red string around both their wrists and blessing them with a lasting marriage.

By late morning, the new couple has received the blessings of family, friends, guests, and monks, and is officially married in the eyes of their community. Their last ritual is to go to every table and greet all the guests individually as food and drinks are served. At each table, more guests toast the couple's happiness, prosperity, healthy children, and good health. As Chou takes sips of tea with her guests, she eyes the food keenly for she has not had time to eat. Out of the corner of her eye, she watches Pheng, who is sweating in his suit and pale from hunger. Though they have said few words to each other, Pheng toasts Chou with their guests and often smiles at her. When they move around the room, Chou notices that Pheng keeps his steps small so she does not have to run.

When the sun passes over the tent and stretches long shadows, the guests have gnawed, chomped, slurped, sucked, and feasted on all eight dishes and sit happily rubbing their bellies. Then family by family, they leave the tent to slowly make their way back home.

Once the last guest has strolled out, Chou changes out of her princess dress and back into her peasant clothes. Back in their loose-fitting village attire, Chou and Pheng quickly eat the food put aside for them by Aunt Keang. Once they've finished, Chou and the female relatives clear the tables, sweep the floors, and wash the dishes and tablecloths. The men disassemble the tent and chop the poles into firewood. Once she is done with the washing, Chou scurries around looking for more chores to do. By early evening, even Khouy has ridden home with Kim and two male cousins piled on his motorbike.

"Take me with you," Chou wants to yell, but she keeps silent and grinds her heels into the ground. Quietly, Chou and Pheng leave Uncle Leang and Aunt Keang's house and walk a few feet to their new thatched-roof home built on the family's land. With heart pounding and palms sweating, Chou watches as Pheng closes their door.

20 write what you know

"Loung, wake up." Eang peeks her head into my room.

"I'm up," I grumble into my pillow, my hair a messy shawl hanging in my face. The clock on the nightstand says it's 6:45 A.M. but with all the curtains drawn, my room is as dark as night. On most days, I'm out of my bed the first time the alarm clock goes off, but today I've pushed the snooze button three times.

"Are you okay?" she asks, her voice full of concern.

"Yeah," I mumble into my pillow.

With bleary eyes, I watch as Eang sits on the edge of my bed and stares at me. Since our contentious beginning as sisters-in-law, Eang and I have become more like a mother and daughter. Unlike Beth's mom, Eang does not speak of her love in words but in her cooking of my favorite dishes, filling up my drawers with warm socks, and always bringing me a bag of salt-and-vinegar potato chips when she does the grocery shopping. I close my lids and feel her fingers brushing my hair off my face. She then lays her palm on my forehead and cheeks.

"You feel cool," she says, "so get up or you'll be late for school."

"Okay," I reply and watch her exit my room.

In the stillness of the house, I sit up and stretch my arms toward the ceiling, and an aching pain travels from my shoulders down my spine and lower back. When I stand up, the pain shoots down my thighs and calves.

In my groin, my stomach cramps while my pelvis throbs, as if my legs are being stretched and pulled apart.

"Ughhh, why do they call it 'friend' when it feels like a damn enemy?" I ask the wall.

In the bathroom, the night's bad dreams hover over my head like dark, thunderous clouds. Every month for a year now, whenever my "friend" visits me, the war and soldiers follow. At night, I thrash in my bed fighting off the soldiers, werewolves, vampires, and other monsters as they try to rape and kill me. In the morning, the girl in the mirror stares back at me with dark, haunted eyes, ashen skin, and lips so dry that bits of translucent skin hang off them like shredded plastic on new construction. With my thumb and index finger, I pull the dead skin like hangnails. The more I pull, the more my lips tear and bleed. I brush my teeth, get dressed, and head out to school with the ghosts nipping at my heels.

At school, the clouds follow me everywhere. As I shuffle to class, the halls darken and lighten with the pulses of pain in my head. The kids around me move their mouths incessantly, their voices guttural and incoherent. In front of me, a group of boys high-five each other, flaunting their easy smiles and casual manner. The girls circle the boys, throw their heads back, and laugh with mouths opened so wide I see the pinkness of their tongues. I stare at these girls as they walk into their class together; their popularity, beauty, and confidence sparkle in the sunlight like magic dust in their wake. I want to run to them, grab them by their shoulders, and shake them until their secrets drop like fruits from a tree.

When I arrive in Mr. Johnson's English class, I find him moving around the room like a 250-pound brown bear, ready to pounce on any unsuspecting student. As he passes our seats, Mr. Johnson frowns and glares at us from behind thick glasses. The girls laugh while the boys toss jokes back and forth with him like a game of Frisbee. It's well known among the students that Mr. Johnson is more of a teddy bear than a grizzly. And this very popular bear is famous for jumping on his desk to serenade a student on his or her birthday.

"Class, settle down." Mr. Johnson's voice booms across the room. "We're going to work hard today!"

With that, Mr. Johnson takes the class on a literary journey into the world of Ernest Hemingway and *The Old Man and the Sea*. As the class dis-

cusses the book, I twitch in my seat as the redness flows out of my body and my thoughts drift to Ma. I look out the window and stare at the bright blue sky. The leaves are beginning to turn brown. Soon they will die and fall off the trees to rot on the ground.

You have to live for them because they died. This thought suddenly snakes its way on to the white page on my desk. I put down my pen and clasp my hands together. *Did they die for me? Did they die for me?* My mind repeats the question like a dark spell. *Could Pa have escaped if he didn't have to worry about me?* Below the desk, my knees shake and knock into each other. I imagine myself lying on the grass under the tree, covered by the falling leaves.

As Mr. Johnson continues, I lower my head and stare at the graffiti drawings on my desk. In faded black ink, I read, S LOVES L; next to it in blue, A + M is scratched inside a heart. Carefully, I pencil C LIKES L into the love fest. For the rest of the class, I daydream about Chris as my mind calms and forgets about Pa.

"All right, class. Because you've been good, here are your papers back." Mr. Johnson slowly returns our papers; he puts my essay on my desk just as the bell rings. While the rest of the students hurriedly leave, I stay glued to my seat and stare at the A+++ grade on top of the paper.

"Mr. Johnson, this must be a mistake!" I stand up and exclaim. Mr. Johnson saunters over and sits on the desk next to me.

"No, it's no mistake," he says, and smiles. "The assignment was to write about an important event that changed your life. And your paper about growing up in Cambodia and the Khmer Rouge coming into your city was great." Mr. Johnson then looks into my eyes and continues in a gentle voice. "I'm sorry you had to go through it. I'm sorry for all your losses." I grit my teeth and stare at the A+++ in my hand. I feel Mr. Johnson's gaze burning onto my cheeks.

"It's my first A+++ ever!" I exhale the words and force a smile onto my lips to get us past the awkward moment. "I'm so used to getting papers back with all the red marks and corrections on them. This is so strange."

"Well, your paper is great. But I will say this: You will not get another A+ in my class unless you learn the grammar rules. There are many grammatical errors in your paper but for this once, I wanted to let you know that sometimes content counts more than correct grammar."

"Thanks, Mr. Johnson." My smile is no longer forced as I gather my books together and shove them into my backpack.

"And, Loung, there is certainly a lot more to your story. If you ever want to write about it, let me know how I can help."

"Thanks."

"All right, now get to your next class."

I leave Mr. Johnson feeling light and head for my appointment with the school counselor. For a moment, the clouds vaporize. Outside, the sun shines through the windows and brightens up the halls. On the ceramic floor, my feet tap to the rhythms of the Pointer Sisters' "I'm So Excited!" which I can't seem to get out of my head. At Beth's locker, I spy the freshmen boys staring at her shapely tan legs in her miniskirt.

"Beth, you've got followers," I tell her, motioning to the boys.

"Yeah, well, they can look but can't touch!" She shuts her lockers and laughs. At fifteen, Beth is now a shade blonder than when we were in junior high school.

"Hey, I just got my first A+++ in Mr. Johnson's class!" I tell her excitedly.

"That's great! He's an awesome teacher."

"Totally," I reply. "Want to come over to my house after school?"

"Sorry, but Mom and I have plans."

And like that, the clouds spring back over me with the force of a marble thrown from a stretched rubber band. *Please tell me what it feels like to have a mom,* I want to say, but I don't.

"See you after school." Beth waves to me and runs to her class.

Above me, the sky grows darker. I try to push it away, to shake it off as I make my way to see Mrs. Berringer, the school counselor. When my *friend* started to visit me, I began visiting Mrs. Berringer. Every few months, I make the appointment to see her with the intention of gathering information about the back pains, the muscle aches, and the dark dreams. But when I'm sitting in her chair, my *friend* is usually not with me, my body is well, and the dark thoughts are forgotten. Today the dark thoughts are with me and growing bigger. As I knock on Mrs. Berringer's door, the clouds dim and buzz quietly like a low-wattage electrical storm over my head.

"Please come in, Loung." Mrs. Berringer motions to the couch in her

office. With a reach of her hand, the door swings closed with a click, shutting both of us in.

I sit on her couch and sink into the cushions. The couch is too big for me and leaves my feet dangling in the air. I hate it when my feet don't touch the ground. I start to swing them, kicking the air as if it is water about to drown me.

"How are you today?"

My face cracks like I'm wearing a mud mask as I say, "Good, I guess."

"Is there something you want to talk about?"

I like Mrs. Berringer. She possesses a kind and maternal face that reminds me of Beth's mom. Still, I can't talk to her. The sadness is so unending, I fear it will swallow me like a black hole. I'm afraid that if I let go and cry, I'll never stop. And so I sit, hands clasped in front of me as I search for something to say.

"Well, I'm having a hard time with grammar," I finally say. Suddenly my eyes are tired and my nostrils are wet from the inside. I turn my head from her gaze to stare at her bookshelves.

"We can get you help, a tutor maybe." Mrs. Berringer writes something in her notebook. And like that, the moment is again broken. "I'll talk to a few teachers and see what we can arrange."

"Well, I'm also mad that Shelly passed a note to Nicole that said I'm annoying. I don't understand at all. I'm not even friends with her but she's saying bad stuff about me." As each word pours out of my mouth, I wish I could cup my hands over them and push them back with my fingers. I want to tell Mrs. Berringer there's so much pain inside me, that I'm lonely most of the time and scared a lot of the time. "Please help me," I want to plead to her. But I don't. I don't know how to make my mouth form the words I need to say.

So for half an hour, I ramble on about nothing. Mrs. Berringer looks at me while I talk without saying much. I speak faster when I think she might be annoyed with me for wasting her time with such petty matters. As my mouth continues to move, above me the black clouds spread out across the room. Behind Mrs. Berringer, last night's dream projects on the wall like a Technicolor silent movie. In it, I am running, the trees sweep past me, my long hair tangles around my neck, and my breath comes out short and shallow. A man chases me; although I can't see him, I know he's

behind me. Suddenly, I run into a house and grab a knife off a kitchen table. The man enters; the door creaks behind him. I grab him from behind and while I hold his neck with one hand, the other slices the knife across his neck. But the knife catches on his skin. I see that the edge is not sharp because I've grabbed a butter knife. Not letting go, I saw his throat back and forth as his blood splatters all over me. The skin on my arms still burns where his blood touches me. The thought stirs the bile in my stomach like thick gray toxic sludge. As the bile moves up, I grit my teeth and swallow a big gulp of air. When Mrs. Berringer looks squarely at me, I become even more nervous that she will ask me if something is wrong, so I begin to talk faster. While I spin my words, the air in the room grows stuffy and hot but my skin is damp and cold.

"Well, our time's up," Mrs. Berringer announces.

"Thanks for listening to me." I hold my smile.

"Come whenever you want. And check back later about the tutor."

"Okay. Thanks again."

I collect my things, leave her office, and head to the bathroom. I hurry down the hall, my steps quickening to a running pace as my body dry heaves and my stomach cramps. Urgently, I shove open the door to a stall, dump my bag on the floor, and kneel down by the toilet. From my gut, a toxic emotion swells and bubbles to the surface as I retch into the toilet. The poison heaves itself up my intestines to my throat, burning my esophagus as it catches there. With one more convulsion of my diaphragm, the venom comes out, spilling onto the sides of the bowl, tasting like spoiled food and rancid liquid. The war comes then, hot and fast in between the burps and hiccups. Then more convulsions, until finally I spit out only sour water.

When the last-period bell rings, I meet Beth at her locker. While Beth packs her bags, I watch Chris wrap his arm around Nancy, one of the most popular girls in school. Instantly, my heart beats rapidly the way it does after a three-mile run in gym class.

"Let's go home," Beth breaks my thought. "And you're way prettier than she is anyway!"

"Whatever!" I pretend to stick my finger in my mouth and make a choking sound of mock disgust at Beth's compliment. "Like gag me with a spoon!" I laugh.

On our walk home, my mood is again up, the sun appears brighter in

the sky, and the wind blows with no hints of waking up any ghosts. As Beth and I chatter on about our day, I do not tell her about my nightmares or how I got sick in the bathroom. In between our talks of school and boys, the clouds slowly roll away and dissipate into the atmosphere.

When I arrive home at three P.M., Eang and Meng hurriedly leave for work.

"Hi, sweetie." I pick up Tori in my arms and hug her tight to my chest. With my other arm, I grab Maria and spin around.

"Whee," she cries happily. "More, more!"

"No, sweetie, I get a headache with this game. Let's play movie star!" I tell Maria.

"Okay!" she hollers and scrambles up the stairs to retrieve my makeup kit. For the next hour, I tie colorful bows and ribbons in Maria and Tori's hair, paint their cheeks, brows, lids, and lips in bright blue shadows and dark lipsticks, dress them up in pretty dresses, and take their pictures with my Nikon camera. Afterward, we sit on the swing in the warm afternoon light, soaking up the smells of Eang's blooming flower garden. By the time I give them their dinners at six P.M., the sky is dark. At seven P.M., as I bathe the girls in the tub, outside the shadows grow and cover the world with an eerie stillness. When the clock strikes eight, the girls are in bed and falling asleep.

"I love you," I tell Maria.

"I love you millions," she replies.

"I love you billions."

"I love you infinity." She finishes the phrases I taught her and sleeps, a sweet smile forming on her lips.

As I leave them, I hear again the words many adults say to Meng and Eang when they are told of our story. "She's lucky she went through the war at such a young age," they sympathize. They believe that my age means I'll heal faster, that I won't remember. They are wrong. I *do* remember, I just don't have the words to tell them about it. And although most of the time I'm silent about the war, it's never silent to me. It's always with me, in the buzz of a low-flying plane, the boom of fireworks, the cry of a child, the hums of a mother, the hands of a father, and the rumbles in my stomach. And I'm sick of it all. I'm tired of waiting for the pain to heal. I want it cut out of my body.

Outside the windows, darkness grows and the wind cries softly while the trees rustle in anger. The darkness seeps into my body like a virus that grows in my stomach and quickly spreads to my chest, lungs, heart, limbs, and head. Wherever the virus travels, it makes my muscles and limbs weak. In my room, black shadows drip down the walls like blood. On the table, the clock ticks the seconds away.

In my bed I close my eyes. When I open them again, I am walking in a graveyard. The nightmare plays out like a déjà vu with the same open coffin in my path, and in it, the same dead girl lies waiting. I wake up and kick off the blanket to see blood on the towel I laid on the bed. Quickly, I toss the towel into the hamper, swallow two Tylenols, and try to return to sleep.

But the girl is always with me now and haunts me even as I lie awake. Through her eyes, I see Keav dying alone on a dirty mat far away from her family. When I turn my head, the soldiers are beating up Ma again for trying to buy a chicken to feed a starving Geak. Then I follow Pa as he walks off with the soldiers into a glorious sunset to stand at the edge of a mass grave.

I get out of bed and make my way to the bathroom, leaning on the wall for support. The wall is cold and unyielding.

"I'm just so sad," I finally say aloud, and in forming the words, something in me is released. "Getting your period means the chemicals in your body change," I reason with myself. "Yes, chemical changes."

In the bathroom mirror, the girl stares at me. Her eyelashes are wet, her face is haunting; she looks like the dead girl in my dreams. And the tears roll over me; like waves in the ocean they crash and pull me under.

"I'm tired." Tired, tired, tired . . . I reach into the medicine cabinet and take out a bottle of Tylenol. I pop four pills into my mouth. But the pain is still there. I pour out another handful. The pills dance in my palms, gleaming white and inviting.

"Just wanna sleep," I whisper. "I miss them so much." The sadness is a black hole in my gut, a vacuum void that sucks all the light in. "I'm so sick of running."

I feel nothing. Yet I feel everything. I cup my hand over my mouth and swallow the pills. The chalk gets stuck in my throat but I force them down. I crawl back into bed and let my body sink into the mattress. I wonder what it feels like to sink into the earth. Somewhere in Cambodia, I

dream that Pa and Ma are sleeping together in the ground. I close my eyes and wait for Pa to come take me with him. In her crib, Tori cries but I ignore her.

"Meng and Eang will be home soon," I whisper to her from my room. But Tori screams louder for my attention. Her wails awaken something in me.

I see images of Maria leaning over me. Her little face scrunches and twists as she caresses my cheeks to wake me up. Beside her, Tori's in dirty diapers crawling over my body, screaming for me to change her. When I don't wake up, Maria cries and pulls at my arm. When Maria disappears, I see four-year-old Geak holding Ma's head in her arms. Her lids are red and puffy as she tries to pry Ma's eyes open with her tiny fingers. When Ma does not wake up, Geak wraps her arms around her neck and refuses to let go. Her silent cries wound me a thousand times deeper than a cut with a knife. Slowly, I force my eyes to open. I know I can't make Maria suffer the way I imagine Geak did.

Finally, I rouse myself from the numbness to vomit out the pills into the toilet. I enter the girls' room and scoop Tori into my arms. Quietly, I change Tori's diaper, feed her, and put her back in her crib. Before I leave, I tuck Maria's blanket under her chin and feet.

"I love you infinity," I say. Wherever they are, I hope Geak, Keav, Ma, and Pa hear my words.

Back in my bed, I turn on the light and pull out a wad of loose-leaf paper from the nightstand drawer. In the sky, the moon smiles approvingly as I pick up a black pen.

"I was born in Phnom Penh, Cambodia." I begin.

part three **reconnecting in cambodia**

21 flying solo

"Kgo, you look purdy!" Four-year-old Tori compliments me.

"Yeah, I like your hair all big and puffy like that." Maria reaches out and pulls one of my curls.

"Careful!" I tell her. "These curls took me two hours with this skinny curling iron." I pull a few more sticky strands of burnt, long black hair off the iron, roll them between my fingers, and toss them into the white plastic trash can where they lie like a cat's nasty, coughed-up fur ball. Normally, I don't spend this much time twiddling with my hair, but what the hell—it's Saturday, and it's the last big party of my high school years.

"Kgo, is that what you're wearing or do you have another outfit in your bag?" At nine, Maria is as smart as she is beautiful.

"Smarty-pants!" I call her and ignore her question, not because I'm afraid she'll tell on me, but because I'm too busy spritzing my curls with maximum-hold hairspray. Even though they're so young, both Maria and Tori innately understand that there are things in my life that their parents do not need to know, especially things involving boys. Since I've had to babysit them from three to midnight all these years, they've met my various male friends who have occasionally dropped by the house to say hi. All these sightings could be used to blackmail me for a later bedtime or more designated TV hours, but they don't do that. Even when Maria's in her

brattiest and most mad-at-me mood, she has never told or threatened to tell her parents anything about me and the boys.

Truth be told, compared to American girls, my experiences with boys are pretty boring and consist of nothing but a few kisses and holding hands. But thanks to cable TV and all the movies about girls doing drugs, hooking up with boys, and dying on the streets, Meng has decided that if I'm allowed the tiniest bit of freedom, somehow I will become the kind of bad girl who does stupid things with boys and drugs. Most of the time, I find laughable the idea that my brother thinks his unpopular sister could have a wild and crazy life full of boys and parties. But sometimes this illusion makes me mad I want to make like Speedy Gonzales and ondele, ondele away from him.

"Beth's here!" Maria looks out my window and yells.

"Thanks, sweetie." I stand in front of the full-length mirror and inspect my matronly brown buttoned shirt and black calf-length skirt. Then I gather my hair in my hands and tie it at the back of my neck.

"Beep, beep," Beth's little blue Honda calls to me.

"Out of my room, sweeties." I chase the girls out, grab my big purse, and close my door. At the bottom of the stairs, I exhale a sigh of relief when I don't see Meng sitting on the couch guarding the door. It is nine P.M., normally the time when he likes to relax on the couch watching TV or reading one of his Chinese books. And unfortunately for me, some very bad designer put the living room in the same space as the front door, thwarting my many attempts to leave the house undetected. But tonight, Meng is nowhere in sight. "Maybe a clean escape this time," I think wistfully. Quickly, I slip on my black two-inch-heel strappy sandals, grab my keys off the top of the TV, and swing open the gate of my prison. As I am about to cross the threshold to freedom, Meng runs into the room.

"Where are you going?" he asks.

"To dinner with Beth, then maybe to a movie or a girls-only get-together," I answer, avoiding the word *party*.

"What kind of get-together starts this late?"

"It's a last-day-of-high-school thing. Everything starts late."

"What time will you be home?"

"Midnight," I lie, and start out the door.

"Wait, come back here," Meng orders me.

"What?" I reluctantly head back in. While I stand frozen in my annoyance, Meng walks over, reaches out, and buttons the neck button on my shirt.

"Okay," he smiles. "Now you can go."

"Huh, thanks." I glare at him with embarrassment.

"Dear god!" I think. "I'm nineteen!" I run out the door angry and jump into Beth's car.

"Hey, babe, thanks for picking me up."

"No prob."

"And sorry I kept you waiting, but you would not believe what my brother just did!"

"What'd he do this time?"

"He buttoned my top button for me!"

"You must be joking!" Beth laughs so hard, she shakes the steering wheel.

"Hell, at this point, I can't even tell if he's joking or not anymore. Just last month I went with the family to Montreal. At a rest stop I went to use the bathroom and some crazy trucker whistled at me. Meng got out of the car and followed me to the restroom! Then he waited outside until I was done to walk me back to the car! I was like, what? What is he going to do? The trucker was probably six foot five and two hundred and fifty pounds. And Meng is five-four and one hundred and thirty pounds. I was so mortally embarrassed."

When Beth stops laughing, she turns to me and says in a serious voice, "You know, babe, he's a decent guy. He's strange, yes. Way overprotective, sure. But he's a hardworking decent guy with good morals, or else you wouldn't have turned out so well."

Of course, I know Beth's right. Meng *is* a decent guy. And I'm thankful that he's fed and sheltered me, and worked so hard all these years so I can stay in school. But I feel like a worm in a cocoon wrapped in all these layers of thread to keep me safe and hidden. I can't wait to bite my way out of all the trappings and find out whether I'm going to fly or fall flat on my face.

"All right, slow down a bit so I can change before we get to the party," I tell Beth when we're safely far enough from my home.

I reach into my bag and pull out a short black miniskirt. Quickly, I

pull down my skirt and shimmy on the tight skirt. Then I shrug out of my button-down shirt and slip on a black sleeveless top that hugs my chest. I reach into my bra and adjust my breasts with hope that they'll appear more heaping and full.

"All these years of 'I must, I must, I must increase my bust' didn't do anything for me!" I complain. I pull down the vanity mirror, let my hair loose, and put on my favorite big silver hoop earrings. "Cool, now I look like Cher!"

"Yeah, your hair is sure big enough!" Beth laughs.

When we get to the party, most of the cool kids are already there smoking cigarettes and downing beers. They hang together in their corner, occupying the space as if they own even the air around it. Circling on the outer ring of the genetically blessed are the leeches who'll do anything to be part of the elite crowd. Like the squirmy, wriggly bloodsuckers I've nicknamed them after, they've got two mouths: one to talk sweet, and one to bad-talk you to anyone who'll listen, just to make themselves interesting. I'm very careful around the leeches and observe with fascination their need to hook and feed on their host.

I can't believe I still care! I fume at myself. *I know I don't belong to any group, except maybe the misfits, but what the hell—I'm leaving all of this very soon! I'm an adult now! And grown-ups don't waste time on such trivial matters as fitting in.*

When I spot Beth talking to a few people we know, I make my way to her in my grown-up clothes. As I walk, my skirt rides up my thighs and I awkwardly attempt to pull it down. When I look down at myself in the dim room, it's as if my body's disappeared into my black outfit and only my legs catch the light.

"Hey, Loung. You've got meaty legs!" Though Tim yelled that to me our freshman year, I hear it still in my head when my insecurities are in full swing. I stare across the room and see Tim lounging in the middle of the cool corner.

For the next hour, I sit and talk to some guy who's probably as bored as I am but I've got no one better to talk to, so we stay together. Whenever he pauses, I search the room for signs of Chris. Finding no trace of him, I ask Beth to leave the party. Since she's not having fun either, we leave.

I arrive home at eleven-thirty P.M.; the house is dark and everyone's asleep.

"So much for Meng's crazy thought of my wild life," I think as I shuffle into my room, kick off my heels, and fall into my bed. "Oh, but tomorrow is graduation day!" I say out loud with glee. "And in two months," I whisper, "I'll be gone and out of the house. Then I'll get a life."

I blame my lack of social life on Meng's strict rules, the endless babysitting, and memories that won't go away. Most of all, I blame Meng for these memories, for keeping me tied to Cambodia. I know that ghosts from the Khmer Rouge are there all the time, floating around in my living spaces, eating out of my plate during dinner and sitting at my desk as I study at night. I prefer to steer out of their way and make no contact with them. But I see them in Meng. And though he and I don't talk about their presence, the look in his eyes and the frown on his face whenever Cambodia is mentioned make it impossible for me to escape them unless I escape him.

In two months, I'll leave them both behind. Even though I'll only move seven miles down the road, I look forward to college as a place where I'll be able to live a guilt-free, indulgent life and not have to worry about how things are going in Cambodia. Away from Meng, I'll be able to splurge on an expensive meal without thinking, "That twenty dollars is Khouy's income for a month." On campus, I'll be able to walk around light-footed and fancy-free, just like the other Americans.

I roll over on my stomach and pick up a letter from the nightstand. All of a sudden, the party's awkward moments disappear as I reread the words on the page.

"Dear Ms. Ung," the letter begins. "We are pleased to inform you that you have been awarded the Turrell Scholarship Fund." I hug the letter to my chest.

"Thank you, Mrs. Berringer, for my ticket out of here!" I send my gratitude into the night air.

I can't believe that just six months ago, I sat in Mrs. Berringer's office thinking I wouldn't go to college. While I sat, Mrs. Berringer worked out the numbers of loans I could take out and what grants I might be able to get. When I saw the price tag, my hands had trembled with fear.

"My family just doesn't have that kind of money," I'd said somberly.

"You can take out loans. You'll get grants." She urged me not to give up. But the idea of signing for a loan that large when the combined income of all of the people in Chou's village was still only a fraction of what I'd have to borrow—well, it tightened that noose around my neck to the point where I felt like I would lose consciousness.

"I can't breathe, just looking at the numbers!" I'd told her.

"And here's an application for a scholarship fund I think you should apply for."

"Mrs. Berringer, my grades aren't good enough. No one's going to give me a scholarship!"

"Just do it. We'll fill out the application together."

Five months and one interview later, I got a letter back from the Turrell Scholarship Fund informing me that the fund would pay for my full four-year college tuition, room, board, books, and health insurance.

"I'm going to college and it ain't costing me a dime!" I laugh and pound my legs into the mattress. "Wherever you are, thank you again, Mrs. Berringer."

As I drift off to sleep, I dream I'm flying. My arms spread to the side like wings, and my hair flows with ribbons behind me. I fly like a dragon. I look up at the sky and yearn to zip right up to the heavens, but I don't. I fear that if I go too high and others see me, they will catch me and cut me open to find out what is wrong with me and why I can fly. So I only hover over the trees.

A few hours later, I open my eyes to the familiar clanging of Eang's pots as she makes our breakfast. Quickly I shower, wash my hair clean, blow it dry, and then dirty it again with hair spray. When I return to my room, I find Eang's Cambodian-patterned sarong and shirt neatly laid out on my bed. I know Meng would like me to wear a piece of Cambodia under my graduation robe. But hanging on my door is my hot pink, less form-fitting, more comfortable, Western-style dress.

I reach under my bed and pull out a shoe box marked BOX OF VERY IMPORTANT THINGS. In it, I keep my artwork, poems on death and dying, letters, and the three hundred pages I wrote two years earlier about Cambodia, our family, and the Khmer Rouge. Over the months and years, as

my body adjusted to its new form and survived the traumas of puberty, the war haunted me less, and the need to write about them disappeared.

As I stare at the pages, my eyes cloud over. After I'd written it and captured my demons down on paper, I shut them in this box and focused on my American life. And two years later, the war seems so long ago that sometimes I can hardly believe that it was me who lived through it.

If the war is a distant story, the girl who wrote these pages is a stranger to me now. As I flip through them, my hands tremble slightly, remembering the guilt and tortured emotions that brought about the story. I remember how when the girl started to write, she couldn't stop. The story was like toxic poison that demanded to be purged out of her body, forcing her to write during breakfast, in class, and at night after everyone had gone to sleep. Sometimes she was so caught up in the battles, she forgot to come down for dinner until Eang hollered for her. For six months, the girl wrote until her fingers cramped and grew calluses, and her forearm ached at night. When she was done, there was a beginning, a middle, and an end, and she believed that her story was finished. She understood then that she didn't want to die, but that she just didn't know how to live with the ghosts. Now that she'd captured them, she thought perhaps she might live.

On my bed, I feel the paper and remember the girl. I know that she is Cambodian and she is me. But it's too soon for us to fully join and become one. Still, today, I will walk with her when my name is called to receive my diploma. I rise up off the bed and wrap the beautiful silk sarong around my waist. I imagine that Keav and Geak are in the room, watching me. When I slip on the shirt, I dream that Ma is there helping me. I am the first girl Ung to graduate from high school. As I put on my blue graduation robe and hat, I picture Pa standing by the doorway, smiling.

22 a motherless mother

"You have another daughter!" the midwife tells Chou. Chou tries to prop herself up to see her daughter but her arms give way and she falls back onto the mat. In her fog of pain, she hears the midwife splashing water on the baby.

Closing her eyes, Chou lets her body sink into the soft mattress of many layers of towels and sarongs. Below her plank bed, a small fire burns to warm her, but the smoke flows up between the wooden slats and stings her eyes. From the altar, burning incense drops white ashes on Chou's floor, waiting for her to sweep it away. Next to the incense bowls, melted candles flicker soft light, illuminating their sparse, one-room thatched hut.

"Here she is. She's healthy and strong like her mother." The midwife wraps the baby in a sarong and lays her on Chou's chest.

"Chang." Chou caresses Chang's cheeks. "You caused me much pain." Chou lifts Chang's hand and presses it against her lips. Chang does not respond and ignores her mother with her closed eyes. For a moment, Chou's thoughts shift to Ma, her eyes well up knowing that her children will never meet their grandmother.

"Chou, drink this. It'll help heal." The midwife brings the concoction of herbal tea to Chou's lips. Balancing Chang on her chest, Chou raises herself up and sips the bitter liquid. With a grimace, Chou forces herself to empty the cup before handing it back to the midwife.

"You rest while I clean you up now," the midwife says as she assists Chou back onto her pillows. As she closes her eyes, Chou is conscious that another person has come into the hut. Moments later, the sound of water being poured into a large plastic basin reminds her of a rushing brook near their hut. The midwife rinses out the cloth and spreads the warm wet rag on Chou's belly. Working in a circular motion, she gently wipes down her groin, pelvis, thighs, and legs. After a few more rinses, the midwife cleans Chou's feet and toes.

"You're all clean," the midwife says and covers her up with a blanket. Next she helps Chou slip on a brown long-sleeved shirt. "The baby is sleeping now but she'll want to nurse soon. So you rest while you can. I will go tell your family the good news." The midwife drops the mosquito net around her.

"Thank you," Chou murmurs. The midwife exits the hut carrying a large silver bowl with the afterbirth and some dirty clothes. Chou raises her head and catches a glimpse of black sky and bright shining stars before the door swings shut and leaves her in the dark again. While Chang and she rest, Chou follows the slapping sound of the midwife's flip-flop sandals as she crosses the patch of ground to Uncle Leang's house. There, Chou pictures her four-year-old daughter, Eng, and two-year-old son, Hok, asleep with Aunt Keang in her mosquito net.

When she wakes up, Chou finds her husband asleep in a hammock. Next to her, he has left a gift wrapped like an egg roll in a piece of old cloth and tied with a few strands of brown straw. Smiling widely, Chou unfurls it to find the most beautiful pair of shoes she's ever seen. Her eyes widen as she brings the shoes close to her nose and admires the tightly knit lines in the straps, and soles that are just her size. The white plastic shoes with their one-inch-thick heels and crisscrossed straps shine brightly in the shimmering twilight.

"Not flip-flops or sandals made out of leftover car tires, but real shoes!" she whispers. "And not a scratch on them." In his hammock, Pheng abruptly turns to his side, scratches his head, and continues to sleep. Chou smiles warmly at him and carefully rewraps her shoes like a pair of precious gems.

For the next two months, Chou grows thin and lean while her fat transfers from her breasts to Chang's chubby body. Chou knows that she is

becoming an ugly woman because she is too thin. In Cambodia, fat peo-
ple are considered to be rich and healthy, therefore it is a compliment to
be told one is fat. And though she tries to keep her body plump and round,
her worries eat at her flesh like a disease. In the cities, as in the villages, fear
of Khmer Rouge attacks have resurfaced and spread through the country.
Pheng tells her it's because after ten years of occupation, the Vietnamese
are pulling out of Cambodia and taking their troops, numbering over
180,000, with them. Without the Vietnamese soldiers and guns backing up
the Cambodian government's army, at night the Khmer Rouge are
brazenly invading villages and towns more frequently to steal food, clothes,
and animals and to kidnap men and boys in a struggle to keep their move-
ment going. When Chou hears this, she is glad Kim is no longer with
them in Cambodia, but is safe in France, living with Ma's youngest sister,
Aunt Heng. Still, she misses him and prays he'll return one day to meet his
nieces and nephew.

On the day Chou began her new life as a wife four years ago, she
knew Kim took it as a sign that it was time to leave his old life behind.
He'd been ready before that, but with Khouy in another town with his
own family, Kim would never have left Chou. Just a month after she mar-
ried, Kim left the village and rode all morning on a wagon to the old cap-
ital city of Ou-dong to live with a distant relative. Kim wrote to Chou that
he was shocked to find hundreds of Vietnamese soldiers there, parading the
city with their guns swinging from their shoulders. At first Kim was glad
for their presence, but as weeks turned into months, the soldiers' smiles
changed into scowls as news of the Khmer Rouge resurgence reached the
city. To counter the Khmer Rouge incursions, the Vietnamese-controlled
Cambodian government forcefully conscripted young Khmer men and
boys to build a five-mile-long bamboo wall along the Cambodian-Thai
border. These men worked in horrible conditions and with little food,
shelter, or medicine. Those who survived returned to tell stories of their
friends dying from mine explosions, starvation, malaria, hard labor, and
diseases. And for all those returnees, there were many who were never
heard from again. For Chou, reading Kim's letters was like reliving the
Khmer Rouge war all over again. Yet in each letter, Kim told how he had
managed to evade the forced labor.

Every month, Kim had visited the village under the guise that he wanted to see the family, but Chou knew he came to check on her. In their quiet times together, Kim described how he felt like a prisoner as he spent his days hiding out from the soldiers, attending high school, and clandestinely searching for ways to leave Cambodia. At night, his headache grew as the old familiar fear and paranoia of being caught, exposed, betrayed, and kidnapped resurfaced. In his sleep, the anger against the Khmer Rouge, Vietnamese, and Cambodian government soldiers intermingled, and his headache turned into searing pain that traveled from his temples to his eyes before flaring out of his nose in deep exhalations. Each day, he woke up more determined to leave Cambodia before it was too late.

Then, six months after he left the village, Kim had disappeared. A few days later, Khouy received word that he was in a refugee camp in Thailand. Four months after that, Khouy received a message telling him that Kim was in France. Chou had been so relieved to hear that he'd found his way to where he wanted to be. Chou is happy for him, and dreams of a day when all the siblings will reunite in Cambodia. Sometimes she still fantasizes of a life living with Meng and Loung in America, but she knows it is too late for her now. And with the birth of each child, she feels her roots growing deeper in Cambodia's soil.

On this day, Chou straps Chang to her chest and tills her land and garden to grow food for her family. In the dirt and mud, her soles slap against her old, worn-out flip-flops. After two months, her new shoes are still wrapped up inside the hut because she can't bear to get them dirty or scratched. On the ground beside her, Eng and Hok play by themselves, their grimy fingers constantly pulling out earthworms from the upturned soil of Chou's shovel. While Chou keeps the house and minds the children, Pheng typically does all the heavy work of collecting water, chopping wood, and farming their rice fields.

By the time Pheng arrives home in the evening, Chou already has their dinner cooked and the children bathed and ready for bed. In the twilight, Pheng eats and plays with his children while Chou serves him, feeds the small children, and devours her food quickly. Then when the sky grows dark, Chou, Pheng, and their children snuggle close to one another

to keep warm under their one old mosquito net as they drift to sleep. Above their porous hut, the moon lights up the land like a giant white Chinese lantern.

One night, the family's peaceful sleep is interrupted by the distant barks of their neighbor's dogs. As if picking up the distress signals, Uncle Leang's two dogs wake the two houses with their desperate screeches and howls.

"Quick, Pheng—the Khmer Rouge!" Uncle Leang shouts as he pounds on their door. The force of his knocks shakes the whole compound. Pheng leaps out of bed to let him in.

"How far are they?" Pheng hastily slips on his sandals and grabs an ax.

"I don't know. Maybe very close. We must go and hide now." Uncle Leang grabs Pheng's arm as he turns back to look at his young family.

"Chou, go to Aunt Keang's house and stay there until I come back," Pheng tells her. And then he and Uncle Leang disappear into the dark woods. The noise of their bodies brushing against shrubs and bushes follows them, but then all is quiet.

In their silence, Chou stands gasping, her heart pushing at her chest. As her eyes fog over, the ringing in her ears turns her mute and deaf.

"Ma," Eng calls out, her voice dazed and confused. "Ma? Pa . . ."

Immediately, Chou snaps back to life. She cinches her sarong tight around her waist and jogs to the bed. Pulling the net open, she scoops up Eng and puts her down on the ground.

"Eng, wake up and make no noise," Chou orders her urgently. Too frightened to answer, Eng rubs her eyes and nods at her mother. Chou then grabs sleeping Chang and Hok and cradles one in each arm. "Eng, walk to Amah's house. Walk in front of Ma. Quickly." Slowly, Eng walks with unsteady legs as she feels her way on the bumpy ground in the dark. A few meters away, tied to a tree, Uncle Leang's dogs bark at them, their front legs leaping into the air.

"Quickly, Eng!" At the sound of her mother's raised voice, Eng begins to cry and her legs stop moving. Chou runs to Eng and picks her up off the ground. With her back bent by the weight of three children, her barefoot wide feet spread out like webs, she marches to Aunt Keang's house.

"Aunt Keang," Chou calls at the door, her voice rising above the barking dogs.

"Chou, come in!" Aunt Keang's voice shakes, and she opens the door. She takes Eng from Chou's hands. "Quickly, find a place to hide."

With the precision of someone who's done this many times, Chou takes her children and crawls under a plank bed while Aunt Keang locks the door with a wooden beam. Chou sits in a cross-legged lotus position while her two small babies sleep on her lap, their heads cradled in her arms. Next to her, Eng holds on to Chou's arm, her small face pressed against her mother's flesh.

"Ma, why don't we let the dogs loose so they can bite the Khmer Rouge?" Aunt Keang's little boy Nam asks her.

"No, my son. That will only make the soldiers more angry and more trouble for us," Aunt Keang explains and wraps an arm around Nam.

"Chou, they will be all right," Aunt Keang tells her in a small voice. "The Lord Buddha will look after them." Chou silently echoes the prayer in her mind.

In the blackness of the room, Chou sees the red amber of the mosquito coil under the other plank bed. Around the small light, the dark shapes of the rest of her family huddle together. On their side of the room, Aunt Keang cradles her infant daughter Hoong in her arms and Amah sits with Nam on her lap. As they try to stay quiet, mosquitoes buzz around them in the hot, oppressive air. Outside, the dogs bark and howl loudly; their cries reach a frenzied pitch when dark ghosts emerge from the forest and run past them toward their master's house.

"Open the door!" a Khmer Rouge soldier barks. Chou's skin goes cold as she places her hand over Eng's mouth. "Open the door or we'll shoot it open!" Chou holds her breath and grits her teeth. In her arms, as if picking up their mother's terror, the babies shiver and stir. "Open the door now! When we count to three, we'll shoot! One!"

"Stop!" Aunt Keang cries out and rushes to open the door. The lead soldier pushes her aside, his rifle hanging off his shoulder and pointing straight out in front of him.

"The rest of you, come out of your hiding place!" Startled by the loud noises and the soldiers' screams, the babies and infant children begin to cry, their wails filling up the hut. "Don't you hear?" the lead soldier demands. "I said come out now!"

Slowly, Amah crawls out on all fours, her bony knees scraping against

the ground. Chou leaves her crying children under the bed and comes out after Amah. Behind her, the older children exit their hiding places while the toddlers and babies scream for their return.

"Only women and babies!" the soldier declares in disgust. "Where are the men and boys?"

"Good comrade," Aunt Keang pleads. "We are a poor family. Our husbands and sons have to travel very far to sell our vegetables and crops. They are not here."

The soldiers ignore her words and shine their flashlights under the beds. They still believe that all Chinese are rich and have gold in their houses. The small units of four soldiers all have guns swinging from their shoulders or waists. They roam through the hut, turning over crates, bags, and boxes. Since they can't find the men, the soldiers sift through the clothes and stuff what they want in a burlap rice bag. Then they walk around the hut as if it's a market and take pots, shoes, bags of rice, and dried fish. While they steal from the family, Chou's breasts wet her dark shirt with milk at her baby's cry. Outside, she hears more soldiers rummaging through her hut while the dogs bark on.

"No men and boys here!" a soldier shouts from Chou's hut. Suddenly Chou hears the soldier curse the barking dogs and many loud solid thuds as he kicks them. The dogs yelp and then whimper, and then finally the lead soldier leaves Aunt Keang's hut.

"Just take whatever we can use, then!" he shouts back in anger. After a moment, he reenters the hut, picks up a crate of the family's silverware, and throws it against the wall. The noise splits open the night air and deafens Chou's ears. "Where are your husbands and sons?" The soldier grabs Aunt Keang's arm and glares at her.

"Please, comrade, they are not here."

"Please, comrade, take whatever you want but don't hurt us!" Chou begs and steps forward to stand by Aunt Keang. "Please don't hurt us." Chou takes Aunt Keang's other arm.

The soldier looks at them with annoyance. "Let's move on!" he hollers to his unit, and exits the hut. The family thanks him profusely as the rest of the soldiers grunt and pick up their bags of stolen goods. Still shaking, Chou watches the last soldier grab Uncle Leang's old bike and

push it out the door. The bike's wheels spin and rattle into the forest until finally everything is quiet again.

"Amah, come." Chou leads her to the bed. "You rest." Chou puts the babies back on the bed under the mosquito net. "Eng, watch your brother and sister."

In the soft golden candlelight, Chou helps Aunt Keang pick up the crates and put their hut back into order. As she works, Chou prays for the safety of her husband and uncle. When the dogs bark again, Chou rushes out to the door.

"Pheng!" she yells, her hand gripping the door.

"I'm here as well," he replies softly. Chou feels her stomach steady and exhales with relief.

"Thank the Lord Buddha you're both safe!" Aunt Keang ushers them into the house. "What happened? Where did you hide?"

Once the women and children tell the men their story, Pheng begins to tell his.

After they left Chou, Pheng and Uncle Leang ran into the woods not far from the hut and made their way to the neighbor's fields. There they found a cluster of big metal containers that the neighbor uses to collect palm juice and make sugar. Though many were full, Pheng found two empty ones where he and Uncle Leang could hide. Quickly, each climbed inside and slid on the wooden lid. Inside the containers, the air smelled of rust and sweet palm syrup. As he sat on top of a layer of sticky sugar, Pheng's feet instantly began to tickle as if marched on by hundreds of little legs. Before Pheng could brush them off, the ants bit his ankles, the soft tissue between his toes, and the arches of his feet. But as he was about to leap out of his container, he heard people approaching. He knew no villagers would travel at night. Pheng clamped his teeth together while the ants feasted on his flesh. As the soldiers passed by, one abruptly banged a metal tin with the butt of his gun. Without thinking, Pheng fell to his knees and crouched lower in his container.

"It's full!" the soldier yelled as he kicked a few more. With each kick, the tin made a small noise as palm juice splashed against the lids. "Should I check the rest?"

"No, let's go!" another soldier replied, and then they were gone.

When Pheng finishes the story, Chou, Pheng, and their children carefully return to their own hut. Chou retrieves a small tin jar of tiger balm and rubs the oil on Pheng's back while he does his legs and feet.

"It's lucky the Khmer Rouge didn't look for the cows in the back of the outhouse," he says. "What else did they take from our hut?"

"Just two of your shirts and a bag of rice," Chou answers quietly.

"We're lucky. I still have one shirt left." Pheng yawns and lies down.

By the time Chou's head sinks into her pillow, she knows that when tomorrow comes, she will sell her new, never-worn white shoes to buy her husband another shirt.

23 no suzy wong

January 1991

My toes are beginning to go numb with cold. I imagine they will soon become gangrened and snap off my feet like icicles off a roof. I wiggle them to get the blood circulating and stare through the glass door at the parking lot. No signs of Mark's jeep. It's twelve noon. He's thirty minutes late already. I press my hands on the door and will him to show up but he doesn't. High above the earth, a small sun shines brightly in the clear blue sky. In the parking lot, tall piles of packed snow are slowly melting and creating black slush on the ground.

When I finally hear the roar of an engine, I glance up only to see an old Honda Civic inching its way toward the front door. A girl sporting a black, lumpy down jacket and a black skullcap climbs out and runs to the door as the car sputters away, white smoke puffing out of its exhaust pipe like storm clouds.

"Hey." The girl opens the door and greets me, sending in a cold gust that stings my cheeks.

"Hi." I smile back as she ascends the steps. I wrap my arms around myself and considering returning to my room. But I live on the fourth floor and am too lazy to make the trip.

Mark and I met last semester in our political science class. I was writing in my journal when he walked into class with his long, dirty-blond hair tied up in a ponytail. As he crossed the room in unhurried strides, I

took in the details of his blue jeans, fashionably shredded and ripped at the knees, and his wrinkled black sweater and multicolor woven belt. I was intrigued. On a campus full of pressed shirts, khaki pants, and brand-name dresses, he didn't look the part of someone attending a four-year private Catholic college. And so in class, I secretly took pictures of him, my eyes like paparazzi cameras snapping up images of him from my perch.

Then after class one day, I approached the professor about an assignment. The next thing I knew, Mark was standing beside me with his questions. As the professor rushed off to his next class, he suggested that Mark and I discuss the material. We decided to meet over coffee. By the time we were through with the first cup, I had told Mark bits and pieces about Cambodia and my interest in politics. Halfway through the second cup, he shared that he took his sophomore year off to travel, and worked as an English teacher at a refugee camp in the Philippines. When we were both sufficiently caffeinated, I told him about the guy I was dating and he talked about his girlfriend. That was six months before.

And now he's predictably thirty-five minutes late to pick me up for our hiking date.

In my mind, Mark's lateness can only mean one of two things: either he's been injured in an accident and is lying somewhere with his head gashed open and red blood melting the white snow around him, or he's dead. I imagine his cold body lying in a hospital, pale and lifeless and unable to reach for a phone to call me. If he is dead, I hope at least that his death will be quick and painless.

When Mark's jeep finally pulls up, he leaps out of the car to open the door for me.

"Sorry I'm late," he says with a sheepish grin.

"Again," I return with a steely gaze.

"Ready?"

"You're always late. You know I hate waiting."

"Come on, I'm sorry. It's a gorgeous day and the sunset will be spectacular!"

I stand my ground and glare at him, my feet frozen to the ground.

"I'm really sorry. Let's go. I'll buy dinner at The Mandarin afterward." Mark knows The Mandarin is my favorite Chinese restaurant.

"Fine, but I'm still pissed," I tell him and get into the jeep.

★ ★ ★

Though it's a short drive to the mountain, it's a four-hour round-trip hike. I tuck my two pairs of long johns into two pairs of socks and tie my heavy Timberland boots tight around my ankles before pulling my jeans over them. Then I put on my wool cap, wrap a scarf around my neck, and slide my hands into my ski gloves. Before I step out of the jeep, I zip up my winter jacket on top of three layers of sweaters.

"Okay, I'm ready," I announce.

"You know, it's thirty-five degrees and sunny," Mark comments as if this makes a difference. He wears only one layer of everything.

"Hey, if it's not eighty degrees, it's too cold," I conclude, and hike in front of him.

On the trail, Mark stops every five minutes to stare out at the lookout points and I have to wait for him to catch up. And after two hours, my body, toes, and fingers are snug and very toasty under all my layers.

"Wow, look at that view." He spreads his arms out like a bird. "It's beautiful."

From two thousand feet above sea level, the snow-covered world is magnificent and silent except for the whistles of the wind above the trees. As I breathe the clean, crisp air, the cold air reaches my warm throat and burns.

"All right, let's go." I cough and resume my exercise.

"Can you believe you're hiking in the winter?" Mark asks beside me.

"Well, you know what they say, if you can't beat them, join them. I still prefer sun and sand but I can't sit around all winter just eating and getting fat," I answer, and reach into my pocket to grab a Snickers bar.

"And you sure like to eat!" Mark laughs.

"Damn right." I chomp into my candy bar. I love food. But not just any food—I love fried chicken, fried shrimps, fried beef, fried catfish, fried pork, fried eggplant, fried mushrooms, and anything Asian and spicy.

"But isn't it beautiful out here? Now?"

"Uhh," I shrug. "It's more beautiful in the summer."

By the time we make it to the top of the mountain, the sun is already sinking behind the horizon. Off the cliffs before us, bright colors of gold, orange, pink, magenta, and red splash across the sky, giving us a majestic sunset that even the gods themselves would admire.

"Wow," Mark utters with awe.

Unlike Mark, each bright color hurts my gut so viscerally I want to reach in and cut out the cause. In each breathtaking sunset, Mark sees romance, peace, and beauty; I see the outline of Pa and two soldiers walking away from me.

"It's getting late. Let's go," I tell Mark, and head back down the mountain.

For the next forty-five minutes, I thrash down the trail, running away from the sunset. By the time I reach the car, my chest burns and my legs shake with exhaustion.

"I'm starving!" I huff.

"Yeah, it's been at least two hours since you last ate," Mark laughs.

"Let's go for some Chinese."

In the jeep, my insides twist into painful knots. I reach into my coat and pants pockets and rummage through my backpack. I'm usually good about having food with me wherever I go, but not today. Suddenly my hands begin to tremble with anxiety. I wrap my arms around my stomach, which growls as if it hasn't been fed for days. I lean back into my seat, close my eyes, and inhale and exhale deeply.

"You okay?" Mark's voice sounds worried.

"I'm starving," I murmur, close to tears. Then suddenly I snap. "Why the hell can't you go faster? God damn it!"

"Chill," he tells me.

"What the hell? I'm starving! How can I chill? What the hell do you know about starving?" I turn my head away from him and dig my fingers deeper into my stomach.

Mark is silent. I focus on the heat blasting at full force through the ventilator. The loud noise distracts my thoughts from food and for a moment calms me.

"Sorry I cracked," I finally tell him. "I just don't like being hungry." I say nothing more and continue to gaze out the window as the jeep curves along the winding road. I stare at each passing road sign, concentrating on each one until my pupils narrow and my surroundings fade out. As time passes, I grow calm, but I've also checked out. My identity has shrunk down to two unblinking eyes zeroing in on road signs with laser-beam precision.

Then in the distance I see a marker for a country store.

"Stop at the store," I tell Mark. "Please."

"I thought we were going to eat at The Mandarin."

"I can't wait that long. We'll go to The Mandarin some other night."

"Okay." He parks in front of the store.

While Mark stays in the car, I walk in and grab a few candy bars, stale bagels, beef jerky, bags of potato chips, and cans of root beer. From the counter, a man in his sixties follows me with his eyes as I make my way around the maze of junk food to the cashier. As he rings each item, he glances up at my face. When I reach into my pocket to pay him, he smiles and says, "Young lady, has anyone ever told you that you look like Suzie Wong?"

"No. No Suzie Wong here." I give him the money and leave with a tight smile.

In the car I crunch on the chips loudly, but the noise does not shut off the old man's question. Most Asian girls who've heard of Suzie Wong dread the comparison. Suzie Wong, after all, is a character in an old movie titled *The World of Suzie Wong*. In the part, actress Nancy Kwan played the character of a popular Chinese prostitute with a heart of gold who falls in love with an older white dude and gets rejected. I was bored with the movie but watched it when it was on TV because it was the first one I saw that actually had an Asian woman playing an Asian woman. After many years of watching movies where white women taped their eyes to play Asians, Kwan was at least the real deal. But I look nothing like her. We have different eyes, noses, mouths, and body types.

It's seven P.M. when we arrive back at my dorm.

"Sorry we didn't get to The Mandarin," Mark says, and stops the jeep in front of my door.

"Oh, don't worry. You'll pay next time," I assure him and get out. Then I stop and turn back. "Sorry again about going psycho on you," I say sheepishly and look away with embarrassment. "I think I'm manic or something." I smile and try to think of something else to say. "Oh, by the way—if you ever run into my boyfriend, pretend you're gay."

"What?" Mark bursts out laughing so hard, his blue eyes squint and disappear just like an Asian's.

"Yeah, he was getting jealous, seeing you in my room all the time, so

I told him you like only boys. And he believed me." Because Mark is so pretty, stylish, and nice, it's easy to convince people he's gay.

"That's why I like you. You're never boring." Mark wipes his eyes. "Pick you up at ten-thirty for the party?"

"Sure. Don't be late!" I holler as the jeep takes off, knowing it's no use.

Back in my dorm room, I quickly glance at my calendar for the week. In between classes on the Old Testament and Luke, Matthew, and Paul, I have feminist theology, Hinduism, and witchcraft. Then there are meetings with the students' Hunger Program, Diversity Club, and International Student Association. On my desk, the piles of homework and study sheets await my attention.

"It's Saturday night. I have Sunday to study," I tell myself and leave the room. I walk down the hall to Suzy, Janey, and Amy's door, but no one's in. Briefly, the insecure high school girl resurfaces as I wonder if all the girls went to some cool party and didn't tell me about it. I shake off the old feeling and knock on Hailey's door.

"Come in," Hailey answers.

"Hi, Hailey. What ya up to?" I ask and plop myself on her bed.

"I'm making a birthday card for a friend." Hailey looks up from her colored papers, scissors, and glue bottles.

I met Hailey on the very first day of our freshman year. We were both assigned to paint a file cabinet in the work-study program. In between sanding off the old paint and splattering on a new red coat, we talked about her year off living in Denmark and my years growing up in Cambodia. After our first day, Hailey researched and read up on Cambodia and the Khmer Rouge. This touched me in such a profound way that my eyes became red when she told me. For once, someone actually took the initiative to read about Cambodia and come to me with facts about the war and the Khmer Rouge's politics that even I didn't knew. For the next weeks, while we painted our one cabinet, Hailey became the very the first person I ever talked with at length about the Khmer Rouge genocide.

And now she's writing a paper on me and my experience in Cambodia for her English literature class.

"Hey, do you have time to finish the interview now?" Hailey asks while peeling bits of tissue off her hands.

"Sure."

"Hold on. Let me get my notes." As Hailey gathers her questions, I stare at the photos taped to her walls. Like Beth, who is at another college, Hailey is blond, blue-eyed, and beautiful. On her desk, pictures of her mom, dad, sisters, and brother line up neatly, forming their perfect family.

"Okay, I'm ready." She sits herself next to me on the bed.

For the next hour, I share the details of how my family and I fled the city to live in overcrowded villages, where we learned to live by a new set of rules. I tell her about the Khmer Rouge's ban on religion, school, music, clocks, radio, movies, TV, and machinery and how the soldiers controlled our travel, friendships, and relationships. I shocked her with facts that during the Khmer Rouge time, there was no dating and no falling in love without the Khmer Rouge's permission, especially if you were from different classes. And if you had sex without permission from the Khmer Rouge government, you could be killed for it. I describe the way we dressed, spoke, worked, and lived. I describe how my stomach ballooned from hunger, and how to survive I ate anything that was edible . . . including many things that should never have been eaten. I give her the details about the taste of rotten leaves, turtles, snakes, and rats. Hailey's eyes glisten when I tell her about eating the animals' brains, tails, hides, and blood, and roaming the fields for grasshoppers, beetles, crickets, and other bugs to help me stay alive another day.

In her warm room, with the heater whistling off as if it had someplace to be, I narrate my story to Hailey as if it all happened to another girl, in another time, but whose memory I possess. Until she asks me about Ma.

"In our conversations, you said you were angry at your ma for forcing you to leave her after the soldiers came for your pa . . ." Hailey's voice trails off as she realizes the implications of her question. "I'm sorry if this is too hard. We don't have to do this."

"No, it's okay. I'm ready to do this." I place my hands on my lap and breathe. "I thought she was weak for kicking me out and not finding a way to keep us together. I thought she didn't love me enough to keep me with her. I hated her weakness. When the soldiers came for her three months

before the war ended, I wondered how she had let herself be caught. I blamed her for being dead. I was angry at her for leaving me. I wanted only to be strong because the weak do not survive. For years, I did not want to be my mother's daughter."

"You know now that she was an incredibly strong woman," Hailey states gently. "She did what she could to save you."

"I'm beginning to realize it now. My sister Chou is like my mother in that way. They both possess a quiet strength that I don't understand." At the memory of Chou, the room suddenly grows cold. Hailey reaches out for my hand.

I try to laugh. "I better go back to my room and try to make myself beautiful for a party."

Hailey stands up and pulls me into a hug. "I'm sorry, sweetie," she whispers into my hair. I bite my lip and hold back my emotions. "Thanks again for sharing with me."

"Sure," I answer her, now embarrassed.

"I changed your name to Serene in the paper, so no one will know it's you."

"That should do it." I smile. Since I'm the only Cambodian girl at the school, I'm not sure how much anonymity that'll give me.

By the time Mark's jeep beeps at my door at eleven-fifteen P.M., my eyelids have been drawn on and darkened, my face powdered, and my lips painted red. In tight black jeans and a purple mock-turtleneck sweater, I am ready to leave Cambodia and party like it's 1999 in America. But when I open the car door, my smile freeze at the sight of Tiffany sitting in the backseat.

"Hi, Loung," she gushes. "Let's party!"

"Hi," I reply coldly. I can't stand that girl and all her fakeness. I loath her big breasts, fake tan, and chic clothes. And she flirts with Mark. As I strap myself in the front seat, a big smile creeps onto my face as I visualize ramming my body into Tiffany's and knocking her to the ground. I bet Tiffany is like one of the pretty girls in those slasher movies—the kind who stupidly prances around in barely there tank tops and miniskirts, running in their high heels from a masked killer wielding a gleaming knife. They inevitably veer off a busy street and into a dark alley where the killer

corners them. If these girls attempt to fight back at all, they slap their pred-ator with open palms as if he's a fly, and not a knife-wielding mass mur-derer.

I know I'm very different—I'm no fly-swatting girl. When Hailey and I attended a women's self-defense course together a while back, we were taught to jab our fingers into our attacker's eyes. While the other women squirmed and shook their heads, I envisioned two wet and bloody eyeballs dangling off my fingers. If it's between me and my attacker, I will take him or her down. Sometimes I really miss fighting and the feeling of balling my hands into tight fists and punching somebody. Unlike Mark and Hailey, who are two of the nicest and gentlest people I know, the path of nonviolence and peace is not an automatic thing with me. If the three of us were to meet someone who was being an ass, Mark would wonder if something was physically wrong, Hailey would question his family history, and I would be ready to kick him in the head. Although I think this way, I don't fight anymore—except with words. Being a peaceful per-son is not an automatic thing with me—I have to consciously choose it every day.

At the party, Mark circles the crowded room to say hi to everybody while Tiffany stands surrounded by a group of boys. In my corner on the couch, I listen as a student named Mike goes on and on about why beer out of a keg is better than bottles. As he blubbers on, his eyes become small, and his drunken skin pulls his face down like melted Play-Doh. All the while, my feet tap with annoyance at the shallowness of it all.

"So," I pipe in when Mike stops long enough to take a breath. "What do you think about the United States invading Iraq?"

"Whaat?" Mike protests, confused.

"January fifteenth, the deadline President Bush gave the Iraqis to pull out of Kuwait. You know Saddam's going to ignore the deadline. The United States will go in with guns and bombs, and it will mean thousands of innocent civilians dead. Whatever the political agendas, we must not forget about the innocent civilians."

"Man, you're a total party pooper," Mike announces. "Whatever hap-pens over there, that's their world, not my world, man."

"There's no 'their world' and 'your world,' Mike. There's only our

world. I hope you're just too drunk to get this and that it's not your actual belief." I look down at Mike like a child, sick of playing up to him because of his good looks.

"See ya, party pooper." Mike takes his beer and leaves.

The next week, I watch the TV news about the invasion. As I flip from channel to channel, a bomber pilot's likening of the bombings to Christmas lights is repeated by many journalists. Upon hearing this, I want to crawl back into bed, curl into a fetal position, and cry until I am all dried up. For I know that when each one of those lights hits the earth, some-body's mother will lose a child, somebody's son will no longer have a father, and some daughter will be orphaned. Suddenly I get up, throw on my clothes, and rush to the student resource center to find a way to help. And at that moment, I decide to become a party pooper from now on.

24 eldest brother returns

"Second Brother is here!" Pheng calls out. Chou hurriedly takes off Chang's soiled cloth diaper and comes out of the hut in time to see Khouy parking his motorcycle at Uncle Leang's hut. The sun is barely up in the sky, but already Khouy's green military police uniform is red from the blowing dust.

"Second Brother, everything is well?" Chou asks. It is not normal for Khouy to travel to the village so early.

"We have another letter from Eldest Brother. We need to show this to Uncle Leang as well. Come quickly." Khouy's voice is full of urgency as he walks into Uncle Leang's hut. His strides are wide and confident, each step fully connecting on the ground before the other takes off.

"Second Brother, is anything wrong?" Chou wrings her hands in her krama as Pheng follows with their three children.

"Don't worry. If it's true, it's the greatest news!" Khouy laughs as Uncle Leang, Aunt Keang, Amah, and the rest of the family gather around him. "Last evening, a man arrived on a motorbike from Phnom Penh. He works for a hotel and said a man staying there paid him to deliver this letter. Since the road isn't safe in the dark, he quickly returned to Phnom Penh after he gave me the letter. I've waited all night to deliver this." Khouy pulls the letter from his shirt pocket and hands it to Uncle Leang, who reads it out loud.

" 'Greetings to young brother Khouy, sister Chou, Uncle Leang, Aunt Keang, the young cousins, and all the family. This is . . .' " Uncle Leang blinks his eyes rapidly and tries to steady his voice. "This can't be true!"

"Uncle, just read it!" Chou demands, a bit too harshly.

" 'This is your brother Meng. I am in Phnom Penh.' "

"Not true!" Chou gasps, and sits down on the bed. The rest of the family yells their disbelief as Pheng comes over and rests a hand on her arm. "What a terrible joke someone is playing on us!"

"The letter continues," says Uncle Leang. " 'This is your brother Meng. I am in Phnom Penh. I am staying at the Phnom Penh hotel. I am waiting to see you all very soon. I will not leave my hotel room until you come. Come very soon to this address. Your brother, Meng.' " Chou stares at Uncle Leang, her head light, but her nose floods with water.

"Chou, this is an old letter from Eldest Brother," Khouy says, and hands it to her. "Look at the writing of the two letters. They match."

Chou grabs the new letter from Uncle Leang and compares the intricate curves and strokes of the handwriting. Then she drops the letters on her lap and covers her mouth.

"It's Eldest Brother," she says in disbelief. "It's really him. He's here." Chang sees her mother anxious and reaches out to her from her father's arms. Chou gathers all three of her children in her arms and smiles through her red eyes. "You're going to meet your Eldest Uncle!" She turns to Khouy suddenly. "When do we leave?"

"Pack quickly. We're leaving now," Khouy announces. "I'll meet you all in Ou-dong. I've arranged for two motorbikes to take us from there to Phnom Penh." With a wave, Khouy takes off.

For the next thirty minutes, Chou showers and brushes her hair, being careful to smooth out the knots. Then she puts on her best blue sarong and pink shirt before dressing her children. While Chou packs her family's clothes, Aunt Keang quickly makes rice balls and wraps pieces of cooked dried fish in a banana leaf for their journey. Outside, Uncle Leang hitches their wagon to the cows as Pheng pours drinking water into plastic petrol containers. When Chou is ready, she and the three children climb into the wagon and are followed by Uncle Leang and Aunt Keang. With a light whip to their behinds, Pheng drives the cows forward as Amah and the other family members see them off.

As they follow the one road to Ou-dong, the sun climbs higher and higher in the sky. The birds leave their tree nests to search for food in the rice paddies. The farmers plow their fields, their calves bulging with muscles as strong as their cows'. Behind the farmers, the birds swoop down and pull earthworms and other bugs out of the overturned earth. As Pheng drives, Chou sits with her back leaning against the wagon. In her arms, Chang sleeps soundly while Hourt huddles in Chou's lap. Next to Chou, Aunt Keang rests her chin on her chest and holds on to Eng while Uncle Leang sleeps sitting straight up with his legs splayed out all over the wagon.

When they arrive in Ou-dong two hours later, Uncle Leang and Aunt Keang hop on a rented motorbike with Khouy's oldest daughter while Khouy piles on his bike with his wife, Morm, and their other three children. Behind them Chou straddles two of her children behind Pheng and balances Chang on her lap on their bike. As they push off, Chou looks back at the village and realizes that this will be the first time she's returned to the city of her childhood home. As if traveling back in time, Chou glances at the open fields they pass and sees herself as a child, sleeping under the stars with Loung. When their bikes pass farmers walking on the roadside, images of Keav holding Geak in her arms as the family marched out of the city sting her eyes.

By midafternoon the city looms in front of her, its tall seven-story buildings pushed into the cloudless skyline like mountains. Chou hugs Chang and holds on to her family as the bike takes her into Phnom Penh. In the city, four-story concrete houses replace thatched-roof huts, and dusty narrow roads widen into gray asphalt boulevards crowded with motorbikes, cyclos, and, to the delight of Chou's son, cars.

"Ma, look!" three-year-old Hourt points excitedly. "Wagon has big eyes! Haha! Big eyes!"

"Cars," Chou corrects him.

"Ma, so many people!" five-year-old Eng screeches. "Where they from?"

"They live here," Chou says.

"Your ma used to live in the city," Pheng tells his daughter.

"Ma, you lived in the city?" Eng asks with awe.

"A long time ago when I was small like you," Chou replies, and her

voice lifts with happier memories of movie theaters, pink dolls, swimming pools, and school uniforms.

In the traffic, their bikes slow as traffic zooms in and out around their traveling party. Right next to them, Chou counts three adults and three children piled on top of one another on one cyclo. The scene reminds her of trips to the market with Ma, when all the sisters would sit on one another. Pheng drives them past the loaded cyclo and past rows of shops selling car tires, mechanical nuts and bolts, woven baskets, shiny golden altars, colorful dresses, and plastic flowers. Chou turns her head here and there and takes in all the details of Phnom Penh. It seems to her that little has changed from her childhood memories of the hustling and bustling city. The only difference now is that she no longer feels that she belongs here.

"Phnom Penh Hotel," Pheng announces after many stops for directions and wrong turns. They pull up in front of an old off-white four-story plain-looking concrete building. Chou stares up at the glass windows wrapping around the walls like little square boxes and wonders if Eldest Brother is somewhere inside.

"Second brother, this is the correct address?" Pheng asks, and parks his bike next to Khouy.

"Ummm," Khouy acknowledges with a nod of his head.

Chou's cheeks twitch lightly as the family meekly follows Khouy into their first hotel. Morm comes up behind her and squeezes her arm.

"I'm so nervous!" she whispers to Chou. "This is so exciting!"

Chou can only nod and will herself to stop shaking.

"Can I help you?" a male desk attendant asks.

"Yes, I'm looking for Meng Ung. He's staying in room 210." Khouy answers casually while Chou stares at the riches of the linoleum floor, the glass windows, the worn couches, ceramic flower vase, electric power lightbulbs, and whirling overhead fans.

"Certainly. Please go up."

Without thanking him, Khouy lights a cigarette and climbs up the stairs. Behind him, Chou takes a deep breath and follows with Chang on her hip. As they ascend the steps, the usually talkative family is quiet; the only sounds coming from them are the coughs of the children trying to spit the dust out of their lungs.

"Room 210." Khouy stares at the number. Slowly, he curls his right hand into hammers and pounds on the door.

"Who is it?" asks a familiar voice from the other side.

When he hears this, Khouy uncurls his fists and lets out a big laugh, then hollers, "Eldest Brother, it's us!"

"Khouy!" Meng swings the door wide open and wraps his arm around Khouy's shoulders. "My brother Khouy!" Meng's tears spill as if a ten-year-old dam has just burst, flooding his face and cheeks. Khouy grips Meng's arm, his eyes red and his jaws hard. "Chou." Meng's voice cracks like a teenage boy as he reaches out to her.

"Eldest Brother." She takes his hand as her lungs choke for air. Meng puts his arm around her as she leans her head on his shoulder. While she sobs into her hands, Meng pats her hair with a gentleness that reminds her of Pa.

"Eldest Brother, you're here," Chou whimpers. Chang clings to her hip. Seeing her mother in distress, Eng runs over and holds on to Chou's leg.

"Second Uncle, Second Aunt," Meng greets them, his voice barely audible. "This must be Morm and Pheng. So good to see you." Meng barely finishes his words when his face crumbles again.

"Meng, come sit." Uncle Leang ushers the family into the room.

"Meng, it's so good to see you, my nephew." Aunt Keang takes his arm and leads him to sit on the bed. "Chou, Khouy, you sit with your brother." The others find places on chairs and the floor.

On the bed, Khouy takes off his shoes, crosses his legs, and introduces Meng to all his nieces and nephews. When he gets to the last one, Meng's smile quivers again as he rubs his eyes. As Meng turns his head to stare at each member of the group, Chou's eyes never leave his face and absorb every detail of his hair, eyes, cheeks, and smile. Though he is older and a little heavier, he looks happier and healthier than the brother who left her ten years ago. Chou reaches out and again touches his arm, elbow, and hand as if to make sure he's real. Each time her fingers pinch solid mass, she smiles more broadly.

"Eldest Brother has good flesh," Chou exclaims, and the group agrees about his good health.

"Eldest Brother." Khouy is the first one to compose himself. "When we received your message, we didn't believe it was you!" When Khouy laughs, his children bellow with him from their corner of the room.

"I don't blame you," said Meng. "I can hardly believe it myself. It's been a very long journey to come back here."

On the day he received Khouy's first letter in 1983, Meng started to plan his visit to Cambodia, but because of the U.S. boycott, he didn't know of a way to get in. For eleven years, Meng read everything he could about immigration and talked to everyone he knew to see if they had any ideas about how he could get back in the country. No one did. Then six months earlier, a friend had introduced Meng to a man whose brother worked for the Cambodian government in Phnom Penh. For a fee, the man said, his brother would help Meng cross the border.

"Here's what my brother said to do," the man had said. "Buy your airplane ticket to Bangkok. In Bangkok, apply for a visiting visa at the Cambodian embassy." Meng had pressed the telephone receiver to his ear, straining to catch every word. "You will not have any problems getting a visa if you bring plenty of cash to pay the bribes. Once you have the visa, buy your ticket from Bangkok to Cambodia. When you have all that, call my brother at his government job and he'll take care of you." The man made clear that the telephone number was for a government phone; therefore Meng had to call during business hours. He then told Meng that the first commercial telephone line in Phnom Penh only went up that year and that very few people or businesses had them.

For three months, Meng smiled and saved money and went to sleep dreaming only of Cambodia and the family's reunion. When he received the approval from IBM for extended time off, he vacuumed the house and took out the trash without any prompting from Eang. The day he purchased his airplane ticket to Bangkok, he spun Tori around the living room until they were both dizzy with joy. The next morning, with Maria peering over his shoulder, he called his Cambodian connection to confirm his plans. When Meng told the man he was about to send a letter to Khouy to let the family know of his visit, the man told him not to send it.

"Why?" Meng had asked as his hands went cold. "Is it not safe to go?"

"No, no," the man replied. "It's safe if you're careful. The political sit-

uation there is unstable now but UNTAC [United Nations Transitioning Authority for Cambodia] is there to keep order. It's probably safer if you don't announce your visit and make it a surprise." Then the man gave Meng a long explanation as to why he should keep his visit a secret to his Cambodian family until he got there.

He told Meng that when the Vietnamese pulled its troops out of Cambodia in 1989, it created a power struggle between the various Cambodian parties, one of which was the Party of Democratic Kampuchea, or the Khmer Rouge, to assume control of the country. To solve this problem, the United Nations had recently agreed to organize and fund an election in Cambodia to take place in 1993. Under the UNTAC, thousands of UN peacekeepers had already arrived in Phnom Penh to work with election experts from around the world to meet this goal.

"So what's the problem?" Meng had asked.

"In this transitional period," the man continued, "there may be more kidnappings and fighting, and that might force the government to deny visas to visitors, even with bribes. But I don't know."

Meng stops talking and looks around the room, still not quite believing he is sitting with Khouy and Chou. Again, a rush of emotion overwhelms him and his eyes tear up.

"So four days ago, I left Eang, Maria, and Tori at the airport. It took one day of flying to get to Bangkok and another day to get my visa. When I arrived in Phnom Penh, the man's brother picked me up in a car and dropped me off at this hotel. I then hired a hotel worker to deliver my letter to you and waited in the room."

"Eldest Brother, you haven't left the room in two days! What have you been eating?" Chou glances around the room and sees that it is filled with only the bed they were sitting on, two chairs, and nothing else. In the bathroom, she sees two clean bowls in the sink.

"I've paid another hotel worker to buy and deliver my meals to the room," Meng chuckles. "It's wonderful. For two U.S. dollars, he buys two bowls of noodles, delivers it, picks up the plates when I'm done, and leaves thanking me many times."

"Eldest Brother, that's too expensive!" Morm declares. "He cheated you."

"No, no," Meng's eyes soften. "I was grateful for his help."

"Eldest Brother," Chou asks quietly. "How are Loung, Eldest Sister-in-Law, and the girls?"

"They are well. Loung is in college and has to study very hard every day. Eang is well and busy with the girls. The girls, they are very American and spoiled!" Meng laughs softly but Chou can see the pride in his eyes. "At eleven and six years old, they already speak Chinese, English, and Khmer!"

"Eldest Brother, how's Kim doing in France?" Khouy asks.

"He's living with Aunt Heng and her family. I went to see him just six months ago and he looks well and is happy." Meng pauses and Chou watches his face fall. "I am filling out all the papers to bring him to America but it may take many years for this to happen."

"Meng, we know you're doing all that you can to reunite your family," Aunt Keang tells him gently as the rest of the family nods.

"When I spoke on the phone with Kim before I left, he sent his greetings and best wishes. He hopes to visit soon." When he finishes his story, Meng delicately pulls out a batch of small sealed red Chinese envelopes, each stuffed full with U.S. dollars.

"Khouy." He puts one in Khouy's hand. "In difficult times, I hope this will help." Khouy accepts it with a quiet thank-you.

"Chou." Meng turns to her. "This is to help you raise your children."

"Thank you, Eldest Brother, but there's no need. It's enough that you are here," Chou says as Meng presses the envelope into her hands.

After Chou, Meng presents Uncle Leang with an envelope for him and his family. And even though each envelope contains more money than each recipient has ever seen in his or her lifetime, as he gives them, Meng repeats his apologies that it's not more.

That night while the women, children, and Uncle Leang dream on the floor in a relative's home, Khouy and Pheng stay with Meng in his room. In the dark, Meng listens to his brother and brother-in-law breathing quietly in their cots and whispers his thanks to Ma and Pa for looking after his siblings when he could not. Now that he knows they are all safe, he sleeps peacefully for the first time in over ten years.

The next morning, fearing that Meng is unaccustomed to long bike rides and hot sun, Khouy hires a car to take him to the village. While

Chou, Aunt Keang, and the children join him in the car, the rest follow on their motorbikes. Meng takes out his video camera and begins to film the family, the roads, the city, and the countryside. But a quarter of the way to the village on the bumpy road, Meng has to take a pill to stop him from throwing up. When they arrive at the village two hours later, Meng swallows two more pills to get rid of his headache. In the village, Meng meets Amah and the adult cousins and relatives whose names and faces he struggles to put together with the children he remembers.

"Chow Pang Ka-la!" he shouts out a cousin's Cambodian nickname, which translates to mean "thief who steals tiger balm oil."

"And you, A-gow." He shouts a boy's Chinese nickname meaning "the Dog." In the grown-up faces of the cousins, Meng soon recognizes "O-kuoy," the black ghost; "Lol-lai," the whiner; and "Thor-moi," the fat sister. When he walks the short distance from Khouy's house to the village market, many more friends, relatives, neighbors, and strangers come out to meet him. Standing beside him, Chou happily introduces Meng to everyone and follows his every word as he delights them with tales of snowstorms and eight-lane highways. And when he shares news that a college is paying Loung to study at their school, and tells them also about her two smart nieces, Chou's eyes shine with pride.

When they return from the market, Khouy chops open a green coconut for Meng while Chou boils his water and lets it cool under the tree. Once it is cool enough, Meng comes over and dissolves a blue pill in the pot. Afterward, Pheng pours the water into a pail and carries it into the outhouse for Meng to shower. When he comes back out, all clean and smelling medicinal, like soap and shampoo, the young nieces and nephews climb all over him and jump on his lap until he's dirty again.

When the sun sets, the family sits together for dinner and Meng asks many questions, never tiring of hearing about the most basic details of their lives. Like a foreign child, he asks for descriptions of how they farm, what crops they grow, and where they catch the best fish. While the others talk, Chou fans Meng with her palm-leaf fan and keeps a vigilant eye on the mosquito coil next to his feet.

And thus, in one full moon cycle, Meng lives ten years' worth of family reunions and gatherings. When not at Khouy's house, he is accompanied by family members as he walks the short distance on the red dirt road

out of the village to stare at the swaying palm trees and green rice paddies. With each passing day and house visit, Chou watches Meng's face become even fuller and Chou notices that the darkness under his eyes is fading away. But too soon, their days together come to an end.

As they gather together at a cousin's house in Phnom Penh, Meng sets up his video camera and asks the family to speak their messages, greetings, and anything else they want to say for him to take back to America.

Wearing a big grin, Khouy is the first to sit in front of the camera.

"Kim, Eldest Sister-in-Law Eang, Loung—I hear you don't like the cold over there. So come to visit. If you want hot, come in April!" He laughs, knowing that April is the hottest month of the year, with temperatures reaching well over one hundred degrees Fahrenheit.

"Khouy, don't joke like that!" Morm laughs, and lightly slaps his arm. "Kim, Loung, Sister-in-Law Eang, please come and visit us. When you get here, no need to worry or do anything because the nieces are big enough now to do all the cleaning and I will do all the cooking."

"Morm, you will not get them here with your cooking. You're a bad cook!" Khouy guffaws next to her.

"Stop!" Morm grins. "Sister-in-Law Eang, Kim, and Loung. We send our greetings and wish you happiness and good health. That's all. I don't know what else to say."

When Meng turns the camera on Chou, she breaks into tears. As her shoulders shake, she bites her lip and looks down at her feet. Then she stares into the camera intently. "Loung, come visit—it's been over ten years," she urges. "I miss you very much. Loung, you have many nieces and nephews here who want to meet you." Unembarrassed, she wipes her eyes and nose with her forearm. "I also miss brother Kim and Eldest Sister-in-Law Eang. Eldest Sister-in-Law, thank you for raising Loung all these years by yourself. Eldest Brother Meng tells us that Loung is a good student and very respectful to her elders. She is lucky to have you to teach her these things. I send my hellos to Maria and Tori. I pray I will see you all one day soon." As she speaks, her cheeks stream with tears and her voice becomes hoarse. When she cannot go on, her daughter Eng comes up behind her and wraps her arms around Chou's neck.

"Chou, don't cry anymore," Aunt Keang urges her. "No need to cry."

At that moment, Chou's eyes flare with anger. "Don't tell me not to

cry," she says. "It took ten years before I could meet with my brother. It may be ten more before I see him again. I don't know when I'll see him next. I don't know if I'll ever see Loung or Kim again." Then her eyes and voice soften and she bows her head, her shoulders heaving up and down.

Meng leaves the camera and walks over to sit next to her. Awkwardly, he puts his arm around her back. As she swallows air and tries to compose herself, he moves his hand from her back to smooth her hair.

"Don't tell me not to cry," she whispers softly. "I only cry because I miss them so much."

25 seeing monkey

May 1992

I'm sitting at a table at an outdoor patisserie, sipping my cappuccino and staring out into the deep blue Mediterranean Sea. In front of me, a stream of Audis, Porsches, and Lamborghinis inch along the road. Every few minutes, the traffic stops to let beautiful, gorgeously dressed women cross the street to the beach, where skimpily clad sunbathers lie half-naked on the sand, soaking up the sun's warm rays. I'm in the south of France, studying at the Cannes International College as part of Saint Michael's College study abroad program. And although I *do* regularly attend my cooking, art, and international politics classes, the majority of my time is spent sunbathing on the beach, visiting museums, going clubbing, and having wonderful cups of coffee in Paris, Marseille, Aix-en-Provence, Corsica, and many other French towns. After two more cappuccinos, I arrive back at the college and plop myself on the grass in the beautiful courtyard. Suddenly, my Swedish friend Pernilla is beside me.

"We have tickets to see the *Strictly Ballroom* premiere tonight. Want to come?"

"Yeah, but I'm running out of evening dresses to wear," I sigh. Because the school is just a few minutes' walk to the Cannes Film Festival, the students were given special passes to attend the screenings. To get the passes, we had to sign papers promising to dress in evening wear when attending night events.

At six P.M., I meet my friends in the lobby. In our colorful dresses, we

look like we're going to a European prom. We make our way to the festival and maneuver ourselves through the crowd, over a sea of expensive dresses and black tuxes. When we arrive at our theater, I spot my favorite American actress, Jamie Lee Curtis. Quickly, I run up to her. Though my palms are wet, I calmly say to her, "Ms. Curtis, I love your work. Thank you."

"Well, thank *you*." She smiles as we part ways.

"She is even more beautiful in person," I gush to my friends about my brush with fame. In front of the theater screening *Basic Instinct,* we walk past a large mass of fans heaving and ballooning up like a blowfish. When the movie's stars, Michael Douglas and Sharon Stone, appear, the fish blows out its air in gasps and screams.

In our theater, I tap my feet through *Strictly Ballroom* and leap up in the end to give it a standing ovation. "That was awesome!" I scream at my friend. "Let's go dancing!"

We are laughing and about to enter a loud, darkly lit club when I hear someone shout, "Loung?"

I whirl around to see a tall, handsome blond European man staring at me. "Paul? Oh my gosh, it's you!" I scream at meeting a friend from Saint Michael's who had recently graduated. "What are you doing here? I thought you lived in Sweden."

"I *do* live in Sweden. But I'm studying car design in Switzerland and am vacationing here at my family's villa."

"Wow. How amazing! I can't believe I actually know someone who lives like the people in the movies!" I gush and reach out to give him another hug.

After a round of introductions, we move the party into the club where Paul buys bottles of champagne for everyone to share. As I sip my champagne, the music beats on and bodies gyrate and grind on the dance floor. Toward the end of the night, Paul and I make plans to see each other again the next day. When our group stumbles back to the school in the early hours of the morning, my lips are stuck in a permanent grin.

"Loung." The dorm attendant stops me as we walk in the lobby and hands me a folded piece of paper. I open it up and read the scrawled message: "Your brother Kim called. He is coming to see you next Saturday." My grin dissolves.

★ ★ ★

A week later, I sit in the lobby and try to calm myself. I haven't seen Kim since I left Cambodia eleven years ago. As I massage the base of my skull, I search the slippery ridges of my brain for suitable excuses as to why I haven't called or visited Kim in the four months I've been in France, since he's only a three-hour train ride away. I glance at the clock on the wall—9:55 A.M. Kim is only a few minutes away now. I get up and tuck my blue shirt into my black pants. When Kim's car pulls up, I brace myself and exit my fantasy world to come face-to-face with Ma's monkey.

"Loung." Kim smiles widely at me. In his big brown T-shirt and blue jeans, Kim looks thin, almost gaunt. Suddenly I'm terrified. As he walks up to me, my stomach twists painfully and the pain in my neck makes me nauseous. My arms stay close by my side. I slowly turn from Kim to stare at Uncle Lim, Aunt Heng, and their eldest son Hung standing beside the car.

"Kim," I greet him. "Uncle, Aunt, Hung, how are you?"

"Good, good." Uncle Lim replies. "Let's not stand around here. Let's drive to Monaco." Hung drives with Uncle Lim in the front seat while I sit in the middle between Kim and Aunt Heng in the back.

"Loung," Aunt Heng begins. "Meng tells me you have to get good grades to keep your scholarship, so you're studying all the time. You probably have no time to see anything." I smile.

As we drive the winding cliff road to Monaco, I "ooh" and "ahh" on cue over the scenery. In between the scenic points, Aunt Heng fills me in on the details about the lives of her eight children. While she talks, Kim and I have little to say to each other, and the knots in my neck clump together to form a big aching ball. *I'm so sick of the Khmer Rouge having power over me,* I think. *I'm so tired of them taking away my family,* I want to scream. Slowly, I glance at my brother and force myself to remember him as the little boy who loved kung fu movies and made funny faces. I gradually begin to relax with him.

In Monaco, Kim, Aunt Heng, Uncle Lim, Hung, and I pass many hours sauntering in front of the world-famous Monte Carlo Hotel and Casino. When our feet grow too tired, we find a café. Over a big latte, Kim talks about his job making plastic eyeglass frames while I tell him about Meng and Vermont. When our feet are reenergized, we stroll by shops filled with riches beyond reach. As the sun shines on the flawless dia-

monds in the glass cases and creates prisms of colors on our skin, Kim and I compare stories of arriving in a foreign country with nothing but the clothes on our backs, dealing with culture shock, and learning a new language. By the time we laugh at our shared dislike of snow and freezing rain, I've begun to separate him from the Khmer Rouge.

"Kim, how did you get from Cambodia to France?" I ask him as we sit down for a late lunch.

"It's a long story," he says. Then he laughs and adds, "It's a bit like an adventure movie."

"I love adventure movies," I tell him.

As he eats his hamburger and potato fries, Kim recounts his story to me.

After Chou was wedded to Pheng, Kim quickly left the village and moved to Ou-dong, where he'd searched for a way out of Cambodia to join Meng and Loung. Then one night in 1985, six months after he left Chou, Dara, a friend of Kim's, told him of his plans to go to Thailand. Dara then said that for three chi gold, Kim could come with him. "You pay the driver half in Ou-dong," he said, "and when you arrive safely at the camp, they will go to your family for the rest. If you want to go, we leave tomorrow."

In the morning, Kim brought nothing with him when he met Dara near their designated bridge, just as he was instructed. He had on an old brown shirt, faded blue jeans, and a pair of green flip-flops. Dara wore loose dark clothes and brown sandals. Around them, life was already bustling with people and vendors going about their business. Young girls walked by carrying baked spiders, and right behind them a man sold French bread in a wooden basket. A live, fat two-hundred-pound pig was tied to the back of a motorbike, its four feet jutting toward the sky. On a side street, young monks in their orange and yellow robes approached a store and waited quietly until someone came out and gave them spoonfuls of rice and vegetables. Once they received the food, they chanted a blessing to their benefactor.

At nine A.M., a truck ferrying people from village to village stopped in front of them. Kim and Dara climbed aboard, talking to no one. In the sky, the sun moved slowly, burning through the haze and darkening their shad-

ows. Silently, Kim said his good-byes to Chou, Khouy, and the rest of the family. For five hours, as the truck wound along the red dirt road to Por-sat, Kim stared at the vast province and knew that somewhere there he left Pa, Ma, Geak, and Keav. Suddenly, the blood in his veins pumped rapidly to his head, causing it to hurt. The road curved around hillsides, then finally flattened as the truck headed to their next stop, Battambang. There, Kim bought rice and fish and was quickly surrounded by amputees hob-bling on wooden legs and begging. Soon the truck took the last twelve riders to a village on the Cambodian side of the Thai border. It was night when Kim and Dara climbed off the truck, their joints aching and stiff. As he stretched, Kim saw nothing but miles and miles of rice fields.

"Someone will come for you shortly," the driver said and stuck out his hand. Kim gave him the money. The driver climbed back into the truck and left. For a few tense moments, Kim kicked at the dirt while Dara stared at the road worriedly. Both breathed a sigh of relief when a young man their age arrived.

"Come, follow me," the guide told them. They followed him to an empty hut hidden behind thick trees and bushes. Minutes after their arrival, an elderly woman delivered a mosquito net, water, rice, and fish to them and disappeared. After they ate, the friends fell into a deep sleep. When the guide woke them, the sky was dark and clear, the stars twinkled, and the moon shone silver lights on them. Kim wanted to ask the guide for the time but didn't.

"Put this on." He handed them each a pair of old, dark, loose pants and a shirt. While they changed, the guide continued. "Don't talk," he said. "I will talk for you. I've told the men we'll travel with that you're my cousins from the city, here to learn how to work. We smuggle dry fish and other things to sell at the Thai border, and buy medicine to sell back here. It is illegal so we travel at night to avoid the police. You'll both carry a bag so you'll look like one of us."

The guide walked them toward a group of nine men, all of them mus-cular and thin. He then slathered mud on his body and instructed his charges to do the same. Kim scooped a handful of mud and spread it on his face, neck, arms, and all over his clothes. The rotten smell made him want to gag, but the guide whispered, "Stinky mud is good mosquito repellent."

The guide slipped a bag on Kim's shoulders. Instantly, the straps dug into his flesh, causing him to stagger backward.

"Just follow my steps exactly," the guide quietly told them. "We have to go fast and pass the Khmer Rouge territory before it gets light." Kim sucked in his breath in fear at the mention of the Khmer Rouge territory, as he'd heard many stories of people who'd been kidnapped, butchered, and killed there. Guided by the moonlight, the group walked single file in silence. Time passed slowly, and with each step the bag grew heavier and heavier on Kim's back.

"We are now approaching the Khmer Rouge territory," the guide whispered to Kim and Dara. "For the next three hours, we have to be on our guard and be absolutely silent."

Kim nodded and followed him. Above them, the moon dipped in and out from behind the clouds. The wind blew playfully, rustling the branches and leaves. Kim's ears picked up all the noise and tried to decipher whether each sound was friend or foe. Occasionally, his mind wandered and dreamed of a future where he was living with Eldest Brother and going to cooking school.

Suddenly, a stench of putrid flesh assaulted Kim's nostrils. The group was silent as they stepped over two dead bodies lying facedown in the path. Kim cupped his hands over his nose and mouth and held his breath, but marched on. A few feet in front of them, a dead cow with its front legs blown off obstructed their path. The guide carefully stepped off the beaten path onto a grassy patch of land. Kim followed his exact steps, his eyes only briefly resting on the cow's protruding bones.

By the time the sky lightened, the group had safely made it through the Khmer Rouge territory. Kim's shoulders felt like someone had pounded his muscles with a mallet. When the group stopped to rest, Kim dropped his bags and was lying on the grass when the guide approached him and Dara.

"You go with new guide." The guide pointed to a thin man in his forties with gray teeth. "I hired two boys to take your bags. Thank you for carrying the bags." He smiled and left with the group.

"I take you camp," the new man told him. Kim and Dara nodded. "But day, night, sleep here." The guide handed them each a package of rice and fish wrapped in banana leaves and took them to a hut outside the

village where they rested for the night. When the sun came up, Kim woke to find his shoes had been stolen. He and Dara followed their new guide in bare feet for two hours before they finally stopped. Kim looked up and his throat closed. Across the worn road, on the other side of a small field of grass, a six-foot-tall barbed-wire fence loomed into the sky and stretched around a camp where Kim imagined thousands of refugees lived in their makeshifts huts, wooden houses, and tents. To Kim, the camp looked like a magical lost city where hopes and dreams could be reborn.

The guide pointed to a barely visible trail. Kim's eyes scanned the slightly crushed grass that led to some dense bent shrubs where there was a small crawl hole hidden under the fence. The guide then pointed out some red signs with skulls and bones in the field surrounding the trail.

"Stay on trail, no land mines," the guide whispered. Kim nodded, his stomach turning.

For forty-five minutes they waited in the bushes by the road until a border patrol jeep drove by. The guide pulled his charges down lower into the bushes, but not before Kim saw one of the Thai soldier standing up, his hand on his rifle. When the roar of the jeep faded into the jungle roads, the guide yelled, "Run!" Kim leapt from his position, his heart pounding in his chest, his bare feet cut up by rocks and splintering wood. He ran. Once he reached the barbed-wire fence, he slid under it like a snake in the grass. When he climbed out of the crawl hole on the other side, he could not control his smile. Right behind him, Dara and the guide entered the camp in the same way. He felt so strong, as if his body could hop many times its height, like a grasshopper.

"Slow, act normal, like you belong here," the guide cautioned him, and led Kim to a hut owned by a woman and her daughter. Now that his job was done, the guide disappeared with Dara. In a few days, one of the guide's men would go to Khouy to collect the rest of their gold.

That first night, Kim's dream of freedom was crushed as the sobering facts of refugee life were explained to him. When he left Cambodia, he hadn't known that the camps were closing and that Thailand was accepting no more refugees. Yet each day, hundreds of refugees continued to arrive. Many were caught, put in jail, and then trucked to the border of Cambodia and Thailand. There, they were forced off the trucks by the Thai authorities to march across the Dangrek Mountains and fields littered

with mines, where starvation, disease, bandits, and Khmer Rouge soldiers lay waiting. Kim heard that many did not make it home and that many of those who did make it home faced shame and poverty. Oh, how naive he'd been to think that all he had to do was tell a refugee worker about his family in America and he'd immediately be allowed to join them.

Five months later Kim was still waiting for his passage to America. Protected by the woman his guide had introduced him to, he would often be forced to hide three feet under her hut, silently sucking in hot air through a porous bamboo bedpost, ingeniously lined up above the hiding place. The space was completely black and not much larger than the width of his shoulders. Locking his fingers together, Kim would pull his knees close against his chest. Above him, hidden under another three inches of dirt, a piece of thick plywood with a small circular hole in the middle covered Kim's hideout. On top of the plywood sat a heavy bed with four bamboo bedposts. One of the posts was punctured with holes and positioned on top of the plywood opening. Straining his neck, Kim would place his nose at the hole and desperately inhale air, forcing himself to stay calm.

After fifteen minutes, he'd be completely drenched with sweat. He longed to massage his neck but he dared not move, too afraid to make the tiniest noise. Above him, half a dozen Thai soldiers marched through the hut, their feet heavy with military boots. The footsteps moved around the room to check behind the curtains, crates, and under piles of clothes in search of illegal refugees. As the Thai soldiers moved around, Kim concentrated on staying calm and totally silent.

"Let's see your papers," barked the Thai soldier in his broken Khmer.

"Here they are, lord." The hut owner scurried over, her steps soft and quick. Kim pictured her presenting the papers, holding them out with both hands to show respect. He could hear three other pairs of foot steps, all quiet and soft.

"One, two, three, four IDs," the Thai soldier counted. "Four refugees living in this one hut."

"No one else is here," another Thai soldier reported after he'd gone through the house.

"All right. Let's move on." As the Thai soldiers left without even the smallest of gesture of farewell, their footsteps shook loose the dirt, which

fell over Kim's head and body like falling ashes. The dirt mixed with his sweat and melted into his skin, making him feel even more grimy. He longed for a shower but all he could do was wipe his hands over the mud.

The seconds stretched into eternity, until he heard no traces of the Thai soldiers' steps. But still he knew he had another fifteen minutes of sitting in his hole just to be on the safe side. Kim imagined the sun setting over the camp where hundreds of thousands of fires were being built for cooking the evening meal. His stomach growled at the thought. How many more months would he need to hide waiting to live his dream of a new life?

The hut owner lived with her nine-year-old son and her thirteen- and nineteen-year-old daughters. Every day, Kim felt grateful to this kind and compassionate woman. He knew that if she were caught harboring an illegal, whether dead or alive, she and her family would face the same punishment as Kim. Though she knew the risks, the woman still chose to help him, a stranger. When Kim asked her why she was doing it, she told him that she'd lost her husband to the Khmer Rouge and now lived only to fight for a better future for her children. She confessed that as soon as she'd helped her children find safety, she would shave her head, become a Buddhist nun, and devote her life to the gods. Until then, she would pave her way with good karma by doing good deeds and helping her countrymen.

Even though he had nothing to offer them but his word, Kim promised the family that he would repay them when he received money from Meng. For the first few months, Kim lived with the family and shared their food like he was one of them, with no letters from America or signs of payment in sight.

During the day, Kim was free to walk around the camp, make friends, and play volleyball with his neighbors, as long as he didn't wander too far from his hiding place. Once a day, the Thai soldiers tried to surprise the refugees with a search at an unspecified time. But the refugees always helped one another, and somehow a warning was sent from one location to another, allowing Kim and the other illegals to go into hiding. At night, while the woman shared her bed with her two daughters, Kim slept next to the son and thought about his own family.

Every week, he borrowed money to send letters to Meng and Aunt Heng in France. He wrote about life in the refugee camp, the family he

lived with, and the growing risks of getting caught by the soldiers. As the human smuggling trade became more sophisticated, and more refugees were smuggled into the camp, the Thai soldiers began stepping up their searches. Kim's hand shook as he described how a friend suffocated to death while hiding in a metal water tank; he'd run out of air because the soldiers questioned his host family for too long. Now every time Kim crouched in his hole and allowed himself to be buried, he feared this would be his fate as well.

In his third month, Kim had received a letter and three hundred dollars from Meng. When he saw the money, he'd thrown his arms in the air, yelped with happiness, and promptly paid the host family for their protection. That night, the dark hiding hole hadn't felt so suffocating. While the soldiers had terrorized the family above, Kim heard Meng's voice telling him to hold on and be patient because help was on the way!

But then two months went by, and with each passing day the hiding hole became more cramped as the Thai soldiers took longer and longer to complete their searches. One day, lifting his mouth to the bamboo post yet again, Kim got a mouthful of falling dust instead of the air he so desperately needed. He felt his chest constrict and explode into a stifled coughing fit. Kim's head flashed white with pain. His breath shallow, he started to scratch at the plywood to get out. Kim had heard the soldiers leave what seemed like an eternity ago but the family still had not returned to rescue him. He raised his arms and pushed at the wood with his open palms, but the trap door refused to budge. With all his might, he pounded his fist at the wood but succeeded only in showering himself with falling dust. Realizing that his efforts were useless, he thought of his family.

Please, Pa, don't let me be buried here, he pleaded silently. *Don't let me die alone.* Just then, Kim heard the unmistakable sound of spatulas digging him out from his grave. Minutes later, they moved the bed and pulled out the plywood. Kim burst from the hole like a drowning rat.

"The Thai soldiers were very careful today," the woman told Kim.

"Yes, very long. Thank you," Kim rasped, kneeling on his knees, thankful he was safe for another day.

That night, he clutched Meng's letter in his hands and called out to him. "Eldest Brother, please come soon. I don't know how much longer I can hold out."

The next day while he was playing volleyball, a man dressed in civilian clothes came looking for him.

"Kim Ung?" the man asked, but sounded as if he already knew it was Kim. His pronunciation of Kim's name gave away that he was Thai.

"Yes?" Kim replied uncertainly and approached. For a moment, Kim's knees almost buckled with fear that the man might be an undercover patrol soldier. He glanced to his right and left and wondered whether or not he should run away. But the man was much older than Kim, had a slight build, and didn't have the menacing look of a patrol soldier. And he was alone.

"Kim Ung," the man repeated under his breath, almost as if he were confirming the name to himself. He then reached into his pocket and fished out a letter and a picture. He looked at Kim and then at the picture again. Satisfied, he put the picture back into his pocket.

"Kim Ung, your aunt in France has sent me to get you. Come with me now," the man announced, then turned and left without waiting to see if Kim understood.

Kim's knees went weak as he followed the man out of the volleyball court without as much as a word of explanation. As he snaked his way out of the camp, he said silent good-byes to his new friends, the woman and her family, and the camp. In front of him, the man walked on, the afternoon sun casting long shadows behind him. Stepping on his shadow's head, Kim bravely marched onward to the next leg of his journey.

When the sun lowered in the sky, the man led Kim out of the camp on a hidden foot trail not guarded by Thai patrols. For the next three hours, Kim kept pace with the man as he wove in and out of roads, trails, and villages until they arrived at their destination. From there, he was passed from one guide to another and finally made to wait without an explanation by the roadside. After an hour's wait, a green military jeep came to a stop in front of Kim and his guide. Through the glass windows, Kim saw that the driver wore large gold-rimmed sunglasses, a green military uniform, and a hat befitting a high-ranking official. The rest of the jeep was shut out by heavy green tarp wrapped all around its body. After a few words, the guide lifted the tarp in the back and motioned for Kim to climb in.

"Go Bangkok, many stops, you no talk," the guide instructed him. Again, Kim entertained a brief thought that he didn't know these men

and that if they were to kill him, no one would know about it. But he quickly cleansed his mind of the thought and climbed into the jeep. *It's too late to think now,* he told himself and resigned to put his future in the hands of these strangers.

For the next eight hours, Kim sat on the floor of the jeep while the captain drove, stopping only to buy food and use the bathroom. With his back against the green tarp, Kim took in only sounds and smells. As the sun speedily crossed over the sky, the roads turned from dirt to pavement and the sounds of cows in the fields to the sounds of cars. The sputtering exhaust from the traffic made the air hot and stale. Kim's eyelids grew heavy with fatigue and his body became sore and stiff from all the bouncing. While the world moved forward, time stopped for Kim as he nodded into an exhausted sleep. When he came to again, the jeep had stopped and the captain was holding the tarp open for him. When he climbed out, Kim saw that they were out of the city. On the horizon, even though the sun was setting, the sky was still bright from all the neon lights. But where Kim stood, the streets were narrow, the houses were only one or two stories tall, and there were no neon lights in sight.

"Wait, sit." The captain pointed to a stall selling snow cones a few meters in front of them. "Long hair girl come." The captain lightly tapped Kim's right shoulder. "If tap, follow her." And with that, the captain got back into his jeep and sped away, leaving Kim standing by the road alone.

Kim obediently walked over to the stall and sat on the grass. For the next twenty minutes, he watched children run up to the vendor with their crumpled bills and leave with their blue snow cones. Kim stared at the fallen shaved ice, and his throat tickled from dryness and thirst.

Then out of nowhere, a hand tapped him on the shoulder. He looked up to see a pretty, slender Thai woman with long braids. Kim exhaled deeply, deflating his chest of worries as his shoulders went limp.

"Come," the girl smiled.

Kim nodded and followed her. As he tried to keep pace with her, he marveled at how a smile could still lift the heart, even in such strange circumstances. After another thirty minutes' walk, the girl entered a one-story large concrete house. Again it struck him how blindly he trusted her—and everyone else on this journey. As he crossed over the threshold,

he prayed that Pa and Ma would look after him and not let him die here. Moments later, all thoughts of his dismembered body being tossed into the garbage disappeared as he was greeted by a man speaking Chinese.

"There are ten of us here now," the Chinese guy said in a whisper as he led Kim into the kitchen where a bowl of rice and stir-fried vegetables waited for him. "Some guys have been here for many weeks; others like us have just arrived."

"How long will we be here?"

"I don't know. Like you, I am Khmer-Chinese and I don't speak any Thai. Some of the others are Vietnamese, Khmer, and even Thai. The Thai guy speaks Chinese and tells us that the smugglers are waiting until they have at least sixteen of us before we go to France."

"France," Kim repeated. His heart sank to his clammy feet. "I had hoped I was going to America. My brother wrote that he wants to bring me to America but that it's easier to get into France. But he said he'd try."

"Ai, Kim. America is very hard to get into. Many people try and get caught. They come back twenty thousand dollars poorer."

"How much is France?"

"France is easier to get into and it's only ten thousand dollars."

Kim felt as if someone had taken his intestines and wrung them out like a piece of wet cloth.

"Whoever sent for you has already paid five thousand dollars; when you arrive safely in France, the smugglers will get another five thousand."

"Ten thousand dollars," Kim repeats. The number weighs heavily on his tongue and conscience. He knows that neither Eldest Brother nor Aunt Heng can possibly have that kind of money. And in Cambodia, Khouy, Chou, and Uncle Leang most certainly had to borrow money to support his journey. When he began, Kim didn't know his dream was going to cost his family so much. At that moment, he vows to find a way to help his family when he gets to safety.

Over the next few days, more and more people arrived until they had their group of sixteen men. For the next twenty days, while the world woke and slept to the journeys of the sun and moon, the sixteen spent their time quietly watching TV and playing cards in small, cramped, windowless rooms. Some residents would occasionally disappear to seek privacy in whatever space they could find to dream their dreams, while others

swung their arms wildly like winged birds and leapt like frogs for exercise. With the exception of the cook who made their meals every day, the host and his team of counterfeit passport maker, tailors, and shoemakers, the residents never saw or met anyone from the outside world. To make sure that they stayed a secret, the host padlocked the door from the outside each time he left the compound.

On day twenty-one, the host arrived with armfuls of custom-made suits of many colors, winter coats, and hats.

"It's time to go to France!" the host announced in Thai. The Thai man translated it into Chinese, and Kim translated it into Khmer. The residents clapped with restrained excitement.

"Here are your fake passports and suits." The host walked around the room and handed each resident his papers and clothes.

"I'm Malay!"

"Singaporean!"

"Chinese!" Kim exclaimed with glee and opened his fake passport to the picture page. In it, he wore the same blue suit the host had just handed him.

"I'm also Chinese," his friend shared with a laugh.

"Settle down." The host calmed them with his upright hand. "You leave in an hour so go gather your things!"

The next two days, Kim lived as if he were a spirit while the world around him moved at fast-forward, breakneck speed. From the compound, a van picked up its well-dressed passengers in their winter coats and took them to the airport. Outside the windows, the scenery changed from residential homes to tall shiny buildings jutting up into the sky like crystals. At the airport, a middle-aged man met them and quickly got them through security as a tourist group. On the plane, while the clock moved backward at thirty-five thousand feet above sea level, the residents slept their way to Russia and woke only to change planes to Germany. In Germany, they disembarked and covered their rumpled suits with their thick winter coats to go through customs. Since they were ostensibly traveling together as tourists, the guide did all the talking for them. Kim noticed the sweat leaking out of the guide's pores on his balding hairline. But before long, the customs officer stamped their passports and let them

through. They passed through the gate with nothing to declare, not even the smallest of travel bags.

Outside the world felt like one big freezer as cold air blasted at Kim's face and hands. He tilted his head to the falling snow as the flakes melted into his skin.

"Falling ice," he murmured before the guide rushed him into yet another van.

All the next day, the group slept off their jet lag in a damp, cheap motel while the sky covered the city in pure white powder. Soon after the sun fell behind the horizon, a car and new guide arrived to pick up Kim and three other Khmers. While the stars sparkled brightly in the dark sky, the car drove all evening to reach the border of France at two A.M. Kim and the other "tourists" pretended to sleep while the guide talked to the customs officer.

When Kim heard the customs officer leaf through their passports, he knew the officer was also staring at their faces. He concentrated to still his facial muscles and calm his breathing. Under his coat, his hands were damp and cold.

"Thank you, officer." The guide shifted the car into gear and the car jerked forward. "Stay still and as you are," the guide warned them. "The customs officer may still be looking at us."

Kim maintained his position and exhaled and inhaled deeply. The air flowed richly into his veins and lungs, making his head light.

"You've made it. I know it's been a long journey for you all. Welcome to France."

Kim fought to control his shakes as his body finally released the stress, worry, and anxiety of the past six months.

When Kim finishes his story, I am filled with guilt for not knowing it already. As if sensing my shame, Kim says playfully, "I can't believe this is the first time I've shared the complete story with anyone!" He begins to laugh.

"Yes, especially when it sounds better than an action movie." I giggle and look at him gratefully.

For the rest of the afternoon, Kim, Hung, Aunt Heng, Uncle Lim, and I spend our hours walking, laughing, and talking more about Cambo-

dia, Chou, Khouy, and the family. Every few blocks Uncle Heng stops us to take pictures of the city and our reunion. While he takes his time directing and positioning us through his viewfinder, I stare at Kim. His face is fuller, his eyes are softer, and small lines traverse his forehead like a map of his life, deepening around his mouth. As the sunlight softly illuminates his face, I see that Kim is no long Ma's little monkey but a full-grown man.

In that moment of stillness while waiting for the shutter to click, I realize that my motto of living life to the fullest, of not missing a single moment, and making every minute count had been all about me and had involved only me. As I look up at Kim, I finally understand that the unconditional joy and happiness I've been seeking to drown out the pain and sadness is an illusion. For no matter how seemingly great my life is in America or France, it will not be fulfilling if I live it alone. I know now that Kim wants the same thing out of his life that Meng, Khouy, and Chou do. Yet somehow they've all seen the truth behind my motto sooner than I—that living life to the fullest involves living it with your family.

26 khouy's town

Chou gazes at the new picture Kim has just sent from France. In it, Kim and Loung stand on a beach with blue-gray water lapping behind them. Kim wears a big smile, a brown T-shirt, and blue jeans and looks straight into the camera. Next to him, in her blue shirt and black pants, Loung poses sideways like a model. Chou stares at her full face and long, beautiful hair and swells up with pride. In his letter, Kim tells her about their trip to Monaco and how well Loung is doing in school. Chou's smile fades a little when she again finds no letter from Loung herself in Kim's package of medicines and clothes. Carefully, Chou puts the new picture on top of the others and folds the cloth corners over them. She then places them gently in her crate of sarongs and shirts.

"Ready to go?" Pheng asks, and takes the crate from her.

"Yes." She slides off the bed and drops her feet to the ground. When she stands, her five-month-pregnant stomach pushes out against her shirt.

"The children are already in the truck," Pheng tells her.

Chou follows Pheng outside to where their old rusted truck sits in the front yard. In the dust-covered truck bed, boxes and crates of their pots, pans, silverware, hammers, hoes, mosquito nets, and clothes are stacked tightly together. In the small spaces left empty, their neighbors busily nudge in bags of rice and dried corn.

"Chou, Pheng, go in health," a man blesses them, as more friends and villagers gather around the truck.

"Thank you all for your help with packing and moving," Chou says. In the past week, their neighbors have already helped send Uncle Leang and his family off to a bigger village, and now they are there to see the last Ungs off.

"I pray for your good business, and to keep your children safe and happy," another neighbor tells them, as others loudly repeat their best wishes and prayers.

"Thank you, thank you." Chou touches the women's hands while Pheng and the men finish tying ropes across the truck bed.

"While we're gone, our good friend here," Pheng puts his hand on their next-door neighbor's shoulder, "will watch our land for us. So you all better be careful what you do to our land or there'll be trouble!" Pheng half jokes. "We hope not to come back, but if we do, we'll still have a place to live."

"Pheng, Chou, you'll always have your land in the village!" one of the villagers yells back as Pheng and Chou climb into the front seat where their three children are waiting.

"Ma-ma." Two-year-old Chang reaches for her. Chou takes Chang out of her big sister's arms.

"Let's go to our big new house!" Pheng announces and the kids cheer him on. As Pheng smoothly shifts the gears, Chou smiles proudly at her self-taught-driver husband. With a push of his right foot, Pheng commands the car forward, its wheels digging up dirt and grass as the villagers wave their good-byes.

Chou stands Chang up as her other kids clamor around her to look out the opened window. As the truck takes them away from Krang Truop, Chou stares back at her hut. She sees her adolescence spent collecting water, chopping wood, preparing meals, and braving Khmer Rouge attacks. By the time the truck reaches the bend in the road, Chou smiles at the memories of her life, their survival, and the births of her children.

Since the first Khmer Rouge raid of their village, Chou had wanted to leave. Uncle Leang, who originally moved the family far away from the growing Bat Deng, had hoped the trees, forests, and their farming skills would keep them safe if the Khmer Rouge were to come back to power. In his mind, the Khmer Rouge killed the city people but let his family live

because they were good farmers. But as the years passed, it seemed less likely that the Khmer Rouge would rule Cambodia again. And while the bigger towns thrived in relative safety, it was the rural villages that continued to suffer from the random raids.

After the first attack, the Khmer Rouge soldiers came back almost every week to steal from them. For Chou, these weekly raids left her anxious, paranoid, fretful, and unable to sleep. After a few months, the Khmer Rouge moved to terrorize another village but, for Chou, the fear they once again instilled in her had stayed. And even when the dogs were quiet through the night, Chou slept badly and dreamed of the soldiers kidnapping her husband and children. When she awoke, she kept her children close to her. Pheng agreed it was time for them to move, but they had no money or land to move to.

Then Meng visited and changed their lives. With the money he gave them, Pheng was able to buy an old truck. For many months, Pheng left the house before sunrise and drove from village to village. Along the way, he stopped whenever he saw people and told them about his taxi service. Since he was the only person with a truck in the surrounding villages, word spread and his business thrived. So every day, he climbed into the front seat alone and by the time he arrived at his destination, his midsize truck was packed body to body with people. After he dropped off his first load of passengers, a second group loaded their rice, chicken, vegetables, corn, and other goods on the truck and headed back to their village, perched on top of their supplies. When they'd saved enough money, Pheng and Uncle Leang pooled their funds to buy a bigger truck. Through the day and into the late night, Pheng drove back and forth until his eyes were too tired to focus and his body too stiff to sit up. Soon, they had extra money to buy an old motorbike.

"Morm is very excited for us to move near her," Pheng says, breaking Chou's train of thought. "Now she'll have everyone nearby—Second Uncle, Second Aunt, and Amah." With the money Aunt Heng and Eldest Brother sent to Amah, she was able to buy her own piece of land and a little house for her, First Aunt, and her daughter to live in.

"At Amah's age, she needs her peace and quiet away from all the great-grandchildren."

"She won't get much of that. How can she, since her place is just one house over from Khouy's?" Pheng chuckles. Chou laughs thinking about Khouy's five rambunctious kids.

From the connections he had made with the villagers and farmers from his taxi business, Pheng learned about their farms and what they grew. Then before the harvest season began, when the villagers were too busy with their farms to travel, Chou and Pheng drove from village to village checking out farms of watermelons, pumpkins, and potatoes. If the produce looked good, they negotiated a deal on the spot to buy the entire crop. When the produce was ready, Pheng and Chou hired a few people to help them pick the ripe fruit. While Chou oversaw the workers and picked fruit herself, Pheng sold their products to vendors and delivered them to the markets.

In their partnership, Pheng makes the deals, but it is Chou who holds the money and pays all the workers and vendors. As their business grows, Chou also walks tall and proud because she discovers that even without schooling, she understands numbers and can quickly work them out in her head. In her hands money grows, and after a season people have come to respect her not as Pheng's wife, but as an excellent accountant.

As Pheng steers their truck around large holes and mounds of dirt in the road, Chou watches the rice fields and green ponds. The sun beats hot rays onto the roof of their truck and warms the children into drowsiness. Soon Hok is asleep against Chou, and Chang breathes softly in her arms. Pheng lowers Eng onto a bag of towels in the middle seat and lifts the child's legs onto his lap. As Chou's arms grow tired and the children's hot bodies make her shirt stick to her sweaty back, she dreams about their new home.

When they arrive at their new wooden house, Aunt Keang, Khouy, and his family are standing in front of it to greet them.

"Second Brother, Sister-in-Law, Aunt Keang," Chou says.

"Chou." Morm takes her hand. "Your house is beautiful!"

"Sister-in-Law, come, let's look at it together." Chou passes Chang to her husband and walks through the double door into a big room. In the corner, a big dark wood plank bed hovers high off the dirt floor, leaving plenty of room for the children to run around. Next, Chou

checks out the smooth wood that makes up the wall of her and Pheng's private room. She enters the room to sit on her bed, and then gets up to push open the two windows. When she leaves, she closes her door and giggles.

"Chou, you have another big room up there!" Morm gushes.

Chou quickly climbs the stairs to her open attic. As she stands, she reaches up and touches its walls. "I can put a lot of things up here," she hollers to Morm.

When she comes back down, Chou passes another door and walks into her kitchen, which is covered only by a tin rolling roof. A round fold-up table stands next to another small plank bed. When she walks into the hut's backyard, Chou squeals at the sight of a well pump sticking out of the ground. While the men unload the truck, the women fill the hut with smells of cooked rice, roasted garlic, and fried fish. Then the adults sit down on white plastic chairs for dinner while the children eat next to them on the plank bed. After he eats, Chou's son Hourt wanders over to crawl on Khouy's lap. Hourt stares at the many strange black markings and dots on Khouy's arm and tries to rub them off. Khouy also has them all over his back and chest.

"Silly boy," Khouy laughs. "They're tattoos. They don't come off."

"Why?"

"The ink was put in there by very sharp needles."

The boy grimaces. "What for?"

"To protect me from the Khmer Rouge's bullets," Khouy says.

"Do you still go fight the Khmer Rouge?" Chou's daughter Eng asks, squirming at the memories of the Khmer Rouge raids.

"Not anymore. In my village I am now the deputy army chief. I have one hundred and twenty men to watch over." Khouy puffs on his cigarette. "But in my years as a foot soldier, I fought many times with Khmer Rouge."

"Tell us about how you fought the Khmer Rouge, Papa!" Khouy's son urges him.

It pains Chou to hear about Khouy's travel to fight the Khmer Rouge soldiers. When he first joined the army, she knew Khouy told his family little of his battlefield experience because he did not want them to worry.

But worry they did. Each time he left, Chou feared he might die in the jungle, alone, and without his family to ease him in his journey from this world into the next. It caused her much anguish to think how Pa, Ma, Keav, and Geak had died alone, their bodies lost so that she could not give them a proper burial. She prays this will not happen to Khouy. And though Chou left Krang Truop to escape the Khmer Rouge, she also came to Bat Deng to be with her brother. With Meng, Loung, and Kim gone, she cannot bear the thought of losing Khouy, too. Even though she is a woman, wife, and mother of three, the small girl in her still wonders what would happen to her if Khouy died.

"Do you really want to hear?" Khouy asks.

"Yes, tell us, tell us," the children plead.

As he speaks, Khouy's voice carries him back into his past. "From 1987 to 1989, when the fighting was at its fiercest, I was often away. One time, I was given barely any notice at all before I was asked to leave."

The army chief ranked higher than Khouy, though their friendship kept them at the same level outside the battlefields. But neither friendship nor Morm's pregnancy prevented the chief from sending Khouy into battles to stop the Khmer Rouge incursions into the surrounding villages.

At twenty-eight, he was already a veteran fighter. He knew he could refuse, but he also knew he would go. As much as he hated leaving, he recognized that someone had to fight to rid the country of Khmer Rouge. And as much as he feared being killed or maimed, as a young father he feared the Khmer Rouge returning to power even more.

The next morning, he packed his hammock, water canteen, small tin pot, spoon, ration of rice and dried fish, and an extra uniform in his green military backpack. Then he strapped his pistol to his belt holster. Before he left, he put a smile on his hard face while he hugged his children and said good-bye to his wife.

Five days later, Khouy found himself crawling in the mud of a rice paddy as Khmer Rouge soldiers' bullets whizzed over his head. He stopped and flattened his cheek into the twigs and dirt. Somewhere ahead of him, a loud explosion tore through the earth and shook the leaves in the trees.

"Damn land mines," Khouy cussed. He gripped his rifle and pushed

himself with his forearms and thighs, crawling on his stomach like a lizard to a big termite mound. With a mud pile for protection, Khouy snuck his head out and counted seven Khmer Rouge soldiers trying to hide in the field. His soldiers outnumbered the Khmer Rouge three to one. *They know they're outnumbered. They're only a minute's run to the jungle. They'll make a run for it,* Khouy thought. He made eye contact with his soldiers lying on the ground and signaled them to wait for his command.

Suddenly he heard water splash as the Khmer Rouge soldiers leapt up and ran.

"Shoot them!" Khouy screamed to his troops and jumped out from behind the mud pile, his rifle going off like a Chinese firecracker. "Kill them!" Khouy's bullet hit a Khmer Rouge in the back. His knees instantly buckled and he fell down face flat into the water. The other Khmer Rouge soldiers tried to fight back, but Khouy's troop charged; seconds later, it was over. Seven Khmer Rouge soldiers lay dead in the fields.

"Brother Khouy," a young soldier called, handing Khouy a dry cigarette. "They shot at you but no bullets could touch you. You are protected." Khouy's eyes landed on the protection tattoos on his arms. He lit his cigarette and for a moment felt invincible.

Back in Chou's kitchen, Khouy cups his hand over his match and lights his cigarette. In the flickering yellow flames, Chou sees that his face is taut and unmoving. Around him, the children's mouths gape open with awe as Chou and Morm sit stiffly, their hearts pounding with fear and gratefulness that Khouy is still with them.

That night, Chou falls asleep for the first time in her new house and dreams of Pa. They are sitting together under a tree, and Pa looks at her with gentle eyes and smiles. Next to him, she is once again a small child, weak, powerless, and full of fear.

"Pa, come live with me," she says in a child's voice. "I have a big house now."

"Chou, you don't need me to," he answers. "I have helped you make a good business and enough money. You now have a good life."

"I don't want money," she pleads. "I just want my family safe."

"They are safe," he assures her, and disappears.

For the first time, Chou dreams that she stops crying and does not run after him. When she looks down, she is a woman again—a woman who is a mother and wife, a provider and protector.

"I miss you," she tells him, but wakes up knowing that whatever happens, she will be able to care for her family.

27 ma's daughters

It's a long drive home to Maine from Vermont, and my 1982 Nissan Stanza makes it seem like forever. My Nissan, which I named Little Red for her color, was a gift from Meng for my college graduation. With her hot temper, Little Red won't go over sixty miles per hour without letting me know I'm hurting her. When I push her, she complains noisily with her creaks and squeaks. In the backseat, my laundry basket full of newly cleaned clothes and Tupperware containers full of Eang's delicious home-made egg rolls, fried wontons, and steamed dumplings rattle against one another as Little Red shakes as if to warn me she will implode and take me with her if I don't slow down.

I heed her warning and ease up. I think back to the time when she became mine. My college graduation. I remembered the thrill of walking into the auditorium to the loud beat of "Pomp and Circumstance" as the brass band played. When the students entered, the crowd of five thousand stood up, clapped, and roared to a fevered crescendo, and somewhere in the mass, I knew Meng, Eang, and the girls were beaming proudly at me for being the first Ung to graduate from college. I looked up into the bleachers and tried to find them, smiling widely at my own accomplishment, when suddenly I realized that among all the parents assembled, mine were missing. Just as quickly, I also knew that wherever they were, Pa and Ma were filled with pride.

After college, I wanted to work with programs that dealt with issues of war, child soldiers, and genocide. However, as I began my research to find such agencies, the nightmares returned. I realized then that my soul needed more time to heal and yet I felt compelled to be involved in anti-violence work. I found a job as a community educator for an abused women's shelter in Lewiston, Maine. Since this is only a four-hour drive from Vermont, I return every few months to see Meng, Eang, Maria, and Tori in Essex Junction.

When Little Red pulled out of their driveway this time, I did something that I knew I shouldn't have—I looked back. Through the rearview mirror, I saw them standing there until I made my left turn onto another road and out of their sight. The image of Meng with his arms around his two daughters, watching me leave, snapped some heartstrings in my chest. As Little Red speeds on U.S. Route 2 into New Hampshire, Mount Washington juts majestically into the sky in front of me. In the clear blue sky, a few wispy clouds cling around the peak of the mountain. Suddenly, the beauty of it all makes my chest heave and my hands tremble.

"Ma, Pa," I call out, "I miss you."

Driving back and forth from Maine to Vermont through the mountainous roads, I've taken to talking out loud to Ma and Pa. Though I don't know for certain that they can hear me, the sound of my voice telling them about my life usually gives me great comfort. Today, however, it seems to make me sadder.

As a child, I used to look forward to a time in adulthood when it would all hurt less. But it doesn't. I still see the faces of Pa, Ma, Keav, and Geak. Alone and safe in Little Red, unseen by anyone except for the red eyes of passersby.

"Ma, Pa, I still miss you so much." As the words tumble out, everything converges: Meng waving in his driveway, the heartbreaking beauty of the mountains, the solitude of my long trip. I feel myself pulled under the currents of dark water, and I don't know if I have the energy to fight my way out. For a brief moment, I think I might not fight, but instead of surrendering, I reach out for Ma and Pa's hands.

"Pa, Ma," I call out to them. My voice is halting and small against the loud rushing wind pushing at Little Red. "I need your help. Please let me

know there are angels out there looking after me. Please show me that I'm not alone," I whimper, feeling lost and lonely. After fifteen years of living in America and four years of Catholic college, I believe in angels. But because of their Buddhist beliefs, I cannot think of Pa and Ma as angels. Instead, I imagine them as spirits that watch over me. "Please, show me others who've gone through what we have and are living happy lives."

For the next hour, Little Red rolls quietly along the road while I compose myself and tell Ma and Pa about my work and friends.

"And Pa, Eldest Brother is planning another trip to Cambodia in a few months," I tell him, as if he doesn't already know.

For a year now, Meng has been planning a trip to Cambodia with Eang, Maria, and Tori. And every time he calls me, he asks me the same question.

"Why don't you come also?"

"I don't have enough vacation days," I always reply. "If I go, I might not have a job to come back to." That's a lie. I don't want to go because when I think about being back in Cambodia, I am filled with fear.

"Well, think about it anyway," Meng says before he hangs up the phone.

It's a conversation we've had weekly, and every time my response is always the same.

By the time Little Red stops in front of my apartment complex, my head is finally clear. I grab my bag and head for the front door. At the bottom of the stairs, I open my mailbox and feel my spirit float off the ground when I see a catalog on angels stuffed inside. Granted, it's a mail-order catalog selling all varieties of angel plates, bells, dolls, pendants, charms, and wings. Still, I bounce upstairs to my apartment, smiling at my sign.

My small one-bedroom apartment is just as I had left it a few days before. My home is decorated with paintings of sunflowers on the walls, tables, and chairs but not a single picture of Ma, Pa, or my family in Cambodia. I plunk down on my couch and turn on the TV, eager to unwind after the long drive. When the picture comes through, Oprah is talking to a Holocaust survivor who escaped from a concentration camp, then married her American rescuer and lived happily ever after. I walk through my glass sliding doors and out onto my balcony. When I close my eyes, I imagine Pa standing next to me. In my mind, I am five years old again. Pa

picks me up and puts me on his lap. As he hugs me to his chest I know that he doesn't just love me, he adores me. I know also that Pa loved Cambodia and would never leave it. And somewhere in Cambodia, he is there waiting for me.

"Thank you," I whisper. "Thank you for letting me know you're there." Then I head back in, curl myself into a ball, and nap in the sunlight on the floor.

When the sunlight moves past me, the phone's ring wakes me up. Groggily, I walk to the desk and pick it up.

"Hello?"

"Loung." Meng's voice flows through the line. "You make it home all right?" he asks in Khmer.

"Yep, no problem. Good driving weather."

"Loung, you forgot to take the videotape," Meng says, referring to the footage he took of his Cambodia trip. I flash to the hours and hours of scenes of splattering rain, swaying palm trees, bustling markets, temples, monks, rice paddies, and Chou, Khouy, and the family eating, walking, sitting, drinking, sleeping, and playing with their kids. Whenever I am home, I can count on the video being in the machine and Meng urging me to watch it with him. This time, I didn't have the patience for it, so I told Meng I'd take the videotape with me and watch it back in Maine.

"You want me to send it to you?" he asks.

"No. That's okay. I'll pick it up next time."

"In September we'll have new videos," he chuckles.

"Yes, we will," I say, and take a deep breath. "I'm going with you."

As the date for my trip to Cambodia approaches, my anxiety increases. My last images of my home country are of garbage-filled broken roads, decrepit charred buildings riddled with bullet holes. Before I fall asleep each night, I see the Khmer Rouge soldiers parading around the villages and guarding the vegetable gardens while my stomach balloons from hunger. In my dreams, I board the plane in America as an independent, self-sufficient, adult woman, only to step off as a child. The child is alone and lost in Cambodia and desperately calls out to her family, for Pa, Ma, and Chou to come find her. But each morning my panic leaves me when I remember Pa and Ma's signs to me. And I know I am not alone.

For many weeks I pack and repack my big backpack in anticipation of my trip. On the day of my departure, my panic finally transforms into excitement. I'm really going to see Chou! When we did not reunite after five years like Meng promised, I had put all thoughts of seeing Chou out of my mind. And through the years, as I became busy with school and life, I left Chou farther and farther behind until, in my mind, the oceans and twelve thousand miles between us seemed impossible to cross.

I strap myself into my airplane seat. Because I could not get time off work, Meng, Eang, Maria, and Tori went to Cambodia ahead of me, leaving me to travel by myself. I lean my head against the window and fantasize about returning to a country where I belong, a place where everyone speaks my language, looks like me, and shares the same history. I can now envision getting off the plane and walking into the open arms of my family, forming a protective cocoon around me, keeping me safe.

Twenty-five hours later, the plane screeches against the tarmac of the short runway. I brace myself for my first meeting with Chou in fifteen years. The stewardess announces for all to remain seated until the plane comes to a complete stop. I grip my armrest in my seat like a revved-up race car, resting in neutral but ready to take off. When I finally exit the plane, the heat and humidity hit me like a blast from the past and reawaken memories of a childhood spent shedding my clothes and playing in the rain.

I slowly inch my way through customs, and it feels like hours before I emerge from the airport. With my backpack strapped on tight, I spot my family in the crowd. Instantly, my hands are hot and sweaty. In front of me, twenty or thirty of them are positioned elbow to elbow, pushing at one another for their first glimpse of me. In the middle is Meng standing next to Eang, Maria, and Tori and looking happier and more peaceful than I've ever seen him look in America. Beside them, Khouy smiles at me from the same face as the one from my memory, wearing a T-shirt emblazoned with I LOVE VERMONT on it. Then I see Chou and my throat tightens. Though she is older, I am still taller and bigger than she. I take in the details of her loose-fitting dark purple shirt, her unwrinkled black pants, and a pair of beige pumps that cover her toes. I fix my eyes on her long black hair, her smooth skin, and her full lips and face made up with pink powder and red rouge. When she smiles, her mouth opens wide to expose her teeth and

gums, reminding me of Ma. She is beautiful. I gaze in amazement at how much my sister had changed.

Suddenly, I notice the frowns. My comfortable, practical, loose-fitting black pants, brown T-shirt, and black Teva sandals draw quizzical looks from my Cambodian family.

"You look like a Khmer Rouge," one male cousin announces.

I stare back at them, aghast that those are the first words I hear from my long-lost family in Cambodia.

"That's how she dresses when she travels," Eang explains gently.

As my face turns pink from embarrassment, Chou's eyes lock on mine and I see that they are the same: kind, gentle, and open. Suddenly, she covers her mouth and lets out a loud cry and runs over to me. The rest of the family watches silently as Chou takes my hand, her tears cool in my palm. Our fingers clamp around each other's as naturally as if the chain has never been broken.

"I can't believe you're here!" Chou exclaims, her voice breaking through her sobs.

"Chou" is the only thing I can manage to say as I bite back my own tears.

"It's really you," Chou rasps, crying and laughing at the same time. I look at her, and the American part of me wants to take her in my arms in a warm embrace, but the Cambodian/Chinese part of me holds back. In America, I hug Maria, Tori, and my friends but never Eang, Meng, or any other Cambodian people. So I stand there, my arms hanging awkwardly by my sides while the crowd watches.

"Loung, don't worry about Chou. She cries all the time," Khouy teases as Chou composes herself.

"Second Brother, Eldest Brother, Eldest Sister-in-Law," I greet Khouy, Meng, and Eang.

"This is Morm, Pheng . . ." Meng introduces me to a sea of new faces and names but I have a hard time turning from Chou's husband. "Not ugly but tall and handsome," I think and am happy for her.

"Come, let us go." Chou pulls me out of the crowd, her eyes still red.

While the others follow with my bag, Chou leads me through a throng of armless and legless men and women beggars. "Land mine victims, many of them of here," she tells me when she notices the halt in my

steps. While the family packs into the back of Pheng's truck, Meng, Eang, Maria, Tori, Chou, and I pile into our small rented car. As the driver takes us into the city, I am filled with many emotions fighting their way to the surface. Next to me, Chou smiles and gapes. Her hand gently touches my arm and then rests in my lap.

"How are you doing, sweetie pies?" I ask Tori and Maria in English. As they describe their trip to the village, I gaze out the window. My eyes flicker darkly when I see young children running in the street with tattered clothes and limbs so thin they look like stick figures. Behind them, men and women sit in the sun on small stools next to piles of garbage, trying to make a living out of their baskets of oranges, pomegranates, and jackfruits as our car kicks up dust into their eyes. Sun-worn gray, one-room thatch huts litter the landscape. But in my eyes, even in the midst of the obvious crushing poverty, the Cambodia I'm in now is not the Cambodia of my nightmares. Though the crumbling buildings and bumpy roads are the same, this Cambodia is crowded with strong-looking people and spirited smiles.

"Loung, you don't feel sick?" Chou asks me. "It was such a long flight."

"No, I slept very well—like a dead person. When I woke up, I read my books. I like flying a lot." As I speak in my heavily accented Khmer, I notice the confusion on Chou's face. Meng and Eang laugh out loud.

"Loung," Meng says to me in Khmer, "in Khmer we say 'ride on plane' not 'fly.' And we don't use the expression 'sleep like a dead person' here."

"Eldest Brother," Chou giggles. "Loung was speaking Khmer?"

"Chou, I will have to interpret Loung's Khmer into Cambodian Khmer for you," Meng chuckles. "After fifteen years speaking mostly English, she literally translates English words into her version of Khmer words."

Though a little embarrassed, I laugh along with them. As Chou, Meng, and Eang banter on, switching from Khmer to Chinese, their happiness makes the air less stuffy. In my mind, I scream in English, "I can't believe I'm here sitting next to Chou! Oh My God! I'm here!" We drive through concrete streets flanked by old three-story buildings covered in gray mold. On a wide side street, a man pushes a cart with big pictures of

ice-cream bars and rings his bell. Suddenly, I remember running up to a similar vendor with Keav, Geak, and Chou and I smile.

"We are at Che Cheung's house," Chou tells me when the car stops in front of a an old two-story house. "She and the other girls have cooked up a big feast in honor of your arrival." Chou reaches for my hand and walks me into a modern-looking big room filled with dark wood plank beds, dressers, and teak chairs. I take off my sandals and throw them on top of a pile of others and cool my feet on the beige ceramic tiles while the whirling fan above blows air on my natty hair. "Che Cheung is very lucky," Chou whispers. "When the UNTAC soldiers came to Cambodia to set up the election, she borrowed money and started a business selling motorbikes. She did very well." Since her first visit to Phnom Penh in 1991, Chou no longer fears the city and returns often to see relatives. But still, I'm taken aback that she knows about UNTAC, the United Nations Transitional Authority of Cambodia.

"Che Cheung, we're here!" Chou calls out. Suddenly a swarm of new faces surround me and my name pops out of lips from every corner of the house.

"Loung, welcome to my home." Out of the crowd, cousin Cheung steps out. A petite mother of five, she runs her hand over my arm. "Isn't she so pretty? Her flesh is so young and smooth," Cheung declares in a tone of a big sister as everyone nods their head. Under their intense gaze my skin transforms from glistening to sweating like a pig.

"Cheung, what are you cooking that smells so good?" Eang saves me.

Taking that as a cue, Cheung's daughters roll out a round table and set it up in the middle of the floor. Then, like expert waitresses, they bring out hot dishes of sweet and sour fish soup, roast duck, steamed chicken, deep fried pork, and stir-fried bok choy.

"Eldest Brother told me you all cannot eat vegetables so I've made many meat dishes." Cheung smiles proudly at the expensive and sumptuous meal.

"Cheung, that is too much," Meng tells her.

"Eldest Brother, we meet together only once in fifteen years," Cheung insists.

The hours after lunch are spent in quiet conversation and storytelling until the drowsy effects of too much food wear off. While the others talk,

I steal fleeting glances at Khouy. He sits with his back straight against the wall and his legs crossed. In his jokes and laughter, I find my brother who loved his bell-bottom pants and listened to the Beatles on his eight-track tapes. As Khouy tells his story, I watch Pheng hold his infant son, Chou's fourth child. In a culture that frowns on public displays of affection, I notice that Pheng's eyes often stay on Chou when she is in the room. When questions are asked of me, my tongue feels foreign in my mouth as I struggle to produce the sounds and tones of my native language. When she sees my difficulty, Chou explains to the family what Meng told her about my difficulties with Khmer in the car.

When the sun is low in the sky and the air is cool, Pheng, Meng, and Tori climb into the front seat of the car while Eang, Maria, Chou, her infant son, and I pile into the back. Pheng turns the car onto a busy street and stops in front of a big, boarded-up movie theater.

"Do you know where we are?" Chou asks as I stare quietly at the crumbling façade.

"Street Charles de Gaulle, Rong Kon Saw Prom Meih." I tell her the name of the theater with fluency. Then I get out of the car and step back into 1975. "Our house," I say with certainty, my voice choking. As I walk on our street, I feel myself growing smaller as visions of naked pink dolls, a yellow ball, and a small furry French poodle rise out of the cement to greet me. When I look up at our apartment, I feel Ma's soft touch on my skin as she wrapped a red chiffon cloth around my body and asked me if I liked it. "The color looks so pretty on you," she'd said, "and the material will keep you cool." She made three identical dresses for Geak, Chou, and me to wear on New Year's. All had puffy sleeves and skirts that flared above the knees.

"The family that lives there has good spirit." Chou brings me back into the present. "They've let us walk through the house. If you want to see it, we can ask."

"I've seen it." Meng is next to me, with his wife and daughters beside him. Suddenly the street is congested with many noisy cars and motor-bikes spewing out fumes that make my temples throb and I realize I'm not ready to see the house.

"No need," I finally tell Chou. "It's getting late. We'll see it some other day."

As I climb back in the car I turn to look again at our old home. I see myself on our old balcony, leaning over the railing, spreading my arms out like a dragon, pretending to fly over the city and not caring if anyone saw me. In his corner behind me, Pa watches proudly. I understand then that though America may be my home for the moment, Cambodia will always be my heart and my soul.

"I'm not afraid anymore," I smile and whisper to him. Chou reaches out and takes my hand as we drive away.

Epilogue lucky child returns

The dogs bark loudly outside the wooden door and wake me from a wonderful dream. With my eyes still closed, I relive the dream scene by scene to etch the details forever in my memory.

I am trekking among the ruins of Wat Banteay Srey, the beautiful and exquisitely preserved rose-colored sandstone temple of women built in the tenth century in Siem Reap. As I touch the cool rough carvings and stare at Apsaras, nagas, elephants, and a myriads of gods and monsters living in the stones, I hear footsteps behind me. I turn to see Ma smiling at me. She is alive and beautiful and basks in a soft twilight that makes her look golden and angelic.

"What are you doing here?" I ask her.

"Just walking with you," she replies as if this is the most natural thing for her to do.

I don't ask her any more questions and wait for her to catch up. As we trek along the thousand-year-old temple steps, neither of us speaks a word. It is the first time I am with her unencumbered by feelings of loss, horror, or sadness. It's as if we're living out a parallel life where the war never existed between us.

When I open my eyes, the feeling of peace and serenity is still with me. I am lying on a spring mattress on top of Chou's plank bed in Chou's room in the village. Through the slits in the wooden windows, there is

only darkness. Even without looking at my watch, I know it is very early in the morning. Inside my mosquito net, the air is fresh and cool. When I hear Chou's footsteps shuffling in the other room, it dawns on me that she and I are living out our parallel lives in this world. Since our first reunion in 1995, we have been forming a new sister bond in a world that does not include the genocide or the Khmer Rouge. I turn on a flashlight and begin to write.

"You're up already?" Chou asks. She's standing by the open doorway, holding an oil lantern in her hand.

It is my first day in the village of a planned three-month stay in Cambodia. And though work will keep me in Phnom Penh on most weekdays, I will spend every weekend in the village with Chou.

"Yes, the dogs woke me up," I tell her in what is now fluent Khmer. "Doesn't their barking wake you up at night?"

"No, I'm used to it." She smiles.

"Can't you tell the owner I'll pay fifty dollars to buy the two dogs? Then we'll make curry out of them."

"We don't do that here," she chuckles, and leaves.

Finished with my writing, I turn off the flashlight, lie on my back, and listen to the rats crawl between the boards over my head. In the other room, Pheng and their five children are still asleep, the children's bodies huddled close to keep warm. On my mattress, I lie awake listening to the hums of the mosquitoes outside the net. My thoughts drift to the little girl in the opened grave who once cried and grabbed for me in my dream. I know she exists, but she no longer haunts me. Instead, she walks beside me in my shadow, finally at peace. I close my eyes, pull my thick blanket over my body, and wait for the sun to brighten up the sky. In the kitchen, I hear Chou snapping dry twigs for a fire to cook the family's breakfast of rice soup.

After I returned from my first visit to Cambodia in 1995, I left my job in Maine and moved to Washington, D.C., to work for a campaign to ban land mines. Then in 1997, I joined the Vietnam Veterans of America Foundation (VVAF), an international humanitarian organization. They run physical rehabilitation clinics that provide free prosthetic legs, arms, wheelchairs, and other mobility devices in Phnom Penh and three other

provinces in Cambodia. As VVAF's spokesperson, I've made over twenty trips back to Cambodia, each time bringing friends and donors to help the country's many land mine and war victims. With each trip, after I say my good-byes to the delegation at the airport, I come to the village.

But the village is more like a town now. It is a bustling, crowded town with over three hundred families and perhaps as many as four thousand people. There is still no running water, but for the past few years, electricity is available from six P.M. to nine P.M. for those who can afford to pay for it. Chou and Pheng no longer run their taxi service; they are concentrating full-time on their produce business. From fruits and roots, they've expanded to sugarcane, palm sugar, bamboo containers, and an occasional truck rental service. Both Chou and Pheng are extraordinary entrepreneurs and, as their business thrives, they fill their house with such modern amenities as a TV, VCR, radio, glass door cabinets, drawers, standing fans, and a squat toilet. As for their five children, Chou makes sure they all go to school three times a day, six days a week to study Chinese, Khmer, and English. When her oldest daughter, Eng, finished ninth grade, Chou sent her to Phnom Penh to live with cousin Cheung so Eng could continue with her studies.

"Wake up, little ones." I hear Chou walk back into the house and wake her children. "It's time to get ready for school." In their nets, the children cough, sniffle, yawn, and complain, but they quietly do as their mother commands. While Chou dresses the little ones for school, Pheng unlocks their front door and greets the arriving villagers. I get out of bed, grab my video camera, and go outside to film the scene for Meng.

Outside, the roosters crow, pigs snort, and the dogs bark loudly as people arrive to set up the market. The villagers' voices grow louder with the light as they arrive one by one, sitting body to body in wagons pulled by ponies and cows; the lucky ones sit on the edge of the cart with their feet dangling free, their mouths spitting tobacco. Others travel on their rusty bicycles carrying piles of morning glory, lemongrass, cassava, tiny bananas, green oranges, sugarcane, meat products, fish, and bamboo shoots attached to the handlebars and back racks. Once there, they set up their stools to sell their few products. By the time the sun burns through the haze, only a few stragglers who have come on foot are still shopping,

as most of the rest have already picked up their supplies and left with bags balanced on their heads, hips, shoulders, or backs. After the throngs leave, all that's left are the rotten fruit, dead fish heads, manure, chewed-up sugarcane, coconut shells, and other garbage, left to the joy of all the flies and bugs.

When the sun climbs high enough in the sky to warm my skin, I make my way to the outhouse for a shower. As I scoop cold water with a little bowl to wash my face, numerous large spiders feast on bugs caught in their webs above my head. I glance around and realize that Chou has never had a hot shower or taken a bath in her life. When I emerge from the outhouse, Chou's children are scurrying around, fetching me bottled water, bringing me a chair to sit on, and taking my towel to hang on the rope to dry. While her family eats plain rice soup with fried eggs, Chou returns from the market carrying a bowl of pork-blood rice congee and seasonal fruit for my breakfast. As I eat, Chou's six-year-old daughter, Ching, climbs on my lap. Ching is the spitting image of Geak, and in my arms I hold them both. But soon Chou shoos all the children off to school.

"Chou, I'm going to visit Second Brother's house," I tell her.

"I'll come with you."

Together we walk the two minutes on the red dirt road to Khouy's house and are greeted by Morm.

"Khouy has already gone to work," Morm informs us. "But sit down for tea with me."

As we sit on the chair swing under the tree, Morm tells me her family is doing well now. Between Khouy's salary and her joint business with Chou, selling sugar and whatever else they decide will be profitable, they have more than enough to eat, clothe themselves, and send the children to school. As we swing in our chair, I tell them about Kim.

After he arrived in France in 1985, Kim started writing to Huy Eng and asked her to wait for him. When he got his French citizenship in 1993, he returned to Cambodia and they married with Amah's and the rest of the family's blessings. When he left, he took Eng with him back to France, where she gave birth to a son, Nick, and a daughter, Nancy. In France, Kim took a French name—Maxine—made plastic glasses frames by day

and learned how to make French bread and pastries at night, dreaming of one day opening his own French bakery in America.

Meanwhile, in America, Meng filed many immigration forms, and in the spring of 2000 Kim finally received his papers to come live with Meng. But after two years, Kim and Huy Eng decided they didn't like the Vermont winter; they moved to Los Angeles to live with Huy Eng's brother and his family. In California, Huy Eng is a stay-at-home mom while Kim has found work making French bread and pastries in a five-star hotel. After four years of hard work, Kim had saved enough money to open his own bakery. Now Max Bakery opens seven days a week.

"Are his cakes good?" Chou asks.

"They're delicious!" I exclaim, my mouth watering. "When I visit, he always makes me my favorite, these great cream-filled cakes the French call éclairs. Mmmm." I smack my lips, rub my belly, and make Chou and Morm laugh.

"Come over for dinner tonight. We'll feed you your favorite Khmer food," Morm tells me. By now, everyone knows I love to eat but do not know how to cook. In Vermont, Eang even calls in advance before my visits to work out a menu so that she can be sure to prepare all my dishes during my stay.

"All right. We'll be here for dinner," I agree quickly.

"Second Sister-in-Law," Chou laughs, "Loung will never learn to cook if we all keep on cooking for her!"

From Khouy's house, Chou and I walk next door to visit Amah, who at ninety-four is no longer able to walk or move unassisted. However, in my prior visits, I got to spend time with this wonderful woman who asked me only for great-grandchildren and a good bottle of Hennessey. I laughed and delivered only the Hennessey, and she told me in all seriousness that a shot a day kept her blood warm and moving, thus giving her long life. Before a stroke last year caused her mind to digress, she was our living history for four generations of the Ung family.

"Amah," I call her and sit by her. Lying on her bed, she reaches out for my hand.

"Ay Chourng," she calls me by Ma's name, her eyes squinting and squeezing out tears. "You look good. You have been gone such a long time."

As I stroke her bony, wrinkled hand, Amah tells me about her life, the family, and her aches and pains as if I'm Ma. When she's exhausted herself with words, I leave her sleeping and dreaming of Ma.

Chou and I cross the road from Amah's house to visit Uncle Leang and Aunt Keang. With their children grown and able to take care of themselves, Aunt Keang finds joy in being a grandmother to her many grandchildren while Uncle Leang spends his time turning the land in back of his house into a lush garden. After Uncle Leang shows me his flowers, chili pepper bushes, cane sugar stalks, guava, papaya, coconut, palm, pomegranates, and mango trees that are all heavy with fruits, we join Chou and Aunt Keang on their concrete chairs around a table in the shade.

"Your land is beautiful like the jungle," I tell him. Then I realize that jungle was probably not what he was trying to create, and add, "I mean a beautiful garden." When I share with him that I'm writing another book about Chou, me, and Cambodia, he nods his head in approval.

"The young children, they don't know," he says, and pauses. "And it is too hard for us to tell them. The little ones, it is good they read your book." Even though my book is published in Khmer now, I know Uncle Leang, Chou, Meng, Kim, and the adults in the family found it too painful and therefore have only read sections of it. But many of my nieces, nephews, and cousins have read it, and then gathered together to discuss it.

"Did you know the book was read over the radio?" Aunt Keang asks.

"Yes," I reply. I'd given permission for two Khmer daily newspapers to serialize the whole book, and for it to be broadcast.

"Many friends told us they cried from beginning to finish," Aunt Keang reports.

"I still think about your ma and pa," Uncle Keang says somberly. "I loved them very much. They were very good people." Then he looks up at Chou and me and continues. "That's why they had such good kids."

As Aunt Keang brings out our lunch of rice and stir-fried vegetables, Chou cuts up ripe mangos and a papaya from Uncle Leang's garden for our dessert. While we eat, I fill them in about Meng and his family.

In 1997, Meng and his family moved into their newly built four-bedroom, three bathroom, beautifully furnished dream home. After many

years at IBM, Meng and Eang now work the day shift, which over the past few years has left their evenings free to watch cheerleading captain Tori at her games and to take Maria out to dinner for making the National Honor Society. Now Maria has graduated from Saint Michael's College and is a chemistry teacher in another town, and Tori is off in college studying to be an architect. Meng and Eang are planning their retirement, which they hope to spend splitting their time between Cambodia and America. Until then, Meng continues to watch the many hours of videotapes I've made for him of Cambodia over my twenty or so trips back.

We are finishing up with our lunch when Chou suddenly says, "I would love to see America and your home one day." Her voice is soft and wistful. "I'm very happy here in Cambodia. I love it here and would never think to leave it and my family, but I would love to see where you live."

While Kim, Meng, and I have visited them many times, none of my Cambodian family has ever been to America to see us. Through the years, they haven't been able to make the trip—first for political reasons, then it was the poor economy, their small children, the Asian market crisis, 9/11, and SARS. Now, however, their children are old enough to care for themselves, Cambodia's political situation is stable, and the planes are flying. Meng's next big dream is to bring Khouy and Chou to America for a visit.

"Eldest Brother and I would love to show you around America someday," I assure her.

"Meng," says Aunt Keang. "He's very kind and gentle like your pa."

The four of us lounge on the outdoor plank bed under the cool shade, talking and eating fruit off Uncle Leang's trees until the sun lowers itself in the sky. When Pheng arrives, he finds us lying on the bed in a state of food coma, letting our stomachs do all the hard work of digesting our food.

"Pheng, it's late afternoon," Chou calls. "Let's take Loung to look at her land!"

And together we're off again, with me straddling the back of the bike, while Chou sits sideways next to her husband. Five minutes out of the village, we arrive at the 2.5 acres of green, flat land I just bought last year, after Pheng informed me it had been de-mined.

"It's beautiful," I tell Chou, staring at my green grass, thick shrubs, and prickly bushes.

"When you build your house here, we'll only be a few minutes' motorbike ride from each other," she smiles and leads me deeper into the field. "And here is your own water well already." She points to a crumbling ring of gray concrete sticking two feet out of the ground. My first thought is that the well wall is too low.

"Someone can easily fall in," I say to her.

"Not in Cambodia," she laughs. "Here we are careful about everything."

I stand at the edge of the well and stare down into the black hole, briefly expecting to see a dead body floating in the water and smell decaying flesh up my nose. But there is no ghost in my well.

"The well is deep," Chou states. "The water is very clear and tastes good."

I nod to her.

"Your water is right here so you don't have to go to the pond. All you need is a pail and a rope and you have all the water you need for your house!" Chou tells me excitedly.

I smile and say nothing, but think to myself, *When I build my house here, I'm covering up the well and putting in a pump and a flushing toilet.*

"It's not only beautiful land but very rich earth," Chou informs me. "Anything will grow on it!"

I turn from the well to survey my land. In the dusky sunlight, the long grass looks like it's been colored with a green Crayola crayon, and moves like waves in the breeze. Hand in hand, Chou and I walk on my very own little piece of Cambodia, and in my mind I envision a jungle garden like Uncle Leang's shading my future small wooden house.

When we arrive back at Khouy's house, I find him in the kitchen, one hand on his hip, the other holding a ladle to his lips.

"Second Brother." I greet him. "What smells so good?"

"Sour fish soup with morning glory vegetables," he replies.

"Mmm, my favorite!" I exclaim as Khouy smiles knowingly. As the man of the house, and a deputy police chief, Khouy rarely makes their meals, yet he is a surprisingly good cook. And when I'm in town, for

a few nights he can be found in the kitchen making his special soups for me.

Over dinner, I slurp down Khouy's soup noisily while little black bugs fly into the strips of clear tape hanging below a long fluorescent tube. Between mouthfuls, I answer questions about my college sweetheart, Mark, whom I married in 2002 after many years of friendship and court-ship. When we came together to Cambodia for our honeymoon, the family accepted him as one of their own. By the time we finish dinner, the tape strips are black with bugs.

After dinner, I return to Chou's and to her comfortable bed. As I drift off to sleep, I travel back to 1998—the year of the Ung siblings' big family reunion in Bat Deng. That summer, while the rest of the world focused on Pol Pot's death, Kim flew in from France while Meng and I came in from America to meet Chou and Khouy. With all the siblings together for the first time in eighteen years, we organized a big Buddhist ceremony to honor Pa, Ma, Keav, and Geak. On that day, over five hundred relatives and friends old and new came to our gathering from the surrounding vil-lages. In between the loud Chinese and Cambodian ceremonial music, Ma's childhood friends told me how she loved to ride bikes and an old friend of Pa's laughed about Pa's love of eating stir-fried clams and day-old rice.

When it came time for all the siblings to pray to them, I kneeled in front of Ma and Pa's picture. With three burning incense sticks pressed between my palms, I raised my hands to my forehead. I stared into their faces, thinking there was so much I wanted to tell them. While the monks chanted and blessed me with holy water with a flick of their wet fingers, my eyes stung and my chest swelled. To Ma, I wanted to beg for-giveness for thinking she was weak and for being angry that she'd sent me away. To Pa, I wanted to thank him for not abandoning us, even though it might have meant his survival. I wanted to tell them that even though I'd witnessed the worst of man's inhumanity to man, in my fam-ily and my life experiences I'd also seen the very best of man's humanity to man.

To Keav and Geak, I wanted them to know that sisters are forever. I touched my hands to my forehead three times and bowed once to the

Buddha for wisdom, to Dhamma for truth, and finally to Sangha for virtue. But in my silent prayers, I told my lost family only that I loved them and missed them. Suddenly Chou was praying beside me. As I stood up and placed the incense into the bowl, I looked at Chou and she smiled at me reassuringly, just as she still does every time our eyes meet. Then she rose, took my hand, and we walked together back into the crowd.

resources and
suggested reading

To learn more about the Khmer Rouge genocide contact:

Documentation Center of Cambodia (DC-Cam)
70 E Preah Sihanouk Blvd.
P.O. Box 1110
Phnom Penh, Cambodia www.dccam.org
Email: dccam@online.com.kh

To inquire about speaking engagements for Loung Ung contact:

CreativeWell Inc.
P.O. Box 3130
Memorial Station
Upper Monclair, NJ 07043
E-mail: info@creativewell.com
Tel. 1-800-743-9182 www.creativewell.com

For updated information about the Ung family, Max Bakery, or Loung's
scheduled appearances and work with other charitable organizations:

www.loungung.com

For information on the Vietnam Veterans of America Foundation's Campaign for a Landmine Free World, contact:

VVAF
1725 I Street, NW
4th Floor
Washington, DC 20009
Tel. 202-483-9222 www.vvaf.org

Suggested Reading

Becker, Elizabeth. *When the War Was over: Cambodia and the Khmer Rouge Revolution*. New York: PublicAffairs, 1998.

Chanda, Nayan. *Brother Enemy: The War After the War*. New York: Simon & Schuster, 1988.

Chandler, David P. *Brother Number One: A Political Biography*. Boulder, Colo.: Westview Press, 1999.

Dith Pran, ed. *Children of Cambodia's Killing Fields: Memoirs by Survivors*. New Haven, Conn.: Yale University Press, 1999.

Gottesman, Evan. *Cambodia after the Khmer Rouge: Inside the Politics of Nation Building*. New Haven, Conn.: Yale University Press, 2004.

Haing Ngor and Roger Warner. *Survival in the Killing Fields*. New York: Carroll & Graf Publishers, 2003.

Kamm, Henry. *Cambodia: Report from a Stricken Land*. New York: Arcade Books, 1999.

Kiernan, Ben. *How Pol Pot Came to Power*. New Haven, Conn.: Yale University Press, 2004.

McCurry, Steve. *Sanctuary: The Temples of Angkor*. New York: Phaidon Press, 2002.

May, Sharon, and Frank Stewart, eds. *In the Shadow of Angkor: Contemporary Writing from Cambodia*. Honolulu: University of Hawaii Press, 2004.

Shawcross, William. *Sideshow: Kissinger, Nixon, and the Destruction of Cambodia*. New York: Cooper Square Publishers, 2002.

Swain, John. *River of Time*. New York: Berkley Publishing Group, 1999.

Wagner, Carol. *Soul Survivors: Stories of Women and Children in Cambodia*. Berkeley, Calif.: Creative Arts Book Company, 2002.

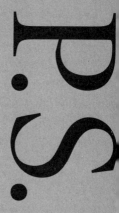

About the author

About the book

Insights,
Interviews
& More...

Read on

Meet Loung Ung

© 2005 by Mark Priemer

LOUNG UNG is a survivor of the killing fields of Cambodia—one of the bloodiest episodes of the twentieth century. Some two million Cambodians (out of a population of just seven million) died at the hands of the infamous Pol Pot and the Khmer Rouge regime.

Born in 1970 to a middle-class family in Phnom Penh, Loung was only five years old when her family was forced out of the city in a mass evacuation to the countryside. By 1978 the Khmer Rouge had killed Loung's parents and two of her siblings and she was forced to train as a child soldier. In 1980 she and her older brother escaped by boat to Thailand, where they spent five months in a refugee camp. They then relocated to Vermont through sponsorship by the U.S. Conference of Catholic Bishops and Holy Family Church parish in Burlington.

"The first English book I remember loving," she says, "was *Froggy Went a-Courtin'*. I can still hear the music in my head. I love the humor and silliness of it all."

Her employment history reaches back to a

> 66 In 1980 [Loung] and her older brother escaped by boat to Thailand. 99

2

local shoe store, where she sold shoes and "developed an intense dislike for smelly feet and socks." After college, she waited tables for two weeks. ("I was fired when the management team found out I was dyslexic with numbers.")

In 1995 Loung returned to Cambodia for a memorial service for the victims of the Khmer Rouge genocide and was shocked and saddened to learn that twenty of her relatives had been killed under the Pol Pot regime. This realization compelled her to devote herself to justice and reconciliation in her homeland. Upon learning about the destruction caused by residual land mines in the Cambodian countryside, Loung also set about publicizing the dangers of these indiscriminate weapons (which number in the millions).

Her memoir *First They Killed My Father: a Daughter of Cambodia Remembers* became a national bestseller and won the 2001 Asian/Pacific American Librarians Association award for "Excellence in Adult Non-fiction Literature." The book has been published in eleven countries and has been translated into German, Dutch, Norwegian, Danish, French, Spanish, Italian, Cambodian, and Japanese (and soon will be published in Greek and Hebrew).

Loung describes her writing process this way: "I handwrite my story in my journal, then flesh it out on the computer." She relies on an improbable source of inspiration while writing: "Long grain, white rice. Rice is my homing device and my security blanket. When I travel or work on a book I must have at least one bowl of rice every day. Where there is rice, I feel at home."

A featured speaker on Cambodia, child soldiers, and land mines, Loung also serves ▶

> 66 She relies on an improbable source of inspiration while writing: 'Long grain, white rice. . . . I must have at least one bowl of rice every day. Where there is rice, I feel at home.' 99

Meet Loung Ung *(continued)*

as spokesperson for the Cambodia Fund—a program that supports centers in Cambodia that help disabled war victims and survivors of land mines. She has been the spokesperson for the Campaign for a Landmine Free World (1997–2003) and the Community Educator for the Abused Women's Advocacy Project of the Maine Coalition against Domestic Violence.

Loung has spoken widely to schools, universities, corporations, and symposia in the United States and abroad (including the UN Conference on Women in Beijing, the UN Conference Against Racism in Durban, South Africa, and the Child Soldiers Conference in Kathmandu, Nepal).

She was named one of the "100 Global Leaders of Tomorrow" by the World Economic Forum.

In her spare time, Loung makes origami earrings for her friends. "I have tiny hands and fingers, which allow me to fold little paper cranes and other creatures," she says. "When my fingers get tired, I go out and ride my purple Huffy bike around the neighborhood. My bike has a very cool bell that looks like a huge eyeball. I like to ring my bell a lot."

Lucky Child is her second book. She is currently working on a historical novel.

66 'I have tiny hands and fingers, which allow me to fold little paper cranes and other creatures.' 99

Loung Ung on the Inspiration for *Lucky Child*

WHEN I WROTE *First They Killed My Father* in 1999, I was at the beginning stage of my reconnection to my sister, my family, and Cambodia. The political situation in Cambodia was unstable, poverty and disease were widespread, and the scars of war were still very raw due to ongoing battles and the continuing presence of the Khmer Rouge. I was very angry when I wrote *First*. I wanted to purge the war from my body and throw it in the faces of readers, decision makers, and people I thought should have heard my cries. I didn't want readers to have an easy read because I didn't have an easy life. In *First* I plunged readers into the depths of man's inhumanity to man—and left them there.

As a book, *First They Killed My Father* had existed within me long before I knew English. When I finally sat down to write, I knew what I wanted to say. Still, I was ill-prepared for the emotional difficulties of writing, and thought many times that I should give up. What kept me writing during those moments was the realization that I was an activist first and a writer second. The activist in me understood that I did not suffer alone the deaths and murders of my loved ones, but that I shared the pain of families from Cambodia, Rwanda, Bosnia, Sudan, and other countries. My activism enabled me to tap into my anger and passion to tell the larger stories of injustice and war when the writer in me was too heartbroken over my personal losses and pain. The act of writing eventually became a ▶

> 66 In *First They Killed My Father,* I plunged readers into the depths of man's inhumanity to man—and left them there. 99

key vehicle for my activism—it enabled me to put a human face on the many innocent civilian casualties of war, to spread the word about the Khmer Rouge genocide and to raise money to help Cambodia. The surprise success of *First They Killed My Father* kept me busy doing just that.

But then 9/11 happened, and the United States went to war in Afghanistan and Iraq. Like other Americans, I read the papers each day hoping the fighting would soon be over for everyone involved. But unlike other Americans, I knew that even after the guns had fallen silent, the war would not be over for the survivors. It was then that the idea for *Lucky Child* bloomed in my mind. In *First* I had told stories of how my family and I survived the war. With *Lucky Child* I wanted to share with readers how we survived the peace. Again, I was writing as an activist.

When I sat down to pen *Lucky Child,* I knew I wanted to tell the larger story of surviving the "peace time" through the parallel lives of Chou and me. I did not know if readers would find our stories interesting—but as a sister I found them endlessly fascinating. Like in the movie *Trading Places,* Chou and I could have easily switched lives had Meng chosen her instead of me to accompany him to America. What if Chou was meant to come to America instead of me? How would I have fared in Cambodia in an arranged marriage—raising five kids instead of marrying in my thirties and choosing not to have children?

Although *Lucky Child* took root in my mind only recently, the book was actually

> 66 When I sat down to pen *Lucky Child,* I knew I wanted to tell the larger story of surviving the 'peace time' through the parallel lives of Chou and me. 99

born the day I sat on the back of Meng's bicycle holding Chou's hands as we said our goodbyes. When Meng peddled his bicycle away, breaking Chou's hold on my hand, I turned my back to her. I knew she would not leave until I was out of sight. In *Lucky Child*, I got to stay in the village with Chou and live as her shadow—our hands never parting.

But in the real world we were separated for fifteen years, and when our palms clasped together again at our first reunion Chou broke down in tears. For Chou, the joys of our first few reunions were always clouded with the fear that another war could erupt in Cambodia and keep us apart. For me, guilt hung heavily on my body like an old wet wool poncho. My physical presence was causing my sister pain. The poncho grew heavier every time the family's talk turned to my rich and easy life in America. It inflamed my skin with shame when I remembered how I tried to erase Chou from my heart and mind. I was convinced that if Meng had chosen Chou instead of me to come to America, she would never have left me behind. She would have written, sent me dresses and food, and worried about me every day. I wondered if Chou could ever forgive me for leaving or if I could forgive myself for abandoning her. I wondered if Chou and I could have a relationship beyond the war and be together without the presence of guilt, shame, and pain. I dreamt of the day when I could throw the poncho off my body and fling it like a useless rag against the wall.

If *First* was about getting lost, being lost, and losing, then *Lucky Child* was about ▶

> ❝ My physical presence was causing my sister pain. ❞

> 66 My heart was healed even more when I realized that Chou is happy in Cambodia and harbors no anger toward me for being the 'chosen one.' 99

being found, finding, and gaining. Chou and I have traveled back into our lost fifteen years numerous times and come out holding hands each time. In the process of doing this—and before I was conscious of it—I had replaced my guilt, sadness, and anger with love, family, and community. My heart was healed even more when I realized that Chou is happy in Cambodia and harbors no anger toward me for being the "chosen one."

When I approached Chou about doing a book that would tie our lives together she welcomed the idea. Before I began I showed Chou the detailed outline of the book and let her know she had final editing power. I am happy to report that she loved the book and gave me her blessing. I find it a truly wondrous thing when words and stories can heal the broken hearts of children and adults as this book has done for Chou and me. We hope readers will feel the same about *Lucky Child* and read it as another volume of our family's love story—and our love story for Cambodia. 〜

"A Birthday Wrapped in Cambodian History"

*The following Op-Ed piece by Loung Ung
appeared in the* New York Times *on
April 17, 2005.*

TODAY IS MY BIRTHDAY. April 17 is what's
written on my driver's license and other
documents. But I don't know for sure and
probably never will. All I know is that I was
born in Cambodia sometime during 1970.

In Cambodia we didn't celebrate birthdays,
so while my mother and father knew the date
I had no reason to remember it. Instead, my
early years were marked by joyous events like
the New Year, the Water Festival, and various
Buddhist holidays.

In the early 1970s Southeast Asia was full
of strife—the Soviet Union, China, and the
United States were fighting in Vietnam, Laos,
and Cambodia. But my earliest years were
wonderfully free of war and conflict. My
father was a high-ranking military officer—
which meant a privileged lifestyle. Our house
was filled with food and toys and even had a
washing machine and an indoor toilet. I spent
my days fighting with my three sisters and
spying on my three brothers as they danced
to Beatles' songs in their bell-bottom trousers.
We went to school six days a week, and on
Sundays we swam or watched movies at the
international youth club in Phnom Penh.

On April 17, 1975, the Communist Khmer
Rouge regime took over our country and
my charmed life came to an abrupt end. I
remember that day well. I was on the street
playing hopscotch with one of my sisters
when rows of mud-covered trucks drove by. ▶

> 66 In Cambodia
> we didn't celebrate
> birthdays, so while
> my mother and
> father knew the
> date I had no
> reason to
> remember it. 99

"A Birthday Wrapped in Cambodian History" *(continued)*

Men in uniform on the trucks were yelling into bullhorns—ordering us to leave our homes. They said that the Americans were going to bomb us and if we didn't leave we would die. Chaos and fear swept through Phnom Penh. More than two million people were evicted in less than seventy-two hours. Later we heard that those who refused to leave were shot dead.

My family was forced to march to a remote village. There we lived without religion, school, music, clocks, radios, movies, television, or any modern technology. The soldiers dictated when we ate, slept, and worked. Desperate to eliminate any threats (real or perceived) to their plans for the country, the soldiers proceeded to execute teachers, doctors, lawyers, architects, civil servants, politicians, police officers, singers, and actors.

While children elsewhere in the world watched TV, I watched public executions. While they played hide-and-seek with their friends, I hid in bomb shelters with mine (when a bomb hit and killed my friend Pithy, I brushed her brains off my sleeve). I will never forget the day they came for my father. They said they needed him to help pull an oxcart out of the mud. As he walked off with the soldiers, I did not pray for the gods to spare his life. I prayed only that his death be quick and painless. I was seven years old.

My war ended in 1979 when the Vietnamese invaded Cambodia and defeated the Khmer Rouge's army. But it was too late for the 1.7 million Cambodians killed (almost a third of the country's population of seven

❝ While children elsewhere in the world watched TV, I watched public executions. ❞

million). Among the victims were my parents and two sisters. My birth date died with them.

In 1980, my oldest brother Meng found a fishing boat that would take us from Cambodia to a refugee camp in Thailand— from where we would eventually be sent to America. Because we could afford to buy only three seats on the boat, the family decided that Meng and I (along with Meng's wife) would make the trip—leaving behind our three surviving siblings.

When we arrived at the camp Meng had to fill out the refugee papers—which asked for my date of birth. He chose April 17—the day the Khmer Rouge took over our country. With a few strokes of his pen he made sure I would never forget Cambodia.

Of course I knew April 17 wasn't really the day I was born, but I loved the American custom of celebrating birthdays. I was excited as each one approached, but I also felt sad and guilty. It was hard to be joyful on a date so many associated with death. In my early twenties I stopped celebrating my birthday, hoping to leave Cambodia and the dead behind.

It wasn't until 1995—fifteen years after leaving Cambodia—that I had the courage to go back. My anxieties increased and my nightmares returned. Though I was eager to see my relatives, I was also filled with guilt knowing that while I had enough food to eat, attended school, and played soccer in America, my sister and her family lived without electricity and running water and struggled to grow their own food in fields littered with land mines. ▶

> **In my early twenties I stopped celebrating my birthday, hoping to leave Cambodia and the dead behind.**

11

"A Birthday Wrapped in Cambodian History" *(continued)*

And when I emerged from customs in Phnom Penh—smiling and dressed like an American traveler in loose-fitting black pants, a brown T-shirt, and sporty black sandals—I was greeted by frowns. "You look like a Khmer Rouge," a cousin announced, meaning my clothes resembled the uniform worn by the soldiers. I realized then that the Khmer Rouge will affect me forever.

Since that awkward first visit, I have returned to Cambodia more than twenty-five times. My heart still breaks when I think about the Khmer Rouge—their corruption, their cruelty, their murderousness, and the devastating poverty they left behind. The sadness turns to anger when I think that, thirty years to the day since the horrific takeover, the surviving Khmer Rouge leaders have not been punished (although an international tribunal is within tantalizing reach).

But when my thoughts turn from the genocide to its survivors, I am immensely proud. Our people have been waiting twenty-six years for justice, but we have stayed strong, resilient, and hopeful. On this anniversary date and on my birthday, these are the strengths that support me when the dark memories resurface. My Cambodia today is beautiful, even as it continues to recover from the killing fields. It is also filled with new memories of life and love shared by a new generation of Cambodians and a new generation of Ungs. I know now that no matter where I live or what my real birthday is, Cambodia will always be in my heart and soul. ∽

Reprinted by permission from the *New York Times*.

> " My Cambodia today is beautiful, even as it continues to recover from the killing fields. "

Food, Good Food!
Loung Ung's Favorite Restaurants

I LOVE TO EAT. Be it at my home, friends' homes, restaurants, ball games, or carnivals—anywhere and everywhere—I love to eat. Sadly, I was not born with any cooking skills. I am, however, blessed to be surrounded by wonderful people like my sister-in-law Eang, my sister Chou, brothers Khouy and Kim, and friends like Susan Bachurski, Jim Trengrove, Sophie Wright, and Gail Griffith who are as fabulous in the kitchen as they are elsewhere in life. And more important, they never seem to mind feeding me when I show up at their front doors.

For all you foodies out there, here are a few of my favorite restaurants and eateries in America. Check them out if you're in the area.

1. Boston, Massachusetts. Every time I'm in Boston I try to get to the Elephant Walk (http://www.elephantwalk.com/main.htm).

 This fusion French-Cambodian restaurant serves some of the freshest food I've ever tasted—and the décor is lovely enough to be a date place. I like their French stuff, but it's the Cambodian dishes that I really go for. If you're in the mood for something special, order their Somah Machou sweet-and-sour shrimp soup or their Cambodian signature dish Amok Royal.

2. Seattle, Washington. The atmosphere is casual and the food is authentic and delicious. If you're in the area don't miss ▶

> **❝** This fusion French-Cambodian restaurant serves some of the freshest food I've ever tasted—and the décor is lovely enough to be a date place. **❞**

the Phnom Penh Noodle House on 660 S. King Street, Seattle, WA 98104-2938; (206) 748-9825.

If I lived in the area I would have their number on speed dial. For a true taste of Cambodia order the Chha Khreoung—a dish made of a mixture of lime leaves, garlic, tumeric root, galangal, and lemongrass.

3. Cleveland, Ohio. Cleveland is my new hometown. When I'm not on the road I can usually be found sitting at my favorite table at Phnom Penh Restaurant (http://www.ohiorestaurant.com/). The owners are newly immigrated Cambodians who serve very authentic Khmer food. Everything is great, but make sure you try their Cambodian Crepe (Banh Cheiv).

If you're not in the mood for Asian food visit McNulty's Bier Market in Cleveland's hip new West Twenty-fifth Street district (www.bier-markt.com/ or 216-344-9944). I lobbied the owners hard about serving fried crickets with their Belgian beers but unfortunately they didn't go for it. Don't be surprised if you see me behind the bar serving drinks. I get free food for working there.

> 66 I lobbied the owners hard about serving fried crickets with their Belgian beers. 99

4. Washington, D.C. There are so, so many fabulous restaurants here, but my all-time favorite is Thaiphoon in Dupont Circle (www.thaiphoon.com/). When I lived in D.C. I ate there four or five times a week. No kidding! Their Drunken Noodles is my absolute favorite!

5. Los Angeles, California. I admit I am biased on this one. My brother Kim is a wonderful cook and baker specializing in French pastries. Whenever I visit him in L.A. he sends me home with Tupperware and bags full of French baguettes, little cakes, and other goodies. If you want to try my brother Kim Ung's delicious food, visit him at his store: Max Bakery, 4233 W. Century Blvd., Inglewood, CA 90304. ∾

Have You Read?
More by Loung Ung

FIRST THEY KILLED MY FATHER

Loung Ung's *First They Killed My Father* is an unforgettable narrative of war crimes and desperate actions, the remarkable strength of a small girl and her family, and a triumph of human spirit over oppression. Loung Ung, one of seven children of a high-ranking government official, lived in Phnom Penh until the age of five. She was a precocious child who loved the open city markets, fried crickets, chicken fights, and sassing her parents. When Pol Pot's Khmer Rouge army stormed into Phnom Penh in April 1975, Ung's family fled their home and moved from village to village—hiding their identity, their education, and their former life of privilege. Eventually the family dispersed in order to survive. Loung was trained as a child soldier in a work camp for orphans, while other siblings were sent to labor camps. As the Vietnamese penetrated Cambodia and destroyed the Khmer Rouge, Loung and her surviving siblings were slowly reunited. Bolstered by the bravery of one brother, the vision of the others, and the gentle kindness of her sister, Loung forged on to create for herself a courageous new life.

"There can be absolutely no question about the innate power of [Ung's] story, the passion with which she tells it, or its enduring importance."
—*Washington Post Book World*

Don't miss the next book by your favorite author. Sign up now for AuthorTracker by visiting www.AuthorTracker.com.